T0177536

Mirror-Touch Synaesthesia

Mirror-Touch Synaesthesia

Thresholds of Empathy with Art

Edited by

DARIA MARTIN

OXFORD

UNIVERSITY PRESS

UNIVERSITY PRESS

Great Clarendon Street, Oxford, OX2 6DP,
United Kingdom

Oxford University Press is a department of the University of Oxford.
It furthers the University's objective of excellence in research, scholarship,
and education by publishing worldwide. Oxford is a registered trade mark of
Oxford University Press in the UK and in certain other countries

© Oxford University Press 2018

The moral rights of the authors have been asserted

Impression: 1

Published in the United States of America by Oxford University Press
198 Madison Avenue, New York, NY 10016, United States of America

British Library Cataloguing in Publication Data
Data available

Library of Congress Control Number: 2017933149

ISBN 978–0–19–876928–6

Printed in Great Britain by
Bell & Bain Ltd., Glasgow

In loving memory of
Rebecca Loncraine (1974–2016), writer, synaesthete
Andrew Martin (1947–2015), empath, artist, father.

Acknowledgements

As editor to this volume, I am of course first and foremost grateful to its contributors, who were intrepid in jumping into the new subject of mirror-touch and also patient in withstanding sustained conversations about their areas of expertise. Many authors also read and fact-checked parts of my introduction and others' chapters. The support of colleagues at the Ruskin School of Art, St John's College, and the Humanities Division at Oxford University, and funding from a Leverhulme International Network Award, as well as an Arts and Humanities Research Council (AHRC) Mid-Career Fellowship, provided crucial support without which the time and resources needed to edit this volume would not have been possible. My dearest thanks go to Elinor Cleghorn, postdoctoral research assistant and now mirror-touch expert, who devoted two years of her time to meticulous investigation of the condition and the many fields into which this volume reaches; to enthusiastically interviewing most of the synaesthetes whose accounts form a basis for this volume; to calmly preparing the manuscript for publication, and much more. Exchanges with her have been intellectually vitalising and emotionally sustaining. Elinor helped to contact mirror-touch synaesthetes through Sean Day (US Synaesthesia Association President), James Wannerton (UK Synaesthesia Association President), and Jamie Ward (volume contributor), to all of whom I am also grateful.

This volume has arisen from a long-standing curiosity about mirror-touch, and seeds for the work were planted years ago in an exhibition at MK Gallery curated by Anthony Spira and supported by the Wellcome Trust. A symposium at Tate Modern on mirror-touch and spectatorship test-drove this volume's ideas, and I thank Marko Daniel and Sandra Sykorova for their encouragement. The ideas of Carolyn Christov-Bakargiev, Brian Dillon, and Lars Bang Larsen spurred further thought, as did others who attended the symposium. An 'I, not We' talk hosted by Melissa Gordon and a panel discussion at 'Saltwater', the 14th Istanbul Biennial, provided further opportunity to refine some of the ideas in this volume's introduction. Three think-tank discussions made space for cross-disciplinary dialogue amongst advisors to the AHRC Fellowship and others, including

Michael Banissy, Nikola Kern, Shannon Jackson, Laura U. Marks, Massimiliano Mollona, Patricia Pisters, Manos Tsakiris, James Wannerton, Jamie Ward, and Catherine Wood. Many of these advisors, together with Elinor Cleghorn, John Jervis, and Rebecca Loncraine, read drafts of this volume's introduction and gave supportive, critical feedback. Laura U. Marks and Patricia Pisters kindly offered special mentorship. Simon Baron-Cohen played devil's advocate. I am grateful for all of this dialogue, from which I personally gained so much, and from which emerged a tensile web on which this cross-disciplinary volume is built.

My gratitude goes to Martin Baum at Oxford University Press, who has been consistently encouraging and supportive. Anonymous press reviewers offered helpful suggestions for the final form of the volume. Mark Barker at Maureen Paley Gallery is always on the ball. Judy Webb, Xiao-Yen Wang, and Katie Veale helped me to carve out time to work. My loving husband Massimiliano Mollona encouraged my curiosity and provided helpful suggestions throughout the editing process.

Finally, my utmost gratitude goes to those who cannot be thanked by name: the thirteen mirror-touch synaesthetes whose testimonies were essential to this volume. Without their candour, we would not know what it is like to experience their ways of seeing.

Daria Martin

List of Contributors

Michael Banissy is a Social Neuroscientist working at Goldsmiths College, University of London, supported by an Economic and Social Research Council Future Research Leaders Award. Banissy has been, and remains, one of the world's leading researchers of mirror-touch synaesthesia, since documenting the first group study of mirror-touch in 2007. Banissy received his PhD in Cognitive Neuroscience from University College London in 2009, has authored over 50 publications, including articles on mirror-touch synaesthesia in *Journal of Neuroscience* and *Nature Neuroscience*, and has been regularly invited to present his findings at conferences and seminars around the world. His work has been widely published and broadcast, including in the *New Scientist*, *Scientific American*, BBC Radio 4, and Good Morning America. He is also regularly invited to write popular science articles and commentaries for magazines, including *AEON Magazine* and *Scientific American*.

Giuliana Bruno is Emmet Blakeney Gleason Professor of Visual and Environmental Studies at Harvard University. Her latest books are *Surface: Matters of Aesthetics, Materiality and Media* (University of Chicago Press, 2014) and *Public Intimacy: Architecture and the Visual Arts* (MIT Press, 2007). For *Streetwalking On a Ruined Map* (Princeton University Press, 1995), she won the Society for Cinema and Media Studies award for best book in film studies. Her seminal book *Atlas of Emotion: Journeys in Art, Architecture, and Film* (Verso, 2002) won the 2004 Kraszna-Krausz Book Award in Culture and History for 'the world's best book on the moving image'. Bruno is featured in *Visual Culture Studies: Interviews with Key Thinkers* (Sage, 2008) as one of the most influential intellectuals working today in visual studies.

Anthony Chemero is Professor of Philosophy and Psychology at the University of Cincinnati. He received his PhD in Philosophy and Cognitive Science from Indiana University in 1999. From then to 2012, he taught at Franklin & Marshall College (F&M) where he was Professor of Psychology. Chemero's research is both philosophical and empirical. It is focused on questions related to dynamical

modelling, ecological psychology, artificial life, and complex systems. He is author of more than 80 articles and the books *Radical Embodied Cognitive Science* (MIT Press, 2009), which was a finalist for the Lakatos Award, and *Phenomenology* (Polity Press, 2015), co-authored with Stephan Kaufer. He is currently editing the second edition of the *MIT Encyclopedia of the Cognitive Sciences*.

Elinor Cleghorn is a researcher and writer specialising in mirror-touch synaesthesia and also theories of embodiment explored through art making and spectatorship. She is editorial assistant to *Mirror-Touch Synaesthesia* and was research assistant to 'Mirror-Touch: Empathy, Spectatorship, and Synaesthesia', a project based at the Ruskin School of Fine Art, University of Oxford, between 2013 and 2015. Cleghorn received her BA and MA from Goldsmiths College, and her PhD from the London Consortium, Birkbeck College in 2012. In 2011, she programmed a season of events and screenings at the British Film Institute commemorating the 50-year anniversary of the death of avant-garde filmmaker Maya Deren, and she has since been published in *The Moving Image Review and Art Journal*, LUX Online, and *Screen*. In 2012, Cleghorn edited a volume of *International Journal of Screendance* dedicated to the work of Deren; she is also an editor of the Arts Council England-supported poetry and science journal *Litmus*.

Thomas J. Csordas is the Dr James Y. Chan Presidential Chair in Global Health, Distinguished Professor in the Department of Anthropology, Director of the Global Health Program, and Co-Director of the Global Health Institute at the University of California, San Diego. He has conducted fieldwork funded by major grants from the National Institute of Mental Health on the Catholic Charismatic Renewal Movement, examining topics including healing ritual, religious language, bodily experience, and child development; amongst Navajo Indians, examining topics including the experience of Navajo cancer patients, therapeutic process in Navajo religious healing, language, and narrative; on adolescent mental health amongst psychiatric inpatients and their families in New Mexico; and on Roman Catholic exorcism in Italy and the United States. Amongst his publications are *The Sacred Self: A Cultural Phenomenology of Charismatic Healing* (1994); *Embodiment and Experience: The Existential Ground of Culture and Self* (1994); *Language, Charisma, and Creativity: Ritual Life in the Catholic Charismatic Renewal* (1997); *Body/Meaning/Healing* (2002); and *Transnational Transcendence: Essays on Religion and Globalization* (2009).

Trisha Donnelly is an artist living and working in San Francisco. Her work has been exhibited in many solo exhibitions in international public galleries since 2005 including at Serpentine Gallery, London (2014), Museum of Modern Art, San Francisco (2013), Portikus, Frankfurt (2010 and 2006), The Institute of Contemporary Art, Philadelphia (2008), Modern Art Oxford, Oxford (2007), and Kunsthalle, Zurich (2005). Group exhibitions include those at The Tanks, Tate Modern, London (2016), Astrup Fearnley Museum, Oslo (2015), The Venice Biennale (2013), and the Museum of Modern Art, New York (2012). Donnelly is the recipient of a number of awards including, most recently, the Wolfgang Hahn Prize, Museum Ludwig, Cologne (2017). Donnelly's work is in the permanent collection of many museums internationally including the Solomon R. Guggenheim Museum, New York, the Walker Art Center, Minneapolis, and the Whitney Museum of American Art, New York.

Vittorio Gallese is Professor of Physiology at the Department of Medicine and Surgery, Unit of Neuroscience, of the University of Parma, Italy; Professor in Experimental Aesthetics at the Institute of Philosophy of the School of Advanced Study of the University of London, UK; and Adjunct Senior Research Scholar at the Department of Art History and Archeology of Columbia University, New York, USA. A cognitive neuroscientist, his research interests focus on the cognitive role of the motor system and on an embodied account of social cognition. His major contribution is the discovery, together with his colleagues of Parma, of mirror-neurons and the elaboration of a theoretical model of social cognition— the embodied simulation theory. He has worked at the University of Lausanne, at the Nihon University of Tokyo, and at the University of California at Berkeley. He received the Grawemeyer Award for Psychology in 2007, the Doctor Honoris Causa from the Catholic University of Leuven in 2010, and the Arnold Pfeffer Prize for Neuropsychoanalysis in 2010.

Judith Hopf is an artist who lives and works in Berlin. She works across a variety of media, including film, sculpture, installation, and performance. She has had solo exhibitions at the Neue Galerie Kassel (2015), Grazer Kunstverein (2012), Badischer Kunstverein, Karlsruhe (2008), Portikus, Frankfurt/Main (2007), and the Wiener Secession, Vienna (2007). Her recent solo exhibition *Testing Time* at Studio Voltaire, London (2013) presented a new film commission, works of sculpture, and a specially conceived installation environment. Hopf has

participated in festivals and group exhibitions, including the Liverpool Biennial (2014), *dOCUMENTA(13)* (2012), Internationale Kurzfilmtage Oberhausen (2007), and the Bienal de la Habana (2003).

Siri Hustvedt is the author of a book of poetry, six novels, three books of essays, and a non-fiction work about the quandaries of psychiatric and neurological diagnoses. In 2012, she received the International Gabarron Prize for Thought and Humanities. Her most recent novel *The Blazing World* was nominated for the 2014 Man Booker Prize and won The Los Angeles Times Book Prize for Fiction. She has a PhD in English literature from Columbia University and is a lecturer in psychiatry at the Dewitt Wallace Institute for the History of Psychiatry at Weil Medical School of Cornell University in New York City. Her work has been translated into over 30 languages.

Wayne Koestenbaum—poet, critic, artist—has published 18 books, including *The Queen's Throat, Humiliation, Hotel Theory, Jackie Under My Skin, Best-Selling Jewish Porn Films,* and *The Anatomy of Harpo Marx*. His newest books are *Notes on Glaze: 18 Photographic Investigations* (Cabinet Books, 2016) and *The Pink Trance Notebooks* (Nightboat Books, 2015). He has had solo exhibitions of his paintings at White Columns (New York), 356 Mission (Los Angeles), and the University of Kentucky Art Museum. He received a BA from Harvard University, an MA from Johns Hopkins University, and a PhD from Princeton University. He lives in New York City where he is Distinguished Professor of English at the City University of New York Graduate Center. His first piano/vocal record, *Lounge Act*, was issued by Ugly Duckling Presse Records this year.

Mark Leckey is an artist who has exhibited widely in the UK and internationally, and has recently had solo exhibitions at the Serpentine Gallery, London (2011); Kölnischer Kunstverein, Cologne (2009); Portikus, Frankfurt (2005); and Migros Museum, Zurich (2003). He has been included in several important international exhibitions, including *10,000 Lives: The Eighth Gwangju Biennale* (2010); *Moving Images: Artists & Video/Film,* Museum Ludwig, Cologne (2010); *Playing Homage,* Contemporary Art Gallery, Vancouver (2009); *Sympathy for the Devil,* Museum of Contemporary Art, Chicago (2007); 9th Istanbul Biennial (2005); and Manifesta 5, European Biennial of Contemporary Art, San Sebastian (2004). Leckey has presented his lecture/performances at the ICA, the Solomon R. Guggenheim,

New York, and the Museum of Modern Art (MoMA), New York. In 2008, Leckey received the Turner Prize. From 2005 to 2009, Leckey was Professor of Film Studies at the Städelschule in Frankfurt am Main. His work is included in the collections of the Centre Georges Pompidou, Paris; Museum of Contemporary Art, Los Angeles; MoMA; Tate Gallery, London; and the Walker Art Center, Minneapolis.

Laura U. Marks works on media art and philosophy, often focusing on the Arab world and Islam. Her most recent books are *Hanan al-Cinema: Affections for the Moving Image* (MIT Press, 2015) and *Enfoldment and Infinity: An Islamic Genealogy of New Media Art* (MIT Press, 2010). She curates programmes of experimental media for festivals and art spaces worldwide. Marks teaches in the School for the Contemporary Arts at Simon Fraser University, Vancouver, Canada, where she is the Grant Strate University Professor.

Daria Martin, artist, has researched mirror-touch synaesthesia for several years and made it the centre of three 16mm-films: *Sensorium Tests* (2012), *At the Threshold* (2014–2015), and *Theatre of the Tender* (2016). Martin's films aim to create a continuity between disparate artistic media (such as painting and performance), between people and objects, and between internal and social worlds. Martin is currently Professor of Art at the Ruskin School of Art, University of Oxford. Her films have been exhibited in international biennales such as Istanbul and Shanghai, and in solo shows at ACCA Melbourne; Museum of Contemporary Art, Chicago; the New Museum, New York; the Hammer Museum, Los Angeles; Kunsthalle Zürich; Stedelijk Museum, Amsterdam; The Showroom, London; and Tate Britain. Martin's work is in the permanent collections of foundations and public galleries such as Tate, London and the Whitney Museum of American Art, New York.

Brian Massumi is Professor of Communication at the University of Montreal. His most recent books include *Ontopower: War, Powers, and the State of Perception* (Duke UP, 2015), *Politics of Affect* (Polity, 2015), and *What Animals Teach Us about Politics* (Duke UP, 2014). He is co-author with Erin Manning of *Thought in the Act: Passages in the Ecology of Experience* (University of Minnesota Press, 2014). Also with Erin Manning and the SenseLab collective, he participates in the collective exploration of new ways of bringing philosophical and artistic practices into collaborative interaction.

Massimiliano Mollona is a visual anthropologist, writer, and filmmaker. He is Senior Lecturer in the Department of Anthropology at Goldsmiths College, University of London, and has carried out extensive fieldwork on the steel industry in Europe, and in Brazil where he is involved in several film projects. Mollona's publications bring together economics, political anthropology, and art and film theory. Amongst his most recent publications are *Made in Sheffield: An Ethnography of Industrial Work and Practice* (Berghahn, 2009); *Seeing the Invisible: Maya Deren's Experiments in Cinematic Trance* (October, Summer 2014); and *Working Class Politics in a Brazilian Steel-Town* (CUP, 2015). Mollona was one of the artistic directors of the Bergen Assembly 2016 (Norway) and the artistic and programme director of the Athens Biennale 2015–17 (Athens).

Rabih Mroué was born in Beirut and currently lives in Berlin, is a theatre director, actor, visual artist, and playwright. He is a contributing editor for *The Drama Review/TDR* (New York) and the quarterly *Kalamon* (Beirut). He is also a co-founder and was a board member of the Beirut Art Center (BAC). He was a fellow at The International Research Center: Interweaving Performance Cultures/FU/Berlin 2013–2014. He has been a theatre director at Münchner Kammerspiele (Munich) since 2015. His works include: *Rima Kamel* (2017), *So Little Time* (2016), *Ode to Joy* (2015), *Riding on a Cloud* (2013), *33 RPM and a Few Seconds* (2012), *The Pixelated Revolution* (2012), *The Inhabitants of Images* (2008), *Who's Afraid of Representation* (2005), and others.

Christopher Pinney is an anthropologist and art historian. He is Professor of Anthropology and Visual Culture at University College London. His research interests cover the art and visual culture of South Asia, with a particular focus on the history of photography and chromolithography in India. Pinney's publications include *Photography's Other Histories* (edited with Nicolas Peterson, Duke University Press, 2003), *The Coming of Photography in India* (British Library, 2008), and *Photography and Anthropology* (Reaktion Books, 2011). His most recent book (together with the photographer Suresh Punjabi) is *Artisan Camera* (Tara Books, Chennai, 2013). He was awarded a Padma Shri by the Government of India in 2013 for contributions to literature and education.

Patricia Pisters is Professor of Film Studies at the Department of Media Studies of the University of Amsterdam and Director of the Amsterdam School

for Cultural Analysis (ASCA). She is one of the founding editors of *Necsus: European Journal of Media Studies*. She is Programme Director of the research group Neuraesthetics and Neurocultures and co-director (with Josef Fruchtl) of the research group Film and Philosophy at ASCA. Publications include *The Matrix of Visual Culture: Working with Deleuze in Film Theory* (Stanford University Press, 2003); *Mind the Screen* (ed. with Jaap Kooijman and Wanda Strauven, Amsterdam University Press, 2008); and *The Neuro-Image: A Deleuzian Film-Philosophy of Digital Screen Culture* (Stanford University Press, 2012). For more information and articles, see http://www.patriciapisters.com.

Joel Salinas, MD, MBA, MSc, is a mirror-touch synaesthete, a neurologist, a writer, and a researcher at Harvard Medical School and Massachusetts General Hospital. He studies how social relationships influence brain health and has a clinical subspecialty in behavioural neurology and neuropsychiatry. Through clinical care, healthcare delivery innovations, and research, he focuses on enhancing population-wide brain health. Dr Salinas has helped provide special insights into the editor's study of synaesthesia through his own experiences as a mirror-touch synaesthete.

Carolee Schneemann (b. 1939, Illinois) received a BA from Bard College and an MFA from the University of Illinois. She holds Honorary Doctor of Fine Arts degrees from the California Institute of the Arts and the Maine College of Art. Schneemann's work has been exhibited worldwide at institutions, including the Los Angeles Museum of Contemporary Art (US), the Whitney Museum of American Art, New York (US), the Centre Georges Pompidou, Paris (France), The Reina Sophia Museum, Madrid (Spain), and the Museum of Modern Art, New York (US). In 1997, a retrospective of her work entitled 'Carolee Schneemann, Up To and Including Her Limits', was held at the New Museum of Contemporary Art, New York. Schneemann's work is included in many important collections such as Centre Georges Pompidou, Paris (France); Hamburger Bahnhof Museum, Berlin (Germany); Hirschhorn Museum, Washington DC (US); Institute of Contemporary Art, London (UK); Institute of Contemporary Art, Chicago (US); Los Angeles Institute of Contemporary Art, Los Angeles (US); Museum of Modern Art, New York (US); New Museum of Contemporary Art, New York (US); Rhode Island School of Design Museum, Providence (US); The Whitney Museum of Art, New York (US); and many others. In autumn 2015, the

Museum Der Moderne Salzburg will hold a retrospective of Schneemann's work, curated by Sabine Breitwieser. Schneemann was awarded the Golden Lion for Lifetime Achievement at the 2017 Venice Biennale.

Fiona Torrance is a multiple synaesthete, predominantly with mirror-touch synaesthesia. Fiona is a self-employed social value consultant and also runs a small cat-grooming business. She has contributed editorial for the UK Synaesthesia Association, experiences to Joel Salinas' *Mirror-Touch* book, and insight for the *Secrets of the Brain* series about mirror-touch. Fiona has passed her PhD viva in Humanities and Social Science and is currently re-submitting her thesis, *Critical Ethnography—How learning sensory disabled people influence technology in work*. Her research aims to promote digital and economic inclusion of learning and sensory disabled people in the UK.

Jamie Ward is Professor of Cognitive Neuroscience at the University of Sussex. His research in the area includes its neural basis and development, the effects it has on cognition, and its relationship to typical modes of perceiving. Ward has contributed to the public understanding of synaesthesia through numerous talks and extensive media coverage, including a documentary produced for the BBC's *Horizon* series. He is the editor-in-chief of *Cognitive Neuroscience*, and the author of several books including *The Frog Who Croaked Blue: Synaesthesia and the Mixing of the Senses* (Routledge, 2008).

Catherine Wood is Curator of Contemporary Art and Performance at Tate Modern since 2003, when she founded the live programme. She was curator of *A Bigger Splash: Painting After Performance*, and co-programmed the opening of the Tanks, *Art in Action*, in 2012. She has organised numerous performance events with artists, including Mark Leckey, Joan Jonas, Katerina Seda, Keren Cytter, and Boris Charmatz/Musée de la Danse, as well as co-curating *Pop Life* (2010) and *The World as a Stage* (2007). She is author of *Yvonne Rainer: The Mind is a Muscle* (MIT/Afterall 2007) and writes for *Artforum*, *Afterall*, *Frieze*, *Kaleidoscope*, *Mousse*, and *Flash Art* magazines. She recently curated *Yvonne Rainer: Dance Works*, which opened at London's Raven Row in July 2014 and is currently working on the opening programmes and displays for the new building at Tate Modern, opening in 2016.

Sha Xin Wei is Professor and Director of the School of Arts, Media + Engineering (AME) at Arizona State University. Sha also directs the Synthesis Center for responsive environments and improvisation with colleagues in AME and affiliate research centres. From 2005 to 2013, Sha was the Canada Research Chair in Media Arts and Sciences and Associate Professor of Fine Arts at Concordia University in Montréal, Canada. From 2001 to 2013, he directed the Topological Media Lab, an atelier-laboratory for the study of gesture and materiality from computational and phenomenological perspectives. Sha's research concerns ethico-aesthetic improvisation and a topological approach to morphogenesis and process philosophy. He is the author of *Poesis, Enchantment, and Topological Matter* (MIT Press, 2013).

Table of Contents

SECTION I

Introduction

Introduction

Daria Martin

Synaesthetic experience is layered. It's like standing on the street looking into a window. You can focus on the contents of the window, or you can shift your focus to the reflections of the street.[1]

Nicola Mamo, mirror-touch synaesthete

. . . a confusion of voice and sight becomes the metaphor for the ground of the rational Situated knowledges are about communities, not about isolated individuals. The only way to find a larger vision is to be somewhere in particular.[2]

Donna Haraway

PART 1

Background: This Volume's Beginnings

A New Synaesthesia in the Arts

Synaesthesia has long been celebrated by artists as a 'larger vision', an expansion of conventionally available sense. Synaesthesia is, after all, a crossing or mixing of the senses in which a stimulus in one modality provokes an 'extra' perception in another modality. Hearing colours, tasting words, and smelling shapes are all examples of real-life synaesthetic experience, manifestations of the hard-wired neurological condition experienced by one in 20 people. Developmental synaesthesia is not conjured up but rather is perceived automatically, as part of the fabric of everyday life. It is robust and lasts a lifetime.[3]

But synaesthesia is also an artistic trope, a provocation to the imagination, a transference of meaning across seemingly distinct realms. Synaesthesia has been reimagined as artistic form by romantics, modernists, hippies; the French symbolist Charles Baudelaire announced in his poem 'Correspondences' that: 'perfumes, colours, tones answer each other '[4] Because synaesthesia breaks down barriers or crosses thresholds, it has been imagined as a door of perception to spiritual worlds.[5] Because it multiplies sensation, it has been upheld as a model of generative excess. Representing an extreme of subjective perception, it has, along with schizophrenia, been championed in the arts as the modernist neurological difference par excellence. Synaesthetes were once, and are still sometimes, celebrated not only for their exceptional ways of experiencing vision, but also, romantically, for **being** visionaries.[6]

The first case of synaesthesia was reported in 1812[7] and by late nineteenth and early twentieth centuries, Europe saw an explosion of both scientific and artistic engagement with the condition. In particular, coloured hearing—shapes and colours that dance in response to sound and music—was celebrated as manifestations of the immaterial, windows to other, more perfect worlds, even harbingers of a new, more spiritual age. Artists, poets, and musicians appropriated synaesthesia's leakages artistically—the Russian composer Alexander Scriabin created a keyboard that beamed light; the pioneer of abstraction Wassily Kandinsky aimed to create sound through his paintings.[8] These *gesamtkunstwerke* (total artworks) reached for the same pinnacles of ethereal transcendence that synaesthetes themselves were thought, at the time, to exemplify.

Coloured hearing is composed of two senses—sight and hearing—that are often described as privileged in the Western hierarchy of the senses, while the 'proximal' senses of touch, smell, and taste are relatively degraded.[9] As feminist critics have recently argued,[10] sight and hearing, 'long-distance' senses, offer the illusion of disconnection from the body and are more likely to be associated with immersion in an internal, spiritual world. Coloured hearing synaesthesia jibed well with the aspects of modernism that looked inwards (and upwards) and embraced abstraction—like the later psychedelic light shows inspired by it, this form of synaesthesia produces abstract images (floating photisms) that appear apart from the body (appearing 'in the mind's eye' or sometimes projected into space, an arm's length away) and responds to the far-reaching sense of sound. Synaesthesia, in this view, is seeing the unseen.

In contrast, mirror-touch synaesthesia, the subject of this volume, reverses this dynamic, bringing vision right up against the body, scrambling sensory hierarchies. Mirror-touch is considered a 'new' form of synaesthesia, having been identified only in 2005 and experienced by about one in 75 people.[11] Mirror-touch synaesthetes feel conscious tactile sensations on their own bodies when they see another person, or even an object, being touched. In other words, they experience touch, the most social of senses, vicariously. Theirs is an extreme form of physical empathy—a movie's fight scene batters such a synaesthete; a glimpse of a father hugging his child imparts the sensation of warm, encircling arms. Most people with mirror-touch also experience (via vision) mirror-pain, and some experience mirror-taste, mirror-smell, mirror-cold, mirrored breathing, and mirrored proprioception (the sense of our body's position in space).[12] For mirror-touch synaesthetes, vision cannot be conceived as separate from the body.

Because these mimetic sensations depend on what others experience, mirror-touch is one of only a few kinds of synaesthesia described as 'social'.[13] Unlike other forms which rely on the synaesthetes' own 'settings' so to speak (for some with coloured hearing, a trumpet's blare will always be yellow; for others, always magenta),[14] mirror-touch relies on outside contact for its form. Mirror-touch bends to the world, responsive to relationships within it. The variegations of these impressions are endless and potentially invasive. James Wannerton, the UK Synaesthesia Association President, who has spoken to thousands of synaesthetes and who himself experiences a constant interruption of flavours and textures in his mouth when he hears words, testified that mirror-touch is the most intimate and personal kind of synaesthesia, shaping the core of those who experience it.[15] Wholly contingent, mirror-touch invites the 'seer' outside to feel, as Siri Hustvedt writes in this volume, 'deeply in and of the world'. A new synaesthesia, it offers arguably a yet 'larger vision' for the arts, one that is profoundly embodied.

A New Neuroaesthetics

Although each of the four organising sections in this volume is roughly matched to a claim made in the neuroscientific literature about mirror-touch, and sometimes synaesthesia more generally, this project as a whole does not start out from the discipline of neuroaesthetics—or if it does, its neuroaesthetics is of a new kind. Traditionally, and appropriately, neuroaesthetics constrain the study

of aesthetic experience to what can be described in current scientific thinking about the brain; for example, experiments have shown that humans generally find faces that are symmetrical more aesthetically pleasing than asymmetrical ones.[16] Research in this area is based on knowledge about the visual system of the brain and often focuses on beauty to probe why we, as a species, appreciate certain forms.[17] Within the context of contemporary art discourse, however, this approach to aesthetics is sorely inhibiting. In this volume, neuroaesthetics are allowed more breadth than when delimited by what is currently accepted in peer-reviewed neuroscience journals, thus pressing forward new kinds of questions.

The textures of human consciousness—what it actually feels like to experience the world—give way to the 'objectively' described science of the brain in only oblique ways. For over a century, neuroscientists have attempted to track neural correlates to our lived, subjective experiences, and for much of the twentieth century, the paradigm of behaviourism, which relies on external measurability, has limited the kinds of questions asked. Since the 1980s, however, following a shift within neuroscience to cognitive psychology and coinciding with a further shift to cognitive neuroscience, studies fuelled by new technologies, such as functional magnetic resonance imaging (fMRI) and electroencephalography (EEG), have probed the internal workings of the mind in increasingly intricate ways.[18] Discoveries that imply a fluid sense of self, the primacy of emotion in reasoning, and the continuity between watching and feeling others' actions have created a sea change within the field of neuroscience. This shift means that neuroscientists are now more interested than ever in so-called 'subjective' states, including the highly subjective neurological condition of synaesthesia.

All scientific investigation of synaesthesia—all hypothesising, stroop testing, fMRI scanning, or other experimentation—is preceded by synaesthetes' self-report. Most manifestations of the condition are, after all, difficult to predict; one of the first documented synaesthetes, the Russian mnemomist Solomon Shereshevsky, described seeing, in response to Sergei Eisenstein's voice, 'a flame with fibers protruding from it';[19] the contemporary synaesthete Michael Watson reported to the neurologist Richard E. Cytowic that sour flavours create the tactile sensation of a sharp object, 'like laying my hand on a bed of nails'.[20] You can't make this stuff up; only the subjectively experiencing synaesthete can inform scientists of what curious new sense-crossings they might hunt for, and this is just how the neuroscientist Jamie Ward, contributor to this volume, and his colleagues first encountered mirror-touch—a young student responded to a

generic email call for synaesthesia test subjects with an unexpected reply: 'I think I might have synaesthesia: I feel touch when I see others being touched'. Ward then proceeded to 'discovery', testing this new synaesthesia in the lab and giving it a name (not a 'diagnosis', as synaesthesia is considered a condition, not a pathology). As scientists like Ward parse new synaesthesias, they help to create new identities in the larger public, beyond the small experimental pool. As synaesthetes encounter these new namings, often through social media and chat sites dedicated to synaesthesia, they send out regular ripples of excitement and affirmation: 'I never knew that seeing auras was a form of synaesthesia!'; 'I'm not squeamish after all; I'm a mirror-touch synaesthete!'[21]

The 'I' in these statements is striking, and the field of neuroscience has not ignored them. Recent developments in 'first-person neuroscience' acknowledge that a new method of investigating neuronal states must be guided by subjective mental states, for example by the subjects' reported emotions,[22] and this approach is commonly used in synaesthesia research. Yet more recently, a 'second-person neuroscience' ('you' or 'we') that brings real-time social encounters into the lab for measurement to produce biological models for how we interact, has emerged.[23] Further, some have proposed that first- and second-person neuroscience cannot be approached in isolation, since social relations are contingent on the subjective perceptions of those engaged in those relations.[24] And yet, none of these perspectives take into account the second-person perspective of scientist towards subject, or subject towards scientist. Following the philosophers of science Isabella Stengers, Bruno Latour, and Donna Haraway, this volume, as a whole, implies ways that scientists and their subjects might create active relationships that influence how, in this case, synaesthesia is conceived and even experienced.[25]

Mirror-touch synaesthetes' first-hand testimonies are crucial to this volume, which includes chapters by Hustvedt, the neurologist Joel Salinas, and the neurodiversity activist Fiona Torrance, all of whom experience mirror-touch and testify to its gifts. In addition, the volume is undergirded at a deeper layer by first-hand report; through both scientific and social groups, the mirror-touch researcher Elinor Cleghorn and I contacted and interviewed at length 13 mirror-touch synaesthetes about their perceptions of the social world and of art. Quotes from these interviews appear throughout the volume and in an edited selection at its end. Starting from these critically supportive accounts, the contributors to this volume, who are scholars and practitioners in other fields, have explored what

mirror-touch evokes transversally for them. Together, they have fashioned new webs of meaning or, what Haraway calls, 'situated knowledges'[26]—mirror-touch is here a conduit for connecting art, science, and the humanities that takes into account the positions of everyone involved.

A Part For a Whole

It may seem presumptuous to ask non-synaesthetes to write, inspired by synaesthetic experiences. One might ask initially: is mirror-touch merely a metaphor here, and if so, what is it a metaphor **for**? It's a natural question, in part because other unusual physical conditions, like the use of prostheses, have been put to hard metaphorical work in the humanities. The question also arises because synaesthesia and metaphor are both transpositions, of sense or of meaning; they are similar in their structure of slippages; in fact, the psychologist Lawrence Marks has argued that the two have a common basis in the brain.[27] And although mirror-touch is a consummately sensuous experience, this volume's text-heavy exploration of the condition begs a rhetorical position couched in language. Finally, metaphor appeals because it is culturally formative and thus holds the possibility of political and social traction. Beginning in '*Metaphors We Live By*', the linguists George Lakoff and Mark Johnson argued that metaphor is not only a flourish of language but is intrinsically bound up in the ways we negotiate the world on a day-to-day basis. Metaphor is based in the body and shaped by our bodily orientation; for example, we 'face' a challenge.[28]

As I implied earlier by the leading quote of this introduction and my argument that mirror-touch brings vision close to the body, this volume, as a whole, offers up a metaphor that contradicts that of 'sight as transcendence' or 'a conquering gaze from nowhere'[29] as a stand-in for (scientific) knowledge. Might mirror-touch, described here in first-person report and then reimagined by others, act as a metaphor not so much for otherworldliness or oneness with spirit, as synaesthesia was for the Symbolists and Romantics, but as a metaphor for partiality, for being 'in and of the world'? Mirror-touch implies knowledge produced through the lived, contingent body. It affirms findings in the field of embodied cognition that insist that the body and its surroundings (and not only the brain) are essential to cognition and rejects Cartesian 'computation' as a valid model for thinking.[30] For some authors in this volume, mirror-touch evokes a Deleuzian

'transcendental empiricism' that includes (rather than contradicts) being in and of the world.[31]

This larger metaphor—embodied sight as embodied insight if you will—forms the backdrop for this volume. But within it nests a more immediate relationship to mirror-touch through another figure of speech, that of 'metonym'—in other words, in parallel with normative experience.[32] While both metaphor and metonym are figures of speech, in which a concept is called not by its own name but by another, the conceptual distinction between the two is important. In metaphor, the substitution is made for something physically unassociated (therefore highlighting the similarities between the two; 'you are the light of my life'), while in metonymy, the substitution is made based on close association ('Hollywood' for the mainstream film industry). A certain kind of metonymy, synecdoche, substitutes a part for the whole ('wheels' for a car). This mode of combination, as Lakoff and Johnson and the influential French psychoanalyst Jacques Lacan before them have elaborated, joins elements together that share a context and, as such, comes with both a shared meaning and an implication of difference.[33] In this volume, mirror-touch synaesthetes, part of the general population, represent the way we all look and feel. We are all eligible for these experiences, even as, paradoxically, we recognise them as distinct.

This rhetorical position has scientific support. Broadly speaking, we all emerge from a synaesthetic ground. There is strong evidence that human babies experience synaesthesia in the normal course of their development and that these early neural connections are later in life 'pruned' as brains develop.[34] Vestiges of cross-modal sense perception stay with us throughout our life; for example, our sense of taste is intrinsically bound up with our sense of smell.[35] It is also now well known that sensory systems act in concert and not in isolation; a louder crackle will enhance the flavour of a potato chip.[36] Additionally, we make cross-modal transpositions in language, such as 'loud colours' that express common 'synaesthetic' associations, similar to those experienced by coloured-hearing synaesthetes.[37]

These are only some of the ways that all of us are broadly, if not clinically, synaesthetic. But there is also a way in which we are particularly close to mirror-touch. A leading scientific theory of the condition, the 'Threshold Theory', describes it as intrinsically related to a highly common brain mechanism.[38] This theory sees mirror-touch as an exaggeration of an unconscious mimetic

responsiveness we all share, heightened to the point at which it pierces through the threshold of consciousness. When the rest of us see someone's face coiled in pain, our own face may tighten; when we watch a caress, our skin may tingle. These and other moments of physical imitation are likely subtle manifestations of another recent and groundbreaking discovery in neuroscience—mirror (neuron) systems.

Mirror neurons are a special class of cells first discovered in the brains of macaque monkeys in 1992 by a group of neuroscientists in Parma, Italy (including Vittorio Gallese, contributor to this volume). The scientists found that single neurons in the monkey fired both when the animal performed an action (lifting a cup, tearing a piece of paper) and, equally, when it merely watched another monkey or person performing that same action.[39] It was as if the neuron was experiencing, vicariously, what was seen, covertly simulating the sensations of others. Although individual neurons cannot practically and ethically be studied in humans, scientists have identified networks of these cells, called mirror systems, that similarly rehearse actions when they are observed—automatically and unconsciously imitating others' somatic states.

The implications of this discovery are controversial and potentially huge; many have claimed that these mirror systems, which disregard the difference between self and other, are a basic organisational feature of our brain that enables intersubjective experience. Mirror systems have been heralded as the source of empathy, a way to grasp others' minds without recourse to reasoning—the so-called 'simulation theory' of empathy.[40] What is agreed, more modestly, is that understanding the tactile sensation of others is a fundamental component of human social capacity and that mirror systems likely play some part in that process of understanding. In day-to-day living, this mimicked touch happens physiologically at a level below the radar of our awareness.

But for mirror-touch synaesthetes, these touches are **not** subliminal; they exceed the threshold of consciousness and are vividly felt. The Threshold Theory of mirror-touch once more suggests that mirror systems are in overdrive in these synaesthetes, who are consequently able to directly sense and articulate a process which structures our human experience.[41] These synaesthetes experience conscious participation in systems that are unconscious to the rest of us. They may also be able to tell us more about the ways that art affects us and about new ways in which we as viewers may 'participate'.

Experience and Participation in Art

Direct participation in art, fashionably glossed as 'social' since the early 90s, has gained urgency since the global economic crisis of 2008. Broad banners used to describe this turn include the terms 'relational aesthetics', celebrated by art curator and critic Nicolas Bourriaud, 'participatory art', coined by the art theorist Claire Bishop, and 'social practice' used within American academic circles,[42] and gather under their domain artworks as diverse as Santiago Sierra's hiring of workers to sit immobilised inside cardboard boxes in a gallery,[43] Phil Collins' real-time video of teenagers dancing to exhaustion in Ramallah,[44] and Tania Bruguera's art academy in her Havana home.[45] Activist art, community art, and artworks that borrow from ethnographic methods[46] approach the meaning of 'the social' in diverse ways—some artists are interested in concrete political change, while others embrace embodiment and collectivity as a medium.[47] Marxist approaches have criticised the art object as a site of commodification and the image as complicit with consumer capitalism. Many artworks of the social turn, therefore, dissolve the art object and image, in favour of the live event (although this is often represented in gallery spaces in the form of documentation). But as much of this work leaves behind an ever increasing accumulation of objects within a materialist world, merging art with life, it risks, as Bishop argues in *Artificial Hells*, relinquishing the affective power of the artistic image itself.[48]

I will, for a moment, rewind history several decades to a moment that anticipated this work, in order to propose one of this volume's focal points—an alternative, parallel trajectory for 'the social' in art spectatorship that points towards other possibilities. The seed for participatory art[49] was arguably planted in the early 60s; it is one outgrowth of art's embrace of phenomenology, the philosophical study of the structures of experience and consciousness. Phenomenology rejected Cartesian dualism that separated body and mind ('I think, therefore, I am'); the influential phenomenologist Maurice Merleau-Ponty's rejoinder to Descartes's famous statement was 'The world is not what I think but what I live through'.[50] Minimalist sculptors of the 1960s like Robert Morris were attracted to Merleau-Ponty's celebration of 'the primacy of perception' and his descriptions, in the *Phenomenology of Perception* (translated to English in 1962) of viewing as an embodied experience, which stood in marked contrast to the dominant ideas of the time, expressed by the

critic Clement Greenberg's emphasis on 'purely optical' models of viewing art. Minimalist sculptors famously wanted to refocus viewers' attention to their physical relationship **to** their sculptures (for example, becoming aware of their awkward movements around reflections in the burnished surfaces of cubes), rather than concentrating on the relationships inherent **within** an artwork (for example, examining the tension between overlapping lines in a painting).[51] The minimalists' phenomenological dance between the viewer and artwork is largely credited for moving the art world past 'ocularcentrism'—the privileging of sight over the other senses. It opened up what Rosalind Krauss in 1979 dubbed the 'the expanded field'[52] that later telescoped out beyond sculpture into performance, installations, and situations that took as their contingent ground the social, the political, and the economic.

Emerging understandings of mirror-touch help to close the divide between supposedly 'virtuous' participatory art and 'suspicious' image or object-based art. By bringing phenomenological approaches to the question of art spectatorship, including an emphasis on attunement, intersubjectivity, and intercorporeality, we are able to reconceptualise optical experiences as encompassing more than vision and 'passive' spectatorship on a continuum with 'active' participation.[53] In this volume, we take up phenomenology's insistence on the experiential in art and re-route it through perspectives from anthropology (Thomas Csordas), embodied cognition (Anthony Chemero), media engineering (Sha Xin Wei), film studies (Laura U. Marks and Patricia Pisters), fiction (Hustvedt), art curation (Catherine Wood), and artmaking (myself), in order to bring forth a different notion of what a 'social' relationship in or with art might look (and feel) like.

While certain current discussions within the art world support similar understandings of spectatorship—the French philosopher Jacques Rancière's notion that art can reorganise a 'distribution of the sensible' comes to mind[54]—my editorial prejudice here is largely indebted to another turn, in film studies, that relied heavily on phenomenology—that of 'embodied spectatorship'. The shift in this field, that began (like so many turns discussed in this introduction) in the early 90s, also responded to a Marxist movement that threw cold water on the visual (feminist, psychoanalytic accounts of films that positioned film spectatorship as that of a controlling male gaze).[55] This turn to embodied spectatorship, grounded in early twentieth-century theorisations of cinema such as the critic Siegfried

Kracauer's description of a cinema that 'seizes the human being with skin and hair',[56] refocused attention to the tactile or 'haptic' effects of cinema. The influential film theorist Laura U. Marks (contributor to this volume) understood film viewing as an intersubjective experience with critical and political implications; like Haraway, she replaced the metaphor of a 'disembodied eye' with a feminist, post-colonial subject. The film phenomenologist Vivian Sobchack rigorously applied accounts of her body as the ground of the film's address to coin the neologism 'cinesthetic subject' (blending synaesthesia with cinema), suggesting the ways that we 'co-constitute' a film with all our senses.

Such a relationship to an artwork—in which we make it and it, in turn, makes us through the medium of our embodied sense—can be subtle. Like mirror-touch synaesthetes, we can't willfully choreograph our perceptions, but we can shift our attention and attune ourselves to new experiences. Mirror-touch encourages us to open up the bandwidth of our sensitivities, to lower our thresholds of sensation—not in order to diminish sensation or to 'turn down the volume' but, on the contrary, to intensify available perception by allowing less conscious (and more embodied) impressions greater awareness. While contemporary participatory art invites viewers to overcome the injunction 'do not touch' and to interact directly—sliding down slides, balancing on wood beams, playing ping pong—might mirror-touch tutor us in new, more nuanced, and receptive ways of touching? Events happening at a distance do affect us. Mirror-touch reminds us of the ways in which the long-distance medium of sight pulls images close to our bodies, impressing themselves corporeally and emotionally. It digs deeper into what vicariousness might mean, giving us greater reach.

What follows is a series of 'partial connections' that play on thresholds between senses, artistic media, self and other, spectatorship and participation, art and life. Each explores the ways that mirror-touch scores a new path between these, articulating difference and relatedness to provoke new ways of conceiving of empathic spectatorship. This volume creates a 'confusion of voice and sight' by bringing together perspectives from neuroscience, philosophy, mathematics, art making, art theory, poetry, curation, film theory, and anthropology, many informing and influencing one other. Cross-pollination is performed at the beginning of each section (and also at the end of the last) through transcribed Skype

conversations between, on one hand, a scientist, and on the other, an art maker, curator, or theorist. Collectively, these voices form a synaesthetic prism through which to look at contemporary art.

PART 2

Foreground: The Volume's Four Sections

Feeling In

> Artworks come alive to me. I remember looking at a painting of a boy with his foot in the water. I felt as if I was really standing in the water, standing inside the painting.

> Fiona Torrance, mirror-touch synaesthete[57]

The Threshold Theory of mirror-touch links the condition to an overactive mirror system, and by extension, to heightened empathy.[58] The concept of empathy, however, is vastly complex,[59] and as the philosopher of cognitive science Frédérique de Vignemont has recently stated, 'there are probably as many definitions of empathy as people working on the topic'.[60] For example, empathy can be conceived as sharing another's emotions, a cognitive understanding of mental states, or both of these, together with a compassionate desire to help.[61] It can be conceived as a blurring of self and other, or as a dynamic that depends on separateness, self-awareness, and emotion regulation.[62] However, in this volume's context, in which ultimately empathy is related to a mirror-touch-inspired spectatorship of artworks, authors focus on the 'simulation theory' of empathy that posits that mirror systems allow us to simulate what others feel and, through that shared feeling, to know what the other is experiencing. Indeed, as Antonio Damasio, the neuroscientist who spearheaded the 'affective turn' in neuroscience has shown, feelings are central to (rather than counter to) reasoning and are built upon physical changes in the body.[63] Despite some ongoing controversy,[64] it may not be surprising, then, that mirror-touch synaesthetes exhibit not only shared physical states, but also unusual degrees of shared emotions.[65]

Several contributors to this section revisit the historical roots of the term empathy in the German term *einfühlung* (literally 'in-feeling'). The late

nineteenth-century philosopher of aesthetics Robert Vischer introduced *ein-fühlung* to describe physical fellow-feeling with artworks,[66] a kinaesthetic form of spectatorship that moved against ocularcentric traditions of aesthetics.[67] Only a few decades later, *einfühlung* was imported by empirical psychologists into English as *empathy* and used in this context, as we now commonly expect, to describe a resonance not with artworks, but with people. A contemporary reapplication of this term to art spectatorship is one provocative way to engage with 'affect', an influential notion that has been taken up, beyond neuroscience, across a wide range of fields. Although some have conflated affect with emotion, it is more aptly understood as comprising pre-individual and pre-linguistic bodily forces that augment or diminish a body's capacity to act or engage with others.[68]

Contributors to this section explore the ways that art 'moves' or 'touches' a spectator. Two authors describe literal mirrors as conduits for viewers' entry into artworks, but equally important, viewers' bodies themselves are conceived as reflecting images. Images, and seeing itself, are at times conceptualised as material, as if these were physical membranes or bridges that connect. However, these authors and others throughout the volume offer suggestions for ways that empathy is also coloured by cultural context and expectation (what neuroscientists call 'top-down modulation'). As a whole, these authors ask: how might we imagine empathy with artworks in new and nuanced ways?

The volume's opening conversation between the neuroscientist Vittorio Gallese, who, together with colleagues, discovered mirror neurons, and the pioneering performance and multimedia artist Carolee Schneemann introduces many of the themes that will thread through later chapters and focuses particularly on the ways that spectators' responses may mirror an artist's gestures. Gallese shares the results of his neuroscientific study that shows that beholding gestural, abstract paintings, such as the 'cut' paintings of Lucio Fontana, awaken representations of hand gestures in the brains of beholders. Schneemann describes some of her early works that lie on a boundary between painting and performance and invite a feeling of the spectator being 'within what they are looking at'. Like Hustvedt, Ward, and the art historian Giuliana Bruno, later in this section, Gallese and Schneemann discuss *einfühlung* to refresh a crossroads between art spectatorship and intersubjectivity.

The neuroscientist Jamie Ward, who, together with colleagues, studied the first known case of mirror-touch in 2005, presents a review of much of the scientific

literature around this form of synaesthesia and compares it to mirror-pain. He reaffirms that both mirror-touch and mirror-pain exist in fainter forms in the general population, where implicitly felt 'vicarious' touch and pain are common responses to observed touch and pain, and suggests that the study of all these phenomena have much to tell us about 'the social brain'. Ward describes the Threshold Theory of mirror-touch that posits mirror systems involved in the perception of touch and pain activated above a threshold of conscious aware-ness. He argues that although mirror-touch and mirror-pain do not accord with the model of empathy developed by the neuroscientists Jean Decety and Philip L. Jackson, in which self and other must be recognised as distinct, they do resonate strongly with *einfühlung*.

The thinking of the influential French philosopher Gilles Deleuze was another major spur to the affective turn, and indeed philosophies largely indebted to Deleuze thread their way throughout this volume. In the next chapter, the film scholar Patricia Pisters connects Deleuze's 'affection image' to the Russian film-maker Sergei Eisenstein's fascination with synaesthesia and his orchestration of sensory elements that impart a 'fourth dimension', or shared feeling, to art. This layer of affective engagement is one that Eisenstein, in dialogue with his Russian contemporaries, the neuropsychologist Alexander Luria, and the cultural psy-chologist Lev Vygotsky, described as both hardwired in the brain and also influ-enced by cultural, social, and historical factors. Pisters takes up the implications of this dynamic interplay by analysing the ways that emotion is communicated in a few contemporary artworks by Rosella Biscotti and by John Akomfrah, and, in particular, the ways that they manipulate the many powerfully affective and contextually specific meanings of the colour yellow. Pisters asks how these artists address the spectator as a 'cultural mirror-touch synaesthete'.

The contributions of three social anthropologists to this volume—Christopher Pinney in this section, and Thomas Csordas and Massimiliano Mollona in the following ones—help us to understand ways in which cultural specificity and more universal human tendencies interrelate in distinct encounters between the ethnographer and his subject of study. Pinney opens by questioning how we might locate 'different registers of evidence' of mirror-touch-like phenomenon in literature and in ethnographic descriptions. He cautions against a simplistic paralleling of these cultural practices and the lived experiences of mirror-touch synaesthetes but nevertheless identifies for the reader a number of instances, mainly within religious practice in India (including aspects of Hinduism, Jainism,

and Sufism) but also encompassing Bombay cinema and the English expat Christopher Isherwood's fiction, that privilege 'vision as touch'. For example, in central India, during ceremonies to rid a victim of *nazar*, or evil eye, vision is explicitly conceptualised as material in burning ghee, an emission that mixes viewer and viewed in an intimate space.

In a different way, the art, architecture, and film theorist Giuliana Bruno invests in the intimate materiality of seeing. Bruno, along with Laura U. Marks, has played a seminal role in shifting discussion of art and film towards the haptic and affective. She suggests that we need to go 'beyond the realm of pure visuality' to engage materially with space and to think about surfaces, rather than images, including what she calls the 'surface tension of media'. These spaces are not, however, only physical; they are sites 'of mediation and projection, a zone of encounter and admixture, memory and transformation' and are moreover sites of empathic transmission. Recalling once more the history of *einfühlung* and citing specific contemporary examples in which it is activated by the architecture studio Diller Scofideo + Renfro and by the artist Krzysztof Wodiczko, Bruno argues that 'surface has depth'.

Authors in this section elaborate on ways that images touch us, as they touch mirror-touch synaesthetes—physically and emotionally. How does this touch reshape the edges of the body? Where does a body end and begin and how can art shift these boundaries? The implications of 'self-other blurring' and of mirror-touch responsiveness to objects, including non-human objects, are explored at greater length in the next section.

Expanded Embodiment

> If I were to attend to a lamp or a potted plant, I would feel my body become many of the object's elements. I sense my body shaped like the hollow, rounded lampshade, or the pointed branches of the plant, or the smooth leaves.
>
> Mirror-touch synaesthete (3)[69]

Scientists have classed two distinct ways of conceiving of mirror-touch synaesthesia, both implied by its name.[70] On the one hand, it is of course categorised as a form of synaesthesia (and this conceptualisation is supported by the fact that people with mirror-touch often have other synaesthesias and may have other

synaesthetes in the family).[71] On the other hand, because mirror-touch synaesthetes' blurring with images is purported to complicate their notion of 'bodily ownership and self-representation',[72] the condition can also be likened to out-of-body experiences and other anomalies of body map perception. Body maps, in neuroscience, are networks of neurons, many of them located in the cerebral cortex, that, in the general population, demonstrate a coherent correspondence to the human body. Body maps (including those of the body's surface, its musculature, and motor intensions) correlate with our awareness of our body's edges and even the 'personal space' just beyond it and can be profoundly flexible, transforming in response to our interaction with our environment. These maps expand during tool use, for example, or when we drive a familiar car or wear a familiar hat, growing to include the object as if it were a part of our body.[73] In contrast or complement (depending on one's point of view, as we shall see), the notion of a 'body schema' is used to describe the felt sense of one's body, the actual experience of its properties and potentials as it moves through the world.[74] Since mirror-touch synaesthetes experience a form of 'self–other blurring', their body schema might be said to include others.[75] Moreover, since mirror-touch synaesthetes often experience touch sensations when they see inanimate objects (and not only people) being touched, the material world creates endless potentials for expansions of the lived body.

This section explores what the implications of this malleability are for art spectatorship and whether self–other blurring can, for non-synaesthetes, encompass the 'other' of art objects. A number of artists and curators[76] in recent years have been inspired by Bruno Latour's 'actor–network theory', in which objects can be conceived as active agents in social networks.[77] Others have taken up the suggestion of Deleuze's pan-psychism to explore the ways that art objects might be imagined to have consciousness, an antidote, perhaps, to overweening conceptualism. From more modest claims to self-other blurring at this section's beginning to imaginings of connection with 'the virtual body' at the section's end, here authors explore bodily resonances with the human and non-human. Later chapters eschew body maps to concentrate instead on the live readiness of the body for transformation, emphasising movement as a vehicle of becoming. Can art, like mirror-touch, move our bodily boundaries and capacities towards new limits?

In the leading conversation for this section, the social neuroscientist Michael Banissy, who has published widely on mirror-touch, discusses with the researcher

Elinor Cleghorn the evidence that mirror-touch synaesthetes' body schemas are highly elastic. Banissy recounts transformational encounters with objects in the non-synaesthetic population, including the 'rubber hand illusion', the 'enfacement illusion', and the use of tools, demonstrating that such elasticity is a common human trait. Cleghorn proposes instances recounted by mirror-touch synaesthetes in which the 'other' with whom they have blurred is inanimate, yet intuitively granted subjectivity, and asks how it is that we might empathise with an entity that is alien to the human form. Banissy concedes that Cleghorn's accounts of synaesthetes' lived experiences challenge the boundaries of scientific investigation of the phenomenon, opening up, for example, new questions about mirrored proprioception.

The author Siri Hustvedt's own life-long experiences of mirror-touch synaesthesia (and the similar phenomenon of 'mirror-cold') and what she calls the 'mixing' of self and other have deeply informed both her fiction and non-fiction writing. Celebrating an attitude to life and art that suggests 'I am because you are', Hustvedt traces her rejection of Cartesian dualism to thinkers such as Merleau-Ponty and the British psychoanalyst D. W. Winnicot, who described a 'transitional space' crucial to creativity. Hustvedt posits intercorporeality and the synaesthesia of infancy as grounds for adult imaginative work, including the work of reading and of looking at art. Questioning neuroscientific claims that mirror-touch synaesthetes suffer from problems with 'agency discrimination', Hustvedt affirms that her perceptions endow her with a rich sense of agency as well as an openness to others.

Laura U. Marks, like Brian Massumi in this section's last chapter, takes an implicitly Deleuzian approach to mirror-touch, emphasising acts of becoming that open or overtake individual subjects.[78] Marks invites us to stretch our perceptions to include what we have in common with non-organic life through the figure of the abstract line, arguing that non-synaesthetes can also cultivate embodied and empathic responses to the abstract and the haptic. Marks draws from perceptual theories from the nineteenth century to the present to elucidate the ways that humans feel the way a line feels. Although the German art historian Wilhelm Worringer saw empathy and abstraction as opposites (a theme taken up in the last section of this volume by Massimiliano Mollona), here we might imagine an empathy **with** abstraction. As examples, Marks presents abstract lines in Islamic art, Western painting, animation, and analogue video synthesis, exploring the particular role that movement plays in enhancing affective impact. The

chapter concludes with a critique of the ways commercial applications attempt to instrumentalise human acts of perception and empathy, and a reaffirmation of the realm of art as one of resistance, enjoyment, and expansion of our capacities for being alive.

The philosopher and cognitive scientist Anthony Chemero's chapter departs from a term that has itself been highly instrumentalised in commercial contexts and reclaims it to enquire about the ways that mirror-touch might be seen as deeply participating in the world. The leading concept of his essay—**synergy**—a term now heard most often in the business world but originating in a different meaning within physics, is 'a collection of components that act as a temporary self-organising unit'. Following Merleau-Ponty, Chemero conceives our lived bodies as open to interaction with the world, rather than as objects in the world, and consequently rejects representationalism, including representation of the body in neural body maps to pursue a way of researching cognition that is 'radically embodied'. In his own research, Chemero has, for example, looked at human-tool synergies, measuring the expansion of the body schema not through changing neural representations, but by showing that the behaviour of a 'human-plus-tool' exhibits the same dynamics as properly functioning physiological systems, suggesting that human-plus-tools can be genuine units in the same way that organs like the human heart are. He ends by querying what it would be like were the rest of us to develop synergies with works of art.

In this section's final chapter, the philosopher and political theorist Brian Massumi, who has played a pivotal role in defining 'affect' within contemporary debate, provides a critical analysis of 'embodiment'. He rejects assumptions underlying research into mirror-touch synaesthetes' 'blurred' representations of self as well as the fundamental notion of empathy, which presupposes two distinct subjectivities. Like Chemero, Massumi eschews the conception of perception as a fundamentally passive reception that results in a private representation of the world (observable on the neural level), instead calling on the philosopher C. S. Peirce (as well as William James) to affirm perception as participation in the world. Massumi sees mirror-touch not as a confusion of spatial relationships, but as a glimpse of vision and touch folded together on 'the virtual body' (a realm of infinite possible relations described by Deleuze). Like Hustvedt, Massumi argues that all of us emerge from a synaesthetic ground, for him an 'original continuum' that the mirror-touch synaesthete retains in greater part

than the rest of us, providing a 'gateway' to the artfulness of the body. Massumi argues that 'every perception is a **composition** of the full spectrum of experience' and that these can be recomposed by art, through movement, 'to form new perceptual habits and skills'.

If the 'virtual' for Massumi implies an order of potentiality that can be fulfilled within the 'actual', a continuous multiplicity 'inseparable from the movement of its actualisation',[79] how might contemporary technology's renderings of another kind of 'virtual' affect the potentialities of art spectatorship? How might the excess of information in the digital age impact on our somatic sensitivities? The ways that art spectatorship invites real and virtual worlds to blur is explored in the next section.

Intimate Alterity

> My mirror-touch sensations feel like a sort of 'phantom limb'—It feels like it should be you, but it isn't you.
>
> <div align="right">Mirror-touch synaesthete (11)[80]</div>

Broadly speaking, synaesthesia is associated with perceptual differences such as increased creativity, mental imagery, and even hallucination. Although synaesthesia is decidedly not an illness or disability (many class it as a gift), studies have shown that synaesthesia for coloured letters and tones is associated with higher levels of schizotypy, a concept that describes some normative experiences as being on a continuum with (rather than categorically different from) schizophrenia.[81] This is not to say that synaesthetes are in any way psychotic, and it is also important to emphasise that synaesthetic experiences are involuntary and automatic, rather than imagined. Yet it is common for mirror-touch synaesthetes to experience other forms of synaesthesia,[82] and many report rich mental imagery that arises from a layering of mirror-touch and accompanying synaesthesias.[83] In addition, synaesthetes broadly are known to have enhanced memories, due to mnemonic coding that happens as a matter of course in daily life.[84]

This section investigates the ways that mirror-touch synaesthetes' images and the images of artists make sense of an excess of information and how these, in turn, might be empathically witnessed. It differs from other sections of this volume in emphasising the often performative voices of artists, but part of what

is interesting about these artists is that they too are spectators. Texts here offer delirious microcosms and dream-like archives, updated 'total artworks' that complicate the aspiration towards transcendence that marked early twentieth-century synaesthetic experiments. Here, as for the mirror-touch synaesthete, the world is corporeally imprinted, recalling Merleau-Ponty's declaration: 'My body is the fabric into which all objects are woven'.[85] Chapters in this section evoke—to borrow the contributor Thomas Csordas's term—an 'intimate alterity', a strange, yet familiar, presence that conflates a vast 'other' and the closeness of one's own body. If the distancing effects of the digital age[86] invite the repair of nearness, mirror-touch offers us a strange embodiment of the paradoxes of virtuality—near, yet far. How might we, as spectators, relate to these new, contingent *gesamtkunstwerke* that navigate an overwhelming flood of seeing and feeling?

The section's opening conversation takes a new format; the phenomenological anthropologist Thomas Csordas unpacks his notion of 'intimate alterity', to refer not to the 'wholly other' posited by phenomenologists of religion, but to an intimation of the animal immediacy of our bodies, always slightly out of reach. The multimedia artist Trisha Donnelly, whose work is known to speak in private languages that nonetheless communicate, responds to Csordas' text with a series of images—her own and others'. Drawing on work in the phenomenology of embodiment, Csordas compares his conceptualisation of otherness to the transgressive writer Georges Bataille's suggestion that we destroy our capacity for tool use to come closer to our original 'creature feeling', as well as to Freud's notion of the uncanny, in which the strange becomes familiar, and the familiar strange, as when we become aware of bodily processes (such as the automatic beating of our hearts) that are largely hidden from us. He offers a concrete example from his ethnographies of Catholic Charismatic healers, describing the ways that 'resting in the spirit', a kind of sacred swoon, is an objectification of intimacy, not with God, but with and of embodiment. Trisha Donnelly hints at intimate embodiment through her idiosyncratically curated group of images that include Adrian Piper's enigmatic self-portrait and her own refracted, stretched, and stratified creations.

The mirror-touch synaesthete Fiona Torrance details, in layered imagery, some of her tactile perceptions, including those arising from automatic processes of the body that are usually hidden but are sometimes palpable for her. She lists imagery that she would like to ideally see in artworks as a form of self-validation, images

that she synaesthetically experiences as part of daily life, but which might, outside the realm of art, confuse or disturb others. Some of these, such as 'noses in mid-air', 'hands with scales', and a set of 'four or five jaws', resemble inventions of the Surrealist tradition. Her description of her body's openness to the world around her evokes Deleuze's 'body without organs';[87] she tells us that 'without the mind's eye I cannot function. It disturbs "seeing without eyes" and "hearing without ears".'

The poet and cultural critic Wayne Koestenbaum, who has written elsewhere about the ways that witnessed opera opens a listener's throat,[88] in this context offers another opening—that of his diary, which he has kept daily since 1976. Beginning in 2012, Koestenbaum wrote instead in a series of 'Trance Notebooks' as a way to transform his journal into a higher pitch of ceremony, an occasion for intensified, unmoored consciousness. He distilled the results into a sequence of 34 assemblages, one of which appears here. In *Nerdy Questions About Exact Pitch*, a series of non-sequiters invite sudden shifts of attention, appealing to taste and distaste: 'I'll never wear Fiesta Bisque'; 'a bowl of inedible/toffee suckers'; 'let's/include cocksucking/in our low-key friendly/chats'. Observations only occasionally offer the possibility of ironic wholeness: 'Christo/Wrapped me' and 'international food/court of 1964'.

Mark Leckey has influenced a number of contemporary artists working in the post-Internet era, who ambitiously attempt to create totalising cosmologies, recycling a virtual world into a more personal or visionary one.[89] In this piece, Leckey chants his vision of the world no less exuberantly, by taking us on a tour through an imagined show, a museum exhibition that combines Animal, Man, and Machine into an animistic whole,[90] coming 'together to make this one colossal, assembled Body'. He proposes a long list of items, most culled from the Internet: 'this is a clay concept car I'd like to get hold of'; 'this is the sun setting on Mars'; 'this is the unveiling of a Henry Moore'; 'this is a life mask of William Blake'; 'this is all the frames from Hitchcock's *Vertigo*'. His array of images ends with the proposal that they be exhibited inside an infinity mirror box, recalling Massumi's suggestion of the virtual body's limitless possibilities.

Might these hyperbolic microcosms empower us to challenge social codes? How might we conceptualise the interplay between receptivity to images and agency in the world? Tension is restored to the relationship between self and other in the next and final section of essays in this volume.

Double Sensation

> I oscillate between absorption—in which my body opens up to the objects and sensations from outside—and moments in which I understand that this blurred state is my own internal property and I become aware of being an individual. This detachment can be politically empowering, creating an understanding of the human condition of being social and collective, but also alienated, individual, and lonely.
>
> Nicola Mamo, mirror-touch synaesthete[91]

Mirror-touch, as we know, is a 'social synaesthesia'—it relies on touch to others.[92] Mirror-touch synaesthetes move through the world, feeling multiple layers of touch: 'direct' touch **to** their bodies, touch enacted **by** them onto others, and also 'synaesthetic' touch that receives touch applied to other bodies (and sometimes to objects). The ambiguity of mirror-touch experiences recalls Merleau-Ponty's description of the 'double sensation' in which one hand grasps the other—one touches and is touched, experiencing the body as subject and as object simultaneously.[93]

This section folds back the excess explored in the previous section to a seemingly simpler but enmeshed 'two', investigating how mirror-touch spectatorship might model a negotiation of the misleading divisions, alluded to earlier, between the visual and the social. Contributors in this section address the ways that non-synaesthetes might begin to approach mirror-touch experience, acknowledging the role that separateness may play in sensitisation. Distance and nearness; self and other; non-synaesthete and mirror-touch synaesthete—in this section, these dichotomies are held in dynamic tension, recalling another double, that of consciousness. Two contributors allude to the civil rights activist W. E. B. Du Bois' charged term,[94] although here, 'double consciousness' loses its pejorative ring and instead suggests that, in certain circumstances, seeing oneself from the point of view of the other as well as the self can make us more alive, more human. While synaesthetes, immersed in the other, may find it necessary to remind themselves of their own perspective,[95] non-synaesthetes may be drawn to move in the opposite direction, to look back from the perspective of the other, including that of the mirror-touch synaesthete. Several contributions imagine art spectatorship as a place of cognitive training,[96] akin to the cultivation of mirror-touch experience.[97] As if in response to the art theorist W. J. T. Mitchell's famous question 'what do pictures want?',[98] contributors here

might respond: 'how do pictures touch?' and 'how might we touch them, in turn?'

In this section's opening conversation, the media artist and mathematician Sha Xin Wei and the curator Catherine Wood relate ways that the social might be choreographed and curated, each proposing new directions for the phenomenological trajectory discussed earlier in this introduction, initiated by the Minimalist sculptors of the 1960s. Sha, like Chemero, came to phenomenology frustrated with the limits of representation in scientific work, and like Pisters, Marks, and Massumi in previous sections of this volume, he brings implicitly Deleuzian thinking to his investigations; at his Topological Media Lab, dancers, philosophers, mathematicians, and designers co-created environments that generated emergent meaning. Wood describes her own critical curatorial investigation of the entanglement of observer and observed, highlighting, for example, the choreographer-artist Boris Charmatz, who challenges the art viewer to recall ways of being human, beyond cognition. Wood and Sha discuss the space of the art encounter as a training of perception; both the artwork itself and the exhibition's frame around it can 'condition' the event of spectatorship, made more powerful, in contrast to digital culture's short attention spans.

As with the other two social anthropologists in this volume (Pinney and Csordas), here the economic and visual anthropologist Massimiliano Mollona makes reference once more to Bataille who, together with Antonin Artaud, inspired Ethnographic Surrealism in 1920s Paris. Continuing in this tradition, in which artists and anthropologists turned Western values on their head, Mollona narrates a journey into the archive of a Brazilian steel town long involved in civic repression and workers' exploitation, in which photographic evidence uncannily mirrors experiences in his fieldwork. In this hallucinatory text, Mollona performs the difficulty of representing 'the other', as boundaries between participation and observation blur into a dream-like space akin to mirror-touch. Drawing on Worringer's seminal discussion of empathy and abstraction, itself informed by economic theories about the abstracting forces of capitalism, Mollona suggests that 'in the context of the de-humanising, impersonal . . . forms of capitalism, becoming human again may entail finding the right distance between dreams and life', and that such a calibration involves a 'double movement', an 'existential duplicity' between absorption and distance.

In the following chapter, I present the case study of my film *Sensorium Tests*, inspired by the first experiment into mirror-touch, that invites spectators to look

as the mirror-touch synaesthete looks, in marked contrast to a pair of scientists studying her through a one-way mirror. Questioning why I and others are fascinated by mirror-touch, I propose ways that images become tangible on the 'medium' of the mirror-touch synaesthete's body, channelling the fainter, implicit mirror system signals common to us all and implying that such mentoring has an analogy in the neuroscientist V. S. Ramachandran's famous mirror-box. Yet, I leave ample room in this picture for frustration with idealised images, which, as the film phenomenologist Vivian Sobchack suggests, can stimulate sensitivities that make one more receptive to transformation.

The artist and playwright Rabih Mroué discusses his work '*Shooting Images*' (2012), a re-enactment of amateur videos produced during the ongoing civil war in Syria, in which he visually expands a moment of eye contact between sniper and victim into a looping *myse en abyme*. Implying a double consciousness that rejects dichotomies of 'good and evil, innocent and guilty', Mroué's artworks slow down and break apart images of violence that would otherwise be unwatchable, allowing the audience the necessary space to 'establish what is off-camera'. He dismisses participatory theatre, describing his artwork as a sharing of doubts with his audience, who are granted adequate distance to form their own opinions.

The artist Judith Hopf and the neurologist Joel Salinas, who is also a mirror-touch synaesthete, complete the volume's chapters with a last conversation. Both experience biological differences from the 'norm' and both gently challenge mainstream ideas within their fields. Hopf uses the tools of sculptural fragility, humour, and her performing body to provoke viewers' awareness of their own physical and social contingencies. Salinas describes his techniques for negotiating personal boundaries, helpfully retreating from 'emotional contagion' in his medical work in order to extend empathic concern to his patients. Within a larger global context of crisis, the two affirm that a movement between distance and intimacy meaningfully animates their connection to the world.

Mirror-touch appeals as a model for a way of looking at art in part because it shows us the ways that 'virtual realities'—a phrase coined by the radical Surrealist Antonin Artaud[99]—can also be visceral realities. In the digital era, in which even the latest virtual-reality devices have not yet learned to 'represent the body', much less touch,[100] what new thresholds might mirror-touch demarcate? Does art make you whole, as early celebrants of coloured-hearing synaesthesia imagined, or does it rend you apart? Does it expand you? Might aesthetic encounters represent, for example, as for Bruno, a 'transmission', for Koestenbaum a 'trance', for Chemero a 'tight connection to the world', or for Mollona an 'existential duplicity'? Although the developmental, clinical form of mirror-touch cannot be induced,[101] some of empathy's aspects can[102] and neuroscientists widely agree that perception is plastic.[103] Images are not distant, and we can make contact with them in ways more intimate than our fingers can touch the flat glass of a touchscreen device. In a world in which focused awareness is a rare commodity, artworks may represent a different horizon of sensitivity to which the spectator is invited. As the French philosopher and activist Simone Weil wrote: 'Attention is the rarest and purest form of generosity'.[104]

Endnotes

1. Daria Martin, Interview with Nicola Mamo, a mirror-touch synaesthete, 2008.

2. Donna Haraway, 'Situated knowledges: the science question in feminism and the privilege of partial perspective', *Feminist Studies* (Autumn 1998), 14, 3, 590.

3. An excellent introduction to synaesthesia as a whole is the '*Oxford Handbook of Synaesthesia*', edited by Julia Simner and Edward M. Hubbard (Oxford University Press, 2013). Earlier surveys include Simon Baron-Cohen and John E. Harrison, eds., '*Synaesthesia: Classic and Contemporary Readings*' (Blackwell, 1996), John Harrison, '*Synaesthesia: The Strangest Thing*' (Oxford University Press, 2001), and Jamie Ward, '*The Frog Who Croaked Blue: Synaesthesia and the Mixing of the Senses*' (Routledge, 2008).

4. '*Les Parfums, les Couleurs et les Sons se Répondent.*' See Charles Baudelaire, '*Correspondances*' (1857), originally published in Baudelaire, '*Les Fleurs de Mal*' (Paris: Auguste Poulet-Malassis, 1857). For this translation, see '*Selected Poems of Charles Baudelaire*', trans. Geoffrey Wagner (New York: Grove Press, 1974), 23.

5. See Kevin T. Dann, '*Bright Colors, Falsely Seen: Synaesthesia and the Search for Transcendental Knowledge*' (Yale University Press, 1998).

6. For two decades, following the publication of Rimbaud's '*Voyelles*', synaesthetes captured the public imagination as 'voyants'. Symbolist artists, poets, and musicians imagined that synaesthesia represented an evolutionary advance in human perceptual ability and that coloured-hearing synaesthetes were actually seeing photisms, described by Theosophists as signs of the astral world.

7. Georg Sachs published a medical dissertation describing his and his sister's albinism, and in passing also described his experience of coloured music and phonemes. See Jorg Jewanski, Sean Day, and Jamie Ward, '*A Colorful Albino: The First Documented Case of Synaesthesia*', by Georg Tobias Ludwig Sachs in 1812, *Journal of the History of the Neurosciences* (2009), 18, 293–303.

8. Kandinsky continued to celebrate synaesthetes' perceptions as divinations in his influential manifesto and attack on materialism '*Concerning the Spiritual in Art*', written in 1912. He romantically describes synaesthetes not only connecting senses but also connecting sense to soul, vibrating 'in sympathy with another instrument'. Kandinsky believed such vibrations were felt more keenly by certain people (and not only synaesthetes), and he constructed an elaborate hierarchy describing the effects, specifically

of colours, on individuals. If an individual were more spiritually developed, then he would feel 'a more profound effect, which occasions a deep emotional response', while those less developed would experience a more 'superficial' response to colour. In addition to creating paintings, which he felt were 'visual music', Kandinsky meditated on a regular basis to cultivate his spiritual development and sensitivity. It is not known whether he had the neurological condition of synaesthesia. See Wassily Kandinsky, *'Concerning the Spiritual in Art'* (1912), trans. M. T. H. Sadler (New York: Dover Publications, 1977), 24/25, 23.

9. See Rosie Braidotti, *'Metamorphoses: Towards a Materialist Theory of Becoming'* (Polity, 2001), 246.

10. See, for example, the feminist scholars Evelyn Fox Keller and Christine R. Grontowski's examination and questioning of the philosophical basis for the 'male logic' of the 'privileged status of the visual organ' in their essay *'The Mind's Eye'* in Sandra Harding and Merrill B. Hintikka, eds., *'Discovering Reality: Feminist Perspectives on Epistemology, Metaphysics, Methodology, and Philosophy of Science'* (Dordrecht, Boston, and London: D. Reidel Publishing Company, 1983), 207–24.

11. For an excellent summary of the scientific literature on mirror-touch, see Michael Banissy, 'Synaesthesia, Mirror Neurons, and Mirror Touch', *The Oxford Handbook of Synesthesia* (Oxford University Press, 2013).

12. Mirror-pain has been examined in laboratory settings (see Jamie Ward's chapter in this volume), while some of the other synaesthesias mentioned here, for example mirrored proprioception, had not been noted by scientists before this volume's set of interviews brought them to light. See Part VI of this volume for some quotes relating to these other synaesthesias.

13. The study of mirror-touch in social neuroscience is a part of a larger growing interest in the neural mechanisms of social interactions, as real-world interactions between individuals are studied in the lab.

14. The form of synaesthesia most commonly studied by psychologists and neuroscientists is coloured letters, in which seen or heard letters evoke a colour. Because the alphabet represents a closed set of stimuli, and because the vision system of the brain is well researched, this kind of synaesthesia is relatively easy to control for.

15. Daria Martin, Conversation with James Wannerton, workshop 1, 29 October 2014, Shoreditch Town Hall.

16. See B. R. Conway and A. Rehding, 'Neuroaesthetics and the trouble with beauty', *PLoS Biology* (2013), 11, 3.

17. For a nuanced argument for contemporary neuroaesthetics, see G. Gabrielle Starr, *'Feeling Beauty: The Neuroscience of Aesthetic Experience'* (The MIT Press, 2013).

18. Daria Martin, Email correspondence with Michael Banissy, 12 September 2014.

19. A. R. Luria, *'The Mind of a Mnemonist: A Little Book about Vast Memory'*, trans. Lynn Solotaroff (originally published New York: Basic Books, 1968; reprinted Cambridge, MA and London: Harvard University Press, 1987), 24.

20. Richard E. Cytowic, 'The Man Who Tasted Shapes' (Cambridge, MA, The MIT Press, 1993), 66.

21. It should also be noted that quite a number of synaesthesia researchers themselves have the condition. See, for example, recent conferences hosted by the UK Synaesthesia Association and the American Synesthesia Association (2014).

22. Georg Northoff and Alexander Heinzel, 'First-person neuroscience: a new methodological approach for linking mental and neuronal states', Philosophy, Ethics, and Humanities in Medicine (2006), 1, 3. doi: 10.1186/1747-5341-1-3.

23. L. Schilbach, B. Timmermans, V. Reddy, et al., 'Toward a second-person neuroscience', Behaviourial and Brain Sciences (August 2013), 36, 4, 393–414. doi: 10.1017/S0140525X12000660.

24. Matthew R. Longo and Manos Tsakiris, 'Merging second-person and first-person neuroscience', Behavioural and Brain Sciences, Behaviourial and Brain Sciences (August 2013), 36, 4, 429–30. doi: 10.1017/S0140525X12001975.

25. The synaesthete James Wannerton has commented that his lexico-gustatory synaesthesia is dampened in the laboratory environment, due to nerves and the clinical surroundings. Daria Martin, conversation with James Wannerton, 18 February 2005.

26. See Donna Haraway, 'Situated Knowledges: The Science Question in Feminism and the Privilege of Partial Perspective' (Autumn 1998).

27. The perceptual roots of synaesthesia might also serve as a root of metaphor per se. See Lawrence E. Marks, 'The Unity of the Senses: Interrelations Among the Modalities' (New York, San Franscisco, and London: Academic Press, 1978) and 'On colored-hearing synesthesia: cross-modal translations of sensory dimensions', Psychological Bulletin (1975), 83, 303–31.

28. See Georg Lakoff and Mark Johnson, 'Metaphors We Live By' (London: The University of Chicago Press, 1980), 43.

29. Donna Haraway, 'Situated knowledges: the science question in feminism and the privilege of partial perspective', Feminist Studies (Autumn 1998), 14, 3, 581.

30. See Lawrence Shapiro, 'Embodied Cognition' (London and New York: Routledge, 2010).

31. For review, see Levi Bryant's analysis of Deleuze's philosophical position as one of 'transcendental empiricism' in his book 'Difference and Givenness: Deleuze's Transcendental Empiricism and the Ontology of Immanence' (Northwestern University Press, 2008).

32. Within the synaesthetic experience, the line between metaphor and metonym blurs. As Vivian Sobchack wrote of the phenomenology of film viewing: 'once we understand that vision is informed by and informs our other senses in a dynamic structure that is not necessarily or always sensually hierarchical, it is no longer metaphorical to say that we "touch" a film or that we are "touched" by it'. Vivian Sobchack, 'What My Fingers Knew: The Cinesthetic Subject, or Vision in the Flesh', in Vivian Sobchack, 'Carnal Thoughts: Embodiment and Moving Image Culture' (University of California Press, 2004), 80. Sobchack extends this argument beyond metonymy to catachresis—language formations that point to a

gap in language such as 'the head of a pin' or 'the arm of a chair'. She argues that our body performs a form of sensuous catechresis, filling in gaps of meaning in the film body.

33. See Georg Lakoff and Mark Johnson, 'Metaphors We Live By' (1980), 36–41; see also discussion of the implication of desire and partiality in the Lacanian formula for metonymy in Anika Lemaire, 'Jacques Lacan' (London: Routledge, 1979), 195–7.

34. See Daniel Stern, The Interpersonal World of the Infant (New York: Basic Books, 1985), and Simon Baron-Cohen, 'Is there a normal phase of synaesthesia in development?', Psyche (June 1996), 2, 27.

35. Cretien van Campen, 'The Hidden Sense: Synesthesia in Art and Science' (Cambridge, MA and London: The MIT Press, 2010), 29.

36. See Lawrence E. Marks, 'Synesthesia, then and now', Intellectica (2011/1), 55, 50–1; and also Charles Spence and Betina Piqueras-Fiszman, 'The Perfect Meal: The Multisensory Science of Food and Dining' (London: Wiley Blackwell, 2014).

37. J. Ward, B. Huckstep, and E. Tsakanikos, 'Sound-colour synaesthesia: to what extent does it use cross-modal mechanisms common to us all?', Cortex (February 2006), 42(2), 264–80.

38. S. J. Blakemore et al., 'Somatosensory activations during the observation of touch and a case of vision–touch synaesthesia', Brain (2005), 128, 1571–83.

39. Vittorio Gallese et al., 'Action recognition in the pre-motor cortex', Brain (1996), 119, 593–609.

40. See Christian Keyers and Valeria Gazzola, 'Expanding the mirror: vicarious activity for actions, emotions, and sensations', Current Opinion in Neurobiology (2009), 19, 666–71 for review. For a cautionary voice about the limits of the theory of mirror systems, see Gregory Hickok, 'The Myth of Mirror Neurons: The Real Neuroscience of Communication and Cognition' (W. W. Norton and Co., 2014).

41. See M. J. Banissy and J. Ward, 'Explaining mirror-touch synaesthesia', Cognitive Neuroscience (2015), 6, (2–3), 118–33. doi: 10.1080/17588928.2015.1042444.

42. See American performance scholar Shannon Jackson's discussion of the development, usages, and implications of the term 'social practice' in her book 'Social Works: Performing Art, Supporting Publics' (New York and London: Routledge, 2011), 11–19. Jackson suggests that the term 'social practice' implies heterogeneity, collaboration, and trans-mediality in art-making, and at once 'gestures to the realm of the socio-political, recalling the activist and community-building ethic of socially engaged performance research' (13). However, Jackson acknowledges the inherent imprecision of the term and argues that the 'social heterogeneity' of this field of artistic engagement complicates the application of 'catch-all' terminology (13, 14).

43. Serra Santiago, 'Six People Who Are Not Allowed to Be Paid for Sitting in Cardboard Boxes', installation performance, KW Institute for Contemporary Art, 2000. See Stefan Heidenreich, 'Santiago Sierra', Frieze (2001), 57, https://frieze.com/article/santiago-sierra.

44. Phil Collins, 'They Shoot Horses', digital video, 2004.

45. Sam Thorne, 'What's the use?: museums take on social practice', *Frieze* (April 2014), 162, https://frieze.com/article/what%E2%80%99s-use.

46. See Hal Foster, 'The Artist as Ethnographer' in '*The Return of the Real*' (Cambridge, MA: The MIT Press, 1995) and '*Contemporary Art and Anthropology*' and '*Between Art and Anthropology*', edited by Arnd Schneider and Christopher Wright (Berg, 2006 and Bloomsbury, 2010).

47. S. Jackson, '*Social Works: Performing Art, Supporting Publics*' (New York, London: Routledge, 2011), 14.

48. See Claire Bishop, '*Artificial Hells: Participatory Art and the Politics of Spectatorship*' (London and New York: Verso, 2012), 275–84.

49. It has also been noted that alternative histories have supported the emergence of the social turn, including early twentieth-century experimental performance and theatre practice; see Rose Lee Goldberg, '*Performance Art: From Futurism to the Present*' (London: Thames and Hudson, 2011).

50. Maurice Merleau-Ponty (1945), '*The Phenomenology of Perception*', trans. Colin Smith (London: Routledge, 2002), xvi/xviii.

51. See Hal Foster, 'The Crux of Minimalism' in '*The Return of the Real: The Avant-garde at the End of the Century*' (The MIT Press, 1996), 35–70.

52. See Rosalind Krauss, 'Sculpture in the Expanded Field', *October*, Vol. 8 (Spring 1979), 30–44.

53. Together with psychologist Jonathan Smith, Elinor Cleghorn and I plan to apply a phenomenological method to our interviews with mirror-touch synaesthetes through an 'Interpretative Phenomenological Analysis' of mirror-touch experience. This volume is based on a looser qualitative study of the condition.

54. See Jacques Rancière, '*The Politics of Aesthetics: The Distribution of the Sensible*', trans. Gabriel Rockhill (Bloomsbury, 2006); see also Jacques Rancière, '*The Emancipated Spectator*', trans. Gregory Elliot (London and New York: Verso, 2011).

55. See Laura Mulvey, 'Visual pleasure and narrative cinema', *Screen* (Autumn 1975), 16, 3, 6–18.

56. See Miriam Hansen, 'With skin and hair: Kracauer's Theory of Film, Marseilles, 1940', *Critical Inquiry* (Spring 1993), 19, 458.

57. Fiona Torrance, '*Four or Five Jaws*' (included in this volume).

58. See M. J. Banissy and J. Ward, 'Explaining mirror-touch synaesthesia', *Cognitive Neuroscience* (2015), 6, (2–3), 118–33. doi: 10.1080/17588928.2015.1042444.

59. See Jean Decety and William Ickes, eds., '*The Social Neuroscience of Empathy*' (Cambridge, MA: The MIT Press, 2011).

60. Frederique De Vignemont and Tania Singer, 'The empathic brain: how, when and why?', *Trends in Cognitive Neuroscience* (2006), 10, 10, 435–41.

61. For an excellent overview, see Jean Decety and William Ickes, eds., '*The Social Neuroscience of Empathy*' (Cambridge, MA: The MIT Press, 2011).

62. See J. Decety and P. L. Jackson, 'The functional architecture of human empathy', *Behavioral and Cognitive Neuroscience Reviews* (June 2004), 3, 2, 71–100.

63. See Antonio Damasio, '*The Feeling of What Happens: Body, Emotion,*

and the Making of Consciousness'
(London: Vintage, 2000).

64. The British neuroscientist, early synaesthesia, and autism researcher Simon Baron-Cohen has recently asserted that mirror-touch synaesthetes are no more empathic than the rest of the population. Studies are ongoing.

65. Michael Banissy and Jamie Ward, both contributors to this volume, found that mirror-touch synaesthetes have greater than average emotional empathy. See Michael Banissy and Jamie Ward, 'Mirror-touch synesthesia is linked with empathy', *Nature Neuroscience* (June 2007), 10, 815–16.

66. See Robert Vischer, 'On the optical sense of form: a contribution to aesthetics' (1873) in '*Empathy, Form and Space: Problems in German Aesthetics 1873–1893*' (The Getty Center for the History of Art, University of Chicago Press, 1993); see also Magdalena Nowak, 'The complicated history of *Einfühlung*', *Argument* (2001), 1, 2, 301–26; Juliet Koss, 'On the limits of empathy', *The Art Bulletin* (March 2006), 88, 1, 139–42; and Robert Curtis, '*Einfühlung* and abstraction in the moving image: historical and contemporary reflections', *Science in Context* (2012), 25, 3, 425–46.

67. See Jonathan Crary's discussion of the 'disassociation of touch from sight' which occurred as a result of the 'pervasive separation of the senses and industrial remapping of the body in the nineteenth century' for further insight into the ways in which the 'ocularcentric regime' necessitated the absenting of embodied engagement in aesthetic experience. Jonathan Crary, '*Techniques of the Observer:*

On Vision and Modernity in the Nineteenth Century' (Cambridge, MA: The MIT Press, 1992), 19.

68. See Patricia Ticineto Clough, '*The Affective Turn: Theorizing the Social*' (Duke University Press, 2007). For a discussion of affect's radical distinction from emotions, see Brian Massumi, '*Parables for the Virtual: Movement, Affect, Sensation*' (Durham & London: Duke University Press, 2002).

69. Daria Martin, Interview with anonymous, a mirror-touch synaesthete, 2 November 2012.

70. Lara Maister, Michael Banissy, and Manos Tsakiris, 'Mirror-touch synaesthesia changes representations of self-identity', *Neuropsychologia* (April 2013), 51(5), 802–8. doi: 10.1016/j.neuropsychologia.2013.01.020.

71. See Jamie Ward's chapter in this volume for further discussion.

72. Michael Banissy, *et al.*, 'What can mirror-touch synaesthesia tell us about the sense of agency?', *Frontiers in Human Neuroscience* (2014), 8, 256.

73. For an accessible introduction to body maps, see Sandra Blakeslee and Matthew Blakeslee, '*The Body Has a Mind of Its Own: How Body Maps in Your Brain Help You Do (Almost) Everything Better*' (Random House, 2009).

74. Maurice Merleau-Ponty discusses 'body schema' in '*The Phenomenology of Perception*'. For a more accessible discussion of body schema, see Stephan Käufer and Anthony Chemero, '*Phenomenology: An Introduction*' (Cambridge and Malden, MA: Polity Press, 2015).

75. See Michael Banissy and Jami Ward, 'Mechanisms of self-other

representations and vicarious experiences of touch in mirror-touch synesthesia', *Frontiers in Human Neuroscience* (2013), 7, 112.

76. Some notable examples are recent curatorial projects by Anselm Franke ('*The Anthropocene Project*', 2013–2014, and '*Animism*', 2012) and by Carolyn Christov-Bakargiev, whose 14th Istanbul Biennial (2015) is indebted to feminist notions of 'intra-action' with the environment. The 30th São Paulo Biennial '*The Imminence of Poetics*' (2012) posited the body—both of artist and of audience—as a social medium through and in which to inventory, store, produce, and transmit experience and knowledge.

77. See Bruno Latour, '*Reassembling the Social: An Introduction to Actor-Network-Theory*' (Oxford University Press, 2007). Similarly, anthropologist Alfred Gell described images and artworks as socially activated by living exchange with the viewer in his book '*Art and Agency: An Anthropological Theory*' (Oxford: Clarendon Press, 1998).

78. For further insight, see Gilles Deleuze, '*Bergsonism*' (1966), trans. Hugh Tomlinson and Barbara Habberjam (New York: Zone Books, 1991), 42–3.

79. See Gilles Deleuze, '*Bergsonism*' (1966), 42–3.

80. Elinor Cleghorn, Interview with anonymous, a mirror-touch synaesthete, 22 May 2014.

81. Michael Banissy *et al.*, 'Increased positive and disorganised schizotypy in synaesthetes who experience colour from letters and tones', *Cortex* (2012), 48, 1085–7. doi: 1085e1087.

82. See Michael J. Banissy, Vincent Walsh, and Jamie Ward, 'Enhanced sensory perception in synesthesia', *Experimental Brain Research* (2009), 196, 565–71.

83. Of the 13 mirror-touch synaesthetes interviewed for this volume (see Part VI), every one experienced at least one other form of synaesthesia. Of course, this group is self-selecting, as most were contacted via online synaesthesia social networks. Some concurrent synaesthesias in this group included 'ideathesia', seeing auras, ticker-tape, motion-sound, and sound-touch, as well as the more common grapheme-colour, sound-colour, and spatial sequential synaesthesias. Full interviews will be published online at http://www.mirror-touch.co.uk in late 2016.

84. See Nicolas Rothen, Beat Meier, and Jamie Ward, 'Enhanced memory ability: insights from synaesthesia', *Neuroscience and Biobehavioural Reviews* (2012), 36, 1952–63.

85. Maurice Merleau-Ponty (1945), '*Phenomenology of Perception*' (London: Routledge, 2002), 273. The archive is of course also an ongoing artistic trope. For example, 30th São Paulo Biennial '*The Imminence of Poetics*' (2012) posits the body—both of artist and of audience—as a social medium through and in which to inventory, store, produce, and transmit experience and knowledge.

86. Sherry Turkle laments the ways we are 'alone together' in the digital age, in her book '*Alone Together: Why We Expect More From Technology and Less From Each Other*' (Basic Books, 2011); philosopher and psychoanalyst Slavoj Žižek complains of a 'plague of fantasies', which cloud our reasoning and understanding of the world and others (see Slavoj Žižek, '*The Plague of Fantasies*' (Verso, 2009).

87. See Gilles Deleuze and Felix Guattari, 'How do you make yourself a body without organs?' in 'A Thousand Plateaus: Capitalism and Schizophrenia', trans. Brian Massumi (Minneapolis and London: University of Minnesota Press, 1987), 149–66.

88. See Wayne Koestenbaum, 'The Queen's Throat: Opera, Homosexuality and the Mystery Of Desire' (De Capo Press, 2001).

89. Massimiliano Gioni's 55th Venice Biennale, 'The Encyclopedic Palace' (2013), which celebrated the all-encompassing nature of the psyche and the ways that microcosms of the world can be represented in art, exhibited by many of these artists, including James Richard, Ed Atkins, Helen Marten, Camille Henrot, and Ryan Trecartin.

90. The show eventually materialised as 'The Universal Addressibility of Dumb Things', touring from the Hayward Gallery, London, and onwards to the Bluecoat, Liverpool, Nottingham Contemporary, and the De La Warr Pavillion, Bexhill-on-Sea, from 2013.

91. Daria Martin, Interview with Nicola Mamo, a mirror-touch synaesthete, 2008.

92. Michael J. Banissy, 'Mirror-touch Synaesthesia: The Role of Shared Representations in Social Cognition' (PhD thesis, Institute of Cognitive Neuroscience, University College, London, 2010).

93. Maurice Merleau-Ponty (1945), 'The Phenomenology of Perception' (London: Routledge, 2002), 93. Christopher Pinney and Thomas Csordas also explore Merleau-Ponty's concept of 'double sensation' in their chapters in this volume.

94. W. E. B. Du Bois, 'The Souls of Black Folk: Essays and Sketches, by W. E. Burghardt Du Bois' (Chicago: A. C. McClurg & Co.; Cambridge, MA: University Press John Wilson and Son, 1903).

95. Within the interviews conducted for this volume, while many mirror-touch synaesthetes described themselves as empathic, nearly all also complained of social alienation, feeling awkwardly mismatched with social conventions. Most described a need to retreat when stimulations become overwhelming.

96. At the symposium 'Mirror-Touch: Synaesthesia and the Social' which provided the impetus for this volume, curator Carolyn Christov-Bakargiev coined the term 'touch-mirror' to describe new ways that contemporary artists, such as Pierre Huyghe and Ryan Gander, create physical conditions ('touch'; for example, Gander filled an exhibition's entrance hall with a gentle breeze) to bring spectators into a state in which they are better able to form visual images in their mind, images akin to dreams ('mirror').

97. At the same Tate symposium, without having coordinated amongst themselves, three speakers playfully introduced sessions of guided hypnosis, asking the audience to close their eyes and imagine.

98. See W. J. T. Mitchell, 'What Do Pictures Want?: The Lives and Loves of Images', (Chicago and London: The University of Chicago Press, 2005).

99. See Antonin Artaud, 'The Theatre and Its Double' (1938), trans. Mary Caroline Richards (New York: Grove Press, 1958), 49. Artaud's 'theatre of cruelty' aimed to expose spectators to the dangers of life, engulfing them in a tumultuous vortex that would leave them powerless and unable to escape.

100. Virtual-reality games have finally overcome the impediment of causing nausea, creating a 'profound sensation of space', but have not successfully integrated the sense of touch, as haptic tools remain cumbersome. See Virginia Heffernan, 'Virtual reality fails its way to success', *The New York Times* (14 November 2014), http://www.nytimes.com/2014/11/16/magazine/virtual-reality-fails-its-way-to-success.html?ref=magazine&_r=1.

101. Cases of acquired mirror-touch synaesthesia and also mirror-pain responses have been reported following injury or sensory loss, for example in amputees experiencing phantom limb phenomena where patients have described tactile sensations in their 'phantom limb' when observing visual stimuli of a hand being touched. (See Jamie Ward *et al.*, 'Mirror-touch synaesthesia in the phantom limbs of amputees', *Cortex* (2013), 49, 243–51). In addition, mirror-touch-like experiences have temporarily been induced in non-synaesthetes in laboratory settings. See Andrea Serino, Francesca Pizzoferrato, and Elisabetta Ladavas, 'Viewing a face (especially one's own face) being touched enhances tactile perception on the face', Psychological Science (May 2008), 19, 434–8; also see Nadia Bolognini, Carlo Miniussi, Selene Gallo, and Giuseppe Valtar, 'Induction of mirror-touch synaesthesia by creating somatosensory cortical excitability', Current Biology (20 May 2013), Vol. 23, Issue 10, R436–7.

102. See Paul Ekman, *'Emotions Revealed: Understanding Thoughts and Feelings'* (London: Phoenix, 2004).

103. For review, see Seitz and Watanabe, 'A unified model for perceptual learning', *Trends in Cognitive Science* (Jul 2005), 9(7), 329–34.

104. Simone Weil, quoted in Miklós Vetö, *'The Religious Metaphysics of Simone Weil'* (Albany: SUNY Press, 1994), 45.

SECTION II

Feeling In

In Conversation

Vittorio Gallese and Carolee Schneemann

VITTORIO GALLESE (VG): Vision is still, for the vast majority of cognitive scientists, a purely visual enterprise, likely underpinned by the functionality of the so-called visual brain. Much effort has been put into investigating the back of our brain—the temporal and occipital cortex—where, indeed, most neurons seem to be tuned to the processing of visual information.

But what we have learned over the last three decades is that vision is a multi-modal enterprise. When I'm looking at the acting body of someone else, that leads to the activation not only of the so-called visual brain, but also of the motor brain and tactile brain. So we literally see not just with the visual part of our brain, but with our skin, our guts, and our muscles. Neuroscientific research has demonstrated that the same neural structures activated by the actual execution of actions or by the subjective experience of emotions and sensations are also active when we see others acting or expressing the same emotions and sensations. Mirror mechanisms have been interpreted as the sub-personal neural expression of a basic functional mechanism of the brain–body system, defined as embodied simulation. This idea of the synaesthetic nature of human beings has been forecast by a lot of people. The more I read, the more I realise how unoriginal I am!

CAROLEE SCHNEEMANN (CS): Working with dreams, synaesthesia, and the muscularity of the body to transmit visual materials—that's all been part of my immediate consciousness. For example, on waking up, I might have felt my lover's leg as a kind of materiality and because of the weight and shape of it, I might start drawing something that looks like logs, and then these forms might get reappraised.

It's the implication of Abstract Expressionism that you have to discover the activation of your muscles as you are looking. If you look at Pollock painting with only a psychological activation, it just looks like spilled spaghetti.

vg: When we started discussing the possibility of doing some empirical work on the aesthetic experience of visual artworks with the art historian David Freedberg, he suggested we start with paintings that portray the body in action or in pain—for instance, Goya. But I thought that this was trivial. I was expecting to find exactly what we supposed would be there. So we thought it was more challenging to start with artworks where there is no body to be seen but where there are indeed traces of bodily actions, for example the cuts on canvas by Lucio Fontana or the brushstrokes of Franz Kline. We investigated in two distinct experiments by means of high-density electroencephalography (EEG) the link between the expressive gesture of the artist's hand and the images those gestures produced. We recorded beholders' brain responses to abstract works by Fontana and Kline. The working hypothesis was that when you look at these cuts or brushstrokes, the representation of the hand gesture is awakened. With both experiments, we were able to show that somehow the artwork is a mediator between the creative gesture of the artist and the beholder. We resonate along with the gesture employed by the artist to realise the image. Indeed, we demonstrated that a similar motor simulation of hand gestures is evoked when beholding a cut on canvas by Fontana,[1] or with the dynamic brushstrokes on canvas by Kline.[2] The visible traces of the creative gesture activate in the observer the specific motor areas controlling the execution of the same gesture. The beholder's eyes catch not only information about the shape, direction, and texture of the cuts or strokes, but by means of embodied simulation, they also reach into the actual motor expression of the artist when creating the artwork. The sensory–motor component of our image perception, together with the jointly evoked emotional reaction, allows beholders to feel the artwork in an embodied manner.

Of course this is only part of what is going on when we face those images; it is only one ingredient of our aesthetic experience. The risk is to flatten our appreciation of art to a highly engaged empathic enterprise. Actually, I think that on many occasions the artist does his or her best not to evoke empathic feelings. I am thinking here of movies. With Michelangelo

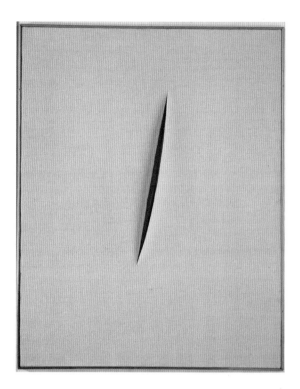

Concetto spaziale 'Attesa', 1960, Lucio Fontana
(1899–1968). Italy © Tate, London 2016.

Antonioni, for example, it's really hard to empathise with his characters be-
cause they cannot empathise with the world. They are totally disconnected. In
Red Desert, Monica Vitti's character says that in order to feel in touch with
the world, she must literally touch the world.

 This vision of art as eliciting only empathy would leave out equally
important aspects, for example what we project onto the artwork, something
that does not proceed from the artwork to the beholder. We think there's a
lot to be investigated and in that respect psychoanalysis still has a lot to say.

cs: Psychoanalysis tells us not just what a viewer projects, but perhaps what
an artist absorbs. Lou Andreas Salome, one of Freud's protégés, was an early
discovery of mine. Her theory of narcissism, which radically broke with Freud's,
related to how a painter dissolves into what is perceived. Narcissism, as she

Michelangelo Antonioni, *Red Desert* (1964). Rizzoli Films/Photofest.

described it, was an aesthetic proclivity, almost a trance-like concentration where you become what you are looking at—you don't define yourself. Narcissus gazed not only at the pool of water, but at the whole of nature reflected in that pool. Nature is the resource where we first learn to see.

Around the time that I became interested in Salome's theories, I was creating assemblages of fractured mirrors. This complex of reflections and refractions shifted fragments of the viewer's self-image into a visual nexus. I love the mirror because it brings in the surrounds and it conflates the viewer with the space of perception, although it may be difficult for them to acknowledge that they become part of what they are looking at; some people have felt frightened by the broken glass or felt that there was an aggression towards them.

My mirrors are always fractured, creating an incremental spatial aspect, letting in more light and more angles. The flat mirror, which Robert Morris used in performances, is predictive. It's more what you expect a mirror to be—self-contained. As soon as the mirrors are fractured, they become multi-dimensional. And the viewer, rather than 'looking at', is 'within what they are looking at'.

vg: I'm reminded of the expression in German aesthetics' post-Romantic era *einfühlung*, meaning literally 'feeling-in'. The notion of empathy was originally introduced in aesthetics in 1872, well before its use in

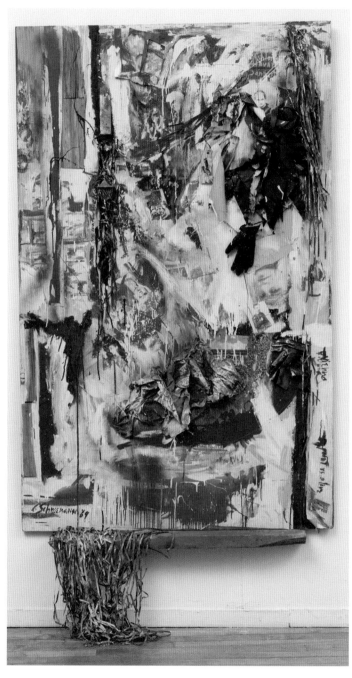

Carolee Schneemann, *Letter to Lou Andreas Salome* (painting construction with recorded text, gloves, photos, etc. 77.5 × 48 × 3.5 inches, 1965). Image courtesy of the Artist and PPOW, New York; Galerie Lelong, New York; Hales Gallery, London. Copyright of the Artist.

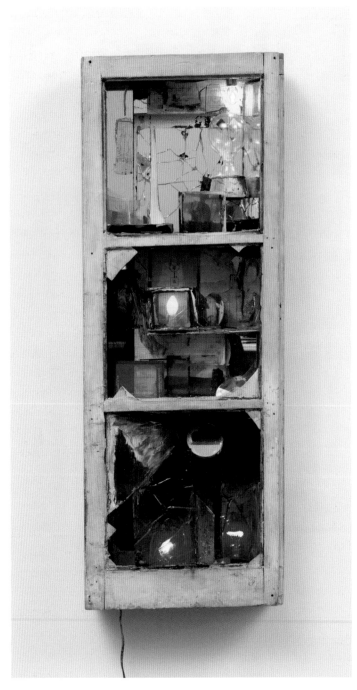

Carolee Schneemann, *Gift Science* (wood box, slides, mirrors, lights, paint, bird, 41 × 15 × 5 inches, 1965).

psychology, to describe the physical response generated by the observation of forms within paintings. Particular visual forms arouse particular responsive feelings, depending on the conformity of forms to the design and function of the muscles of the body, from those of the eyes to our limbs and to our bodily posture as a whole. Robert Vischer, a German philosopher who invented the term, clearly distinguished a passive notion of vision—seeing—from an active one—looking at. According to Vischer, looking best characterises our aesthetic experience when perceiving images in general, and art works in particular. Aesthetic experience implies an empathic involvement encompassing a series of bodily reactions of the beholder.

It's interesting to notice that a similar notion can be found in Giambattista Vico, a Neapolitan philosopher of the Enlightenment era. He made explicit the point that when we relate with inanimate objects, we normally do it by means of transpositions of the human body and of the human passions.

cs: My work has done this in yet more literal ways; I step through the painting space, and my gesture emerges beyond the frame. My active body replicates aspects of the formal properties of the arm painting on canvas. For example, in *Up To and Including Her Limits*, my body was suspended within a tree surgeon's harness, swinging between papered walls, as I drew arcs created by my extended hand stroking the surrounding walls with coloured crayons. The movement was an enlargement of the motion of the arm drawing paint across canvas. The degree to which I feel completely at one within the vertical suspension of the rope is what seems to, quite mystically, accumulate energy in the rope, so that I am in movement before I intend to move. I had to struggle against pre-existing literal interpretations of the naked female body suspended in a harness—a tree surgeon's harness at that—which permits all potential movement. The feeling is not one of captivity or restraint, but one that resembles more the feeling of a child on a swing.

In another transitional work *Eye Body: 36 Transformative Actions for Camera* (1963), I literally transposed myself into the object of my construction. I wanted to include my body in the work's perceptual realm. The painting constructions that I was making at the time included complex kinetic elements (motorised umbrellas, for instance), as well as juxtapositions of collage materials. I positioned my naked body as a form of extended collage within these painting constructions. I painted, glued, and combined materials on my body. The artist Erro

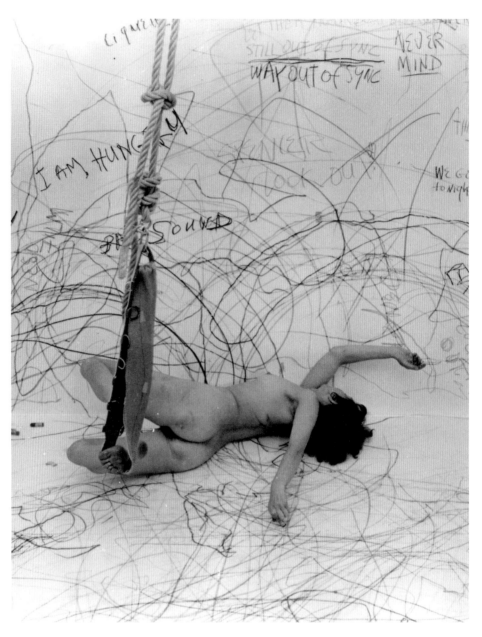

Carolee Schneemann, *Up To And Including Her Limits* (performance at The Kitchen, NYC, 1976).

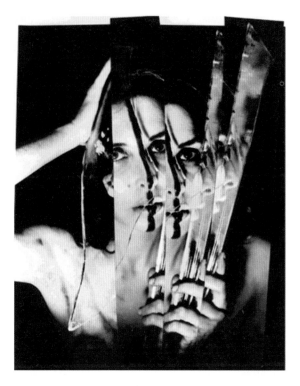

Carolee Schneemann, *Eye Body – 36 Transformative
Actions for Camera* (1962). Photo by Erro.

was on camera. I was entranced with sequences of swift physical combinations
within my constructed materials. I did not take 'a pose'. Later I was taken aback
that the body dominated the overall structure, within which I wanted to be seen
as a form of collage. The body itself became the source of reference, rather than
part of the works including it. I now understand that this was inevitable; but I
didn't anticipate it.

The motivation for *Eye Body* had to do with the fact that there was no inte-
gral depiction of a self-defined female form. I was working against Pop Art—that
synthetic, slick mechanisation of the female body. I was also resisting the fetishi-
sation of the female body, which is what surrounded me in aesthetic culture at
the time as I was growing up into my performance–painter life. So the work has
this very strong underlying political motive. I have a messianic sense that with
my most adventurous, radical works, the audience will recognise this work as

what is necessary in the culture—as the next necessary step. That's just a wish or intention. I know that the presentation of the body in this radicalising way has been of tremendous use to younger women artists as a bridge to explore their own physicality as a material.

vg: I have a question for you, Carolee: this is something that has puzzled me. My very first acquaintance with a new way of employing the body in art was in the late 70s; I was regularly going to the theatre to see Brecht, Pinter, and others. One evening, I was on the way to my seat (I always had the same seat) and I found a lady tied with ropes in the seat next to mine. It gave me a strong feeling of uneasiness—I found it bizarre and I was totally moved by it. That lady turned out to be Judy Malina—it was a performance of the Living Theatre. Soon I discovered Pina Bausch and the like. My question to you is the following: in an age when the body found a revolutionary role in art to support political and feminist issues, how, as an artist and pioneer of this use of the body, did you relate yourself to the mainstream in art criticism? How did you relate in an age where meantime, at the theoretical level, everything had to go through linguistic mediation and cognitive mediation and where there was very little room left for the body? On the one hand, the body for the very first time was willfully at the centre of the stage—it was used as a tool to put forward a new theoretical discourse—and on the other hand, scholars in art theory fully neglected the body. I should add that, during the same years, a similar attitude was shared by cognitive science with its logocentric, almost complete neglect of the embodied dimension of cognition. How did you react, as an artist, to this turn that art theory took in the 70s?

cs: I reacted with a work titled *Vulva's Morphia*. I had a huge accumulation of reactionary cultural research that I thought was suffocating the energies of women's self-definition within art history. I had accumulated a group of papers by Lacan, Freud, Masters, and Johnson, and statements from the Pope on feminism as witchcraft. There was a pile of permutations, concerning female genital mutilations, as well as historic and contemporary genital images from nature, sacred artefacts—including personal erotic images, such as the vaginal penetration by my lover.

The scale of these elements in juxtaposition could never be defined as pornographic, but I was having trouble organising them. And then I had a special

dream—an occurrence beyond my intentions. The voice of a man I do not know appears in a dream with crucial advice. He usually sounds very annoyed with me. In this instance, he said: 'You'll never solve the problem of those erotic elements unless you let Vulva do the talking!' In the morning, I hurried upstairs and asked Vulva to respond with a statement for each group of research. She provided a succinct sentence for each contradictory unit. I was then able to organise her 'text' with my complementary visual grid!

VG: I have seen video footage of *Meat Joy* (1964) and the impression I had was exactly how playful and joyful the human body is.

CS: Well, pleasure! That requires empathy and trust and that's not available for many people. Those are some of the many psychological aspects of freedom and expressivity. I'm thinking of little two-year-old children dancing with ecstatic energy and precision to the rhythm of music and how pure that pleasure is. And then how cultural suppression deforms it. And the pervasive invisibility of abuse.

VG: Empathic perception is in part learned. We understand that there is a rudimentary form of mirroring mostly focused on the face, which turns out to be very useful to foster the earliest forms of attachment between neonates and their caregivers. But as in all kinds of neural mechanisms in our brains, it is highly plastic and entirely open to experience. This has been well investigated in the field of dance. Colleagues in London showed that if you are a classic ballet dancer, your motor system is more activated when you see a video clip of classic ballet than when you see a clip of capoeira, for instance. If you are a dancer and you are exposed to a choreography that you have never practised before, your motor system resonates along, but if you are also instructed in that movement and are able to perform it, this gives some extra strength to your motor simulation.[3] There is definitely a lot of plasticity in this mechanism.

CS: I know that my work will be very disturbing to people who have had negative physical experiences, particularly women who have been abused or men who have been subjected to extreme regimentation.

VG: We have been investigating the role of pervasive, early traumatic experiences in relation to empathic response. We started investigating former child soldiers in Sierra Leone. And recently, we investigated a group

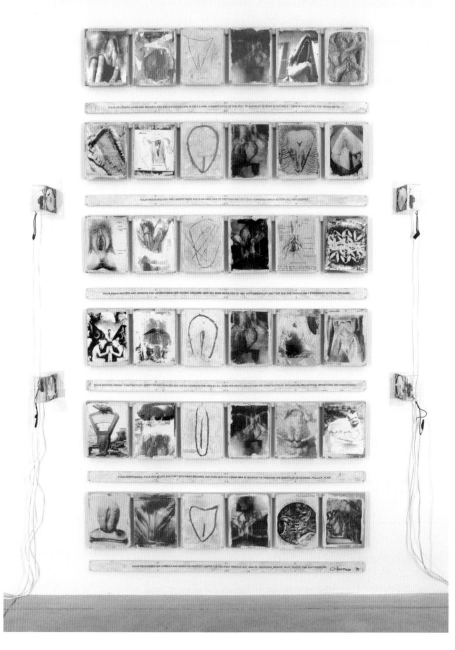

Carolee Schneemann, *Vulva's Morphia* (photogrid with text contrasting of sacred erotic taboo genital details and forms in nature; 36 photographic panels with handpainting, 1995). Image courtesy of the Artist and PPOW, New York; Galerie Lelong, New York; Hales Gallery, London. Copyright of the Artist.

of adolescents—former street boys—restricted in a horrible jailhouse in Free-town, and also even younger street boys. What we found is pretty consistent with results obtained in experiments on post-traumatic stress disorder—an inability to resonate along with specific emotions, particularly sadness. The facial muscles of the traumatised boys we studied did not activate in response to the observation of the facial expression of sadness. Interestingly, at the cognitive level, these boys misrepresented sadness as anger.[4] The first time I showed these results to my good friend, the late psychoanalyst Daniel Stern, his first reaction was that this was a dramatic example of denial. So traumatic experiences profoundly and deeply affect the way we empathise or resonate with others.

cs: In my teaching, the range of empathy is at times absolutely constrained and demonised. If I'm teaching a class of soldiers or marines, there's a whole other threshold of feeling that's been highly constrained. The fluidity of feeling, empathy, uncertainty, and risk could be extremely difficult for those students.

I don't work with any social intentions as such, but because my work eroti-cises what is perceived, then it is in counter-distinction to regimentation and certain kinds of skill learning. The voyeuristic gaze is a very natural, hungry curiosity and we're hoping that it doesn't become suppressed so that it becomes violent and controlling.

vg: There have been some preliminary attempts to look at empathy across cultural groups. For example, the other's political conviction may af-fect your empathy and the response of this neural mechanism. If the other is tagged as someone who pursues ideas that are very far away from yours, the empathic response gets diminished. So there is a lot of gating and top-down control in the brain that helps to magnify and suppress these mirroring re-sponses.

cs: The intense example now would be Israelis and Palestinians, who come from the same desert origins and share the same DNA. There is an ancient break-ing of empathy and embodiment.

My work often attacks dominant, controlling, militaristic forces that remain hidden or occluded. I'm dealing with residual evidence all the time. The Vietnam work, *Mortal Coils*, and *Terminal Velocity* (made in response to 9/11) all share a radical implicit analysis of who's responsible without making that explicit:

'How can this happen?' The Italian expression is '*Chi beneficerà*'—who benefits? That's where my motive is taking its force. What is the underlying transference or identification with this configuration? I'm thinking of how outraged we are by natural disasters that destroy sacred churches or when fanatics chop up religious sculptures that have always been sacred or unique. There's a visceral identification with the materiality and what it embodies. The same is true of a ruined village.

Gaza is in rubble. The hospitals are rubble. The schools, the libraries, the theatre, the schools are all rubble. The bakery, the café, the food market are buried in debris. There are no pistols to shoot the wounded livestock. Displays of feathers from the mutilated chickens vibrate in the debris. There is no toilet paper, there are no crayons, there is no drawing paper, there is no electricity, no water. The children are traumatised, mutilated, wounded, or dead. The Latani River has been bombed to change its natural course so that it is no longer in Palestinian lands. The grapes, the arbors, the ancient olive groves, the fields of lavender, oranges, figs are all debris. The parks are debris. The trees, the ponds, the windows are shattered. The steps are shattered . . . yes, the mosques are shattered. What do I do with this visceral sorrow and rage?

vG: One of the issues that led me to start this new field of empirical investigation into looking at artworks is the relationship between what we take to be real and what we take to be fictional. I was always very sceptical about the solution originally proposed by Coleridge, namely the idea that you turn off a cognitive switch so that you suspend your disbelief and finally you can inhabit a fictional world. This theory doesn't, for example, explain how fictional worlds are often more powerful than real worlds in engaging us. So there must be something more, and I think that something more has to be found in the body.

Another element that intrigues me in looking at artworks is the fact that our ontology is no longer the outcome of what we can perceive with our naked eye. We confer the same status of reality to worlds that are beyond our grasp with our normal vision; we use prosthetic vision in microscopes and telescopes. With new media, the relationship between what is fictional and what is real becomes more blurred. You don't know if you are watching a movie or journalistic footage of the war in Iraq. Since Orson Welles, the media has

had the power to make us believe what is true. I'm curious to see, by looking at the brain–body system, if we can shed new light on where to draw a line between what is real and what is fictional and where this border lies. How can we deconstruct the concepts that we normally employ linguistically to define these different worlds?

Endnotes

1. See M. A. Umiltà, C. Berchio, M. Sestito, D. Freedberg, and V. Gallese, 'Abstract art and cortical motor activation: an EEG study', *Frontiers in Human Neuroscience* (16 November 2012), 6, 311. doi:10.3389/fnhum.2012.00311.

2. See B. Sbriscia-Fioretti, C. Berchio, D. Freedberg, V. Gallese , and M. A. Umiltà, 'ERP modulation during observation of abstract paintings by Franz Kline', *PLoS ONE* (9 October 2013), 8(10), e75241. doi:10.1371/journal.pone.0075241.

3. See B. Calvo-Merino, D. E. Glaser, J. Grèzes, R. E. Passingham, and P. Haggard, 'Action observation and acquired motor skills: an MRI study with expert dancers', *Cerebral Cortex* (August 2005), 15(8), 1243–9. Epub 2004 Dec 22.

4. See M. Ardizzi, F. Martini, M. A. Umiltà, M. Sestito, R. Ravera, and V. Gallese, 'When early experiences build a wall to others' emotions: an electrophysiological and autonomic study', *PLoS ONE* (10 April 2013), 8(4), e61004. doi:10.1371/journal.pone.0061004.

The Vicarious Perception of Touch and Pain: Embodied Empathy

Jamie Ward

Synaesthesia and Mirror-Touch Synaesthesia

People with synaesthesia report 'extra' perceptions of the world relative to normative experience,[1] although the synaesthete would not refer to these perceptions as 'extra', but rather as merely different facets of the same thing. As one synaesthete puts it: 'There have been times when I have had one sensation such as toothache and observed the color of the pain and its taste and smell. All these synesthetic perceptions are aspects of one overall experience. I perceive them as related in the same way that windows, a door, and front steps combine to become the image of a house'.[2] The so-called 'bodily senses' (such as touch, pain, proprioception, and balance) can also participate in synaesthesia. In general, the stimulus that elicits the synaesthesia is termed the **inducer** and the extra experience is termed the **concurrent**.[3] For some, pain or touch may act as the inducer. They may trigger experiences of dynamic coloured forms, in addition to the experiences of pain or touch themselves, as in the quote above.[4] For others, pain and touch are the concurrent experience and these forms of synaesthesia are the primary focus of this chapter.

As a researcher of synaesthesia, I recruit most of our research participants from the general population, including our undergraduate cohort. In 2003, I sent an email to our undergraduate students describing synaesthesia and asking if anyone had it. I received the following reply: 'I think I might have synaesthesia. I can feel touch just by looking at someone being touched'. This student, in our first conversation, reported that seeing someone touched on their left cheek would elicit a feeling of touch on her own right cheek (i.e. a mirror reflection) and similarly for other parts of the body. It would be felt on the same side of the body if facing away from them. Even a word such as 'slap' elicited a feeling

on the cheek. With colleagues, it was decided to conduct a brain imaging study (using functional magnetic resonance imaging (fMRI)), and for this student, we ultimately used a colleague who had hitherto assumed everybody experienced mirror-touch, although, of course, she didn't have a name for it.[5] Subsequent research, with Michael Banissy, studied a whole group of people reporting these experiences,[6] and we developed a cognitive measure of its authenticity.[7] They were shown images of people being touched, while at the same time they were touched (using an electrical device attached to the skin). Some touches corresponded to one another, as in a mirror, so that observed and synaesthetic touch reinforced one another, while other touches complemented one another (real touch on the right cheek and synaesthetic touch on the left cheek, or vice versa). Participants with mirror-touch showed a tendency to confuse observed touch for felt touch, sometimes sensing touch on both cheeks, even when they were only physically touched on one. In her chapter in this volume, Daria Martin describes a film *Sensorium Tests*, inspired by this early study.

Mirror-Touch: From Synaesthesia to Embodiment

It is worth commenting on how mirror-touch relates to more prototypical variants of synaesthesia (e.g. those involving colour). In broad agreement with others, I have argued that synaesthesia has three defining features:[8]

1. That the experiences are explicit and percept-like. This is essentially based on first-person report that there is a parallel between the synaesthetic experience and that of physical seeing, feeling, tasting, etc. Other lines of evidence may corroborate this (e.g. brain imaging studies showing that perceptual regions of the brain are active during synaesthesia). Mirror-touch clearly meets this criterion. If given a list of qualitative descriptors that includes 'touch' but also includes other plausible options such as 'tingling', 'itchiness', or 'other', mirror-touch synaesthetes choose 'touch'.
2. That the experiences are elicited (i.e. they are triggered by an inducer). This is clearly the case in mirror-touch synaesthesia.
3. That the experiences are automatic. From a first-person point of view, they appear inevitably without being willed or controlled. This is

almost certainly one of the reasons why synaesthesia subjectively resembles perceiving rather than imagining. Our research has established the automaticity of mirror-touch synaesthesia by showing that, when asked to respond to physical touch (delivered from an electronic tapper attached to the face or hands), these participants are unable to ignore their synaesthetic touch (elicited by observing touch to another person presented on a computer screen).[9]

Superficially, at least, there is good justification for referring to mirror-touch as synaesthesia. However, others have pointed to potentially important differences. Rothen and Meier (2013) argue that the nature of the inducer in mirror-touch is very different in kind to other types of common synaesthetic inducers (e.g. sounds, letters of the alphabet).[10] Originally we referred to mirror-touch as 'vision-touch synaesthesia',[11] but it is clearly a great over-simplification to refer to 'vision' as the inducer. A more accurate description of the inducer is that of 'observed touch'. This is particularly the case when it is observed touch to a human body,[12] although touch to inanimate things is important to a lesser, and more variable, degree. In mirror-touch, the relationship between the inducer (observing touch) and the concurrent (feeling touch) is non-arbitrary, but other forms of synaesthesia have a higher degree of arbitrariness (e.g. synaesthetes will disagree on the colour and texture of a sound). This has led some to query whether mirror-touch should be grouped with other forms of synaesthesia, or rather with other phenomena.[13]

The ultimate resolution to the question of 'what is synaesthesia?' will come via an understanding of its causes, rather than its superficial characteristics.[14] Other forms of synaesthesia are known to run in families and have a genetic contribution.[15] It is unclear whether this applies in mirror-touch. Some of our mirror-touch synaesthetes report a familial history of grapheme-colour synaesthesia, but it would be important to establish whether this occurs more than through chance, and current evidence is equivocal.[16] Certainly, mirror-touch has a developmental origin, like other typical examples of synaesthesia (although mirror-touch/pain in amputees is an interesting exception).[17]

Most of the research on mirror-touch has focused on touch, rather than pain. However, the brain circuitry that is involved in processing both touch and pain is very similar. Anecdotally and through more systematic assessment, it has been demonstrated that people with mirror-touch also have comparable responses

to observing pain (i.e. they feel pain when observing pain).[18] It should be noted that the converse (i.e. that all people with mirror-pain have mirror-touch) is not necessarily true, and this may reflect the increased intensity linked to pain relative to touch.

Although mirror-touch can be regarded as a form of synaesthesia, its interpersonal (i.e. social) nature sets it apart from other forms.[19] The representation of the body in the brain is constructed from information from various different senses, including touch, pain, proprioception (the position of the joints), interoception (the internal state of the body such as heart rate and breathing rate), and vision. With regard to vision, when we see a body, there is no privileged information in the visual signal that specifies whether the seen body belongs to oneself or another person. Instead, the brain implicitly infers who the seen body belongs to by linking it to other kinds of information—does it match the tactile and proprioceptive signals I am receiving or could it be a reflection in a mirror of my body? As such, the links between vision and touch are both dynamic and potentially errorful. To some extent, mirror-touch can be regarded as a tendency to misappropriate the sight of touch onto the synaesthete's own body ('self-other confusion'), a notion explored in more depth below. While, in this section, I have outlined some of the ways that mirror-touch (and mirror-pain) may be regarded as forms of synaesthesia, below I will link these to research in mirror (neuron) systems, a brain mechanism common to nearly all humans that involves feeling with another.

Touch and Pain—the Physical and the Social

If we see someone being stroked or in pain, do we, in any sense, share these experiences? Of course, understanding what another person is experiencing need not imply a shared experience, although both processes could arguably be described as empathic. Research in the neurosciences over the last decade has established that we can and do empathise in a more literal, embodied sense. Our initial research on mirror-touch demonstrated that, in non-synaesthetic controls, **observing** touch to a face or neck (relative to observing touch to inanimate objects) activated parts of the brain involved in the physical perception of touch.[20] That is, a purely visual stimulus elicits a matching embodied response, even in non-synaesthetes. This basic finding has been corroborated by many

other studies.[21] Subsequent studies have revealed a more detailed pattern. When observing touch, there is a tendency, in the general population, to activate a network of brain regions involved in the action and feeling of touching (i.e. the active parts of the event), in addition to the brain regions involved in the feeling of being touched (i.e. the passive aspects of the event). Similarly, the effects aren't specific to seeing a **human** touched—some parts of the network respond when seeing inanimate objects touched, a possible anthropomorphic embodied response.[22] This may occur because, in these studies, stimuli depicting humans and inanimate objects are interleaved. In general, one can conclude from these studies that the same brain networks that support the physical perception of touch (on our own bodies) also support a social perception of touch (on other bodies and, to an interesting degree, objects). But note that controls do not report explicit feelings of touch on their own bodies, so this mechanism tends to operate implicitly in most people. This is referred to as vicarious touch (or vicarious pain).

As has been described elsewhere in this volume, in macaque monkeys, a particular type of mirror neuron has been found that responds both when a given part of the body is touched (e.g. physical touch to the hand) and when the same body part of another person or monkey is observed to be touched.[23] In humans, neurons have been found that respond both to physical pain (a pinprick) but also to observed pain.[24] How do these neural systems operate in people with mirror-touch? Two brain imaging studies have been conducted to date: one on a single case[25] and one on a group of ten synaesthetes.[26] Although the details of the two studies differ (both in terms of methodology and exact pattern of results), both studies found that when mirror-touch synaesthetes watched touch to another human, they activated regions within the brain involved in the physical perception of touch, and to a significantly greater degree than controls who do not report overt touch experiences. As such, we described the underlying mechanism in terms of hyper-activity within a mirror system for touch in people with mirror-touch when they observe touch. Or, to put it another way, this system is activated above the threshold of conscious awareness in synaesthetes, but below that threshold in most others. This is consistent with a wide range of other evidence suggesting that consciously perceived stimuli (relative to unconscious stimuli) are linked to greater activity in perceptual regions of the brain. In support of this Threshold Theory of mirror-touch, it has been shown that external stimulation of the somatosensory cortex in non-synaesthetes leads to a profile that

resembles mirror-touch synaesthesia in terms of behaviour and subjective experiences when observing touch to humans.[27] One could argue that the external stimulation helps to raise the activity above the threshold of awareness in these people, but in mirror-touch synaesthetes, it is intrinsically raised above that level by particular kinds of cognitive processing (relating to the observation of touch).

The Threshold Theory does not, however, offer a full account of mirror-touch synaesthesia. The brain imaging study of Holle *et al.* (2013) points to some problems with this account.[28] Although mirror-touch synaesthetes show hyper-activity in somatosensory regions (relative to control participants) when observing touch to humans, they show lower than average activity when observing touch to dummies. This suggests that it is the unconscious **modulation** of this system (both up and down) that differs in mirror-touch synaesthetes, rather than a consistent amplification of this system. Further insights came from a consideration of the structural differences in the brains of these synaesthetes. Mirror-touch synaesthetes showed differences in the amount of grey matter in various regions of the brain, particularly those linked to social cognition. Findings such as these led Banissy and Ward to suggest that mirror-touch may be accounted for not only by the Threshold Theory, but also in terms of disruption of a self-other gating mechanism.[29] This 'self-other blurring' theory accounts not only for why the somatosensory system appears to be hyper-active in synaesthetes but may also account for other differences not directly related to somatosensation (e.g. in social cognition). I will explore the implications of this theory further, below.

In the preceding paragraphs, I have described how mirror-touch may relate to mirror systems in the general population. Although research into mirror-pain has only just begun, the embeddedness of the perception of pain in the social brain is relevant to the concerns of this volume.[30] Pain is multi-dimensional in nature, having both affective and sensory components. Pain may either be localised or generalised on the body. Touch, on the other hand, is invariably localised and need not have an affective component. Pain always has an affective component and, as such, serves as a potent social cue. Observing pain activates many of the same regions involved in physically perceiving pain. The extent to which this includes parts of the brain coding for the sensory aspects of pain differs according to factors such as whether a localised painful event can be observed (e.g. an injection), as opposed to expressed through a pained facial expression.[31]

Parts of the brain involved in physical pain perception are involved in the vicarious perception of pain in others. However, certain social situations may

also tap these central pain networks even when no physical pain is implied.[32] These social situations include separation (e.g. from a loved one) and social rejection or exclusion. Animal models of separation have established that separation distress from parents is linked to modulation of the pain pathways.[33] In human brain imaging, viewing a photograph of a loved one activates the reward system of the brain and has pain-reducing (analgesic) effects.[34] However, in states of grief, viewing an image of a departed loved one is linked to **increased** activity within the pain system.[35] Social exclusion has been manipulated experimentally in a simple (virtual) ball-passing game in which a small group of participants decide who to throw the ball to. In the exclusion condition, the other participants stop throwing to one of the other players. An increased activity in the pain network of the brain has been linked both to when the subject is excluded and to when the subject watches someone else excluded.[36] In sum, the use of the brain's system for touch and pain extends deeply into the social.

Empathy Through and Beyond Mirror Systems

The previous section outlined the evidence that vicarious pain and touch (from observing others) use many of the same mechanisms in the brain as physical sensations of pain and touch (namely, mirror systems for pain and touch). The key feature of mirror systems is the fact that comparable responses occur for both self and other (i.e. shared representations).

This wider concept of mirror systems has been postulated to provide a neural basis for empathy.[37] This particular theoretical account is termed the Simulation Theory and states that we come to understand and empathise with others by recreating their actions, feelings, and sensations on our own neural architecture for experiencing those states (either implicitly or consciously). Thus, we understand that someone is disgusted not simply by looking at them and drawing a logical inference ('they are disgusted'), but because we activate our own system for generating disgust feelings. Our ability to read off our own feeling states can be used to infer those of others. People who score higher on questionnaire measures of empathy tend to have greater activity in regions of the brain representing disgust when seeing someone else disgusted[38] and have greater activity in parts of the brain processing pain when they see someone else in pain.[39]

This version of the Simulation Theory is wedded to an arguably rather narrow conceptualisation of what empathy consists of—namely an interpersonal sharing or resonance of states. This is indeed the spirit in which the term 'empathy' was introduced at the turn of the twentieth century to distinguish it from 'sympathy'.[40] Empathy denoted a 'feeling into' or social immersion, whereas 'sympathy' in the contemporary context connotes an air of social distance or condescension (as in the related notion of pity). The term empathy was also introduced to describe a feeling into the natural world, as well as the social world, and this idea is picked up in many places throughout the present volume. However, many contemporary researchers propose empathy to be a more multi-faceted concept than is implied by the Simulation Theory. Some have argued that, for empathy to occur, there is a need for a mechanism that separates self from other by recognising them as similar but distinct. Simulating all the time may lead to emotional overload[41] or confusion between our own feelings and those of others.[42] The application of different models of empathy to the phenomenon of mirror-touch is explored further, below.

It may also be the case that top-down modulation affects empathy. Empathy for pain has been a particularly fruitful research paradigm in which to explore this. There is a general tendency for vicarious pain to resemble physical pain in terms of brain activity (consistent with the Simulation Theory), but this tends to be strongly modulated by context (suggesting influences beyond simple simulation). Singer et al. (2004) invited couples (non-synaesthetes) into the functional magnetic resonance imaging (fMRI) room, such that either they experienced a mild shock or their partner did.[43] The relationship between strangers was also investigated. The follow-up study used previously unknown people with whom the participant interacted in a cooperative game.[44] Some players behaved fairly (they cooperated) and others unfairly (they exploited the participant). After the game, the players received a mild shock. In neurophysiological terms, there was more empathy for pain for the fair player than the unfair player—regions of the brain involved in pain perception were activated more when the participant was told that the fair player was receiving a shock. Males down-regulated their empathic reaction more than females when the unfair player received the shock and, moreover, these shocks activated reward centres of the brain. Thus, in some situations, seeing pain can be rewarding (if you are a male watching someone else being punished, say) and this tendency correlated with subjective reports of desire for revenge. This is a reversal of normal simulation (pain for pain, pleasure for pleasure).[45]

Mirror-Touch, Mirror-Pain: Empathy and Expanded Embodiment

Given that participants with mirror-touch show greater simulation, would they show increased empathy in any broader sense? The answer is not straightforward.

Banissy and Ward (2007) found that people with mirror-touch self-reported higher empathy on one particular measure termed 'emotional reactivity' (linked closely to the concept of simulation) but not necessarily on other aspects of empathy.[46] Whereas questionnaires measure empathic tendencies and are also based on self-report, there are certain tasks that measure empathic accuracy—an objective measure of the ability to correctly infer the feelings of others. Using images of subtle facial expressions, Banissy et al. (2011) showed that mirror-touch synaesthetes perform significantly better on the task of naming the emotion depicted. They do not perform better on other tasks involving non-emotional facial processing (e.g. matching faces from different views).[47] It is important to note this task does not involve touch per se. However, facial or bodily expressions are, like other kinds of actions, associated with somatosensory states (the position in the joints and musculature, etc.). There is evidence, from non-synaesthetes, that viewing and interpreting facial expressions does use some of the same neural resources involved in physical touch.[48] People with mirror-touch tend to rely more on this kind of embodied empathy mechanism.

As mentioned earlier, one way of conceptualising empathy requires a separation of self and other in order to experience the resonance between them. Decety and Jackson (2004) attribute this self-other discriminating mechanism to the function of the right temporo-parietal junction (rTPJ),[49] which has a known role in social cognition.[50] We have found that mirror-touch synaesthetes have **less** grey matter in this region,[51] as well as in the medial prefrontal cortex—also incorporated in Decety and Jackson's model of empathy and implicated in the **regulation** of simulation (e.g. keeping self and other as distinct).[52] This has led us to suggest that mirror-touch can be regarded as a form of self-other confusion.[53] Rather than explaining mirror-touch just as a hyper-activity within the mirror system for touch (as in the Threshold Theory), the hyper-activity within the mirror system for touch is regarded as an inability to regulate this system, depending on who the person is that is observed being touched. As such, Banissy and Ward proposed an important refinement—namely that mirror-touch synaesthetes engage in increased simulation of touch (and probably other body states

such as pain), but this is an outcome of less flexibility within a self-other gating mechanism.[54]

This aspect of mirror-touch and mirror-pain also implies a different style of embodiment. Derbyshire *et al.* (2013) administered a test of perspective taking to people with mirror-pain, in which participants had to state the number of visible objects either from the self-perspective or from the perspective of an avatar.[55] In some cases, the number of objects visible to the avatar differed from the number of visible objects from the self-perspective. Those with mirror-pain were better able at taking the avatar's perspective, whereas controls were better able at taking the self-perspective. These results support the view that there are wider cognitive differences in embodiment in these people that transcend the initial symptom of interest (i.e. the tendency to experience the touch and pain of others).

The rTPJ region is involved in taking the bodily perspective of other people[56] and is activated more when thinking about other people's feelings relative to one's own feelings.[57] Electrical stimulation of this region leads to out-of-body experiences.[58] As we know, mirror-touch synaesthetes have less grey matter in the TPJ region, and one consequence of this may be an expanded body map that leads to a tendency to feel what they see. It may also account for a number of other anecdotes that have little or nothing to do with 'touch' but clearly capture the notion of disrupted embodiment, including, for example:

> 'I loved to stand in front of the Giacometti . . . and it is a very good feeling. So I love to stand in front of them and feel I am getting longer.'[59]

> 'I'll look at a work of art and suddenly my leg or knee needs to move up, when I see a certain shape; or my elbow needs to move in a particular direction. When I look at a large artwork I will actually do an automatic contortion of my body.'[60]

The quotes from these mirror-touch synaesthetes, interviewed by this volume's editor Daria Martin and the mirror-touch researcher Elinor Cleghorn, point to blurred boundaries between their own body and that of others (and indeed objects). However, they tend not to involve an external projection (like an out-of-body experience), but rather an absorption of other bodies within their own. Whatever the interpretation, the descriptions clearly go beyond descriptions of 'touch'. As such, mirror-touch and mirror-pain may resemble less Decety and Jackson's model (which suggests that self and other must be recognised as

distinct, yet resonant) and more the original meaning of empathy in *einfühlung* (literally feeling-in). Aesthetic philosopher Robert Vischer had intended the term to imply feelings of becoming one with an artform—an immersive, body-centred response to an artwork. Extending this to the social domain, Gallese refers to this general mechanism as we-centred, emphasising the role of shared representations, mirror systems, for coupling perception with feelings and actions.[61] The relationship between empathy and art is as old as the term empathy itself, and mirror-touch helps us to think about the complexities of empathic spectatorship.

Endnotes

1. J. Ward, 'Synesthesia', *Annual Review of Psychology* (2013), 64, 49–75.
2. C. J. Steen, 'Visions shared: a firsthand look into synesthesia and art', *Leonardo* (2001), 34, 203–8.
3. P. G. Grossenbacher and C. T. Lovelace, 'Mechanisms of synaesthesia: cognitive and physiological constraints.' *Trends in Cognitive Sciences* (2001), 5, 36–41.
4. G. J. Dudycha and M. M. Dudycha, 'A case of synesthesia: visual pain and visual audition', *Journal of Abnormal Psychology* (1935), 30, 57–69; J. Simner and V. U. Ludwig, 'The color of touch: a case of tactile-visual synaesthesia', *Neurocase* (2012), 18, 167–80.
5. S. -J Blakemore, D. Bristow, G. Bird, C. Frith, and J. Ward, 'Somatosensory activations during the observation of touch and a case of vision-touch synesthesia', *Brain* (2005), 128, 1571–83.
6. Some synaesthetes, including the first people we studied, report that their experiences are a mirror-reflection of that observed (assuming face-to-face interaction), whereas others report a kind of mental rotation, such that observed touch to the left is felt on their own left side. We referred to these as specular and anatomical subtypes (both fall under the label of mirror-touch), but, to date, we have not shown that these two subtypes differ from each another in other respects, owing to the rarity of the anatomical subtype.
7. M. Banissy and J. Ward, 'Mirror touch synaesthesia is linked with empathy', *Nature Neuroscience* (2007), 10, 815–16.
8. J. Ward, 'Synesthesia', *Annual Review of Psychology* (2013), 64, 49–75.
9. M. Banissy and J. Ward, 'Mirror touch synaesthesia is linked with empathy', *Nature Neuroscience* (2007), 10, 815–16.
10. N. Rothen and B. Meier, 'Why vicarious experience is not an instance of synesthesia', *Frontiers in Human Neuroscience* (2013), 7. doi: 10.3389/fnhum.2013.00128.
11. S. -J Blakemore, D. Bristow, G. Bird, C. Frith, and J. Ward, 'Somatosensory activations during the observation of touch and a case of vision-touch synesthesia', *Brain* (2005), 128, 1571–83.
12. H. Holle, M. J. Banissy, and J. Ward, 'Functional and structural brain correlates of mirror-touch synaesthesia', *NeuroImage* (2013), 83, 1041–50.
13. R. Nicolas and B. Meier, 'Why vicarious experience is not an instance of synesthesia', *Frontiers in Human Neuroscience* (2013), 7. doi: 10.3389/fnhum.2013.00128.
14. J. Simner, 'Defining synaesthesia', *British Journal of Psychology* (2012), 103, 1–15.
15. J. E. Asher, J. A. Lamb, D. Brocklebank, *et al.*, 'A whole-genome scan and fine-mapping linkage study of auditory-visual synesthesia reveals evidence of linkage to chromosomes

2q24, 5q33, 6p12, and 12p12',
American Journal of Human Genetics
(2009), 84, 279–85. doi: 10.1016/j.
ajhg.2009.01.012.

16. C. A. Chun and J. -M Hupe, 'Mirror-touch and ticker tape experiences in synesthesia', *Frontiers in Psychology* (2013), 4. doi: 10.3389/fpsyg.2013.00776.

17. B. M. Fitzgibbon, P. G. Enticott, M. J. Giummarra, R. H. Thomson, N. Georgiou-Karistianis, and J. L. Bradshaw, 'Atypical electrphysiological activity during pain observation in amputees who experience synaesthetic pain', *Social, Cognitive and Affective Neuroscience* (2012), 7, 357–68. doi: 10.1093/scan/nsr016; A. I. Goller, K. Richards, S. Nowak, and J. Ward, 'Mirror-touch synaesthesia in the phantom limb of amputees', *Cortex* (2013), 49, 243–51.

18. J. Ward and M. J. Banissy, 'Explaining mirror-touch synesthesia', *Cognitive Neuroscience* (2015), 6, 118–33.

19. The term 'social' in psychology is used to refer to the actual, imagined, or implied presence of others. That is, it concerns the perceiver's beliefs and inferences about the presence of others. This definition opens the doors to various ambiguities such as the perception of social attributes (e.g. animacy, agency) in objects which, in the present definition, can be properly construed as 'social'. The development of *in vivo* neuroimaging methods in humans has led to an increased tendency to study social processes neuroscientifically.

20. S. -J. Blakemore, D. Bristow, G. Bird, C. Frith, and J. Ward, 'Somatosensory activations during the observation of touch and a case of vision-touch synesthesia', *Brain* (2005), 128, 1571–83.

21. C. Keysers, J. H. Kaas, and V. Gazzola, 'Somatosensation in social perception', *Nature Reviews Neuroscience* (2012), 11, 417–28.

22. H. Holle, M. J. Banissy, and J. Ward, 'Functional and structural brain correlates of mirror-touch synaesthesia', *NeuroImage* (2013), 83, 1041–50.

23. H. Ishida K. Nakajima, M. Inase, and A. Murata, 'Shared mapping of own and others' bodies in visuotactile bimodal area of monkey parietal cortex', *Journal of Cognitive Neuroscience* (2010), 22, 83–96.

24. W. D. Hutchison K. D. Davis, A. M. Lozano, R. R. Tasker, and J. O. Dostrovsky, 'Pain-related neurons in the human cingulate cortex', *Nature Neuroscience* (1999), 2, 403–5. doi: 10.1038/8065. Note that human neuroimaging methods (e.g. fMRI) do not enable individual neurons to be visualised, but this particular study used intracranial recordings that do permit this level of visualisation.

25. S. -J. Blakemore, D. Bristow, G. Bird, C. Frith, and J. Ward, 'Somatosensory activations during the observation of touch and a case of vision-touch synesthesia', *Brain* (2005), 128, 1571–83.

26. H. Holle, M. J. Banissy, and J. Ward, 'Functional and structural brain correlates of mirror-touch synaesthesia', *NeuroImage* (2013), 83, 1041–50.

27. N. Bolognini, C. Miniussi, S. Gallo, and G. Vallar, 'Induction of mirror-touch synaesthesia by increasing somatosensory cortical excitability', *Current Biology* (2013), 23, R436–7. doi: 10.1016/j.cub.2013.03.036.

28. H. Holle, M. J. Banissy, and J. Ward, 'Functional and structural brain correlates of mirror-touch synaesthesia', *NeuroImage* (2013), 83, 1041–50.

29. M. J. Banissy and J. Ward, 'Mechanisms of Self-other representations and vicarious experiences of touch in mirror-touch synesthesia', *Frontiers in Human Neuroscience* (2013) 7. doi: 10.3389/fnhum.2013.00112; J. Ward and M. J. Banissy, 'Explaining mirror-touch synesthesia', *Cognitive Neuroscience* (2015), 6, 118–33.

30. C. Lamm, J. Decety, and T. Singer, 'Meta-analytic evidence for common and distinct neural networks associated with directly experienced pain and empathy for pain', *NeuroImage* (2011), 54, 2492–502.

31. C. Lamm, J. Decety, and T. Singer, 'Meta-analytic evidence for common and distinct neural networks associated with directly experienced pain and empathy for pain', *NeuroImage* (2011), 54, 2492–502.

32. G. MacDonald and M. R. Leary, 'Why does social exclusion hurt? The relationship between social and physical pain', *Psychological Bulletin* (2005), 103, 202–23; J. Panksepp, 'Why does separation distress hurt? Comment on MacDonald and Leary (2005)', *Psychological Bulletin* (2005), 131, 224–30. doi: 10.1037/0033-2909.131.2.224.

33. J. Panksepp, 'Why does separation distress hurt? Comment on MacDonald and Leary (2005)', *Psychological Bulletin* (2005), 131, 224–30. doi: 10.1037/0033-2909.131.2.224 2005.

34. J. Younger, A. Aron, S. Parke, N. Chatterjee, and S. Mackey, 'Viewing pictures of a romantic partner reduces experimental pain: involvement of neural reward systems', *PLoS One* (2010), 5, 7. doi: e1330910.1371/journal.pone.0013309.

35. M. F. O'Connor, D. K. Wellisch, A. L. Stanton, N. I. Eisenberger, M. R. Irwin, and M. D. Lieberman, 'Craving love? Enduring grief activates brain's reward center', *Neuroimage* (2008), 42, 969–72. doi: 10.1016/j.neuroimage.2008.04.256.

36. M. L. Meyer, C. L. Masten, Y. Ma, C. Wang, Z. Shi, N. I. Eisenberger, and S. Han, 'Empathy for the social suffering of friends and strangers recruits distinct patterns of brain activation', *Social Cognitive and Affective Neuroscience* (2013), 8, 446–54. doi: 10.1093/scan/nss019; N. I. Eisenberger, M. D. Lieberman, and K. D. Williams, 'Does rejection hurt? An fMRI study of social exclusion', *Science* 2003, 302, 290–2.

37. M. Iacoboni, 'Imitation, empathy, and mirror neurons', *Annual Review of Psychology* (2009), 60, 653–70. doi: 10.1146/annurev.psych.60.110707.163604.

38. M. Jabbi, M. Swart, and C. Keysers, 'Empathy for positive and negative emotions in gustatory cortex', *NeuroImage* (2007), 34, 1744–53.

39. C. Lamm, J. Decety, and T. Singer, 'Meta-analytic evidence for common and distinct neural networks associated with directly experienced pain and empathy for pain', *NeuroImage* (2011), 54, 2492–502.

40. R. Greiner, '1909: The Introduction of the Word 'Empathy' into English' BRANCH: Britain, Representation and Nineteenth-Century History (2013).

41. A. Bandura, 'Reflexive empathy: on predicting more than has ever been observed', *Behavioral and Brain Sciences* (2002), 25, 24.

42. F. de Vignemont, 'Shared body representations and the 'Whose' system', *Neuropsychologia* (2014), 55, 128–36. doi: 10.1016/j.neuropsychologia.2013.08.013.

43. T. Singer, B. Seymour, J. O'Doherty, H. Kaube, R. J. Dolan, and C. D.

Frith, 'Empathy for pain involves the affective but not the sensory components of pain', *Science* (2004), 303, 1157–62.

44. T. Singer, B. Seymour, J. P. O'Doherty, K. E. Stephan, R. J. Dolan, and C. D. Frith, 'Empathic neural responses are modulated by the perceived fairness of others', *Nature* (2006), 439, 466–9.

45. Thus, one can take an extreme extension of the concept of empathy to include sadism; you need to know what another person feels to get off on it.

46. M. Banissy and J. Ward, 'Mirror touch synaesthesia is linked with empathy', *Nature Neuroscience* (2007), 10, 815–16.

47. M. J. Banissy, L. Garrido, F. Kusnir, B. Duchaine, V. Walsh, and J. Ward, 'Superior facial expression, but not identity recognition, in mirror-touch synaesthesia', *Journal of Neuroscience* (2011), 31, 1820–4.

48. R. Adolphs, H. Damasio, D. Tranel, G. Cooper, and A. R. Damasio, 'A role for somatosensory cortices in the visual recognition of emotion as revealed by three-dimensional lesion mapping', *Journal of Neuroscience* (2000), 20, 2683–90; D. Pitcher, L. Garrido, V. Walsh, and B. C. Duchaine, 'Transcranial magnetic stimulation disrupts the perception and embodiment of facial expressions', *Journal of Neuroscience* (2008), 28, 8929–33. doi: 10.1523/jneurosci.1450-08.2008.

49. J. Decety and P. J. Jackson, 'The functional architecture of human empathy', *Behavioral and Cognitive Neuroscience Reviews* (2004), 3, 71–100.

50. J. Decety and J. Grezes, 'The power of simulation: Imagining one's own and other's behavior', *Brain Research* (2006), 1079, 4–14. doi: 10.1016/j.brainres.2005.12.115.

51. H. Holle, M. J. Banissy, and J. Ward, 'Functional and structural brain correlates of mirror-touch synaesthesia', *NeuroImage* (2013), 83, 1041–50.

52. J. Decety and P. J. Jackson, 'The functional architecture of human empathy', *Behavioral and Cognitive Neuroscience Reviews* (2004), 3, 71–100.

53. M. J. Banissy and J. Ward, 'Mechanisms of self-other representations and vicarious experiences of touch in mirror-touch synesthesia', *Frontiers in Human Neuroscience* (2013), 7. doi: 10.3389/fnhum.2013.00112; J. Ward and M. J. Banissy, 'Explaining mirror-touch synesthesia', *Cognitive Neuroscience* (2015), 6, 118–33.

54. M. J. Banissy and J. Ward, 'Mechanisms of self-other representations and vicarious experiences of touch in mirror-touch synesthesia', *Frontiers in Human Neuroscience* (2013), 7. doi: 10.3389/fnhum.2013.00112.

55. S. W. Derbyshire, J. Osborn, and S. Brown, 'Feeling the pain of others is associated with self-other confusion and prior pain experience', *Frontiers in Human Neuroscience* (2013), 7, 470.

56. S. Arzy, G. Thut, C. Mohr, C. M. Michel, and O. Blanke, 'Neural basis of embodiment: distinct contributions of temporoparietal junction and extrastriate body area', *Journal of Neuroscience* (2006), 26, 8074–81.

57. P. Ruby and J. Decety, 'How would you feel versus how do you think she would feel? A neuroimaging study of perspective-taking with social emotions', *Journal of Cognitive Neuroscience* (2004), 16, 988–99.

58. O. Blanke and S. Arzy, 'The out-of-body experience: disturbed self-processing at the temporo-parietal junction', *Neuroscientist* (2005), 11, 16–24. doi: 10.1177/1073858404270885.

59. Elinor Cleghorn, Interview with Anna Mandel, a mirror-touch synaesthete, 15 May 2014.

60. Elinor Cleghorn, Interview with anonymous, a mirror-touch synaesthete, 21 July 2014.

61. V. Gallese, 'Empathy, embodied simulation, and the brain: commentary on Aragno and Zepf/ Hartmann', *Journal of the American Psychoanalytic Association* (2008), 56, 769–81.

Orchestration of the Senses in Yellow: Eisenstein's Fourth Dimension, Memory, and Mirror-Touch Synaesthesia

Patricia Pisters

Luria, Eisenstein, Vygotsky

In the 1920s, the famous Russian neurologist Alexander Luria received the news-paper reporter Solomon Shereshevsky in his office. 'S.', as Luria called his soon-to-be patient, had been sent by his employer because he never took any notes and yet seemed to remember every detail of his assignments. Luria began to test S. in his laboratory and soon found out that 'the capacity of his memory had no distinct limits'.[1] Luria was interested in the total personality and life history of his patients, and he followed S. for over 30 years. In *The Mind of a Mnemonist: A Little Book About a Vast Memory*, published in 1967, the neurologist reveals 'a glimpse of his patient's inner world', combining scientifically observed data with more biographical impressions of S.'s life.[2] In probing S.'s mind, Luria soon understood that his seemingly limitless memory was related to multiple forms of synaesthesia. Words settled in his mind as 'puffs of steam or splashes'[3] and were translated into rich images. Voices arrived as metals, in colour, with taste and texture; they might be 'yellow and crumbly' or they might, like the film-maker Sergei Eisenstein's, feel 'like a bouquet, protruding a flame with fibers'.[4] Eisenstein knew S. and in his own book *The Film Sense*, the filmmaker reminds us that S. was the prototype for Hitchcock's Mr Memory in *The Thirty-Nine Steps*.[5] Like Mr Memory, S. became a vaudeville act, astonishing audiences with his mnemonic capacity. In Hitchcock's film, Mr Memory's performance is intro-duced with the announcement that 'Mr Memory has left his brain to the British Museum', indicating a fascination for the brain that is very familiar to a con-temporary audience. Likewise, Eisenstein, an artist discovering the powers of cinematography, was fascinated by the secrets of the brain.

Eisenstein at work in his lab.

It was no coincidence that Eisenstein knew Luria's patient S. In fact, from the mid-20s onwards, Eisenstein, Luria, and the sociologist and cultural psychologist Lev Vygotsky carried out a common and long-standing research programme that 'aimed to combine neurosciences, social sciences and cinema theory to address the neural basis and semiotics of screen aesthetics'.[6] Luria, Vygotsky, and Eisenstein shared a deep interest in the brain which they approached from different angles: physiology, sociology, and aesthetics. Although to this day, very little is known about this collaboration (as much of especially Eisenstein's work was for a long time censored and still needs to be translated from Russian),[7] it is clear that, in combining their disciplinary backgrounds, the neuroscientist, sociologist, and filmmaker shared an integrative conception of the brain and mind, positing that 'cognitive processes descend from the complex interaction and interdependence of biological factors that are part of physical nature, and cultural factors that appeared in the course of human evolution'.[8] The collaboration of this unique Russian trio intriguingly anticipates certain areas of contemporary neuroscience—in particular the Embodied, Embedded, Enactive, Extended, and Affective, or so-called '4EA' strands in which the brain is not only seen as pure neuronal materiality, but also as a dynamic system that is fundamentally connected to the body, to actions and affections, and to the world and other elements that extend and influence the brain beyond the skull.[9] And, as I will suggest by returning to

Eisenstein, we might find visionary inspiration in this historical reference for the transdisciplinary investigations in mirror-touch synaesthesia that are the focus of this volume. More specifically, the phenomenon of synaesthesia is of particular interest for Eisenstein in his theories about art, which I will elaborate in relation to mirror-touch.

Synaesthesia and the Magic of Art

Let's first return to Russia in the first half of the twentieth century and to Eisenstein's own ideas about synaesthesia in art. Establishing a profound relation between art (film art) and human experience, he writes: '(. . .) we shall see that Man and the relations between his *gestures* and the *intonations* of his voice, which arise from the same emotions, are our models in determining audio-visual structures, which grow in an exactly identical way from the governing image (. . .)'.[10] For Eisenstein, thought, emotions, subjectivity, and the language of cinema are fundamentally interconnected; the (audio-visual) image operates according to the same logic as human behaviour and emotion. One important way of understanding this deep connection between screen, body, and brain is by way of synaesthesia. In a late text entitled *The Magic of Art* which was preserved in Luria's archive for 50 years after Eisenstein's death and which is now the prologue to the 2002 Russian edition of Eisenstein's still untranslated *Methods*, Eisenstein stated that 'magic' here is not an empty figure of speech:

> For art (the real one) artificially turns the spectator back to the sensory thinking stage, to its norms and types, and this stage is in reality a stage of magic interrelation with nature. When you have reached, for example a synaesthetic merging of sound and image, you have placed the viewer's perception under sensory thinking conditions, where the synaesthetic perception is the only possible one – there is still no differentiation of perception. And you have the spectator 're-oriented' not to the norms of today's perception, but to the norms of a primordial sensory one – he is 'returned' to the magical stages of normal sensation. And the idea that has been brought about by such a system of influences, incarnated into a form by such means, irresistibly controls emotions.[11]

According to Eisenstein, art has the capacity to bring the spectator back to a 'sensory thinking stage,' a stage that he imagines as pre-existing our habitual perceptions. This primordial stage can be compared to what 4EA-cognitivists call

the impersonal affective dimensions of emotions that are immediately embodied.[12] I will return to this point momentarily. What is important for now is that Eisenstein was interested in the relation between the human (embedded, embodied) mind and the power of art to change perceptions (and memories, experiences, etc.).[13] Synaesthesia was for Eisenstein an important first step in understanding how a good work of art can make a formal translation to reach this primordial sensory stage. In *The Film Sense*, Eisenstein discusses elaborately how the different senses can be 'synchronised' in an artwork. Touch, smell, sight, light, colour, hearing, temperature, and movement (speed, slowness, rhythm) can be rendered in many different ways and in different combinations in a 'polyphonic montage' that 'advances multiple series and lines' and produces an orchestration of the senses.[14] He gives an example of the graphic, dramatic lines in the procession sequence in *The Old and New* (*The General Line*, 1929):

1. The line of heat, increasing from shot to shot
2. The line of changing close-ups, mounting in plastic intensity
3. The line of mounting ecstasy, in the dramatic content of the close-ups
4. The line of the women's voice (faces of the singers)
5. The line of the men's voices (faces of the singers)
6. The line of those who kneel under the passing icons (increasing in tempo)
7. The line of grovelling, uniting both streams in the general movement of the sequence 'from heaven to dust'. [15]

Each shot contributes to the totality of the film, around the theme from the 'old' to the 'new'. After 'the old' of the religious procession sequence, the milk-separating sequence builds towards 'the new' of the communist revolution. But in bringing all these lines together, they need to be synchronised at some deeper level, Eisenstein argues.

The principles are the same for the sound film, even if this extra audio line (in itself also complex) invites even more careful composition in relation to the image. About *Alexander Nevsky*, Eisenstein explains: 'Here the lines of the sky's tonality—clouded or clear, of the accelerated pace of the riders, of their direction, of the cutting back and forth form Russians to knights, of the faces in close-up and the tonal long-shots, the tonal structure of the music, its themes, its tempi, its rhythm, etc. (. . .) Many hours went into the fusing of these elements into an organic whole'.[16] What Eisenstein is aiming at with his synchronisation of

the senses into an organic whole is not a consonance between all the sensory elements. On the contrary, music and sound, for instance, might have quite a dissonant relation or even a counter-punctual one,[17] and as is known, Eisenstein's conception of montage is a dialectic one, based on conflict and dynamic encounter between shots.[18] And yet he searched for an 'organic wholeness', proceeding from an 'inner synchronisation' of the senses inspired by this primordial synaesthesia.

Making Sense of Colours

In *The Film Sense*, Eisenstein devotes an entire chapter to different kinds of colour synaesthesia, especially relating to the colour yellow and referring to well-known examples in literature and art. He is highly critical of the Russian painter Wassily Kandinsky's experimental theatre piece *The Yellow Sound* because Kandinsky's synaesthetic merging of music and colours is too abstract, too uniform for Eisenstein's likings. He calls Kandinsky's method a 'conscious attempt to divorce all formal elements from all content elements' which evokes 'obscurely disturbing sensations' that do not, however, enter into meaningful relationships.[19] While it is of course perfectly fine not to look for meaningful relations (and just enjoy the formal qualities of ' yellow sounds'), it is significant that Eisenstein includes feeling **and** meaning, form **and** content, when he talks about his orchestration of the senses. Moreover, according to Eisenstein, Kandinsky looks for the common denominator between the arts but does not leave intact the medium specificities that Eisenstein finds so important to keep in mind.

In contrast to Kandinsky's highly abstract form of synaesthesia, on the other side of the spectrum, Eisenstein also discusses the meanings culturally ascribed to colour, which he sees as equally non-instructive about the true synaesthetic connections colours can make to other sense-impressions and to other media. Eisenstein quotes many literary and artistic examples (from T. S. Elliot and Walt Whitman to Picasso and Van Gogh) that demonstrate the spectrum of positive gold-yellow to negative pale-green yellow with ascribed meanings ranging from warmth and light to perfidy, treason, and sin. He emphasises that these colours contain 'a directly sensual base' into which associations are woven.[20] However, yellow should not automatically be equated with wisdom, warmth, and light or envy, illness, and deception as, for instance, in the French expression '*un bal jaune*'.[21] Abstracting colour from the concrete phenomenon and seeking **absolute**

Shutter Stock Yellow.

correlations of colour and sound, colour and emotion, and colour and eternal meaning will get us nowhere, Eisenstein argues.[22]

Eisenstein wants to preserve the direct sensual and embodied effect of colour and, at the same time, keep its meaning open to contextual elements of form and content in a much more varied way than fixed interpretations suggest. As a more positive example, he refers to the nineteenth-century French poet Arthur Rimbaud's classic synaesthetic poem on the colours of vowels. Rimbaud does not speak of an 'absolute correspondence' but of 'images to which he has attached personal colour concepts'.[23] The vowel 'I' for Rimbaud corresponds not merely to 'Red' but to ' . . . purples, blood spit out, laugh of lips so / Lovely in anger or penitent ecstasies'.[24] Eisenstein argues that colour, as exemplified by Rimbaud's poem, stimulates a conditioned reflex, which recalls a complex constellation of memories and senses. In *The Film Sense*, he quotes the complete poem, connecting the pronunciation of each vowel moreover to instrumental timbres and sounds, and to a whole catalogue of emotions.[25] Each colour becomes an interplay of senses (as both sensations and meanings) that can and needs to be reinvented and brought into resonance again and again in new and variegating ways, orchestrated by the artist for maximum effect on the reader/ spectator.

All this does not mean that Eisenstein denies a direct relationship between colours and emotions. Here he refers to the scientific neurological experiments that had established that certain sense-impressions operate in 'dynamogeneous' or 'inhibitive' ways on the brain's distribution to the body; red, for instance, is

'*Voyelles*' by Arthur Rimbaud (1872)

> Vowels: Black A, white E, red I, green U, blue O,
> Someday I shall name the birth fro which you rise:
> A is a black corset and over it the flies
> Boil noisy where the cruel stench fumes slow,
>
> Shadow-pits; E, candor of mists and canopies,
> Shiver of flowers, white kings, spears of the glacial snow:
>
> I, purples, blood spit out, laugh of lips so
> Lovely in anger or penitent ecstasies;
>
> U, cycles, divine vibrations of green seas;
> The peace of animal pastures, peace of these
> Lines printed by alchemy on the great brows of the wise;
>
> O, the great Trumpet strange in its stridencies,
> The angel-crossed, the world-crossed silences:
> – O the Omega, the blue light of the Eyes
>
> *Vowels* by Arthur Rimbaud (1854–1891), Translation by Muriel Rukeyser, quoted in Eisenstein, *The Film Sense*, 90.

dynamogeneous, while violet is inhibitive.[26] But again these affects can be integrated in complex colour pallets and constellations of memories and meanings. It is here, too, that Eisenstein recalls patient S.'s remarkable forms of synaesthesia. In a conversation that Eisenstein had with S., the synaesthete told him that 'the scale of vowels was seen by him not as colours, but as a scale of varying light values. Colour for him is summoned only by the consonants'.[27] And for S., each word, each number, each sound was connected to a light scale or colour that gave him his vast memorising capabilities. While, for S., these automatically summoned synaesthetic images may be absolute in his system, Eisenstein makes a strong point in claiming that, in art, there are no absolute relationships that are decisive. Even within the limitations of a colour range of black and white, in which Eisenstein himself made most of his films, the colour sensations

and meanings are not pre-determined. He gives the examples of even the use of simple black and white in very different ways—in *The Old and the New*, black stands for old, criminal, outdated; and white signifies new, life, abundance, happiness. In *Alexander Nevsky*, on the other hand, white is related to the cruelty of Germans, while black is positively connoted to the heroic Russian warriors. And so Eisenstein argues that, in artistic synaesthesia, 'the emotional intelligibility and function of colour will rise from the natural order of establishing the colour imagery of the [part of the] work, coincidental with the process of shaping the living movement of the whole work'.[28] Each work creates its own inner synaesthetic resonance—or in any case, it is for the artist to draw it out.

The Fourth Dimension and Mirror-Touch Synaesthesia

So far, the focus of this chapter has been on different kinds of synaesthesia (especially coloured phonemes and sound) and its relation to art production. The question of spectatorship and mirror-touch as a newly discovered form of synaesthesia will be more central in the remainder of this chapter. As Jamie Ward and Michael Banissy (also contributors to this volume) have demonstrated in scientific experiments, mirror-touch is related to empathy because of 'the shared affective neural systems in which common brain areas are activated during both experience and passive observation'.[29] And, as we can learn from Eisenstein, this physiological form of empathy is not unrelated to the other forms of synaesthesia as an orchestration of the senses, especially if we want to reach this 'primordial' level where art can deeply move us. All of Eisenstein's reflections on synaesthesia in the artwork take 'as its guide the total stimulation through all [senses]' and ultimately aim at reaching the 'feeling of the shot as a whole', or what Eisenstein calls the fourth dimension: 'In this way, behind the general indication of the shot, the physiological summary of its vibrations as a *whole*, as a complex unity of the manifestation of all its stimuli, is present'.[30] This 'feeling of the shot as a whole' is what Eisenstein calls the filmic fourth dimension. An artist who manages to synaesthetically orchestrate the senses reaches this primordial physiological fourth dimension within the artwork and touches the audience in their own primordial physiological (and largely unconsciously operating) synaesthesia. At this deep level of the fourth dimension, artworks affect audiences by way of mirror-touch.[31]

To explain this further, let's look at a few more ways in which Eisenstein expresses this fourth dimension. In his cinema books, the French philosopher Gilles Deleuze discusses Eisenstein's aesthetics by focusing on the ways in which his films produce this deep affective quality. Deleuze gives a physiological definition of affect as 'a motor tendency on a sensitive nerve' moving between a 'reflecting surface and intensive micro-movements'.[32] He refers to the dynamic graphic lines in Eisenstein's *Battleship Potemkin*, but also to the particular use of close-ups that express power as change and transformation, as qualitative leaps.[33] Deleuze calls these close-ups 'affection-images'. Affection-images in Eisenstein express power, such as the call for revolutionary change in the close-ups of hands and faces of the rising people in his revolution films. According to Deleuze, affection-images speak directly to the spectator's feelings of empathy; they touch us in a direct and embodied way.[34]

Affection-images can also express a more contemplative affective quality of wonder and sorrow, as in the face of Renée Falconetti in the Danish filmmaker Carl Dreyers' famous film *The Passion of Joan of Arc*. Affection-images are not limited to close-ups of faces or hands. They can be induced by colour, graphic patterns, disorienting spatial framings, and other aesthetic means.[35] I will return to colour in affection-images further on. But in close-up, the face (or faciality

Graphic line in *Battleship Potemkin* (Eisenstein, 1925).
Reproduced with permission of FSUE Mosfilm Cinema Concern.

Face and hands in Potemkin (Eisenstein). Reproduced with permission of FSUE Mosfilm Cinema Concern.

and expressive qualities of body parts or objects in close-up) and affection are intrinsically intertwined.

And here we also move once more from the synaesthetic and affective qualities in the work of art to how these images affect us as spectators. Affection-images touch us directly on a physiological level, the physiological level of the fourth dimension that Eisenstein was investigating through his art, but also in

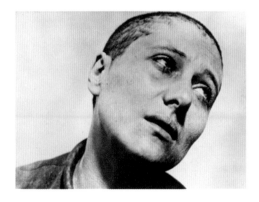

The Passion of Joan of Arc (Dreyer).

collaboration with Luria and Vygotsky. In more contemporary neuroscientific terms, it is possible to argue that affection-images seem to activate our mirror (neuron) systems, neural circuits that are activated in both active subjective experience and passive observation of an experience of others.[36] This mirroring is beautifully shown in Jean-Luc Godard's *Vivre sa Vie* when Anna Karina, sitting alone in a dark cinema, watches Falconetti's face in Dreyer's *Joan of Arc*, her emotions directly reflecting those of the face on the screen. And both faces in close-up touch us as spectators, in turn.

Mirror-touch is associated with excessively active mirror systems, which seem to play a role in the embodied empathy of affection-images.[37] Mirror-touch seems to be a special kind of synaesthesia that mediates not only between self and other in the social world, but also between artworks and spectators—mirror-touch is linked with empathy via a physiological process of simulation. In the collection of interviews with mirror-touch synaesthetes gathered by the editor of this volume, many synaesthetes report that they are able to pick up the deep dimension of what others are feeling,[38] mirroring emotions on the level of the 'fourth dimension' that Eisenstein referred to in his theoretical reflections on synaesthesia in art. It seems that the 'orchestration of the senses' enfolds and unfolds this deeper emotional level that could be considered a complex synthesis of all other synaesthetic sense-events because it concerns the 'feeling of the shot as a whole'. One synaesthete even speaks of an 'orchestration of emotions' that can be picked up on different levels: 'The emotions of another person are like an orchestral piece, where there is a general key, and mood to the piece at a moment in time, but there are so many emotional layers. (. . .) I feel all of this'.[39] What

Vivre Sa Vie (Godard).

is even more remarkable is that the interviewee adds that he cannot feel the same depth and dimensions of his own emotions, except when he hears himself on recorded playback. Mediation, at least in this instance, seems to be key in experiencing the depths of the fourth dimension. This mediation can be another person, or an aesthetic experience, an audio-recording, a film, an artwork—the other as artwork, art as the other.

In other cases, some form of mediation to create distance from the self, and self-other empathic blurring, seems to be important for a full mirror-touch synaesthetic experience that is not too overwhelming. Most mirror-touch interviewees report on different methods they use to create distance and mediation, sometimes as an active strategy (for instance, stroking the velvet of a movie-house chair to dampen the pain sensations of seeing a horse getting injured),[40] sometimes as an effect of cognitive framing (for instance, the framing of gruesome scenes of body horror as generic conventions of fantastical fiction makes them more bearable),[41] or by acknowledging that the body in pain that is seen is only a dummy, knowing that blood is just fake blood.[42] Mirror-touch and mirror systems do not function independently of other neuronal circuits, cultural framings, and artistic conventions.[43] Empathy with the other is never complete—or only in very problematic (pathological) ways. Some critics even argue that mirror systems and mirror-touch do not play a role at all in empathy or argue that the emphasis on embodiment and physiological dimensions is overrated.[44] However, as the qualitative accounts, neuroscientific investigations, and artistic explorations that are presented in this book suggest, it is more justifiable to argue that mirror systems and mirror-touch communicate with more cognitive circuits in the brain and with cultural knowledge and framing in dynamic and variegated ways.[45]

This is also a point made by Eisenstein in respect to art. While he believed that the magic of art depended on the synaesthetic ways in which the senses orchestrate to reach the fourth dimension of the feeling of the artwork as a whole and while he was very invested in finding the physiological basis of any kind of artistic and lived experience, at the same time, Eisenstein was very conscious of a spectator's subjective memories as well as the cultural, historical, and cognitive framings that operate alongside these effects. His collaborations with Luria, the neuroscientist, and Vygotsky, the sociologist/cultural psychologist, were based on this dual framing of bio-cultural processes that are always operative in various combinations. He even called this the *Grundproblem* (central problem) of art (and perhaps of human experience). As cultural and film theorist Julia Vassilieva

explains: 'Eisenstein construed this [*Grundproblem*] as arising from the para-doxical coexistence of two dimensions in the work of art: logical and sensuous, cognitive and emotional, rational and irrational, conscious and unconscious'.[46] These two dimensions (what we cognitively know or can imagine and what we physiologically feel) are not mutually exclusive but coexist and influence one another by way of dampening, neutralising, confirming, contradicting, or inten-sifying the (syn)aesthetic experience as a whole. In their collaboration, which aimed at a holistic understanding of experience, Eisenstein, Vygotsky, and Luria seemed to anticipate many of the current transdisciplinary debates on empathy and the particular ways in which art can engage us as spectators.

Orchestrations of Yellow

In the exhibition *For the Mnemonist S.* (2014), the artist Rosella Biscotti contin-ues in a new way the legacies of this transdisciplinary approach. Like Eisenstein collaborating with Luria and Vygotsky, Biscotti brings together aesthetic, sci-entific, and social/political aspects of life in different works that resonate in the space of an exhibition. Focusing on the complex interweaving between history and memory, Biscotti pays homage to Luria's vision that the scientific should not be 'merely pure descriptions of separate facts' but that it must 'view an event from as many perspectives as possible'.[47] As indicated earlier, Luria, as a scientist, just like Eisenstein, as an artist, did not want to reduce reality and experience to abstract general laws, but to capture the complexity of 'living reality'.

In a similar vein, Biscotti's artworks propose very specific and layered slices of 'living experience', questioning both history and memory in her particular orches-tration of the senses. Some of Biscotti's works remember and re-embody historical political events or situations.[48] Other works focus on traumatic memory, evoking a resonance between art and science. *Yellow Movie* (2010) is a monochrome film that is composed by means of the 'Desmet Method', after its Belgian inventor, the film archivist and restorer Noël Desmet.[49] Biscotti exposed the 16mm film mate-rial in different degrees to filtered light inside the laboratory, which gives different colour intensities. The spectator experiences these different degrees of yellowness that gives visual depth and vigour to accompanying voices and words. The film is an affection-image in the sense that Deleuze argued that colour is affect itself because of its absorbent characteristics, 'the virtual conjunction of all the objects

which it picks up'.[50] In Biscotti's work, the objects are the voices and words we hear bathed in yellowness. The colour field is picked up in an embodied empathy with the image, a 'becoming-yellow'. But this experience is intensified and enriched with the content of the audio part of the installation that is composed of recordings of psychoanalytic sessions conducted in the 1980s wherein the patient was given the 'truth serum' Pentothal.[51] Personal memories of the patient and collective memories of the Second World War merge in a strange form between fact and fiction and mingle with the intensities of the different shades of yellow, transporting the spectator to a fourth dimension of empathy, aesthetic experience, history, and memory. Contrasting image and sound, the abstract and the concrete, the conscious and the unconscious, *Yellow Movie* integrates the spectator in a way that speaks to the orchestration of the senses akin to Eisenstein and to the levels of emotion experienced in mirror-touch. *Yellow Movie* addresses carefully layers of both emotion and cognition, inviting the spectator into an empathic relation to the collective and personal layers of the past.[52]

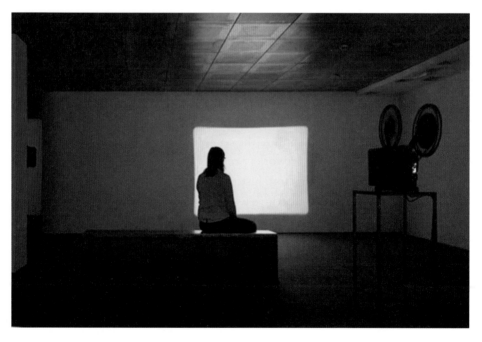

Rossella Biscotti, *Yellow Movie*, 2010 16mm film, optical sound, 22', subtitles in Italian edition of 4 + 2 A/P installation view: Galleria Civica di Trento, Trento (IT), 2010. Photo: Hugo Munoz. Courtesy Wilfried Lentz Rotterdam © Rossella Biscotti.

A similar strategy is employed by the English artist and writer John Akomfrah. Akomfrah does not directly address any scientific discourse, but he composes and orchestrates a complex and holistic experience that can touch the spectator deeply and on many levels at the same time. *The Nine Muses* (2010) is Akomfrah's retelling of the history of African and Asian migration to England, using previously unseen British archival material, edited in a powerful montage with more abstract poetic images of anonymous figures in a yellow (or sometimes blue or black) coat in a snow-covered Alaska landscape. These 'coloured figures' give an affective abstract quality to the images that makes the particular historical references directly accessible to a much wider context of migration and journeying. The audio track adds other layers containing voices from audiobooks, texts, and poems by James Joyce, Dylan Thomas, and Emily Dickinson, amongst others, and with music and song by Paul Robeson and Leontyne Pices. Akomfrah literally unfolds the archive, retrieving and bringing back to life from the mnemonic depths of our mediated and recorded past countless anonymous figures. Juxtaposed to the yellow figures in the snow, and connected to poetry and music, all these unknown men, women, and children, working, driving, walking, dancing, and dwelling onscreen, become aesthetic figures on their own terms. By way of Akomfrah's orchestration of the senses, they transcend the particularities of the historical circumstances, while at the same time these circumstances are important to know and to deepen the understanding of the affects/effects of migration. In *The Nine Muses*, the monochromatic yellow of the coat is an affective aesthetic sign, signalling our attention, moving us in the elegy of the long journeys of migration, showing the dignity of the lives of the anonymous people on screen, briefly recovered, synaesthetically remembered in a 'layered, immersive, lyrical, densely woven film tapestry that profoundly moves'.[53] Just as in Akomfrah's installation for Stuart Hall, *The Unfinished Conversation* (2012), the layers of personal and collective history, private memories, poetry, literature, and music, alongside the sparse and poetic use of colours, draw us into this artistically mediated, remembered world. Sitting in front of these works, immersed in the colours, forms, sounds, and layers of meaning, we become mirror-touch synaesthetes that can grasp Eisenstein's *Grundproblem*. The artwork extends the invitation to be touched by an involuntary synaesthetic orchestration of the senses, but also to feel and understand layers of pain and recall or, recover for the first time, layers of history into consciousness.

The Nine Muses (Akomfrah). © UK Film Council, Smoking Dogs Films 2010.

When Eisenstein posited that the fourth dimension, the 'feeling of the whole shot', could be reached in a synaesthetic orchestration of the senses, he described something akin to the newly 'discovered' form of synaesthesia that is our concern in this volume. Mirror-touch is not only a neurological phenomenon nor is it a simple affective merging with the other, or with an artwork, even though that is part of what happens. Rather, mirror-touch works in combination with all kind of cognitive and cultural framings that can dampen or intensify, contradict or confirm, embodied empathy. As such, the understanding of the complexity of the world in which cinema and art function today has a lot to learn from renewed transdisciplinary collaborations, picking up on the discontinuous legacies of Vygotsky, Luria, and Eisenstein.

Ivan the Terrible, Part II (Eisenstein). Reproduced with
permission of FSUE Mosfilm Cinema Concern.

Endnotes

1. Alexander Luria, 'The Mind of a Mnemonist', trans. Lynn Solotaroff (Cambridge, MA and London: Harvard University Press, 1987), 11.
2. Luria, 'The Mind of a Mnemonist', 95.
3. Luria, 'The Mind of a Mnemonist', 22.
4. Luria, 'The Mind of a Mnemonist', 24.
5. Sergei Eisenstein, 'The Film Sense', trans. Jay Leyda (San Diego, New York, and London: Harcourt Brace & Company, 1947), 149.
6. Julia Vassilieva, 'Eisenstein/Vygotsky/ Luria's Project: cinematic thinking and the integrative science of mind and brain', Screening the Past (2013), 38, 1.
7. See Julia Vassilieva, 'Eisenstein and his method: recent publications in Russian', Senses of Cinema (2006), 69, 1–5.
8. Vassilieva, 'Eisenstein/Vygotsky/ Luria's Project', 5.
9. See, for instance, John Protevi, 'One More Next Step: Deleuze and Brain, Body and Affect in Contemporary Cognitive Science', in Rosi Braidotti and Patricia Pisters, eds., Revisiting Normativity with Deleuze (London and New York: Bloomsbury, 2012), 25–36. See also Antonio Damasio, 'Looking for Spinoza: Joy, Sorrow and the Feeling Brain' (Orlando: Harcourt, 2003).
10. Eisenstein, 'The Film Sense', 71. Emphasis in original.
11. Vassilieva, 'Eisenstein/Vygotsky/ Luria's Project', 12.
12. Antonio Damasio, for instance, makes the distinction between emotions (immediately embodied, instinctive, unconscious, not 'owned') and feelings (more cognitively processed, 'owned'). Emotions and feelings are not separate but form feedback circuits that can enhance or dampen affective engagements. See Damasio, 'Looking for Spinoza', 80. Vittorio Gallese addresses the primordial sensory stage in relation to mirror neurons, those neurons that start firing not only when we experience something ourselves, but also when we see somebody else experiencing something. Vittorio Gallese, 'The shared manifold hypothesis: from mirror neurons to empathy', Journal of Consciousness Studies (2001), 8, 5–7, 33–50.
13. See also Pisters, 'The Neuro-Image: A Deleuzian Film-Philosophy of Digital Screen Culture' (Stanford: Stanford University Press, 2012). In this book, I argue that contemporary cinema gives us direct access to the brain spaces and mental landscapes of its characters, and hence addresses us as 'neuronal men'. But this does not mean that we have become our brain. In line with 4EA cognitive neuroscience and contemporary new materialist strands in philosophy, the neuro-image shows us how affective, how embodied and embedded in the world and related to the other we are.

See for the way in which the complex interrelations between emotions and feelings are addressed in the passages on 'the neurothriller', 110–16.

14. Eisenstein, 'The Film Sense', 75.

15. Eisenstein, 'The Film Sense', 75.

16. Eisenstein, 'The Film Sense', 77.

17. Eisenstein, 'The Film Sense', 85.

18. Sergei Eisenstein, 'Film Form: Essays in Film Theory', trans. Jay Leyda (San Diego, New York, and London: Harcourt Brace & Company, 1948), 38.

19. Eisenstein, 'The Film Sense', 117. See also N. Cook, 'Analysing Musical Multimedia' (Oxford: Clarendon Press, 1998), 49–51.

20. Eisenstein, 'The Film Sense', 127.

21. Eisenstein, 'The Film Sense', 133.

22. Eisenstein, 'The Film Sense', 140.

23. Eisenstein, 'The Film Sense', 141.

24. Eisenstein, 'The Film Sense', 141.

25. Eisenstein, 'The Film Sense', 90–1.

26. Eisenstein, *The Film Sense*, 146. See also Jamie Ward, *'The Frog Who Croaked Blue: Synaesthesia and the Mixing of the Senses'* (London and New York: Routledge, 2008), 1–26 and 73–81; and Julia Simner *et al.*, 'Non-random associations of graphemes to colours in synaesthetic and non-synaesthetic populations', *Cognitive Neuropsychology* (2005), 22(8), 1069–85.

27. Eisenstein, *'The Film Sense'*, 149.

28. Eisenstein, *'The Film Sense'*, 151.

29. Michael Banissy and Jamie Ward, 'Mirror-touch synaesthesia is linked with empathy', *Nature Neuroscience* (2007), 10(7), 815.

30. Eisenstein, *'Film Form'*, 67.

31. In the catalogue to her exhibition *Sensorium Tests*, Daria Martin quotes Eisenstein reflecting on Japanese Kabuki, another beautiful example of an experience of this primordial fourth dimension: 'Occasionally (and usually at the moment when the nerves seem about to burst from tension) the Japanese double their effects. With their mastery of the equivalents of visual and aural images, they suddenly *give both*, "squaring" them, and brilliantly calculating the blow of their sensual billiard-cue on the spectator's cerebral target. I know no better way to describe that combination, of the moving hand of Ichikawa Ennosuke as he commits hara-kari – *with* the sobbing sound offstage, graphically corresponding with the movement of the knife (. . .) and we stand benumbed before such a perfection of – montage'. Quoted in Daria Martin, *Sensorium Tests* (Milton Keynes: MK Gallery, 2012), 139.

32. Gilles Deleuze, *'Cinema 1: The Movement-Image'*, trans. Hugh Tomlinson and Barbara Habberjam (London: The Athlone Press, 1986), 87–8.

33. Deleuze, *'Cinema 1'*, 91.

34. Deleuze, *'Cinema 1'*, 97.

35. Deleuze, *'Cinema 1'*, 87–122. See also Patricia Pisters, *'The Neuro-Image'*, 28–33.

36. Michael Banissy and Jamie Ward, 'Mirror-Touch Synaesthesia is linked with Empathy', 815.

37. Michael Banissy and Jamie Ward, 'Mirror-Touch Synaesthesia is linked with Empathy', 815.

38. Daria Martin, Interview with Anonymous, a mirror-touch synaesthete, 15 October 2012.

39. Martin, Interview with Anonymous, a mirror-touch synaesthete, 2012.

40. Martin, Interview with Anonymous, a mirror-touch synaesthete, 23 October 2013.

41. Elinor Cleghorn, Interview with Anonymous, a mirror-touch synaesthete.

42. Henning Holle, *et al.*, '"That is not a real body": identifying stimulus qualities that modulate synaesthetic experiences of touch', *Consciousness and Cognition* (2011), no. 20, 725. In the interviews conducted with mirror-touch synaesthetes by Martin, a similar observation was made by one of the interviewees (in interview 5). Seeing a dark spot on a friend's foot, the interviewee reports: 'My first visual sense was that he was bruised, but once I realised it was hair, there were no more synesthetic feelings. My synaesthesia had been tricked; in the same way it might be tricked on Halloween by someone with fake blood on them.'

43. Raz, Gal, *et al.*, 'Cry for her or cry with her: context-dependent dissociation of two modes of cinematic empathy reflected in network cohesion dynamics', *Social Cognitive and Affective Neuroscience* (2013), 1–9.

44. See, for instance, Ruth Leys, '"Both of us disgusted in my insula": mirror neuron theory and emotional empathy', *Nonsite.org* (2013), issue 5, 1–25; and Jan Slaby, '*Against Empathy: Critical Theory and the Social Brain*'. Slaby rejects mirror neurons as 'neuronal wifi' and proposes the concept of agency as a concept for empathy.

45. See also Patricia Pisters, 'Dexter's plastic brain: mentalizing and mirroring in cinematic empathy', *Cinema&Cie*, Special Issue Neurofilmology (2014), in press.

46. Vassilieva, 'Eisenstein/Vygotsky/ Luria's Project', 6.

47. Alexander Luria, '*The Mind of a Mnemonist*', trans. Lynn Solotaroff (Harvard University Press, 1987), xv.

48. '*The Trial*' (2010–14), for instance, re-embodies in an even changing performance and installation the 1979 trial of Italian philosophers such as Toni Negri and Paolo Virno for being responsible for shaping the minds of young students who later took up arms and engaged in political action. *I dreamt that you changed into a cat . . . gatto . . . ha ha ha* (2013) is the result of a workshop Biscotti conducted with 14 inmates of a women's prison, exchanging memories of their dreams.

49. See Simon Brown, Sarah Street, Liz Watkins, eds., '*Color and the Moving Image: History, Theory, Aesthetics, Archive* (New York and London: Routledge, 2013), 222–3.

50. Deleuze, '*Cinema 1: The Movement-Image*', 118.

51. The sessions were conducted between 1987 and 1991 in The Netherlands. The patient was Dik de Boef. The psychiatrist was Prof Dr Jan Bastiaans, who was famous for his controversial methods of war trauma treatment using Pentothal and LSD.

52. Moreover, two additional works remind us of other aspects connected to this constellation of aesthetic/ scientific/living experience. '*Pharmaceutical Dreams*' (2010) shows advertisements for Pentothal in the form of exotic postcards. And *168 Sections of a Human Brain* is an installation with silver gelatin photographs, reproductions of one of the first photos of sections of the human brain by G. Jelgersma at the University of Leiden (1908–1911) to create a scientific tool for psychoanalysis, especially for memory retrieval. With this installation, Biscotti exhibits a well-read copy of Luria's '*The Mind of a Mnemonist*'. See also Flora Lysen, 'De meetbaarheid van een hersenspinsel' in *Metropolis M*, no. 5 okt/nov 2014.

53. Kieron Corless, Review of '*The Nine Muses, Sight & Sound*', February 2012.

Ocular Objecthood in India and Beyond

Christopher Pinney

Eyes touch. There are times when I look outside and it is like the physical veins and muscles of my eyes extend out into the branches of the trees.

Fiona Torrance, *Four or Five Jaws*[1]

It is not only out of arrogance that Westerners think they are radically different from others, it is also out of despair, and by way of self-punishment.

Bruno Latour, *We Have Never Been Modern*[2], translated by Catharine Porter, Copyright © 1993 by Harvester Wheatsheaf and the President and Fellows of Harvard College

How might one locate diverse genres, the different registers of evidence, within which one might find echoes of the phenomenon of 'mirror-touch'? Do literature, neuroscience and anthropology tell similar stories? Are the different domains or scales in which they manifest commensurable? Do they all speak in parallel ways about something that modernity and 'official knowledge' has suppressed? How does one locate cultural practice and metaphor (see the introduction to this volume) in relation to phenomena that can be replicated in laboratory settings? Consider, as an example of this, three descriptive passages which appear in short succession in Christopher Isherwood's 'fictional' narrative of 1930s Berlin *Mr Norris Changes Trains*. Isherwood is celebrated for his passive recording voice enshrined in the phrase 'I am a camera'.[3] In *Mr Norris*, this metaphor of the eye as apparatus and the potential mutuality, or conversely unidirectionality, of vision are frequently underlined. In the first instance, William Bradshaw, Isherwood's alter-ego seeks futile reassurance from Arthur Norris: 'As a final test I tried to look Arthur in the eyes. But no, this time-honoured process didn't work. Here

were no windows to the soul. They were merely part of his face, light-blue jellies, like naked shell-fish in the crevices of a rock. There was nothing to hold the attention; no sparkle, no inward gleam' (1947: 205). Two pages later, Bradshaw is on a train to Switzerland with Baron Kuno von Prenitz, whom he spies early in the morning exercising with a chest expander: 'He was obviously unaware that he was not alone. His eyes, bare of the monocle, were fixed in a short-sighted, visionary stare which suggested that he was engaged in a private religious rite' (1947: 207). Following an urgent telegram recalling him to Berlin, Bradshaw finds himself succumbing to the 'neutral inquisition of [the] friendly eyes' of the soon-to-be-murdered communist activist Ludwig Bayer (1947: 230). Here the eye is incarnated as a potential interlocutor in a complex ecology of reciprocal vision, as a mode of internalisation and transcendence, and as a kind of extractive touch. Isherwood dramatises the relationality of vision in which 'seeing' comprises a small part of the spectrum of the work which the eyes undertake.

The fecundity of Isherwood's ocular metaphors is striking and the fact that this is a single text by a single author, self-consciously using the power of imaginative fabrication, raises the question of scale. Scale here becomes a means of raising the question of how we authenticate different kinds of behaviour, experience, and desire without reference to a reductive notion of truth or falsity. Within the world of creative fiction, Isherwood's testimony is completely valid and beyond reproach. The question of scale allows us to investigate the additional work that may be required of this testimony when it is aligned with other genres and other idioms of experience. What happens when a sample of one (Isherwood as an individual author) becomes a sample of several millions (as in the case of the diverse Indian practices discussed below)? What happens when 'literature' becomes 'social fact'?

I find this a helpful frame through which to introduce a consideration of those religious practices in India (including aspects of Hinduism, Jainism, and Sufism) that privilege vision as a form of touch. This connection is in some cases metaphorical (and in this sense perhaps not unlike Isherwood's) and in other cases is perceived 'naturalistically' as extramissive (in which vision is understood to involve the emission of optical rays or flows)[4] contact which may involve the physical 'mixing' of viewer and viewed. In other words, those caught up in this practice might describe their formulations as 'a way of talking' (and not much else), whereas others would declare that these are descriptions of physical phenomena that would be replicable in laboratory settings. 'Seeing' is thus capable

of opening the body to **transactions** that are primarily optical (as in media theorist Friedrich Kittler's physicalist sense—hence **optical**, rather than visual, media) but also engages practices that have a strong linguistic dimension, as in the case of *nazar* or 'evil eye'. My assumption is that individual and collective acts of the imagination, articulated in both physicalist and metaphorical registers, can lead us to understand 'subjugated' knowledges and experiences that may continue to be widespread—these are 'non-modern' knowledges and practices that continue to survive within different scales.

The relationship of vision to touch in India can be approached through different registers and locations. The largest frame is that of the Indic tradition as a whole in the study of which Sanskritist Diana L. Eck's book *Darśan: Seeing the Divine Image in India*, first published in 1981, has had an enormous influence. The term 'darshan' has many connotations in Sanskrit and vernacular north Indian languages. It describes philosophical knowledge and also the sight of a god. Following Eck's research, it has emerged as something of a foundational

Jain worshippers offering *arti* to a tirthankara in a Jain temple. Madhya Pradesh 2014. Image courtesy of Christopher Pinney.

category for describing Hindu devotional practices and has been used to stress the visual component of human–divine interactions, together with the mutuality of looking that often lies at the heart of such procedures.

Eck's study, in turn, drew sustenance from Sanskritist Jan Gonda's pioneering *Eye and Gaze in the Veda* (1969) which drew attention to early very explicit conceptualisations of vision as physical transaction: 'A prolonged look or fixed regard . . . becomes a means of participating in the essence and nature of the persons or objects looked at . . . The mere act of looking could be regarded as practically identical to touching or grasping'.[5] This emphasis on transaction as physical exchange finds a parallel echo in the anthropologist of India McKim Marriott's[6] stress on the flows of bio-moral substance, which are endlessly reconfiguring 'partible' Indian persons (what he terms the 'fluidarities' of Indian thought, as opposed to the 'solidarities' of Western thought), and a broader echo in the phenomenological approach of Maurice Merleau-Ponty to vision as 'haptic'.[7]

Darshan features prominently in discussions of popular religiosity (the anthropologist C. J. Fuller affirms Eck's description of it as an 'exchange of vision' and argues that it is 'central to Hindu worship')[8] but also the regimes of viewing that characterize audiences' interactions with popular cinema.[9] Such has been the popularity of the term as a civilisational key that it has come to over-determine Hindu ritual practices. This essay will attempt to restore the ecological complexity of discourses and practices about vision and touch in India, documenting their rather complex distribution in ways that avoid presenting 'India' as a territory that simply affirms, in any reductive essentialising manner, the phenomena of mirror-touch.

Anthropological observations, couched in the specificity of location and a particular cultural practice, have always had a complex relationship to ontology and generalisation. Rousseau's famous dictum that 'In order to study man one must study men from afar' (taken up, for instance, by the anthropologist Claude Levi-Strauss) assumes that a myriad of different and contrasting investigations of 'men', in their local difference, can ultimately be assembled into a single, unified vision of 'man'. Current formulations of this dynamic between the local and the universal are less coherent and more tactical. They bounce particular ethnographic insights onto the fractures of 'modern' practice to point at some underlying commonality. Such tactics often construct global circuits of revelation and analogy—'dividuals' were first 'discovered' in India, then in Melanesia, and subsequently became a prototype for a putatively normative 'western' agency.

The currently fashionable Latourian tactic (i.e. following the work of the social theorist Bruno Latour) involves a generous handful of ethnographic justification (e.g. Philippe Descola's Amerindian confounding of Levi-Straussian nature–culture dichotomies) mixed with a larger serving of an ontology that allows the proclamation that 'we' (which means everyone, but especially Europeans) 'have never been modern'.[10] This endeavour to recover a world 'before' that disenchantment from which we 'moderns' seek escape[11] is one for which I have much sympathy. My reservation lies not in the attempt to learn lessons from 'ethnography', but in the best procedure for describing the 'ethnographic reality' which we seek to co-opt into our project of redemption. Hence the following examples that juxtapose 'ethnographic' examples with self-conscious cultural innovation are intended to explore the trajectory through which ontology trades off localised cultural practices. The examples all come from India and are presented in ascending 'scale'.

1.

Consider an elaborate practice that I witnessed in a rural household in central India in 2012. It is called *nazar utharna*, or the removal of the evil eye, and is a procedure which is deployed when necessary, that is whenever anyone in this household is affected by the evil eye (*nazar*). In the case of this particular household (which has four members), this is about twice per year. The person afflicted with *nazar*—the patient—sits before the healer (in this case, the healer was the patient's father, but elsewhere it is likely to be Brahman priests or Dalit shamans—*ghorlas*) who perform this procedure. The healer prepares a roughly one-foot long wick made from raw cotton, which is then soaked in ghee (clarified butter). This is then placed in front of the head of the patient seven times before being tied to a short stick and allowed to hang vertically over a small water pot (*lota*) that is placed directly in front of the patient.

The wick is then ignited and as it burns, with the accompaniment of much hissing and spluttering, drops of burning ghee regularly drop into the water pot below where an accumulated patter of soot starts to gather. This material process visualises the transference of the physical presence of *nazar* into the water pot, the relocation of *nazar* from the body of the afflicted onto the surface of the water. It recalls the common anti-*nazar* phrase to be seen throughout north India written in Devanagri which declares *buri nazar wale tera muh kala* (evil

Anti-nazar (evil eye) apotropaic dazzle board
displayed on the front of a truck in Madhya Pradesh,
2012. Image courtesy of Christopher Pinney.

nazar person your mouth [will go] black), except that, in *nazar utharna*, it is a
kind of watery eye that turns black. The *buri nazar wale* slogan is often writ-
ten on the back of vehicles from which may hang a shoe or a *todka* (a lime
with green chillies on a thread) but will more commonly display the grimacing
face of a demon or an apotropaic spot pattern. The demon's face and the spot
pattern are intended to deflect the malevolent extramissive vision of the *nazar
wale*.

In the discussion below, it will become apparent that there are many other
practices and beliefs that help me, as an anthropologist of central India, to con-
textualise this relationship between vision and blackness and the idea of vision as
substance, something extramissive but which, as this procedure shows, can also
be extracted and neutralised. But watching *nazar utharna* made me also think of

the fluid continuum of ocular objecthood traversed in Georges Bataille's *Story of the Eye* of 1928. In a magnificent commentary on this otherwise puzzling minor pornographic narrative, Roland Barthes asked 'How can an object have a story?', concluding that whatever else it was, Bataille's narrative was indeed the 'story of an object'.[12] He noted how the 'Eye' is 'varied' or 'declined' through a number of 'globular' objects (tears, yolk, circular stain), 'recited like flexional forms of the one word, revealed like states of the one identity, offered like propositions, none of which can hold more meaning than another'.[13] Bataille's endlessly meta-phorised Eye thus continually mutates, producing what Barthes terms a 'wavy meaning',[14] and 'Objects apparently quite remote from the eye are thus caught up in chains of metaphor'.[14] The narrative is simply ' a kind of flow of matter',[15] in which, for instance, 'the sun need only become a disc and then a globe for its light to flow like a liquid and join up, via the idea of a "soft luminosity" [. . .] with the eye, egg and testicle . . . '[16] This imagery can be juxtaposed with a more 'anthropological' zone, through Hayward's discussion of 'fingery eyes' prompted by the encounter during her fieldwork in a marine biology laboratory with cup corals and used to describe the transfers of knowledge experienced in study-ing permeable species boundaries.[17] Hayward provides a way of thinking about 'wavy meaning' (what may seem to be a peculiarly literary construction) in a laboratory context.

2.

At a village level, the observation and study of **practices**, rather than **discourses**, provides more evidence that illuminates the vision and touch continuum. In an earlier account of these village practices (I have been conducting fieldwork in the same village intermittently since 1982), I had recourse to Merleau-Ponty's observations concerning the 'double sensation' to explain the zone of tactility that encloses visual relations between villagers and the images of deities that they worship. Merleau-Ponty's account in *The Phenomenology of Perception* of the 'ambiguous set-up'[18] of the relationship between 'touching' and being 'touched' when a right hand is grasped by the left hand provided a useful way of grasping the circuit of visual mutuality that informed villagers' accounts of the relation-ship they had with their images (and which echoes the testimony of the mirror-touch synaesthete quoted at the beginning of this chapter.

The 'double sensation' in central India was used to evoke the zone of intimacy between beholder and picture surface which was vividly apparent in villagers' relationship with framed printed images. In some cases, printed images were made visible within mirrored frames. The tain (the silvery reverse) of the mirror was scratched away (usually by vendors of images at pilgrimage sites) to provide a clear space within which the printed image of the deity could be pasted. In an earlier publication,[19] I described one particular image of the deity Badrivishal, which had been purchased at the pilgrimage site of Badrinath in the Himalayas and brought back to the village, and suggested that the 'benefit from the purchaser's point of view is that they can now visually inhabit the space of the picture, alongside the deity with whom they desire the double sensation. Mirrored images allow the devotee to (literally) see him or herself looking at the deity'.[20] If *darshan* involves seeing and being seen by the deity, mirrored images make that transaction more tangible—you have visual confirmation of your seeing and being seen by that deity who gazes out through the gap in the tain.

The double sensation in this earlier account was also encompassed by the notion of 'corpothetics', i.e. corporeal aesthetics, a neologism that was intended to offer release from a Kantian paradigm that stressed disinterest.[21] Corpothetics describes a highly interested and embodied relationship with images in which shininess and bright colours are frequently crucial to establishing the circuit between picture and beholder which underpins what the image is able to 'do'. Aesthetics in this model is linked to 'image acts' in a world very different to that desired by Kant.[22] We will shortly encounter other evidence at different scales, which will support the claims made above. Before that, we must note, however, that while the corpothetic quest for the double sensation certainly in my view describes the dominant regime in rural central India, at the level of discourse, there are dissenters.

In April 2015, collecting material specifically for this chapter, I had a conversation about vision and touch with the (Jain) family already mentioned above in connection with the *nazar utharna* protocol. As we have already seen in that connection, vision is materialised in a peculiarly explicit fashion in order that its negative aspects can be ejected. However, when discursively asked to make connections between vision and touch, they largely declined any strong connection, probably, in large part, because of a distinction made in Jain ritual teaching. The Hindi word for touch *spersh* is also used to name a particular and complex form of Jain puja (worship). So to ask about *darshan* and *spersh* provokes

observations about two different kinds of puja (ordinary puja, usually referred to as *darshan*, and *kesar chandan puja* [saffron and sandalwood puja]).

Both Pukhraj and Tapish Bohara, my Jain interlocutors, made a fairly decisive break between *darshan*, brief encounters with deities based purely on vision (*drishti*), and *spersh puja*, puja which usually lasted for an hour and which explicitly involved touch. I explained the Radhasoami theory (which is detailed below and involves the very explicit discursive conceptualisation of the mixing of visual fluids) and they were sceptical, choosing to see the meeting of vision as metaphorical, rather than literal. They were dismissive of the common *filmi* technique of extramissive vision (in which, for instance, a deity manifests their power through a kind of fiery 'fingeryeye'), seeing this as too crude and not doing justice to the subtlety of their own experiences. Jain *kesar chandan puja*, otherwise known as *spersh puja*, identifies eight points on each side of the body which must be mentally visualised and then touched (with a finger) before the *puja* proper. This (according) to Pukhraj sensitised you to the *kampan* or vibrations from the *murti*. These vibrations, known in Malwi as *jhinjhini*, produce a very strong internal physical sensation of well-being, an internal sense of calm as the external presence of the divine is internalised.

If village Jains present an account of the relationship between vision and touch which is less explicit than that provided by the anthropologist Lawrence Babb (see below) on the matter of *nazar* or evil eye, they provided ample evidence of the ways in which visual effects were felt as physical force. *Nazar* was usually felt with great rapidity ('getting the feeling that you need a saline drip', Tapish, the son, said alluding to the onset of heat exhaustion, while for his father Pukhraj, the range of responses included loss of appetite and feeling of sickness). These were all effects that Pukhraj had certainly felt in childhood, but since he started *puja-path*, i.e. systematic orthodox worship, he had not experienced them.

The general tone in discussing *nazar* is that it is all pervasive and its originary agency is usually impossible to determine ('you take your buffaloes out to the field and anyone can give them *nazar*, you never know who it is'). During my last visit to the village in April 2015, a fierce and divisive argument had developed between two sections of the village over a contested Panchayat (village council) election. One of the manifestations of this was a heightened concern about *nazar* to the extent that one farmer (who supported the losing side in the elections) attributed falling milk yields from one of his buffaloes to *nazar* generated by a member (as yet unknown) of the winning faction. Having milked his cow and

three buffaloes in the rear courtyard, the farmer appeared with a small metal bowl of coals in which he was burning *gugal* resin to produce clouds of therapeutic smoke (*gugal ki dhuni*). He waved this around the head of each animal, along the top of their backs and then paid special and prolonged attention to the udders. Finally he held the bowl up high, so that the dhuni could permeate the *ban ka sadhan* tied to the metal struts under the corrugated sheeting that sheltered the cattle from rain. The *ban ka sadhan* are small bundles sewn up in red cloth containing grains of rice, pins, lime, perfume, flowers, and ash collected by a medium, and are assumed to have protective benefits against *nazar*. Bataille would no doubt point to their general sphericity—they might be thought of as a 'declension' or 'variation' of the eye.

Here we see very strong evidence of a praxis which connects vision with physical effects—the *nazar* of a malevolent villager had impacted a buffalo's health such that its milk yields had fallen. And yet it should also be noted that *nazar* is not exclusively visual in its mechanism of transmission. It is primarily visual, but when one raises this as a topic of conversation and debate, the matter becomes slightly more complex. Hence interlocutors dwelt on the phrase *kali zuban vale* (black-tongued person). This is a common way of describing the originator of *nazar* but which clearly emphasises the intentionality in language, rather than the operation of the eye. In this context, villagers are keen to explain that *nazar* originates in the mind (usually as the result of jealousy—why is their buffalo producing seven litres of milk?) and has a visual mechanism. Several were keen to stress that the visual dimension was secondary in causal ranking. First the tongue, then the eye, is what some villagers are keen to claim discursively, though their practice continues to foreground and affirm 'corpothetic' engagements with pictures and artefacts (ranging from offset lithographs and photographs to painted clan shrine stones and buffaloes).

3.

Hindus are quite likely to describe the reason for a visit to a temple as '*darshan lena*' to take *darshan* (although this is not the default setting that Eck suggests).[23] What might be thought of as the originating point of much north and western Indian modern visual practices is the town of Nathdwara, 50 km north of Udaipur, which I was fortunate enough to visit in 1994 and again

Purificatory resin is offered to a protective *ban ka sadhan* tied to the roof of a farmer's cattle shed. Madhya Pradesh 2015. Image courtesy of Christopher Pinney.

in 2015. Here in the Shrinathji temple, *darshan* is a strictly time-regulated affair with Shrinathji, the famous Krishna *svarup* (self-made image), being made visible to worshippers between 11.30 a.m. and 12.15 p.m. and after 3 p.m. in the afternoon. He manifests in his main form in the central part of the temple where devotees jostle together in long snaking lines, waiting for a brief snatched vision of the distant deity, and also in the diminutive form as Ladu Gopal in a much smaller and more intimate setting. In numerous rooms set around the temple (technically a *haveli* or mansion), workers are busy seeing to the god's various needs: his love of milky sweets, his need for elaborate and regular changes of dress, complex regimes of jewellery, and ornate and elaborate garlands produced in one of the most interesting parts of the temple filled with historically important paintings. All this is part of a complex infra-structure, spatial and temporal, which facilitates the delivery of short periods of hyper-intensified *darshan*. In these moments of visual encounter, one feels

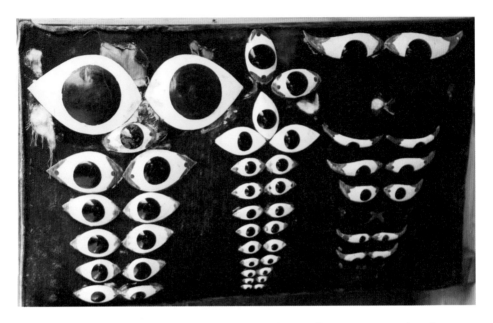

Dharmendra Radhashyam's display of enamelled eyes for installation on images of Krishna. Nathdvara, Rajasthan 2015. Image courtesy of Christopher Pinney.

the crowd of devotees physically projecting their desires through their eyes, and their bodies, in turn, being invigorated by the reciprocated vision from Shrinathji. If the temple is a massive infrastructural project marshalling gold, sweets, cloth, and flowers, it is Shrinathji's lotus-shaped eyes which lie at the centre of the entire transaction and the complex institution that makes its delivery possible.

In the nearby New Bazar, there are several shops with elaborate displays of enamelled eyes for sale. The most spectacular belongs to Dharmendra Rahdashyam whose shop is dominated by two vertical and one horizontal vitrines with all manner of eyes ranging in size from the merely ordinary to the super-human. It is these eyes that devotees will buy to install in the final rite of initiation of their gods—the *pran pratishtha*. This ritual conveys a great deal of information about the relationship between eyes and embodiment, and extramissive vision as a force of energy. *Pran pratishtha* is the final act of empowerment and usually involves the opening of the deity's eyes (sometimes by applying paint to the eyes or wiping them with honey) immediately after which mirrors are usually placed around the image to reflect back into the deity the very intense

and potentially harmful visual field generated by this act. Without mirrors controlling this newly generated force-field, other bodies in its vicinity would be endangered.

4.

The *pharmakon* quality of vision, as both destructive and curative, feature in the next scale of analysis, the imagery deployed in commercial Bombay cinema. Most famously, this is evident in a low-budget 1975 mythological film *Jai Santoshi Maa* which fast-tracked a previously minor goddess to great prominence across north and central India. The anthropologist Veena Das has suggested that the filmic narrative acted as a myth, serving to establish and test the new goddess's credentials.[24] Crucial to our present purposes is a scene towards the end of the film in which the goddess is being celebrated following the re-union of the heroine and her husband. Two jealous daughters-in-law squeeze lime juice into offerings made to the goddess in a deliberate attempt to derail proceedings. Lawrence Babb has argued that 'the vernacular movie is a rich and greatly underutilized source of cultural data'[25] and then provides a compelling account of the repercussions of the event alluded to above. Babb describes how 'normal' visual relations between deity and devotee have already been established by a peculiarly intense form of shot/reverse-shot that cuts back and forth between faces that gaze at each other in a zone of *darshanic* mutuality.

Following the deliberate flouting of the taboo on sour offerings to the goddess, we see immediately that she has become very angry—we see volcanoes, storms, and general destruction and '*from her eyes* comes a fire that burns the bodies of the wicked sisters-in-law'.[26] Following this, the heroine implores Santoshi Ma to reveal her compassionate side and starts to sing a haunting song. 'The camera turns to the goddess's image, and then to the goddess herself in heaven; the anger is beginning to leave her face. Now we see the heroine looking up at the goddess, eyes flooded with tears',[27] after which the goddess descends to earth and restores the damage. Having revealed that she is an enormously powerful addition to the pantheon, the film ends with this image of her beneficence, the filmic myth having demonstrated that she has reserves of power but also a generosity towards her devotees.

For Babb, this is one example of the manner in which, in the Hindu world, '"seeing" seems to be an outward–reaching process that in some sense actually engages (in a flow-like way [. . .]) the objects seen'.[28] It is in the teachings of the Radhasoami sect, according to Babb, that this is most explicitly theorised, especially through the notion of the *drishti ki dhar* (current of vision), which valorises the benefits of the devotees' vision uniting and 'mixing' with that of the sect's guru. The current of vision is a 'fluid-like "seeing" which flows from the guru's "third eye" through his physical two eyes and "from there out into the world"'.[29] The sociologist of religion Mark Juergensmeyer reports that, amongst Radhasoami devotees, 'the eyes are energy centers and energy trans-mitters' and cites one follower, writing that 'On beholding the Guru there is an indescribable ecstasy which is spontaneous and permeates every pore of the body'. Juergensmeyer affirms Babb's suggestion that, amongst Radhasoamis, 'you become what you see'.[30]

Ethnography reveals Indian practices to be complex and differentiated; there is certainly no single 'Indic' tradition. I have tried to present the intricacy of a number of different traditions and provide a sense of the contradictions that ethnographic fieldwork throws up in its investigations of these questions. The ecology of beliefs is something rather different from the tightly and systemati-cally integrated cultural practice advanced by the anthropologist Clifford Geertz and may (I hope) seem rather closer to Isherwood's novelistic observations with which we began. People narrate visual experience and possibility to themselves, and sometimes this forms the basis for a community of people with similar beliefs and experience; sometimes it does not. 'The choice here should not be seen as simply one between a universalism and a cultural specificity: rural India corpothetics exist in a space that is less than universal and more than local'.[31] Likewise, phenomena may become visible in novels, everyday lived practice, and the laboratory. They are neither identical nor wholly different, for they exist in that space in between the specific and the general. The ethnography of Indian image practices throws up many practices that resonate with the mirror-touch phenomena discussed elsewhere in this book. This account has tried to preserve the complexity and integrity of what this author has encountered as an eth-nographer. Necessarily, it echoes some themes raised elsewhere, but it does not simplistically 'mirror' them.

Endnotes

1. Fiona Torrance, 'Four or Five Jaws' (included in this volume).
2. Bruno Latour, 'We Have Never Been Modern' (Harvard University Press, 1993), 114.
3. 'I am a camera with its shutter open, quite passive, recording, not thinking' (Christopher Isherwood, 'Goodbye to Berlin' (Harmondsworth: Penguin, 1945), 7.
4. Extramissive vision has been largely displaced by modern science's consensus about intromissive vision, in which the eye becomes a passive receiver of light from external objects via photons.
5. Jan Gonda, 'Eye and Gaze in the Veda' (Amsterdam: North Holland Publishing Company, 1969), 20, cited in Preminda Jacob, 'Celluloid Deities: The Visual Culture and Cinema and Politics in South India' (Lanham: Lexington Books, 2009), 249.
6. McKim Marriott, 'Constructing an Indian Ethnosociology' in McKim Marriott, ed., India Through Hindu Categories (New Delhi: Sage, 1990), 3.
7. Maurice Merleau-Ponty, 'The Phenomenology of Perception' (London: Routledge, 1962).
8. C. J. Fuller, 'The Camphor Flame: Popular Hinduism and Society in India' (New Delhi: Viking, 1992), 60.
9. Rachel Dwyer, 'Filming the Gods: Religion and Indian Society' (London: Routledge, 2006), 19; and Passim & Jacob, 'Celluloid Deities', 223–56.
10. Latour, 'We Have Never Been Modern'.
11. Latour, 'We Have Never Been Modern', 114.
12. Roland Barthes, 'The Metaphor of the Eye', trans. J. A. Underwood, in Georges Bataille, 'Story of the Eye', trans. Joachim Meugroschal (Harmondsworth: Penguin Books, 1987), 119.
13. Barthes, 'The Metaphor of the Eye', 120–1.
14. Barthes, 'The Metaphor of the Eye', 125.
14. Barthes, 'The Metaphor of the Eye', 121.
15. Barthes, 'The Metaphor of the Eye', 123.
16. Barthes, 'The Metaphor of the Eye', 122.
17. Eva Hayward, 'Fingeryeyes: impressions of cup corals', Cultural Anthropology (2010), 25(4), 577–99.
18. Maurice Merleau-Ponty, 'The Phenomenology of Perception' (London: Routledge, 1962), 93.
19. Christopher Pinney, 'Photos of the Gods: The Printed Image and Political Struggle in India' (London: Reaktion Books, 2004).
20. Pinney, 'Photos of the Gods', 197.
21. Pinney, 'Photos of the Gods', 8.
22. For a parallel, broader argument, see David Morgan, 'The Sacred Gaze: Religious Visual Culture in Theory and Practice' (Berkeley: University of California Press, 2005).

23. Diana L. Eck, 'Darśan: Seeing the Divine Image in India' (Chambersburg, PA: Anima Books, 1981), 3.
24. Veena Das, 'The mythological film and its framework of meaning: an analysis of Jai Santoshi Ma', *India International Centre Quarterly* (1981), 8(1), 43–56.
25. Lawence, A. Babb, 'Glancing: visual interaction in hinduism', *Journal of Anthropological Research* (1981), 37(4), 391.
26. Babb, 'Glancing', 392.
27. Babb, 'Glancing', 392.
28. Babb, 'Glancing', 393.
29. Babb, 'Glancing', 391.
30. Mark Juergensmeyer, '*Radhasoami Reality: The Logic of a Modern Faith*' (Princeton: Princeton University Press, 1991), 84.
31. Pinney, '*Photos of the Gods*', 193.

Surface Encounters: Materiality and Empathy

Giuliana Bruno

There exist what we call images of things,
Which as it were peeled off from the surfaces
Of objects, fly this way and that through the air. . . .
I say therefore that likenesses or thin shapes
Are sent out from the surfaces of things
Which we must call as it were their films or bark.

> Titus Lucretius Carus, *De rerum natura*[1]
> By permission of Oxford University Press

For Lucretius, the image is a thing. It is configured like a piece of cloth, released as matter that flies out into the air. In this way, as the Epicurean philosopher and poet suggests to us, something important is conveyed—the material of an image manifests itself on the surface. Lucretius describes the surface of things as something that may flare out, giving forth dazzling shapes. It is as if it could be peeled off, like a layer of substance, forming a 'bark' or leaving a sediment, a veneer, a 'film'. This poetic description and its philosophical fabrication go to the heart of my concern in this text, which addresses matters of aesthetic encounters on the surface of things.

What constitutes an aesthetic encounter? How do we experience the material of an aesthetic space? To address this issue, we must go beyond the realm of pure visuality. The matter of my concern is not simply visual, but tangible, spatial, and environmental—that is to say, material. I would therefore begin by questioning the place of materiality in our visual world. To engage materiality and our encounters with material space, I suggest that we think about surfaces, rather

than images, and, in so doing, explore the fabrics of the visual and a phenomenon I call the surface tension of media. In order to pursue a receptive materialism and to approach the transmission of empathy in art, I propose performing critical acts of investigation on the surface, focusing especially on screen surface and mobilising the wide potential of material expression across the 'screens' of different media.[2]

I have long argued for a shift in focus away from the optic and toward the haptic, in order to understand the tangible spatiality of the visual arts, their moving, habitable sites, and the intimate experiences they offer us as we walk through the public spaces in which they reside and with which they interact.[3] The **haptic**, a relational mode derived from the sense of touch, is what makes us 'able to come into contact with' things. This reciprocal **contact** between us and objects or environments occurs on the surface. It is by way of such tangible, 'superficial' contact that we apprehend the art object and the space of art, turning contact into the communicative interface of a public intimacy.

This is why I prefer to speak of surfaces, rather than images, in order to experience how the visual manifests itself materially on the surface of things where time becomes material space. Digging into layers of imaging and threading through their surfaces, my theoretical interweaving of materials emphasises the actual **fabrics** of the visual: the surface condition, the textural manifestation, and the support of a work, as well as the way in which it is sited, whether on the canvas, the wall, or the screen. I am particularly interested in what we may call the phenomenon of the 'becoming screen'—that is, in the play of materiality that is brought together in light on different, intersecting screens—and in offering a theorisation of the actual fabric of the screen as a material surface space. I am also interested in the migratory patterns of such visual fabrications and in tracing their material history as well as their shifting geographies. In this way, I want to rethink materiality and show how surface matters in the fabrics of the visual, for it is on the surface that textures come alive and the 'feel' of an aesthetic encounter can develop.

Surface Matters in Visual Fabrics

In this age of virtuality, with its rapidly changing materials and media, what role can materiality really have? How is it fashioned in the arts or manifested in technology? Could it be refashioned? I ask these questions at a time when

contemporary artists themselves appear preoccupied with materiality in different forms and are questioning the material conditions of their media. There is much potential for a reinvention of materiality in our times. In claiming that it is visibly and actively pursued in the visual, plastic, and moving image arts, as well as in architecture, I wish to theorise it as a surface condition. The surface is, for me, configured as an architecture—as a partition that can be shared, it is explored as a primary form of habitation for the material world. Understood as the material configuration of the relationship between subjects and objects, the surface is also viewed as a site of mediation and projection, a zone of encounter and admixture, memory and transformation.

Most importantly, I argue that materiality is not a question of materials but rather concerns the substance of material relations. I am interested in the space of those relations and in showing how they are configured on the surface of different media. As we consider that art, architecture, fashion, design, film, and the body all share a deep engagement with superficial matters, we can observe how surfaces act as connective threads between art forms and structure our communicative existence. In order to open this theoretical space for a reinvention of materiality, I therefore want to address in particular here how the surface mediates material relations, which include affects and the passage of empathy.

In proposing that we pay attention to surface materiality, I engage deeply with the pleats and folds that constitute the fabric of the visual and, in this regard, pursue what Gilles Deleuze calls a 'texturology'—a philosophical and aesthetic conception of art in which its 'matter is clothed, with "clothed" signifying . . . the very fabric or clothing, the texture enveloping'.[4] To make this textural shift involves tracing what we might call the enveloping 'fashioning' of the image and weaving this across different media.

This requires thinking of images materially, for it means viewing them as textures, traces, and even stains. The visual text is fundamentally textural and in many different ways. Its form has real substance. It is made out of layers and tissues. It contains strata, sediments, and deposits. It is constituted as an imprint, which always leaves behind a trace. A visual text is also textural for the ways in which it can show the patterns of history, in the form of a coating, a 'film', or a stain. One can say that a visual text can even **wear** its own history, inscribed as an imprint on its textural surface. It can also show affects in this way. After all, the motion of an emotion itself can be drafted onto the surface of an image, in the shape of a line or in the haptic thickness of pigment, and it can be tracked

down with tracking shots. An affect is actually 'worn' on the surface as it is threaded through time in the form of residual stains, traces, and textures. In visual culture, surface matters, and it has depth.

To understand materiality, we thus need to expose the work of the surface and show how textural matters manifest themselves there. As we plumb the depth of surfaces that surround visual culture, we can also see how they envelop **us**. Skimming the surface, we not only can weave together the filaments of visual existence, exposing their traces in layers of experience, but also trace patterns of transformation. Surface especially matters as a site in which different forms of mediation, transfer, and transformation can take place.

The Surface Tension of Media: Screen, Canvas, Wall

A material transformation occurs as images travel across the surface of different media. Many changes affected by the migration of images happen on the surface and manifest themselves texturally in the form of a kind of surface tension, which affects the very 'skin' of images and the space of their circulation. In this sense, I claim that aesthetic encounters are actually 'mediated' on the surface and that such mediated encounters engage forms of projection, transmission, and transmutation.

Let me offer some examples to make this aspect of the material fabrics of the visual and their relation to a surface tension more concrete. In contemporary architecture, as exemplified in the work of Herzog and de Meuron, the facades of buildings are engaged as pliant surfaces. These surfaces, which have become lighter and more tensile, may be energised by luminous play, texturally decorated as if they were canvas, stretched as membranes, and treated increasingly as envelopes.[5] In contemporary art, such surface tension has emerged as a textural form of fashioning the image as well and, as a concept, is driving an aesthetic development that emphasises the dressing of visual space.[6] Such wearing of surface is an important phenomenon that art and architecture also share with cinema. Think of the cinema of Wong Kar-wai, in which atmospheric forms of imaging are stitched together on the surface in patterns of visual tailoring. Here we find a dense, floating surface in which one senses the material of light and the fabric of colour, emphasised by the visual pleating of editing that itself creates volume and depth, grain and granularity—the final effect being that residue

and sedimentation appear retained in the saturated surface. We almost never see clearly through the fabric of this screen, for several coatings and planar surfaces are constructed out of different materials and all are folded together. There are so many layers to traverse on the surface that the screen itself, layered like cloth, takes on volume and becomes a space of real dimension in which the viewer is empathetically absorbed.

The Skin of the Wall

To further address the issue of surface encounters, we can also turn to the interdisciplinary and multimedia practices of Diller Scofidio + Renfro.[7] This architectural studio performs acts on the surface, creating moving images and an enveloping 'fashioning' of continuous surface space. They make surface into a medium and, at times, even turn it into a structural form. Diller Scofidio + Renfro produces this surface condition by weaving surfaces together and across the fabric of different artistic media. Here, the architectural surface is the vehicle for visual transmission, becoming a form of mediation and transformation. The studio constructs spaces that are actually 'mediated' on the surface, as it engages the surface of the screen in the process of building space. Furthermore, in its sites, the surface can become animated and create forms of imaginary projection. In this way, these architects create surface encounters that can induce empathy with space.

Think of Alice Tully Hall in New York's Lincoln Center for the Performing Arts, as refurbished by the studio. Here the surface has acquired its own performative character, taking centre stage in a luminous form. Curtained with a thin veneer of wood, the interior walls of the auditorium are as light as curtains, and they become as luminous as screens. As light transpires from behind the thin layer of their material surface, it creates atmosphere and mood in the entire auditorium. This surface effect is enhanced by the fact that the pinkish light emerges through the walls as if perspiring through the surface of their skin, giving the impression that the walls are blushing. This form of 'superficial' contact is an expression of spatial empathy, and it makes possible a communicative interface. Here the surface shows its tangible potential to become fully a theatrical space. When light is filtered outward in this way in the auditorium, it creates a textural surface that takes on the shifting, performative qualities of a space of projection. The surface

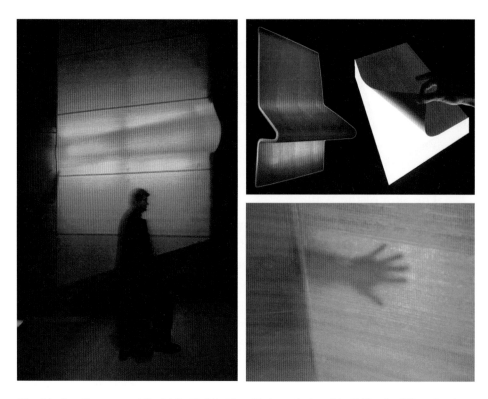

'Touching' wall screen at Alice Tully Hall in New York, as designed by Diller Scofidio + Renfro in 2009. Courtesy of Diller Scofidio + Renfro.

becomes a screen, and it creates a spectatorial public intimacy. Activated with atmospheric translucency in this way, wall, curtain, and screen are no longer separate entities but take on related characteristics, becoming conflated spaces of mediation, transmission, performativity, and spectatorship.

The surface encounters that Diller Scofidio + Renfro creates show that a material transformation occurs as luminous textures travel across the surface of different media. In fact, surface tension here affects the very 'skin' of images, creating aesthetic encounters that are physically 'mediated' on the surface and engaging forms of projection that become transmission, and this includes the creation of atmosphere and the transmission of affects.

Diller Scofidio + Renfro constructs a dialogue with the material of projection, performing mediatic interventions, or builds by 'installing' in space a frame for atmospheric luminous play. Architecture and film are related in fundamental

ways as 'superficial' spatial practices and even end up converging as modes of screening. In the cantilevered media centre of Boston's Institute of Contemporary Art, for example, the studio actually framed the exterior sea view and put it in dialogue with the display of computer screens that face the large window. Here the notion of aperture is reimagined, becoming the screen of a new atmospheric cinema. In such a way, the work creates moving frames in architecture and produces 'mediated' surface encounters.

When a surface condition is activated in this way on visual planes, it changes our way of thinking about space. This new form of superficial materialism initiates a major transformation—it demands a re-vision of space, challenging received modes of visuality and the specificity of medium. If we consider Diller Scofidio + Renfro's form of fashioning space within this larger frame, the very nature of what we have traditionally understood as canvas, window, and wall changes to incorporate another form—the screen. An architecture of mediatic transformations comes to the surface at this very junction where surface tension can turn both facade and framed picture into something resembling a screen. This filmic screen, far from representing any perspectival ideal, is no longer a window but is reconfigured as a different surface. Made of translucent fabric, this screen is closer to a canvas, a sheet, or a curtain. Partition, shelter, and veil, it can be a permeable material envelope. On this material level, the current intersection of canvas, wall, and screen is a site at which distinctions between inside and outside temporally dissolve into the depth of surface. The screen itself is reinvented as a material architecture of 'becoming'—the tensile surface that connects and mediates texturally between art forms. It all appears to fold back into the screen surface—that reflective, fibrous canvas texturally dressed by luminous projections.

Becoming Screen

This 'becoming screen' is a fundamental aspect of Diller Scofidio + Renfro's work, and it also defines the state of our contemporary visual culture. Such a phenomenon is at the centre of a material reconfiguration of visual space that involves the projective surface and the way in which it constitutes a place of encounters. The screen has become an omnipresent material condition of viewing, and this is occurring paradoxically just at the point that cinema, at the very

moment of film's own obsolescence, comes to inhabit today's museums and art galleries. A refashioning of visual space is taking place in a proliferation and exchange of screens. Such refashioning of the fabrics of the visual displays tension at the edges, in the space that exists beyond a particular medium, in the interstices between art forms, at junctions where both transgressive and transitive exchanges between the arts become palpable on the surface.

The screen acts as the actual surface of this refashioning by returning us to the absorptive materiality of a permeable space of luminous projections. As screen-based art practices enact such a return to materiality by emphasising surface luminosity and textural hapticity, the memory of film is materialised in contemporary art. The screen is activated outside of cinema as a historically dense space—re-enacted, that is, as a mnemonic canvas that is fundamentally linked to the technology of light. Walking through the art gallery and the museum, we encounter webs of cinematic situations, reimagined as if collected together and recollected on a screen that is now a wall, a partition, a veil, or even a curtain.

It is important to engage the virtual movements that are taking place in material ways in our environment of screen surfaces. This passage is crucial because it affects the sedimentation of the visual imaginary—its residues—as well as further transmissions and transformations. To be sure, the exchange that has taken place on the field screen of visual archives profoundly affects the fabric and architecture of the visual experience. In suggesting that we weave through this visual fabrication and the material relations that link together screen, window, and wall across time, exposing the threads that connect the visual to the spatial arts, including the migrations between cinema and architectural space, my aim is to reclaim materiality as a surface condition and to foster further explorations in surface tension and depth.

Empathy, Projection, and the Surface of Things

In theorising surface materiality, I also want to touch on the surface of things and to suggest that this membrane conveys the material relation that develops between subjects and objects. I am particularly interested in surface encounters and in considering how they can express a form of empathy. It is important to emphasise in this regard that empathy is a form of exchange.[8] This process of connection occurs not only between people, but also between persons and such

things as space. As the German philosopher and psychologist Theodor Lipps clearly put it when defining his vision of empathy at the cusp of modernity, *einfühlung*, or empathy, can be a mimicry or transfer that is activated between the subject and his or her surroundings.[9] One can empathise with expressive, dynamic forms of architecture, with colours and sounds, or with scenery and situations, and these 'projections' include atmospheres and moods. In Lipps's words, 'a landscape expresses a mood. Such "expression" says exactly what we intend by the term "empathy"'.[10]

Empathy is thus a form of 'transport'—a psychic passage set in motion not simply with physical beings, but also with material space, including such things as the surface of the earth, settings and locales, forms and formations, tints and tones, hues and shapes. According to Lipps, *einfühlung* can be an actual function of these spatial configurations and relations, and it expresses the 'feel' of the ambient. Understood in this way, empathy can be seen as a particular form of transmission and mediation that occurs on the surface of things and in the environment. I would ultimately claim that empathy is an atmospheric matter, activated in the projective layers of material surface encounters. And these kinds of encounters include all that passes on surface space, whether skin or screen.

In this sense, empathy can be further articulated in terms of a material passage and even interpreted as a form of 'projection'. An aid in advancing this interpretation comes from the writings of Wilhelm Worringer. The art historian writes that empathy is the exchange of a vital feeling and represents a material form of encounter with aesthetic space. Let us listen to his specific words on this subject, which suggest that empathy may be configured as a kind of projection:

> A gratification of that inner need for self-activation [is] the presupposition of the process of empathy. In the forms of the work of art we enjoy ourselves. Aesthetic enjoyment is objectified self-enjoyment. The value of a line, of a form consists for us in the value of the life that it holds for us. It holds its beauty only through our own vital feeling, which, in some mysterious manner, we project into it.[11]

I return against the grain to Worringer's notion of empathy, in contrast to the opinion that empathy and abstraction occupy distinct aesthetic realms. In light of Lipps's theory of *einfühlung*, we now fully recognise that one can empathise with any spatial or abstract phenomenon. One can feel empathy with an abstract figure, shape, or form and even empathise with an outline, a silhouette, a contour, or a line. Spatial construction is an active process that, as the art historian

August Schmarsow also showed, engages our capacity to sense our surroundings haptically, and such a process can involve a kind of projection from within the subject onto abstract forms of space.[12] In this sense, we can further elaborate on Worringer's idea that the impact 'of a line, of a form consists in the value of the life that it holds for us'. A dynamic is created in an evolving, twofold empathetic exchange between subjects, objects, and spaces. At the heart of empathy is an image in motion, the expression of an internal movement, which arises in surface encounters. As Worringer himself would have it, empathy is the projection of a vital energy of the beholder and also a spirit that moves in matter. In listening to his words again, we may 'sense' this matter of projected life energy in a passage in which he cites Lipps's own formulation of this projective resonance:

> The urge to empathy as a pre-assumption of aesthetic experience finds its justification in the beauty of the organic . . . 'What I empathise into it is quite generally life. And life is energy, inner working, striving and accomplishing. In a word, life is activity.' . . . The crucial factor is, therefore, rather the sensation itself, i.e. the inner motion, the inner life, the inner self-activation.[13]

Recapturing Worringer's line of argument and taking it a step forward in a different direction, I therefore suggest thinking of empathy as something that moves, both inside and outside of oneself. Empathy is something that moves in us. It is also something that moves in matter.[14] This vital matter can be a projection of our inner activation—that is to say, a material manifestation of our inner motion. Conversely, the energy of space and the vibrancy of matter can transfer onto our bodies. What is at stake, then, in addressing empathy is a relation that can be understood as a form of projection. This necessarily involves engaging with surface space as a threshold or membrane, which has the capacity to hold in its very shape a set of projections between the interior and exterior space.

Projection and Surface Encounters

With this in mind, we can approach some final issues that pertain to surface encounters and projection. I am interested in the creation of permeable membranes that can offer the possibility of material aesthetic encounters. In this sense, I want to draw attention to the 'surface tension of media', because this phenomenon can open up a space for material relations in our times and because, at the same time, it can advance the idea that surface encounters on screens can project

a form of empathy. Let me offer a telling example of these possibilities as materialised in the luminous use of visual technology and new media practiced in the public art of Krzysztof Wodiczko. Since 1980, this artist has produced more than 80 large-scale public projections on buildings, in many different countries.[15] Wodiczko uses the medium of projection to make the face and facade of architecture into a dense surface, creating a permeable site for mediated experiences of memory, history, and subjectivity. In this way, he exposes the actual architecture of projection in a mediation of various media that is material and creates empathy.

Wodiczko's projections sensitise us to the texture of the surface onto which the image is projected. The space onto which these images are projected is never invisible but always rendered tangible. In *The Tijuana Projection* (2001), for example, Wodiczko animates the human body in projection against the body of a building's form. The face of a woman mouthing her story is projected as if her facial skin were adhering to the spherical surface of the dome of the city's Centro Cultural, and in this way we are made to empathise with both face and facade at

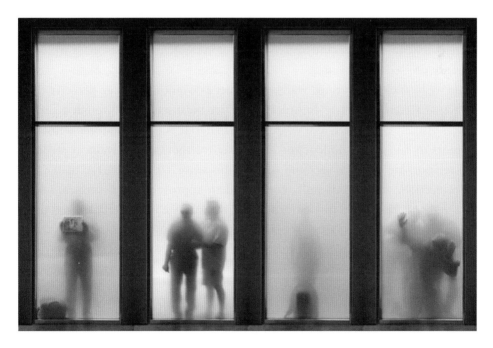

Krzysztof Wodiczko, *If You See Something . . .* , 2005. Four projected video images with sound. Installation view. Courtesy of the artist and Galerie Lelong, New York.

once. In *Hiroshima Projection* (1999), gesticulating hands are projected in close-up onto the moving surface of a river, thereby appearing to activate mnemonic flow and creating empathy with this fluid space. In these works, the moving image is carved out of the material surface of the architecture that supports it, animates it, and moves it. A form of mediation, the architectural surface acts for Wodiczko as a partition—that is, it functions as a visible screen of projection, which includes the projection of empathy.

Guests, an installation from 2009, makes this even more evident. Walking into the dark space of the Polish Pavilion at the Venice Biennale, you thought you were seeing eight windows, scattered on three walls, and, looking up, one sky-light. But the walls had no openings. These frames were not carved in stone. The windows are projections—'screens' on which one can catch glimpses of the life of immigrants, the 'guests' of the country in which we are. *If You See Something . . .* , from 2005, was similarly structured. The surface of these imaginary windowed architectures functions as an elaborate form of mediation, for these luminous screens provide access to, and create empathy with, the personal narratives of society's invisible citizens. It is significant that the migrants are never seen or heard clearly. They appear as shadows through the light, silhouettes in a digital shadow theatre. The interrelation of visibility and invisibility in society is concretely materialised here, uncovered on the non-existent panes of glass windows that are dressed as screens.[16]

As we look closely at these walls, which act as windows, we can perceive them as actual screen surfaces.[17] In order to see, we must navigate through a surface that is visually configured as a white, dense material. A milky, textured substance appears to our senses, and, acting as a cover for the window walls, it mediates the relationship between seer and seen. In this sense, we perceive the materiality of projection, which is digitally configured to approach screen surface. Closer to a veil or curtain than to a pane of glass, this surface is the actual visual tissue of projection. And thus, as we try to make out the foggy figures of the displaced people and hear their stories through muffled sound, we experience the mediatic quality of the screen as a veiled, and veiling, surface.

In the installations of *If You See Something . . .* and *Guests,* screens can act as membranes. As the figures of the migrants move in a blur, their contours come in and out of focus, becoming more consistent as they approach the limit of the screen. The effect makes the screen feel like a tissue, a permeable, thin sheet that appears to move like a membrane being stretched. Some

visitors to the installation come up to the site of projection as if wishing the space actually could extend or stretch like such a membrane. In turn, the migrants act as if the partition could bend or warp to create a passage, or as if it could be visually traversed, like a veil. They push their bodies up to the surface and hold up hands, pictures, and objects as if wishing to push them through a layer of tissue. In many ways, this screen is shown to be elastic, flexible, and pliant.

Surface tension occurs here. This membrane is an actual screen also in the sense that it is a partition. On this site of partition, the migrants can negotiate status and story, for this membrane-like surface acts simultaneously as a protective layer and as a wall. There is substance, which is also a form of resistance, in this material of projection. As if to rebel against their status as shadows, the migrants push up against the partition, as they would against a real border. But let us not forget that the virtual architecture constructed by Wodiczko is also a window; that is, it is the kind of architecture in which positions between inside and outside can be mediated. In this capacity as aperture, the resilient surface does not merely divide but also enables a passage—the channelling of empathy—which finally becomes a potential crossing of borders. Possibilities of openings and a hope of exchange can be sited on this composite, tensile, permeable screen that acts as a membrane of empathy.

Einfühlung: Atmospheres of Projection

Coated in the material fabric of projection, this space of traversal includes spectatorial projections and the transmission of empathy. As a visitor to this space, one is not safely positioned on the other side of the screen but rather stands on the border, for in order to perceive, one must cross over and project oneself across the threshold. The fabric of this screen is so absorbent that it absorbs the viewer too in its surface tension. To look is to feel this tension, challenging, as the process of empathy does, who and what is outside and inside. One cannot simply stare passively at this surface. The tension of its tensile surface forces one to become engaged—to the point of wishing that borders might be crossed and contact might be made through the membrane, across the fabric of the screen. Not only a site of critical distance, this kind of screen is at once resistant and embracing because it holds affects in its fabric. Its porous membrane enables the

passage of empathy, which is itself a form of projection. In staging an epidermic form of exchange, this surface membrane thus mediates the potential for relatedness that is inscribed in the material of projection.

The atmosphere of projection is thick. It is dense with moody, luminous light particles dancing in space, imbued with an air of cloudy, permeable palpability. The visible is here 'a quality pregnant with a texture'.[18] Projection was indeed always an environment, and in recent times it is becoming even more of an atmosphere. Screen space is a site haunted by 'the perturbations of surfaces'.[19] And this is what creates that particular form of 'feeling in' space that is *einfühlung*.

To fully sense these textural matters, think of the material history of the screen. After all, an ethereal consistency is the material base of the act of screening, as the idea of projection was historically born out of atmospheric surfaces. The act of projection was designed to make images flare out and move, in the way Lucretius envisioned it, surfacing from the fabric of light and the density of air. Early forms of projection, such as magic lanterns and phantasmagoria, were a weathered kind of space, imbued with vaporous things such as smoke and fog. Projection was also closely associated with elusive substances such as the hazy, misty quality of shades, silhouettes, and shadows. It is no wonder, then, that such materials of resistance and permeability, integral to the very activity of screening, would find their own digital substance in a new atmosphere of projection.

A place of passage and a point of contact between worlds, the screen continues to mediate today, crossing the borders of media in surface tension and fostering the passage of *einfühlung*. In the atmosphere of projection, a form of curtaining, partitioning, and partaking of space occurs, beyond medium specificity, in an architecture of 'becoming' that connects and mediates texturally between art forms. Far from being responsible for dematerialisation, the persistence of projection in the art gallery continues to refashion mobile and communal architectures of materiality. It even reactivates the public potential of the cinematic mode of exhibition, along with its potential to create empathy. And so as the shadow theatre that is cinema is reconfigured and rematerialised architecturally, and the white cube of the gallery turns luminously dark, we are given back the absorbent, envisioning, relational fabric of projection, displayed on yet another form of screen membrane, where empathy can take place as a moving surface encounter.

Endnotes

1. Titus Lucretius Carus, 'On the Nature of the Universe: A New Verse Translation by Sir Ronald Melville' (Oxford: The Clarendon Press, 1997), 102–3.

2. I expand here upon a central concern of my book 'Surface: Matters of Aesthetics, Materiality, and Media' (Chicago: University of Chicago Press, 2014), in which I turn to the concept of surface in order to investigate the place of materiality in our contemporary world.

3. See also Giuliana Bruno, 'Atlas of Emotion: Journeys in Art, Architecture, and Film (London and New York: Verso, 2002); and Bruno, 'Public Intimacy: Architecture and the Visual Arts' (Cambridge, MA: MIT Press, 2007).

4. Gilles Deleuze, 'The Fold: Leibniz and the Baroque', trans. and foreword Tom Conley (Minneapolis: University of Minnesota Press, 1993), 115.

5. See, amongst others, David Leatherbarrow and Mohsen Mostafavi, 'Surface Architecture' (Cambridge, MA: MIT Press, 2002); and Philip Ursprung, ed., 'Herzog & de Meuron: Natural History' (Montreal: Canadian Centre for Architecture, 2002).

6. See, for example, David Joselit, 'Surface Vision', in Nicholas Baume, ed., Super Vision, exh. cat. (Boston: Institute of Contemporary Art; and Cambridge, MA: MIT Press, 2006); and Joselit, 'After Art' (Princeton: Princeton University Press, 2013); Chrissie Iles, 'Surface Tension', in Francesco Bonami, ed., Rudolf Stingel, exh. cat. (Chicago: Museum of Contemporary Art; and New Haven: Yale University Press, 2007), 23–9; and Cassandra Coblenz, ed., Surface Tension, exh. cat. (Philadelphia: The Fabric Workshop and Museum, 2003), http://www.fabricworkshop.org/exhibitions/surface/essay.php.

7. For a reading of the multiform practice of this architectural studio, see the exhaustive monograph by Edward Dimendberg, 'Diller Scofidio + Renfro: Architecture after Images' (Chicago: University of Chicago Press, 2013). See also Hubert Damisch, 'Blotting Out Architecture? A Fable in Seven Parts', Log (Fall 2003), no. 1, 9–26; and Mark Hansen, 'Wearable Space', Configurations (2002), 10, 321–70.

8. The literature on this subject is extensive. For an introduction, see Harry Francis Mallgrave and Eleftherios Ikonomou, eds., 'Empathy, Form, and Space: Problems in German Aesthetics, 1873–1893' (Santa Monica: The Getty Center for the History of Art and the Humanities, 1994). For an overview of the history of Einfühlung, see Juliet Koss, 'On the limits of empathy', Art Bulletin (March 2006), 88, no. 1, 139–57. See also Robin Curtis and Gertrud Koch, eds., 'Einfühlung. Zu

Geschichte und Gegenwart eines ästhetischen Konzepts' (Munich: Wilhelm Fink, 2008); and *'Art in Translation'* (Dec 2014), special issue on *Einfühlung*, vol. 6, no. 4.

9. See Theodor Lipps, 'Empathy and Aesthetic Pleasure', in Karl Aschenbrenner and Arnold Isenberg, eds., *Aesthetic Theories: Studies in the Philosophy of Art* (Englewood Cliffs, NJ: Prentice-Hall, 1965).

10. Aschenbrenner and Isenberg, *'Aesthetic Theories: Studies in the Philosophy of Art'*, 405.

11. Wilhelm Worringer, *'Abstraction and Empathy: A Contribution to the Psychology of Style'*, trans. Michael Bullock and with an intro by Hilton Kramer (Chicago: Elephant Paperbacks, 1997), 14.

12. On Schmarsow's theory of space, see Mitchell W. Schwarzer, 'The Emergence of Architectural Space: August Schmarsow's Theory of *Raumgestaltung,' Assemblage* (August 1991), no. 15, 50–61.

13. Worringer, *'Abstraction and Empathy'*, 4–5.

14. On the subject of a vibrant materialism, see Jane Bennett, *'Vibrant Matter: A Political Ecology of Things'* (Durham and London: Duke University Press, 2010).

15. See, amongst others, Krzysztof Wodiczko, *'Critical Vehicles: Writings, Projects, Interviews'* (Cambridge, MA: MIT Press, 1999); Andrzej Turowski, ed., *'Krzysztof Wodiczko: Pomnikoterapia'*, exh. cat. (Warsaw: Zacheta National Gallery of Art, 2005); and Rosalyn Deutsche, 'Krzysztof Wodiczko's *'Homeless Projections'* and the Site of Urban Revitalization', in *Evictions: Art and Spatial Politics* (Cambridge, MA: MIT Press, 1998), 3–48.

16. See Ewa Lajer-Burcharth, 'Borders', in *Krzysztof Wodiczko: Guests*, exh. cat. (New York: Charta Books, 2009), 32–45; and Lajer-Burcharth, 'Interiors at risk', *Harvard Design Magazine* (Fall–Winter 2008–09), no. 29, special issue 'What about the Inside?', 12–21.

17. My critical reading of Wodiczko's work here and in *Surface* owes much to private and public conversations with the artist, whom I wish to thank. See in particular Giuliana Bruno, 'Krzysztof Wodiczko,' an interview for 'In the Open Air: Art in Public Spaces', a project of *Bomb* magazine and PBS's *Art 21*, Sculpture Center, New York, 29 October 2007, online at http://bombsite.com/issues/999/articles/3592.

18. See Maurice Merleau-Ponty, 'The Intertwining—The Kiasm', in *The Visible and the Invisible*, trans. Alphonso Lingis (Evanston: Northwestern University Press, 1968), 136.

19. See Georges Didi-Huberman, 'The imaginary breeze: remarks on the air of the quattrocento', *Journal of Visual Culture* (December 2003), 2, 3, 280.

SECTION III

Expanded Embodiment

In Conversation

Michael Banissy and Elinor Cleghorn

MICHAEL BANISSY (MB): As a neuroscientist, I first came across mirror-touch when it was identified in 2005. At the time, I was working on social neuroscience and also synaesthesia. Mirror-touch fascinated me because of its unique blend of synaesthesia and interpersonal experience. It's also a unique experimental group to study social behaviours that can inform us about the 'normal' population.

There is ongoing debate in the scientific community about how to categorise mirror-touch. Although it's indeed a case of visual stimulus creating a tactile sensation, it's different from forms of synaesthesia that have been studied in more detail such as coloured hearing and coloured phonemes (letters and numbers). In these more 'traditional' forms of synaesthesia, there is an idiosyncratic linkage between the stimulus and a whole range of colours. For example, the letter A may be orange for one synaesthete, but blue for another. Whereas in mirror-touch, the linkage is sometimes described as having minimal 'bandwidth', it is one-to-one, rather than idiosyncratic.[1] There is less variability in the mirrored response to stimulus. Because of this difference, there is debate as to whether to expand notions of synaesthesia to include mirror-touch, or rather to categorise it with other phenomena, namely self-other blurring or cross-modal correspondences. One of our key theories of mirror-touch is that there is a blurring of self and other—people with mirror-touch have difficulty in inhibiting the experiences of other people.[2] Their body maps may be extended to incorporate those of other people and of objects.

ELINOR CLEGHORN (EC): I'm interested in the overlap between these two conceptions of mirror-touch. In the so-called 'traditional' synaesthesias, the

stimulus—the sound or the letter—is not conceived of as an 'other'. But in the interviews we have done with mirror-touch synaesthetes, the 'stimulus'—another person that is touched or even an object that is touched—is indeed an 'other'; this so-called stimulus is granted subjectivity.

MB: This is one reason why we call mirror-touch a 'social synaesthesia'. The maps that our brain constructs between the self and the other are quite dynamic and they can be extended to include objects or things that look like humans—mannequins, for instance. The classification of an 'other' can extend to dimensions beyond the human.[3] An example of this includes the rubber hand illusion where tactile stimulation delivered in synchrony to the participant's own unseen hand and a visible fake rubber hand can induce illusory ownership over the rubber hand. That is to say, the participant attributes the tactile sensations on their own hand to the touch they can see on the rubber hand.[4] They feel as though the rubber hand is theirs. A similar self-other blurring happens in the general population during the so-called 'enfacement illusion'. When viewing another person's face being touched at the same time in the same place, a sensation of merger of self and other is created.[5]

EC: And what structures that dynamic—that relationship between the self and other? Is the feeling for the other really what we might call, in some definitions of the word, 'empathic'—receptive, or is it structured by one's own experience—more of a projection? I think both interpretations are present in our interviews with mirror-touch synaesthetes; in certain cases, there are mappings of specific personal memories during visual encounters, and at other times, the stimulus is very alien, and yet the synaesthete still somehow responds.

MB: Anecdotally, there seems to be a memory component to mirror-touch. One synaesthete with whom I worked recalled that it was only after she had been in labour that watching videos of other women in labour would give her the corresponding sensation. Mirror-touch sensations are almost by definition empathic, in the sense of the capacity to share the feelings and experiences of others.

EC: Your example brings to mind that of a young mirror-touch synaesthete who, when watching a kissing scene on television—before he had been kissed on the lips himself—would feel this as the 'light touch' of a peck on the cheek.[6] Once he'd been kissed, on the lips, he felt mirror-touch lip kisses in the 'correct' place.

Albrecht Dürer, *Adoration of the Magi* (oil on wood, 1504). Reproduced with permission of Uffizi Gallery.

So memory and experience seem to inform mirror-touch. Perhaps by extension, intriguingly, many of the mirror-touch synaesthetes we interviewed describe feeling touch in response merely to imagining touch. For instance, one synaesthete stated that when she looks at a work by Albrecht Dürer, she can feel the brushstrokes as if they were blades of grass against her cheek. Similarly, another synaesthete describes how she is attracted to Constantin Brancusi's sculptures because she can feel an empathic affinity with the touch that has gone into the creation of this work; she feels that touch is somehow embedded within the artwork.

MB: For comparison, we could think about mirror neurons that respond to actions. In macaques, mirror neurons respond when the monkey sees an action that is completed, but there is also evidence that a subset of these neurons respond if the monkey only hears the associated sound that

goes with the end of the action. They might see someone about to break a peanut, but not the peanut breaking. Just the sound of the completed action—the sound of the break—will cause the mirror neuron to fire.[7] So there is an argument to suggest, if there is a tactile mirroring going on, that imagining the tactile consequence might lead to these kinds of experiences. That being said, I don't know of any studies that have systemically investigated this in non-human primates, mirror-touch synaesthetes, or non-synaesthetes.

EC: The German High Renaissance example is also interesting because, in this instance, the touch is felt on the synaesthete's cheek. Another synaesthete felt an image in her mouth. In reply to a question about whether she had mirror-touch responses to abstract patterns, she said: 'Yes, but all feel different according to the pattern, for instance the static on the TV can feel like little prickles on my fingertips, but the left side of *Portrait and a Dream* (1953) by Jackson Pollock feels like floating shapes in my mouth and the right side feels like gritty shapes in my mouth'.[8] This isn't an isolated incident of mirror-touch responses being located in the mouth; Joel Salinas also describes a rolling feeling in his tongue and at the back of his mouth, of his throat, when he sees a rolling shape.

Jackson Pollock, *Portrait and a Dream* (1953). Oil and enamel on canvas 58 1/2 × 134 3/4 in (148.59 cm × 3 m 42.26 cm). Dallas Museum of Art, gift of Mr and Mrs Algur H. Meadows and the Meadows Foundation, Incorporated © The Pollock-Krasner Foundation ARS, NY and DACS, London 2016.

MB: Your example reminds me of the account of 'the man who tasted shapes'[9] and, in this sense, might be closer to 'traditional' forms of synaesthesia because the range of associations is more arbitrary—the experiences have more 'bandwidth'. Perhaps we could argue that these experiences are forms of visual–tactile synaesthesia and that mirror-touch is a subset, but it's difficult to say. The boundaries are fuzzy.

EC: And coming back to the question of projection and memory, what about mirror-touch sensations of being pulled out of familiar experience? Some of the synaesthetes we interviewed describe their empathic sensations as transformative and destabilising. One of our interviewees, for instance, describes the provocative tactile experience of encountering an abstract glass sculpture by Dale Chihuly, a spherical piece with spikes—as he looks at it, he begins to 'have the sensation of actually being that sphere with spikes' and feels his skin 'stretched out and turned and twisted' into the form of the sculpture.[10] How is it that the mirror-touch synaesthete—or the rest of us—can relate to something rather unlike their own body's experiences?

MB: That is interesting; in 2009, we developed a neurocognitive model for mirror-touch and suggested that there may be three mechanisms at play: Who, What, and Where.[11] In the context of 'Where', we drew a distinction between embodied (the sense of being localised within one's own body) and disembodied representations of the body (e.g. autoscopic phenomena in which individuals experience the location of the self outside of one's own body).[12] We postulated that a similar division can be made for the 'mirror' versus the 'anatomical' division in mirror-touch synaesthetes. Synaesthetes in the former category experience mirror-touch as if looking in a mirror (touch to someone facing them will occur on the other's right cheek and on the synaesthete's left cheek), while in the latter category, synaesthetes transpose the touch so that touch to another's right cheek will always be to the synaesthete's right cheek, no matter where the other is located. Experiences that occur under a mirrored frame we considered embodied, while for the anatomical subtype, the spatial mapping between self and other could be considered disembodied in that the synaesthete's body is placed in the perspective of the other person. We suggested that some mechanisms which give rise to the spatial frames adopted by mirror-touch synaesthetes are modulated by mechanisms similar to those observed in autoscopy, or out-of-body experiences.

For example, disembodied experiences have been suggested to arise from functional disintegration of low-level multisensory processing mechanisms and abnormal activity at the temporal parietal junction.[13] If so, these may account for some of the experiences you report, but it has not been tested.

EC: The example of the glass sculpture is also interesting though, because the synaesthete is not actually observing it being touched. Instead he is experiencing a sensation of becoming that sculpture without any touch being applied.

MB: That's right; this is not an instance, then, of mirror-touch, strictly speaking, but could be part of an associated cluster of phenomena. We can't be sure whether this does or doesn't rely upon the same mechanisms that we think are at play when individuals mirror the tactile experiences of others. It could be that his body map is extended and that he is then incorporating

Dale Chihuly, glass sculpture installed in *Chihuly in the Garden*, Desert Botanical Garden, Arizona (2013–2014).

this representation into himself. In fact, all of us have mental representations of our bodies that typically encompass our body and the space around our body. But if we start to use tools, our representations of the space around our body expand to incorporate the object. This has been tested in primates by training them to use rakes.[14]

EC: But do you see any overlap, again, between these two conceptions? Might empathy, including emotional empathy, implied by the overactive mirror system in mirror-touch synaesthetes, be a result of this expansion of body maps or a cause of them? We know, based, in part, on your own studies, that mirror-touch is associated with enhanced emotional empathy or emotional contagion[15] (even if it is still unclear whether this results in greater compassion or pro-social behaviour). Does this emotional empathy extend to objects when the body map expands to include them? Several of our interviewees specifically named 'object personification' as a kind of synaesthesia they have, in addition to mirror-touch.

Objects encountered by synaesthetes without touch driving the stimulus have included things like a tall and thin lamp post with a curved top that skews bodily perception and also invites personification of the lamp post. Surfaces and textures have also been described as provoking emotional responses in synaesthetes. Sheets of paper were described by one synaesthete as provoking difficult or negative emotions, and smooth, reflective surfaces were described by another synaesthete as triggers for a disturbed sense of imbalance. Could object personification be a phenomenon closely related to mirror-touch?

MB: There are lots of layers in those examples. For instance, even for a non-synaesthete, certain colours or textures or surfaces might evoke an emotional reaction; you might feel uncomfortable with shiny, pink objects, for instance. This type of correspondence could either be driven by sensory associations or cultural experience. Object personification, attributing personalities and genders to objects, is a disputed form of synaesthesia and is more common in people with other kinds of synaesthesia than in non-synaesthetes. A related trait is personified letters and numbers.[16] For example, some people describe the letter 'K' as an energetic female, but 'M' as an old lady.[17] You don't have to be a mirror-touch synaesthete to experience this.

EC: Yet, it's easy to imagine how emotional empathy might extend to objects for mirror-touch synaesthetes who are sensitive to touch to objects. If someone

strokes the edge of a water glass and you feel that touch as a stroke to your ribs, for example, mightn't it follow that you would attribute mirrored feeling to that glass?

MB: Absolutely, if you are mapping objects onto your body, you might start to think of them as having elements to their lives beyond tactile experiences.

EC: In the example I gave, I imagined a mirror-touch synaesthete watching someone stroke a glass and feeling that stroke on their torso. But equally, might they feel it on their fingertip, identifying, as it were, with the person, rather than with the object?

MB: It depends on the extent to which the synaesthete is likely to experience the sensation either as 'active' or 'passive' touch. For the most part, it tends to be passive touch (receiving another's touch) that drives mirror-touch experiences, at least that is what we have come across in our studies to date. That being said, I have anecdotally come across one synaesthete who reported a sensation in his fingertip when someone else touched a glass. It should be said, however, that experiencing sensations in response to viewing objects being touched is less common than viewing humans being touched. In the work Henning Holle[18] has done with mirror-touch synaesthesia, he has found that in order to experience mirror-touch, the stimulus tends to be a real body, but this finding has been contested. We know less about the interaction between the perception of animism and mirror-touch.

EC: I've noticed in our interviews that more intense mirror-touch responses to objects have an intriguing correlation with the 'usefulness' implied within those objects: cups, spoons, used objects, handled objects. There seems to be a connection between this 'feeling as the object' and its frequent use. Could mirror-touch synaesthetes experience a special sensitivity to objects that are used as tools? Might there be an amplified sensitivity for tools that extend our reach in everyday life where there is an overlap with the kinds of expanded body maps that the general population experiences?

MB: Other examples are hats and so on. The work done on tools has not focused on mirror-touch synaesthesia. It's a very interesting question.

EC: There have been quite a few anecdotes in our interviews about technology. In particular, one synaesthete described how when somebody else touches

her mobile phone, she feels a distinct tapping sensation on her back. Perhaps this corresponds to a sense of 'ownership' that's being messed around with.[19] And coming back to the question of emotional empathy, do we feel more emotional empathy for things like computers, guitars, or hats that are incorporated into our lives on a daily basis?

MB: Intriguing. When people talk about simulation processes in empathy, there is evidence showing that we have greater empathic activity when we're looking at individuals who are more similar to ourselves.[20] You might expect that if an object is more associated with your own body, perhaps that would increase your empathy for it—but to my knowledge, there's no systematic study to give us a clear-cut answer. To what extent is my iPhone a part of me, and how emotionally involved am I with this object?

EC: One interviewee describes how she had a boyfriend who was in a coma. When she had the explicit knowledge that he was anaesthetised during procedures that she was witnessing, she didn't have any mirror-touch responses. But when she understood him not to be anaesthetised and procedures were happening, she did have mirror-touch responses.

MB: Your example suggests that mirror-touch may not just be a passive sensory experience but that it may be affected by top-down modulation. This is true of tactile empathy in the rest of the population. For example, knowing that somebody is a supporter of the same political party can modulate the level of shared representations with others.[21]

EC: I know that there are studies showing that mirror-touch synaesthetes are not so responsive to touch to dummies.[22] This calls to mind 'the uncanny valley', the place on a spectrum of recognition where we come uncomfortably close to a human form, but not quite close enough, and consequently feel alienated and disgusted. Might mirror-touch synaesthetes experience an amplified, uncanny valley? Or could it be that dummies do not evoke empathy because of their static quality?

Another trait that we've uncovered in our interviews that seems closely wedded to mirror-touch is mirror-proprioception where a synaesthete feels their body's position in space and movement through space reflecting that of another person gesturing and moving. One synaesthete described watching an Olympic gymnast move through her routines and in response her muscles started to twitch. The more she watched, the more the muscles in her legs would fire.[23]

MB: I think it's a fascinating development. It's not something that I had come across before your interviews. It puts a new twist on things because we've been thinking about mirror-touch in the context of exteroception—caused by an outside stimulus, rather than a sense coming from the inside. Proprioception relies on different neural mechanisms to passive touch, so if the reports can be verified, then it would be interesting to examine the extent to which the type of experience you describe is separable or experienced in conjunction with mirror-touch.

EC: Another synaesthete described how, while watching a fantasy film with scenes of human flight, her body would feel as if it was being lifted, inclining upwards.[24] In fact, one particular interviewee describes how her mirror-touch responses are **only** provoked by movement, whether live on-screen, whether literal, or evoked by an abstract pattern.[25]

Endnotes

1. See Nicolas Rothen and Beat Meier, 'Why vicarious experience is not an instance of synesthesia', *Frontiers in Human Neuroscience* (2013). doi: 10.3389/fnhum.2013.00128.

2. M. J. Banissy and J. Ward, 'Mechanisms of self-other representations and vicarious experiences of touch in mirror-touch synesthesia', *Frontiers in Human Neuroscience (2013)*, 7, 112. doi.10.3389/fnhum.2013.00112.

3. See H. Holle, M. Banissy, T. Wright, N. Bowling, and J. Ward, '"That's not a real body": identifying stimulus qualities that modulate synaesthetic experiences of touch', *Consciousness and Cognition* (2011), 20(3), 720–6. doi: 10.1016/j.concog.2010.12.002; see also Angelo Maravita and Atsushi Iriki, 'Tools for the body (schema)', *TRENDS in Cognitive Sciences* (2004), 8, 2, 79–86.

4. Matthew Botvinick and Jonathan Cohen, 'Rubber hands "feel" touch that eyes see', *Nature* (1998), 391, 756. doi:10.1038/35784.

5. See A. Tajadura-Jiménez, M. R. Longo, R. Coleman, and M. Tsakiris, 'The person in the mirror: using the enfacement illusion to investigate the experiential structure of self-identification', *Consciousness and Cognition* (2012), 21(4), 1725–38. doi: 10.1016/j.concog.2012.10.004.

6. Daria Martin, Email correspondence with Anonymous, a mirror-touch synaesthete, 12 March 2008.

7. See Evelyne Kohler, Christian Keysers, M. Alessandra Umiltà, Leonardo Fogassi, Vittorio Gallese, and Giacomo Rizzolatti, 'Hearing sounds, understanding actions: action representation in mirror neurons', *Science* (2002), 297, 846–8. See also Vittorio Gallese and David Freedberg, 'Motion, emotion and empathy in esthetic experience', *TRENDS in Cognitive Sciences* (2007), 11, 5, 197–203, for descriptions of research connecting mirror neuron activity and embodied spectatorial responses to artistic gestures.

8. Elinor Cleghorn, Interview with Anonymous, a mirror-touch synaesthete, 5 October 2013.

9. See Richard Cytowic, '*The Man Who Tasted Shapes*' (MIT Press, 1993), and also V. S. Ramachandran and Edward Hubbard, 'Hearing colors, tasting shapes', *Scientific American* (2003), 53–9.

10. Daria Martin, Interview with Anonymous, a mirror-touch synaesthete, 5 November 2012.

11. M. J. Banissy, R. Cohen Kadosh, G. Maus, V. Walsh, and J. Ward, 'Prevalence, characteristics, and a neurocognitive model of mirror-touch synaesthesia', *Experimental Brain Research (2009)*, 198, 261–72.

12. See O. Blanke, T. Landis, L. Spinelli, and M. Seeck, 'Out-of-body experiences and autoscopy of neurological origin', *Brain* (2004), 127, 243–58, and also O. Blanke and C. Mohr, 'Out-of-body experience,

heautoscopy, and autoscopic hallucinations of neurological origin: implications for neurocognitive mechanisms of corporeal awareness and self-consciousness', *Brain Research: Brain Research Reviews* (2005), 50, 184–99.

13. See O. Blanke and C. Mohr, 'Out-of-body experience, heautoscopy, and autoscopic hallucinations of neurological origin' (2005).

14. See Angelo Maravita and Atsushi Iriki, 'Tools for the body (schema)' (February 2004).

15. For example: 'Mirror-touch, before I knew the word, I would think of in terms of empathy. I feel what other people feel more perhaps, and I am very sensitive to the atmosphere in a group or in a room, or even in a landscape.' Elinor Cleghorn, Interview with Anonymous, a mirror-touch synaesthete, 15 May 2014; 'If I'm around someone whose emotional experience is very strong, for a sustained period of time, it gets to a point where I will take on a lot of those emotions and reflect a lot of those physical characteristics, and I can put myself in a very dark place because of it.' Daria Martin, Interview with Anonymous, a mirror-touch synaesthete, 5 November 2012.

16. See Maina Amin, Olufemi Olu-Lafe, Loes E. Claessen, *et al.*, 'Understanding grapheme personification: a social synaesthesia?' *Journal of Neuropsychology* (September 2011), Special issue: Synaesthesia, 5, 2, 255–82.

17. Julia Simner and Emma Holenstein, 'Ordinal linguistic personification as a variant of synesthesia', *Journal of Cognitive Neuroscience* (2007), 19, 4, 694–703.

18. See H. Holle, *et al.*, '"That's not a real body': identifying stimulus qualities that modulate synaesthetic experiences of touch' (September 2011).

19. Elinor Cleghorn, Interview with Anonymous, a mirror-touch synaesthete, 21 July 2014.

20. See S. Han, Y. Fan, X. Xu, *et al.*, 'Empathic neural responses to others' pain are modulated by emotional contexts', *Human Brain Mapping* (2009), 30(10), 3227–37. doi: 10.1002/hbm.20742; I. T. Mahayana, M. J. Banissy, C.-Y. Chen, V. Walsh, C.-H. Juan, and N. G. Muggleton, 'Motor empathy is a consequence of misattribution of sensory information in observers', *Frontiers in Human Neuroscience* (2014). doi: 10.3389/fnhum.2014.00047; see also A. Avenanti, A. Sirigu, and S. M. Aglioti, 'Racial bias reduces empathic sensorimotor resonance with other-race pain', *Current Biology* (2010), 20, 1018–22. doi: 10.1016/j.cub.2010.03.071.

21. A. Serino, G. Giovagnoli, and E. Làdavas, 'I feel what you feel if you are similar to me', *PLoS One* (2009), 4(3). doi: 10.1371/journal.pone.0004930.

22. See H. Holle *et al.*, '"That's not a real body": identifying stimulus qualities that modulate synaesthetic experiences of touch' (September 2011).

23. Daria Martin, Interview with Anonymous, a mirror-touch synaesthete, 24 October 2013.

24. Elinor Cleghorn, Interview with Anonymous, a mirror-touch synaesthete, 22 May 2014.

25. Daria Martin, Interview with Anonymous, a mirror-touch synaesthete, 23 September 2013.

Becoming Others

Siri Hustvedt

When we see a stroke aimed just ready to fall upon the leg or arm of another
person, we naturally shrink and draw back our own leg or our own arm . . .
Persons of delicate fibres and a weak constitution of body complain that in
looking on the sores and ulcers which are exposed by beggars in the streets,
they are apt to feel an itching or uneasy sensation in the corresponding part
of their own bodies.

Adam Smith, *The Theory of Moral Sentiments* (1759)

At some moment in my childhood, I became aware that my visual and tactile
senses worked differently from those of most people I knew, not because of my
mirroring touch sensations while looking at others, which I assumed were uni-
versal, but because, even on a sweltering day, the sight of an ice cube, Popsicle,
or ice cream cone generated a shiver in me and had done so for as long as I could
remember. The mere thought of ice can produce an involuntary sensation of cold
in me (whereas looking at, or thinking about, fire does not make me warm). For
years, I asked people, including neurologists, about my see-ice-feel-freeze experi-
ences but was inevitably met with puzzled faces.

I have always been on guard against the jangling, disorienting riot of bodily
sensation produced in me by both sights and sounds. If I see someone touched,
my feelings of that touch are only shadows of what I would feel if I were the
person actually being touched. Nevertheless, as a girl, I could not fathom how
the other children were able to look at horror movies, watch daredevil stunts, or
calmly inspect the cuts, bruises, and broken bones of an injured friend. I found
the rambunctious antics of Looney Tunes characters on television unbearable
and preferred the soothing adventures of Casper, the friendly ghost. Now, when
my husband and I watch films on television, I leave the room during fights or

battering episodes. A walk down a crowded New York City street can leave me tingling with sensation or feeling bumped and banged. I experience the emotional weather and shifting moods of the people near me as a sensible quality, a pain in my stomach, or a pressure under my ribs or in my face. The pleasures of heightened sensuality should not be discounted, however. When I lightly caress my husband's arm or cheek, I feel the touch myself, albeit as a weaker trace. When I walk on the street and see a father caress a child, or a young woman press her mouth to her lover's, or a toddler rubbing her head into her mother's chest, the gentle sensations the gestures produce are gratifying, and they make me feel that I am deeply in and of the world. My tactile responses to seeing someone hurt, the sounds that jolt and burn through me, and the emotion that seems to originate in you and is felt by me—these never struck me as anything other than an empathic response, or what my mother called being 'too sensitive for this world'.

When a thing is named, it emerges from an undifferentiated background into an illuminated foreground. It takes on a shape and borders. After mirror-touch became one of the many categories of synaesthesia in 2005, my life-long hypersensitivity—my sisters called me 'princess on the pea'—began to look less like a character defect and more like a neurological condition, not unlike the migraines I have had since I was young. But I have come to believe that untangling personality from the complexities of the nervous system is both artificial and futile. I do not **will** my responses to looking at ice or other people. They simply happen. They are not under my conscious control. What I can control, to one degree or another, is how I understand and live with my crossed senses as a permanent feature of my daily existence.[1]

The most fascinating aspect of mirror-touch synaesthesia may be precisely that it lies at—indeed appears to cross the border between—self and other but does so in a way that forces us to examine the limen itself and what it means for empathic and imaginative experience. It is fair to say that the question of borders between a **me** and a **you**, the problem of a self or an identity in relation to others, and the nature of intersubjectivity have been obsessive themes in both my fiction and non-fiction. Is my insistent questioning of this self/other border related to my mirror-touch? We all have intuitive attractions to some ideas more than others. Many academics and scientists find it distasteful to admit this, sullied as the notion is with subjectivity, but character (and the nervous sensitivities that are inextricable from it) is often predictive of thinking style and content.

As the American philosopher William James noted in a lecture: 'Temperaments with their cravings and refusals do determine men in their philosophies, and always will'.[2]

In the following conversation from my third novel *What I Loved* (2003), Violet Blom has just told the narrator Leo Hertzberg an erotic story about herself and two men and proposes a way to think about the self in relation to others.

> 'I've decided that *mixing* is a key term. It's better than *suggestion*, which is one-sided. It explains what people rarely talk about, because we define our-selves as isolated closed bodies, who bump up against each other but stay shut. Descartes was wrong. It isn't: I think, therefore I am. It's: I am because you are. That's Hegel—well the short version.'
>
> 'A little too short,' I said.
>
> Violet flapped her hand dismissively. 'What matters is that we're always mixing with other people. Sometimes it's normal and good, and sometimes it's dangerous. The piano lesson is just an obvious example of what feels danger-ous to me. Bill mixes in his paintings. Writers do it in books. We do it all the time ...'[3]

I share Violet's anti-Cartesian position and, although her summation of Hegel is 'too short', she has a point. It is now fashionable to lambast René Descartes's dualism, his division of human beings into psyche and soma, two distinct sub-stances held precariously together. But Descartes's enclosed mental space, inside of which a lone thinker finds his 'I', has had a lasting power that haunts many sci-entists and a good many philosophers, who continue to think of the human mind as a disembodied information-processing machine. For Hegel, unlike Descartes, the road to self-consciousness, the ability to know that we know, is discovered through a combative relation with another person that turns on recognition. It is only through the eyes of another person that you can become an object to yourself. In the highly abstract master–slave chapter of *The Phenomenology of Mind*, Hegel makes a distinction between *an sich*, in itself, and *für sich*, for itself.[3] An embryo or baby may be said to be there in itself, but not yet for itself, not yet self-conscious. Violet's declaration 'I am because you are', however, can be expanded beyond this Hegelian reflective 'for itself' being to a kind of 'in itself' being, what is now called a pre-reflective or minimal self, a bodily sense of self that does not involve thinking about itself, a lived self awareness that does not include knowing that you know.[4]

Violet proposes open, dynamic bodily subjects that are continually 'mixing' with one another, for better and for worse, subjects that negotiate porous self-other boundaries. After all, everyone's head is filled with other people, with memories of their faces and voices and movements and touch. And we are all made through those others and the culture we find ourselves in. No one grows up nowhere alone. Violet further suggests that the visual and literary arts necessarily partake of this mixing, that mixing plays a role in imaginative work. Where do fictional characters come from, after all? I am not Violet or Leo, and yet they emerged from me, or rather from an internal geography made from my experience with others, both conscious and unconscious. They are not remembered persons but figments, which I believe are born of a self-other relation.

How do I know that I am I and you are you? Each one of us is enclosed in an envelope of skin. Each one of us feels the movements of her body in the world as 'mine'. Unless a person is mad or has terrible brain damage, through which he has lost his bodily boundaries, he takes for granted his feeling of being I and not you. And yet, each of us was once an embryo inside the body of a woman, wholly dependent on that body for nourishment and survival. Pregnancy is the mixed state par excellence, from which all mammals emerge. Scientists now believe that a pre-reflective, minimal self is present from birth. The newborn baby is not a confused blob of flesh who cannot tell where she ends and her mother begins. The infant researchers Andrew Meltzoff and M. Keith Moore have filmed, photographed, and theorised about newborns as young as 45 minutes old and their capacity to imitate the expressions of adults.[5] It seems clear that the newborn's ability to imitate faces indicates the presence of a **body schema**, an unconscious dynamic motor–sensory orientation in space, a sense of location and corporeal boundaries.[6] But at what moment does the fetus acquire a body schema and this minimal or pre-reflective self, and how is that self lived as separate from the mother inside which it is? Signs of 'non-random' fetal movements in utero suggest a form of intention well before birth and a degree of bodily integrity, but it is not obvious how we should interpret this.[7]

Some authors, such as the philosopher Jane Lymer, have criticised Meltzoff and Moore for their 'overly mentalist' conclusions. Lymer thinks the two researchers have attributed too much cognitive ability to newborns and have ignored the role that the mother's feelings and movements play in the creation of a fetal body schema in prenatal life. At some point during gestation, probably in the second trimester of pregnancy, Lyman suggests one can begin to speak of a relation of

some kind between mother and fetus, rather than a merged or fused identity of the two, but before that, she argues, the earliest fetal movements belong to the mother.[8] Focusing exclusively on the development of the fetus, as if it could be lifted out of its amniotic world and studied separately, is absurd. It would be strange indeed if the mother's rhythmic heartbeats, her even or quickened breathing, her movements that rock the fetus to sleep or conversely wake it up have no effect on its gestation. In any event, we all start out inside, and attached to, another person via the umbilical cord, a connection that is not severed until after birth.

The twentieth-century French philosopher Maurice Merleau-Ponty developed the concept of **intercorporeality** from Edmund Husserl, the German philosopher who founded phenomenology—the study of consciousness. Intercorporeality is a bodily connection between people that does not require a reflectively **conscious** analogy—I do not have to think of what it might be like to be you and then try to work out a likeness between us.[9] It is not a thinking connection, but one made possible by my already existing body schema. The neuroscientist Vittorio Gallese's concept of **embodied simulation** is the neurobiological sibling of inter-corporeality, a word he also uses to explain his theory. Through mirror systems in the brain, we are able to participate virtually in the other person's body. We have an automatic motor-sensory, affective relationship through simulation of the other person. Gallese also refers to a 'we-space' and 'a shared manifold,' his words for framing a two-in-one interactive between-zone, through which we inhabit another person's acts, intentions, and feelings.[10] In *The Philosopher and his Shadow*, Merleau-Ponty writes: ' . . . each one of us is pregnant with others and confirmed by them in his body'.[11] For those of us with mirror-touch, others are continually confirmed in us through bodily sensations that arrive just by looking at them, a heightened form of embodied simulation. Mirror-touch may involve a greater activation of mirror systems that results in actual sensation, but there are broader implications as well. The imagination itself, the 'as if' realm of human life, is not generated by purely mental gymnastics, by conscious thinking processes, but originates in our fundamental intercorporeality.

There is growing evidence that everyone begins life as a synaesthete, that in babies the senses are merged, creating a multisensory cloud of touch and taste and smell and sight and sound. Although there is controversy about how this all works and what it means, the idea has been around for some time. In *The Interpersonal World of the Infant*, published in 1984, the psychiatrist and

psychoanalyst Daniel Stern used the term **amodal perception** to characterize a baby's experience: 'The information is not experienced as belonging to any one sensory mode. More likely it transcends mode or channel and exists in some unknown supramodal form'.[12] In most people, the senses become differentiated. In other words, synaesthetes retain what others lose. In a 1996 paper on the subject, the psychologist Simon Baron-Cohen wonders about 'the cost to reproductive fitness' in those of us for whom 'one sense [is] leaking into another'.[13] He admits that many people with synaesthesia don't consider it a disability and that this is odd from an evolutionary point of view since if most people acquire distinct senses, lasting synaesthesia should therefore be maladaptive. The psychologist Phillippe Rochat takes a different position. He considers our early sensory conflation a form of 'competence', not 'incompetence', because he views it as important for a baby's acquisition of affective meanings that are crucial to subjective experience.[14] From this point of view, adult synaesthesia might simply retain some of the cross-modal richness of early life.

What is certain is that no subjective meaning is achieved in solitude. The human infant is born strikingly premature and is weak and dependent for a long time. If he is not cared for physically and emotionally, he will die or 'fail to thrive'. His fate is in the hands of others, and he grows through his interactions with them. The paediatrician and psychoanalyst D. W. Winnicott wrote about how a meaningful, imaginative subjective life comes about. It is interesting to note that he was influenced by Jacques Lacan, the French psychoanalyst, who was himself influenced by the philosopher Alexandre Kojeve, who lectured on Hegel at the École Practique des Hautes Études in the 1930s in Paris. Lacan's 'mirror stage' turned Hegel's battle for self-consciousness into a purely intrapsychic drama. Hegel's other became the child's own self-image in the mirror. When she recognises herself, she becomes a unified object to herself.[15] Winnicott moved this dialectic back in time and returned it to a relation between two real people: 'In individual emotional development *the precursor of the mirror is the mother's face*'.[16] For the infant, a responsive mother comes before the 'me' recognised in the mirror. The child sees himself in his mother's face because in her expressions, he finds what **she sees**—himself. The developmental psychologist Edward Tronick's experiments, in which he asked mothers to present 'still' or blank faces to their babies, are painful to watch, but they demonstrate the vital importance of an answering face in human development.[17] The child desperately tries to bring back the animated parent with smiles and sounds and gestures but

eventually withdraws and collapses in despair. Self and other are intimately and expressively linked. We all need to be recognised. When I lose the face of the other, I also lose something of myself.

Researchers no longer talk about **transitivism**, a phenomenon explored by the child psychologist Charlotte Bühler, but it is something every parent witnesses.[18] A little boy watches his friend take a tumble and bursts out crying. A child slaps her friend hard and then insists it was she who was hurt. Very young children appear to move back and forth between self and other in ways grown-ups do not. Transitivism looks a lot like mirror-touch synaesthesia. How do we parse this imitative, vicarious, virtual between-me-and-you zone in a newborn or in toddlers? Do we find a distinct 'I' and 'you' or perhaps a more blurred 'we'?

Winnicott created an opening between child and mother that might be called a blurred zone or a form of we-between-ness. He referred to it as 'transitional space', and although he does not say it, he borrowed it from Freud's idea of trans-ference in psychoanalysis. For Freud, transference took place in an 'intermediate area' between patient and analyst. Amongst other descriptions, Freud used the word *Tummelplatz* to describe this charged between-zone of projection, which then became 'playground' in James Strachey's translation.[19] Winnicott's transi-tional space is not entirely inside a child, but it is not entirely outside her either, and it is a place where she can play. 'Transitional objects' and 'me-extensions' are things a baby uses, a chewed bit of blanket or a beloved stuffed toy, for example, but also rhythmic babble, words, or songs, through which she creates an illusory, symbolic connection with her mother—things which are neither quite here nor there, neither me nor the not-me of the external world. This potential or imagi-native space is where the child plays and the artist works; it is 'a third area', one Winnicott maintains we never outgrow but to which we continually return as part of ordinary human creativity. One might say there is a form of normal mix-ing going on here. The making of art takes place in a borderland between self and other. It is an illusory and marginal, but not hallucinatory, space.[20]

Transitional phenomena necessarily mingle self and other. They have a **sym-bolic** function as **representations** of a connection to the maternal body. What the pre-linguistic, rhythmical realm of inchoate senses in infancy is actually like can only be imagined (even for those of us who retain some sensory overlaps), and yet I am convinced it lives on in us and is crucial to the meanings we make, lying at the root of all meanings, including linguistic meaning. The philosopher and psychoanalyst Julia Kristeva's *semiotic chora* is a maternal space, an affective,

patterned, shifting reality dominated by biological drives, which predates the speaking subject. After a person learns to speak, to represent the world in symbols, Kristeva argues that the semiotic and symbolic exist in a dialectical tension within language itself. The semiotic is especially present in poetic language because it is metaphorical, cadenced, musical.[21] I have argued elsewhere that the rhythmic, sequential, dialogical multisensory patterns of exchange during early life generate what will become story.[22] They serve as a proto-narrative, which, with language acquisition, becomes true narrative, and a narrative is always directed at another person. There is always an 'I' talking to a 'you'—a teller and a listener—and one is not possible without the other. A story's meaning is never purely semantic. It lives also in affective bodily rhythms, in juxtapositions and repetitions, in surprising metaphors, in which one sense invades another, that jar or lull the listener and evoke in him felt bodily memories. They summon musical patterns of harmony and dissonance and fused, mobile sensory experience, established long ago between a pre-reflective infant self and a grown-up reflective self. One can argue that there is a synaesthetic, metaphorical quality to all art experiences, that art revives a multi-modal sensory self.

Without an ability to imaginatively transpose one sense into another, none of us could speak of loud or soft colors or cold and warm people. And how could we read Emily Dickinson's lines 'The Music in the Violin/Does not emerge alone/But Arm in Arm with Touch, yet Touch/Alone—is not a Tune'?[23] Metaphor is more than a mental dance; it emerges from embodied experience. In their landmark book *Metaphors We Live By*, George Lakoff and Mark Johnson argue that metaphor, thinking of one thing in terms of another, rises from lived human experience. Metaphor, they insist, is not just a question of language but of conceptual structure. 'And conceptual structure is not merely a matter of intellect—it involves all the natural dimensions of our experience, including aspects of our sense experiences: color, shape, texture, sound, etc.'[24] Looking at a painting, reading a poem or a novel, listening to music requires a **natural** loosening of sense boundaries, a blur that invigorates artistic experience. A character is round or flat. A musical passage can burn, and a line may taste bitter. These transpositions open avenues into the otherness of the artistic work, which is more than a thing; it is always also the traces of a life.

When I write as one of my characters, I move into that person while I am writing. I know I am sitting at my desk typing, and yet the character takes over my internal narration and begins to direct it. I occupy a transitional space. I do not

believe I have actually been transformed into someone else, and yet the character's voice is distinct and unlike my own. I inhabit her or him, or rather she or he inhabits me. The story moves in directions I do not expect. The words begin to write themselves. This is a common experience for fiction writers—every writer is pregnant with others. One could argue that the characters are 'me-extensions', transitional phenomena made only of words, but then language itself is always shared; it belongs to you as much as to me.

Reading a novel too requires not just an ability to move with the figurative metamorphoses of the book's language, but also the further empathic ability to enter the characters, to lose yourself in them and **feel** their sufferings and their triumphs, to give up your inner speech and allow the words on the page to take possession of your thoughts. And this experience does not just happen in the proverbial cave of your mind. You read and laugh, or read and flinch, or read and weep. If the whole of the person is not engaged in the motion of the narrative, then the meanings of a text will be betrayed.

As the Russian language theorist M. M. Bakhtin has argued, language is not a closed dead system of revolving signs and their designated impersonal meanings. It is alive and flexible in speakers and writers and readers who engage in the to and fro, the ricochet of dialogue. Words cross the borders of our bodies, and they are fundamentally dialogical: 'Language lies on the borderland between oneself and the other . . . the word in language is half someone else's'.[25] To write or to read a novel means becoming others, while knowing I am still myself. 'Where do I end and where do the characters begin?' is not a simple question. Don't we all enter or become another in the process of digesting a poem—or a sculpture?

In Western culture, which places a high value on autonomy and the individual subject, a subject that has almost universally been coded as male, transitional, blurred, between-states will be seen as feminine, weak, or sick. As the anthropologist Mary Douglas argued in her classic work *Purity and Danger*, all marginal border states carry cultural danger, pollution, or magical potential because they are indefinable, mixed, not one thing or the other. Bodily borders are particularly vulnerable to various cultural meanings. 'The body is a model which can stand for any bounded system,' Douglas writes, 'Its boundaries can represent any boundaries, which are threatened or precarious . . . We cannot possibly interpret rituals concerning excreta, breast milk, saliva, and the rest, unless we are prepared to see in the body a symbol of society.'[26] Research has found that mirror-touch synaesthetes are more vulnerable to blurred self-other boundaries

and identity shifts, and feel more empathy for other people.[27] None of these findings seems startling, but it is vital to understand that science does not escape cultural frames, that its body is also interpreted according to normative ideas.[1]

In their 2014 paper *What Can Mirror Touch Synaesthesia Tell Us About the Sense of Agency?*, Maria Christine Cioffi, James Moore, and Michael Banissy discuss how the 'self-other blurring' in mirror-touch is related to a person's agency, the sense of having control over one's own actions.[28] They point out that a feeling of bodily ownership cannot be separated from agency. If I don't know my leg belongs to me, I won't feel responsible for its movement. They further note that a sense of agency is disturbed in psychiatric ailments, such as schizophrenia, as well as in a number of neurological conditions, and that parts of the brain—the temporo-parietal occipital junction (TPJ) and the anterior insula—have been implicated in these disorders. The authors do not identify mirror-touch as a pathological state. They do write: 'We are clearly suggesting here that mirror-touch is primarily a "disorder" of ownership, which can have consequences for SoAg [sense of agency] and which in turn can further worsen ownership disturbance.' This raises an interesting question: to what degree do my tactile sensations, experienced while looking at another person, compromise my sense of owning my own body? What, in fact, allows me to make the distinction between my body and yours?

My sensory mirroring does not partake of the radical displacements of schizophrenia. Schizophrenics suffer from what Louis Sass has described as a diminished sense of 'existing as a vital center consciousness'.[29] They may lose all sense of location in space and may suffer from depersonalisation and even a confusion of pronominal identity: I may become **you**. Their feelings of a self-affective reality may vanish. The writer Antonin Artaud, who suffered from schizophrenia, wrote: 'In matters of feeling, I can't even find anything to correspond to feelings'.[30] This is a profound remark. Without an inner sense of a grounded I-perspective, feelings are literally disembodied. As a mirror-touch synaesthete, the other is present in me as sensation, but the feeling is in **my** ankle, **my** arm, **my** face, not somewhere across the room.

While these touch sensations in relation to what I see happening to someone else never create the delusion of actually **being the other**, they serve as an involuntary means of connecting with the other person, a powerful 'as if' state. Mirror-touch is a liminal experience, one that takes place in the between, where there is a danger of over-mixing, especially when the person before me is someone I

love. In such cases, I may perceive your pain also as my pain, and your pain may take on the quality of a demand: 'Do something to make it better!' I want to relieve you because I, too, need relief. And yet, I have always retained a sense of me as me and you as you in the process. How much autonomy, self-ownership, and agency is needed before a person goes to pieces? Enlightenment ideas in the West about individual freedom and self-agency necessarily infect the frames and categories of our science. An awareness of the difference between me and you is essential to my functioning in the world, but, then again, without you, who would I be?

The asthmatic, hypersensitive Marcel Proust did not have mirror-touch synaesthesia, as far as I know, but he did have various **hyperaesthesias**, including 'auditory hyperaesthesia', the term Proust's character Robert Saint Loup uses to describe the narrator's ears in *À la Recherche du Temps Perdu*.[31] The author wrote his masterwork in a cork-lined bedroom with the window shades drawn at 102 Boulevard Haussmann in Paris, in an apartment he also laboured to keep odour-free. From this cocoon cleansed of sensory stimuli, Proust wrote an immense work of precise, and often voluptuous, sensuality, but also of human sympathy. The irony is vivid, and it is easy to turn Proust into the ultimate example of the quivering artistic sensibility, so delicate it had to be wrapped in layers of protective gauze. And yet, Proust illustrates the complexity of human character. His extreme sensory sensitivity was coupled with extraordinary endurance, will, and strength.

Mirror-touch synaesthesia partakes of a continually shifting, dynamic intercorporeal between-space we all find ourselves in, a space of difference and sameness, of back and forth exchanges in feelings, gestures, and words. We imitate and we empathise because human beings are not closed, wholly autonomous creatures. We are born of another person and open to others from birth onwards, and this openness is by its very nature ambiguous, reciprocal, and mixed. People with mirror-touch may live more intensely in the between. There are times when it seems we are too sensitive for this world, but at other times that very same sensitivity may be a catalyst for making or entering new worlds—in music and in paint, in dance and in words.

Endnotes

1. See Siri Hustvedt, 'The Shaking Woman or A History of My Nerves (New York: Picador, 2009). In 'The Shaking Women', I investigated another neurological symptom, and its resonances with current neuroscientific research.

2. William James, 'Pragmatism: A New Name for Some Old Ways of Thinking' (Cambridge, MA: Harvard University Press, 1975), 24.

3. Siri Hustvedt, 'What I Loved' (New York: Picador, 2003), 91.

3. G. W. F. Hegel, 'The Phenomenology of Mind', trans. J. B. Baillie, second edition (London: Allen and Unwin, 1949), 232.

4. See Dan Zahavi, 'Minimal Self and Narrative Self', in Thomas Fuchs, Heribert C. Sattel, and Peter Henningsen, eds., The Embodied Self: Dimensions, Coherence and Disorders (Stuttgart: Stattauer, 2010).

5. Andrew N. Meltzoff and M. Keith Moore, 'Imitation of facial and manual gestures by human neonates', Science (1977), 198, 75–8. See also their paper, 'Imitation in newborn infants: exploring the range of gestures imitated and the underlying mechanisms', Developmental Psychology (1989), 25, 6, 954–62.

6. For a discussion of body schema, see Sean Gallagher, 'How the Body Shapes the Mind' (Oxford: Clarendon Press, 2005), 17–25.

7. Joyce W. Sparling, Julia Van Tol, and Nancy C. Chescheir, 'Fetal and neonatal hand movement', Physical Therapy (2008), 79, 1, 24–39.

8. Jane M. Lymer, 'Merleau-Ponty and the affective maternal-foetal relation', Parrhesia: A Journal of Critical Philosophy (2011), 13, 123–43.

9. Maurice Merleau-Ponty, 'The Philosopher and His Shadow', in Signs, trans. Richard C. McCleary (Evanston, IL: Northwestern University Press, 1965), 159–81.

10. Vittorio Gallese, 'Embodied simulation theory and intersubjectivity', Reti, Saperi, Linguaggi (2012), Anno 4, 2, 57–64.

11. Merleau-Ponty, 'The Philosopher and His Shadow', 181.

12. Daniel Stern, 'The Interpersonal World of the Infant' (New York: Basic Books, 2000), 51.

13. Simon Baron-Cohen, 'Is there a normal phase of synaesthesia in development?' Psyche (1996), 2–27.

14. Phillippe Rochat, 'What is it like to be a newborn?', in Sean Gallagher, ed., The Oxford Handbook of the Self (Oxford: Oxford University Press, 2011), 57–79.

15. Jacques Lacan, 'The Mirror Stage as Formative of the I Function', in Ecrits, trans. Bruce Fink (New York: Norton, 2006), 75–81.

16. D. W. Winnicott, 'Mirror Role of Mother and Family in Child Development', in Playing and Reality (London and New York: Routledge, 1982), 111.

17. 'Still Face Experiment: Dr Edward Tronick', accessed 19 July 2014, https://www.youtube.com/watch?v=apzXGEbZhto.

18. Merleau-Ponty cites Bühler in 'The Child's Relation to Others', in *The Primacy of Perception*, trans. William Cobb (Chicago: Northwestern University Press, 1964), 148. See also Peter Brugger, 'Reflective mirrors: perspective taking in autoscopic phenomenon', *Cognitive Neuropsychiatry* (2002), 7, 188.

19. See Siri Hustvedt, 'Three Emotional Stories' in *Living, Thinking, Looking* (New York: Picador, 2012), 175–95.

20. D. W. Winnicott, '*Playing and Reality*'.

21. Julia Kristeva, 'Revolution in Poetic Language', in Toril Moi, ed., *The Kristeva Reader* (New York: Columbia University Press, 1986), 89–136.

22. Siri Hustvedt, 'Three Emotional Stories'.

23. Emily Dickinson, 'no. 1576, lines 5–8', in Thomas H. Johnson, ed., *The Complete Poems of Emily Dickinson* (Boston: Little Brown & Co., 1951), 654.

24. George Lakoff and Mark Johnson, '*Metaphors We Live By*' (Chicago: The University of Chicago Press, 1980), 235.

25. M. M. Bakhtin, '*The Dialogic Imagination: Four Essays*', Michael Holquist, ed., trans. Caryl Emerson (Austin: University of Texas Press, 1992), 294.

26. Mary Douglas, '*Purity and Danger: An Analysis of the Concepts of Pollution and Taboo*' (London: Routledge & Kegan Paul, 1966), 122.

27. See Lara Maister, Michael J. Bannisy, and Manos Tsakiris, 'Mirror-touch synaesthesia changes representations of self-identity', *Neuropsychologia* (2013), 51, 802–8. See also Michael J. Bannisy and Jamie Ward, 'Mirror-touch synaesthesia is linked with empathy', *Nature Neuroscience* (2007), 10, 815–16.

28. Marina Christine Cioffi, James W. Moore, and Michael J. Banissy, 'What can mirror-touch synaesthesia tell us about the sense of agency?' *Frontiers in Human Neuroscience* (2014), 8, 256. doi:10.3389/fnhum.201400256.

29. Louis A. Sass, 'Self-Disturbance in Schizophrenia: Hyperreflexivity and Diminished Self Affection', in Tilo Kircher and Anthony David, eds., *The Self in Neuroscience and Psychiatry* (Cambridge: Cambridge University Press), 244.

30. Antonin Artaud, 'Excerpts from Notebooks and Private Papers (1931–32)', in Susan Sontag, ed., *Selected Writings*, trans. Helen Weaver (New York: Ferrar, Straus and Giroux, 1976), 195.

31. Marcel Proust, '*In Search of Lost Time*', vol. 3, trans. C. K. Moncrieff and Terence Kilmartin, revised by D. J. Martin (New York: Modern Library, 1992), 86.

I Feel Like An Abstract Line

Laura U. Marks

People with the special condition of mirror-touch synaesthesia are capable of extraordinary embodied responses to the world—an extreme empathy to other people and also to non-human and non-living things. This essay will argue that non-synaesthetes can also cultivate embodied and empathic responses to inorganic forms. My case study will be the 'abstract line', a line that describes no figure but exhibits its own feeling qualities. Perceptual theories from the nineteenth century to the present suggest ways that humans can relate to a line, feel the way a line feels, even without projecting human qualities on it. Feeling like an abstract line then allows us to feel what we have in common with non-organic life. I will discuss abstract lines from Islamic art, abstract painting, animation, and analogue video synthesis. The point of cultivating these capacities is to enjoy life more—and also, I'll argue, to protect ourselves from machinic intelligences that try to pre-empt our capacities for empathy, and to develop collective powers.

Some mirror-touch synaesthetes relate experiences that show they feel like abstract lines. In an interview with the artist Daria Martin, editor of this volume, the mirror-touch synaesthete Fiona Torrance writes:

> Patterns engulf me. . . . A patterned carpet like the one at the Crown Plaza in Speke, Liverpool can be overwhelming, as the way the colours and lines/shapes are combined makes parts of the body feel pulled out of shape. By stepping in particular shapes or on specific colours you can keep a better balance. My entire body, physical sensation and movements are affected by patterns. I love some patterns for the way they make me feel. Some are calming and rhythmic while others are divisive and disturbing depending on the objects and angle of the walls in the room.[1]

Carpet, Drake Hotel, Chicago. Photo by Laura Marks.

And consider this statement by another mirror-touch synaesthete interviewed by Martin: 'If I were to attend to a lamp or a potted plant, I feel my body become many of their elements—the roundness of the lamp or the hollow round sensation of the lamp shade . . . I sense my body shaped with the pointed characteristics of the branches of the plant and smooth portions corresponding to its leaves'.[2] This person also says that when he sees patterns with 'lots of dots, especially very small dots, or lines, I get the feeling of the lines on my body'.[3]

These two mirror-touch synaesthetes describe attitudes of empathy with objects, a feeling of shared embodiment, that I believe non-synaesthetes can cultivate too. We can do this by letting go of our human scale a bit and allowing the other thing to fully inhabit our perception—to 'enworld' us, as phenomenologists say. Such empathic attitudes call to mind a concept of perception proposed by the mathematician and philosopher Gottfried Wilhelm von Leibniz (1646–1716) in *Monadology*.[4] Leibniz describes a universe in which a single embodied soul

subdivides into innumerable souls, each protected by its body. Souls are aware clearly of only part of the world close to them, according to what their bodies give them to know. They're aware only dimly of the rest, the area the monad's body shares with other bodies. Leibniz's conception of a world of interconnected, sensing souls remains influential in our time, in part through the philosophy of Gilles Deleuze. In Leibniz's terms, mirror-touch synaesthetes have a larger clear area—they are aware, including painfully aware, of their entanglement with the experience of others, including non-human others.

For sure, synaesthetes have special capacities that other people don't. But many of us are capable of a great deal of embodied empathy, not only with creatures but also with non-organic things. Of course we 'identify' with figurative images and feel empathic, embodied responses to them. The Western literature on identification with figures goes back as far as Aristotle and spans art history, philosophy, cinema theory, and cognitive science, so instead of summarising it, I'll give you one recent tidbit. A study published in 2009 presented chimpanzees with computer animations of chimpanzee heads making various expressions.[5] The yawning computer-animated chimpanzee induced contagious yawning in the chimpanzee viewers. (Note that while the modern concept of mirror neurons explains this result, so too does 'Carpenter's effect', a term introduced in 1876 for the way people reproduce the actions of others they see with their own bodies.)[6] The researchers plan to experiment further by showing alternately enhanced and degraded animations, in order to determine whether the chimpanzees are identifying with the animated figures (so an enhanced animation would induce even more yawning) or responding to a generalized stimulus (so a degraded animation would still produce the same effect). The researchers note modestly that 'the ability to custom-design behaviours allows for new questions to be asked'.[7] I imagine the results will be of great interest to designers of interfaces for computer games, nursing robots, and other products that solicit empathic engagement. Companies will be able to manufacture cheap empathic robots to stand in for humans and other living things capable of real empathy. This is just one of the ways our empathic responses to other faces are being thoroughly colonised, at least for people who are vulnerable to computer-assisted surveillance—I'll mention some more later. Media technologies have completely colonised people's identification with faces and figures.

Therefore, my protagonist in this essay—the hero in the struggle against empathic colonisation—is the abstract line. In the thought of the philosopher

Gilles Deleuze and the psychoanalyst Félix Guattari, the abstract line is the companion form of haptic space—a perceptual field that invites the eyes not to perceive figures from a distance but to draw close and almost touch forms without distinguishing them.[8] Both haptic space and abstract line invite a viewer to feel with the art form in an embodied way, instead of responding cognitively to what the art depicts. Haptic space invites a viewer to lose her boundaries and merge with the thing beheld, as I've argued in *The Skin of the Film: Intercultural Cinema, Embodiment, and the Senses*.[9] Or, if there is no thing, to merge with the scene of the depiction itself: to feel like a landscape, to feel like a starry sky, to feel like a screen full of static. So haptic space and haptic visuality raise questions for the limits of what a spectator can stand before she loses her identity altogether. Abstract line raises these questions too, as we will see.

'Abstract line' is what Deleuze and Guattari called a line that does not serve to delimit a figure but that has its own independent life. 'This streaming, spiraling, zigzagging, feverish line of variation liberates a power of life that human beings had rectified and organisms had confined, and which matter now expresses as the trait, flow, or impulse traversing it. If everything is alive, it is not because everything is organic or organised but, on the contrary, because the organism is a diversion of life'.[10] Many paintings by Henri Matisse are animated by abstract lines that show that 'everything is alive'. For example, his *Harmony in Red* (1908) at the Hermitage Museum is not a non-figurative painting, but one in which the life of the line precedes the life contained in organic beings, like the woman at the table, the trees outside the window, the fruits on the table, and the flowers pictured on the wallpaper. An independent life both informs and moves beyond the life contained in living beings.

Haptic space and abstract line are subsets of what Deleuze and Guattari call smooth space, that is, space that is organised intensively, rather than by forms imposed from outside. 'A line that delimits nothing, that describes no contour . . . that is constantly changing direction, . . . that is as alive as a continuous variation—such a line is truly an abstract line, and describes a smooth space'.[11] A wax cloth from Côte d'Ivoire at the Seattle Art Museum exemplifies a line propelled by its internal vitality; it is patterned with snaking black lines on a cream background that branch and curl and that are fringed with little lines that call to mind eyelashes or centipede legs. The patterned cloth also shows how an abstract line, multiplying and changing direction, gives rise to a haptic space. Our vision, rather than focusing on a figure, moves around

The Dessert: Harmony in Red (1908) by Henri Matisse. The State Hermitage Museum, St. Petersburg. Photograph © The State Hermitage Museum /photo by Vladimir Terebenin. © Succession H. Matisse/ DACS 2017.

the composition, in and out, taking in the whole and the detail dialectically. Imagine that you encounter an Ivoirian woman wearing clothes and a head wrap made of this fabric. The independent life printed on her clothing will amplify her own vitality and lend it the mysterious depth of a life that originates from elsewhere.

Deleuze and Guattari write: 'This self-organizing, individuating line is not opposed to figuration but shares something in common with depictions of animals in early art, a 'pure animality' that precedes the animal'.[12] 'Pure animality' describes abstract lines that are derived from animals, such as Celtic compositions based on twining snakes, and Asian designs based on dragons such as this Caucasian dragon carpet at the Pergamon Museum. I would add that a 'pure vegetal life' arises from abstract lines derived from vines and other plants. Classical Greek, Roman, and Persian art developed rich vocabularies from plant life. Islamic art, as we will see, abstracted these plant forms into a vegetal life

Wax-print cloth, Côte d'Ivoire, Seattle Art Museum, (1999). Photo by Laura Marks.

unconstrained by organic rules. In this vitalist aesthetics abstract line and its companion form, haptic space, do not represent life but **are** life.

Cultivating our responses to these forms helps get around the way perception is learnt and organised. Perception is a judgement—gestalt psychology, figure/ground differentiation, and many more cultural formations of perception pre-form in us judgements about what is important to perceive. Feeling like an abstract line means letting go of the judgements that create meaning for a little while and allowing sensations to affect you. Let the line's rhythms move you. Feel languorous, exhilarated, dizzy, frivolous. Put up with its lack of meaning; postpone interpretation—for now.

Deleuze and Guattari derived the concept of abstract line from the German art historian Wilhelm Worringer's concept of primordial abstraction (picked up later in this volume in Massimiliano Mollona's chapter) and its later avatar in the 'Gothic line'. According to Worringer, abstraction is 'any linear treatment of forms whose geometric, inorganic character repudiates any association with our

Dragon Rug. 18th century. Wool and cotton. Philadelphia Museum of Art, The Joseph Lees Williams Memorial Collection, 1955-65-23. Artwork by unknown, *Dragon Rug* © 1948 Philadelphia Museum of Art, reproduced with permission of Philadelphia Museum of Art.

vital feelings as organically designed beings'.[13] This implies that if we feel along with abstraction, we are accepting the repudiation of our own organic life. But while Worringer distinguished empathy and abstraction, I argue we can have empathy **with** abstraction. So how can we feel empathy with a line? Do we only project human feelings on lines?

The computer scientist and artist Mauro Annunziato makes digital drawings that are generated by a program that makes lines act like living things. In one of them *Migration* (2000), lines are programmed to 'live' as long as possible—to extend as much as they can, including by curling in on themselves—to multiply, producing what Annunziato calls 'sons' that, in turn, try to stay alive and multiply. So it's a drawing of life-like striving and triumph, defeat and death—of all the struggles involved in migration, the title of the work. We can easily feel like an abstract line looking at Annunziato's lines. This drawing shows how far we can go by identifying with a line, projecting human feelings on it.

However, I want to argue that we do not only project human feelings onto abstract lines. Something arises in the encounter between our vision and the line

Detail, Mauro Annunziato, *Migration* (2000).

that did not exist in our prior experience. One way to think about this is in terms of the concept of affect, first proposed by the Dutch philosopher Baruch Spinoza (1632–1677), which has become very popular in recent years as an account of human experience as an ever changing series of non-cognitive encounters with other entities. It is valuable as a way to account for experience that occurs in the body, prior to emotion and thought. We can say the encounter between the line and our vision produces affections, non-cognitive bodily responses. Lines make us feel their crawling, twining, voracious capacities. Lines that break up or drive themselves into corners give us a feeling of defeat. The abstract line gives rise in us to affect, which Spinoza defined as the 'lived transition or lived passage from one degree of perfection to another'.[14] In Deleuze's adaptation of Spinoza, he emphasised that it need not be the whole human body that responds to an affection, but rather that parts of our bodies may enter into combinations with the other entities we encounter. Hence he and Guattari privileged the 'molecular' nature of these encounters over the larger, 'molar' scale at which meaning, narrative, thought, and even emotion take place. The molecular scale is where those micro-perceptions occur, of which, I have suggested, mirror-touch synaesthetes are more aware than most people are.[15]

When we start to think this way, feeling like an abstract line is not a projection of human feelings on the inanimate. This is because it embodies a life force that precedes, and is both larger and smaller than, individual bodies. The abstract line participates in a life force anterior to particular life forms. If we feel something lively within ourselves in response to it, this may make us feel even more alive. Or we may feel this life coming from the outside as a threat to our discrete form. In this way, the abstract line behaves similarly to what Deleuze calls the Figural. The Figural bypasses meaning and speaks directly to the nervous system.[16] It both suggests a figure and destroys it, in a way that might create a feeling of nausea or exhilaration. I agree that it addresses the nervous system, and not the brain, by which Deleuze meant the site of cognition.

Let's chase the abstract line back to one of its richest origins. The Gothic architecture that inspired Worringer was, in turn, inspired by forms developed in Islamic art. Craftsmen devised the fascinating form termed the bevelled style for the decoration of Balquwara palace on the shore of Tigris river in the mid-ninth century. The style spread rapidly throughout the Abbasid caliphate. The bevelled style abstracts the vine forms of Late Antique and Sasanid Persian art. The fascinating thing about this style is that it hints at figures of plants and creatures

'Bevelled style' panel, Samarra, ninth century. Museum für Islamische Kunst, Staatliche Museen Berlin. Photo by Georg Niedermeiser.

that disappear when you look at them from a different angle. The line seems to invest the plant-like or animalish form and then twist away from it and move on, impelled by its own interior life. I find that as my eyes follow these lines that flirt with figure and slip away, a feeling of internal movement teases me out of my own solid figuration and makes me feel molecular.

Islamic art, inspired to creativity by the religious avoidance of figurative images, performed all kinds of experiments with abstracted plant forms, for example on the tile facade of Sheikh Lutfollah Mosque, how abstract line gives rise to haptic space, especially for a viewer who is there in Isfahan and can walk around and experience the tiles from different vantage points. Looking at this, one can feel a connection to the vine-like and snaky movement of the lines. Different kinds of lines intertwine. Gracefully spiralling blue lines, derived from vines, terminate in flowers. More abstract white 'islimi' do not directly reference a plant origin; some scholars suggest those green-and-white forms are highly abstracted dragons or other animals, gone into hiding inside the abstract line. Red cloud bands,

Zahra and Fatemeh Khansalar outside Sheikh Lutfollah Mosque, Isfahan (1603–1616). Photo by Laura Marks.

derived from Chinese art, have a more bunchy, staccato form. Each of these abstract lines creates a different feeling independently, and as they interweave, the clever divisions and intersections that suggest these forms can twine to infinity, giving rise to a complex feeling of abstract linearity, or becoming-abstract-line, in the beholder.

You can also get a sense of the materials of the medium and 'identify' with the work in its materiality. In the ceramic tile, one can see the smoothness, imagine how sturdy it is, see how the maker has joined the pieces skilfully, and observe the cocoon of an insect living on the surface of the tile. At the same time, a viewer can respond affectively to the colours, the gleam, the reflections in the tiles. So the abstract line and haptic space in these tiles are living and material, as well as a life form beyond materiality.

From the early Renaissance, Islamic aesthetics travelled clandestinely into European art. Often the abstract line migrated by hiding in a carpet, whose

Detail, tile facade of Sheikh Lutfollah Mosque. Photo by Natalie Sorenson.

abstract patterns, often called simply arabesque, so excited European painters that they found ways to incorporate them in their figurative paintings. I argued in *Enfoldment and Infinity* that the abstract line of Islamic art, after it twined into European art of the Renaissance, has continued to poke up periodically.[17] Notably, it is featured in art forms that are considered decorative, frivolous, feminine, or decadent such as Renaissance ornament, the rococo, and psychedelic art.

However, the abstract line was a minor form in Western art until the twentieth century. Western thinkers always gave precedence to figures over abstractions. The late nineteenth-century Austrian art historian who was most fond of the abstract line Aloïs Riegl, writing in 1893, held that art should maintain a balance between two aesthetic modes—subject matter and decoration, or **argument** and **ornament**. Ornament and argument complement each other, but ornament should be subservient to argument.[18] It's interesting to see this balance between argument and ornament in European Renaissance art. The arguments of early Renaissance religious paintings and portraits were balanced with the ornament

of richly decorated frames based on Islamic arabesques. The excavation of Nero's palace the Domus Aurea in the fifteenth century revealed a wealth of frivolous abstract lines in the painted wall decorations, which distracted from the serious subject matter of sculpture; Italians called these forms *grottesche*, from the grotto. Renaissance painters, including Raphael, decorated luxurious interiors with meaningful paintings framed, and often overwhelmed, by frivolous grotesques. And many an ornamented utilitarian object, such as the pictured German wheel-lock rifle, played out the struggle between argument and ornament.

Ornament offers a respite from the exhortation of argument. It suggests a feminist resistance to ideology. It also exercises our perceptual skills. And ornament creates affects that give us micro-liveliness. So we can return renewed to the 'meaningful' representation in the subject matter (or get back to shooting or continue down the stairs).

The eighteenth-century rococo used motifs of chinoiserie, but Jean Pillement's etching shows its typical weird and lovely C-curves and S-curves that (some argue) are deconstructions of the Islamic arabesque. Jumping forward to psychedelic poster art of the 1960s, which was influenced by these earlier incarnations of the abstract line, we see how the abstract line in concert posters by Peter Max, Bonnie Maclean, and other artists of the period amplifies the sense of enhanced perception under the influence of music and psychedelic drugs.

Detail, wheel-lock rifle, Germany, Wallace Collection, London (1630s). Photo by Laura Marks.

Jean Pillement, etching (1755). Courtesy of Victoria and Albert Museum, London.

The figurative impulse is overwhelmingly strong. For a long time and in most societies, the representational meaning of an image has been considered more important than its plastic qualities. Even so, at the height of cultures of representation, there have always been abstract lines (and haptic space) around to relieve the brain, as these examples show.

Let me return to the history of thinking empathically about the abstract line. As well as Riegl, many other late twentieth- and early twenty-first-century thinkers were onto empathic relations with non-human forms. The German psychologist and philosopher of aesthetics Robert Vischer, writing in 1873, argued that sensation, which 'constitutes the most primitive form of the sense of universal coherence', gives rise to a more abstract feeling of the self as 'a subordinate part of an indivisible whole'.[19] Vischer described how a perceiver experiences an embodied similarity to the forms she perceives. He termed this emotional projection *einfühlung*, 'feeling oneself in'. Vischer attributed this embodied relationship to the way the muscles of the eye move along paths described by the form of the thing seen, so that 'my conscious second self' identifies with the line. 'I too rise and plunge along those rocky contours, along the "heaving mountains". I follow the unpredictable twists and turns of a tree and internally repeat them for myself'.[19] Note that Vischer is accounting for feeling like the **shape** of the mountain or the tree, not feeling like the mountain or tree itself. I argue that we can 'feel ourselves in' to this wallpaper by Christopher Dresser, designed a couple of decades after Vischer wrote, feel affects of rising and plunging as our eyes follow its serpentine lines, and, like Vischer, even feel ourselves to be part of a larger, interconnected whole in the course of this empathic perception.

In 1886, the Swiss art historian Heinrich Wölfflin wrote that empathy consists in the 'enjoyment of the self projected into a body or form', suggesting that people 'empathise' with abstract forms insofar as those forms undergo experiences that we too might undergo. The inorganic forms of the physical world 'can communicate to us only what we ourselves use their qualities to express'[20]—projection, in other words.

Wölfflin remained determined not to unmoor the human sense of self as an embodied soul. However, the German philosopher of aesthetics Theodor Lipps, writing in 1903, extended Wölfflin's concept of bodily empathy to non-figurative forms. Lipps was mostly concerned to account for how humans directly experience in their own bodies the states of other humans, as in contagious yawning. But Lipps also described an *einfühlung* with inanimate objects. For example,

Studio of Christopher Dresser, Furnishing fabric (roller-printed cotton, 1899). Courtesy of Victoria and Albert Museum, London.

when we look at a Doric column, we feel pleasure in its achievement of standing straight and supporting a load. He concluded: 'Thus, all pleasure produced by spatial forms and, we can add, any kind of aesthetic pleasure, is a feeling of *sympathy* that makes us happy'.[21]

We find a wavy line beautiful, he wrote: 'because its progression, its quicker and slower self-bending, the tension and release lying therein, is felt by me as a free activity and an exuberant feeling of my own contemplating ego sunken into the wavy line'.[22] The vitalist fascination with the life of forms in the early twentieth century resonates in art nouveau and Judendstijl. The art historian David Morgan cites the art critic Karl Scheffler, who wrote in 1901 that we humans share a feeling with everything organic, since 'our organism is a sort of instrument whose strings are set in sympathetic vibration'.[23] Scheffler may have said organic, but his examples, such as a floating puff of cigar smoke and a photograph of a glacier, are organic in the broadest sense—that is, in Leibniz's sense that all monads have a soul, and everything, down to the smallest particle, is a monad.[24] For example, in Alphonse Mucha's famous advertisement for Job rolling paper, the smoke rises from the lady's cigarette in saccadic twists that give a sense of non-organic life. Or, in Leibniz's sense, of many lives—each particle of smoke is a monad, whose body expires as its soul rises up in a cloud of carbon ash.

The German term *einfühlung* was translated into English as 'empathy' in experimental psychology in the early twentieth century, in the work of the psychologists James Ward at the University of Cambridge and Edward B. Titchener at Cornell.[25] Developing on the work of Vischer, Worringer, Lipps, the German physiologist, philosopher, and founding psychologist Wilhelm Wundt, and others, Titchener used empathy to mean not psychological fellow-feeling but kinaesthetic imaginative projection, a shared sense of movement.

Alphonse Mucha, *JOB* (color lithograph, 1897). Courtesy of Victoria and Albert Museum, London.

These early twentieth-century accounts begin to suggest that it is possible to relate to a line, feel the way a line feels, even without projecting human qualities on it. We can understand this through phenomenology, which posits that we feel a shared embodiment and a material commonality with what we behold. Existential phenomenology supposes an open and generous body that transforms in interaction with the world. And we can understand it through the Deleuzian view that our body is too big to be the site of transformation and always ends up appropriating experience to the human scale. Deleuze criticised phenomenology for privileging the human centre of perception, thus taking too large-scale and anthropocentric a view of what occurs in the encounters between bodies. Instead, he argued, we need to analyse effects on the body at a molecular level. As Spinoza provocatively wrote: 'No one has hitherto laid down the limits to the powers of the body, that is, no one has as yet been taught by experience what the body can accomplish solely by the laws of nature, in so far as she is regarded as extension'.[26] Feeling like an abstract line exercises our capacities for extension and connection. Affects put parts of our body in connection with forces beyond it. They unmake and remake the body.

Despite the differences between phenomenology and Spinozan–Deleuzian theory of affect, both of them affirm that opening to outside forces, though it threatens our integrity, also expands us, makes us more in touch with others, more sensitive, more alive. It seems that in encounters with many abstract lines, the affect arrives first, exciting responses in us, rhythms, micro-movements . . . and then later we respond with our whole body, in the way phenomenology describes. First we are moved from outside, then we might inhabit a body-to-body relationship, between your body and the body of the abstract line. Unless, of course, the abstract line is entirely colonised by figuration, as it is in most cartoons—then it is no longer an abstract line at all.

Now let's think about how we feel empathy with lines actually in motion. It might be harder to avoid projecting human feelings onto moving images, even abstract ones. Animation gives life—breath, *anima*—to non-organic forms, making them feel alive, even when there are no figures. Tom Gunning argues that we feel movement directly; rhythm moves us. 'We do not just *see* motion and we are not simply affected emotionally by its role within a plot,' Gunning writes, 'we *feel* it in our guts or throughout our bodies'.[27] Rapid camera movement, handheld camera, fast or rhythmic editing, and of course the movements of bodies on-screen all excite kinaesthetic responses in embodied viewers. I'm sure you've

felt yourself moving your head and shoulders in saccades and ellipses, maybe even feeling queasy, as you follow the movement of the dogmatically hand-held cameras of the Dogme movement, or leaning forward as you watch a chase scene edited with a fast rhythm like *The Bourne Identity*, or testing in your own body the kinetic precision of the dancers in a Beyoncé music video. These forms in motion give rise to embodied, affective responses as our bodies (or parts of our bodies) encounter them.

Gunning extends this kinaesthetic empathy from photographic film to animation. Animation is a moving image practice that derives much of its power from abstract lines. It allows us to feel impossible movements in our bodies, to contract and bounce, surge, and spread. Sergei Eisenstein was fascinated by what he called the 'plasmaticness' of Disney animations, and computer animation also allows us to experience embodiments, speeds, and rhythms of which our actual bodies are incapable.

I think we are far beyond 'identification' with another body when we empathically feel cinematic movement. The best animations don't subordinate the rhythmic line to figurative needs but allow it to exceed, and even direct, the feeling. The line resolves around the human or animal figure, but it also has an independent expressive quality. For example, Lina Ghaibeh's animation *Sad Man* depicts a Beirut bachelor whose everyday routine is broken only by electrical power cuts and running out of water. The simple event of facing each new day at the bathroom mirror transforms into a series of surreal solutions: the man's sad face wipes off onto the towel; it gets sucked into a bottle; his tears flood the room. Ghaibeh suggests the man's figure and face simply with thick, irregular, expressive lines, and she uses the same to empathise with the man, and the room, and the water, until all is empathy.

What about animation that challenges the way a line is constituted? Masayuki Kawai does live performances with analogue video feedback and makes compositions from the results. His *Video Feedback Auto-generated Piece 40*, for example, is not a painted animation, so we can't identify with the hand of the artist or with the indexicality of a pre-existing line. It's not a computer animation, so the lines are not extrusions of algorithms.[28] We can enjoy these ambient pastel forms and the abstract lines they generate for both phenomenological and affective reasons—that is, it both supports an extremely distended experience of our body, and it unmakes our body. Affectively, *Video Feedback Auto-generated Piece 40* brushes against our perception and incites fluid micro-movements in response to

Still, Lina Ghaibeh, *Sad Man* (2004). Still from animated short by Lina Ghaibeh, *Sad Man* © 2002 Lina Ghaibeh, reproduced with permission of Lina Ghaibeh.

its own. Phenomenologically, we relate to it as to another body. For there is still a body here—the body of the video medium. Analogue electronic interference produces these abstract lines (and their haptic space) in the struggle between the electron beam and the video raster lines that would normally contain it. Personally, I am very fond of electrons, those tiny 'souls' that we humans harness into disciplined armies to do our bidding. I like it when they escape these bonds and do things they want to do. Our bodies resonate with the struggles of the electronic medium. So we feel a shared embodiment and materiality with video itself.

I've been arguing that we can cultivate an innate capacity for empathy with non-organic objects. We can develop our capacities to live across the porous boundaries between ourselves and everything else, to live in Leibniz's 'grey area' and Spinoza's encounters between bodies. Unfortunately, empathy makes us vulnerable. Power has invaded our very acts of perception and feeling. Technologies to analyse our sensations and perceptions are harvesting us as consumers and providers of data to corporations. In the attention economy, our perceptions translate into information useful for capital.[29] Commercial media and industrial

Still, Masayuki Kawai, *Video Feedback Auto-generated Piece 40* (2011). Courtesy of MORI YU GALLERY and Chi-Wen Gallery.

design are working to instrumentalise our acts of perception and empathy. As scholars like Pasi Valiaho and Steven Shaviro have shown, movies, games, and device interfaces are designed to stimulate maximum affective response. They are exploiting the very kind of empathic openness that I have been arguing we need to develop. They are drawing people into an ersatz oceanic feeling deployed at the very micro-levels of perception and affect.

For example, facial recognition software, combined with technologies to analyse human facial micro-movements, is able to read our faces and anticipate our responses even before we can. The company Affectiva has developed a platform, based on research at the MIT Media Lab, called Affdex Facial Coding. It 'reads emotional states such as liking and attention from facial expressions using a webcam . . . to give marketers faster, more accurate insight into consumer response to brands and media'.[30] Affectiva's software accounts for cultural differences, so nobody is safe![31]

And Facebook has developed a program called DeepFace that combines artificial intelligence (AI) software and big data to identify untagged faces with

Image from Affectiva website, captured 2014.

97.25% accuracy—about as good as human capacity. Facebook developed DeepFace from programs it acquired when it bought the Israeli company Face. com in 2012 for US $60 million.[32] Most likely, the software was originally developed for military surveillance, a big concern for Israel. I note for my pixel-loving friend Azadeh Emadi that DeepFace is squeezing the maximum labour out of pixels by algorithmically aligning images of faces for most effective recognition. The researchers write: 'The network architecture is based on the assumption that once the alignment is completed, the location of each facial region is fixed at the pixel level. It is therefore possible to learn from the raw pixel RGB values, without any need to apply several layers of convolutions as is done in many other networks.'[33] This is not empathy software but powerfully supports the antisocial anticipation of empathy that other programs like Affectiva's have achieved.

So our faces and their varying moods will soon be subject to instant recognition both online and in places equipped with surveillance cameras. Luckily, face masks are in fashion again, in designs by Hussein Chalayan, Alexander McQueen, Gareth Pugh, and others, so we can hide our expressions when we go shopping and search the web on our camera-equipped devices.

Meanwhile, synaesthesia, the skill of sensory empathy, or feeling like an abstract line, has become a hot commodity. Designers of computer interfaces,

online avatars, mobile electronic devices, hotel lobbies, and a raft of other things are starting to corral perceptual empathy to make appealing objects. The Ford Motor Company employs a synaesthete to do 'cross-sensory harmonization' for Ford, optimising the relationships between the look, sound, and feel of Ford car doors, steering wheels, etc.[34] Some of these applications can make life in the well-designed world more pleasant. But they also dull our senses by pre-empting our sensory engagement with the world.

Recall that Riegl's terms ornament and argument originally corresponded, respectively, to narrative, figurative images, and non-narrative, relatively non-figurative images. In our time, argument continues to arrive in the form of figurative images, but as capitalism invades the perceptual field, all kinds of perceptibles have become hortatory. Ornament too is designed for instrumental purposes. This means not all abstract lines are really abstract—some are designed to soothe, some to stimulate. Argument now shapes not only perceptibles, but also the act of perception itself.

Of course, there are some people who are not vulnerable to these acts of perceptual surveillance. The very poor, who do not use computers or mobile phones that subject them to social media, are free of it. So are the very rich, people who can afford to absent themselves from computer-assisted surveillance. But most everyone else in the world is having their time taken from them by corporations. Poor people around the world are wasting their time playing Candy Crush Saga.

How on earth can we resist? My first answer is that instead of playing games or checking Instagram, we do exercises in feeling like abstract lines. This will develop our perceptual resistances.

Next, how to prevent our most intimate capacities from being harnessed and used against us? Synaesthesia, empathy, and feeling like an abstract line are capacities much broader, richer, and more 'useless' than commercial applications need them to be. The ally of perceptual uselessness is, of course, art. Art gives us perceptions and affects and opens us up to unforeseen empathies for no reason but to challenge and expand our capacities for being alive. In Spinozist terms, colours, shimmer, tuneful melodies, infectious rhythms, and abstract lines make us more alive. They affect us, make us open and vulnerable, yes, but they also make us aware of the larger-than-human powers of which we are a part. A Spinozan criterion for social political collective action: do new experiences (technology, design) increase or decrease capacity to affect, be affected, and act?

My third suggestion is that cultivating our abstract line feeling can develop collective powers, or what Walter Benjamin called collective innervation. Benjamin argued that new technologies redesign our perceptions. Importantly, this need not occur against our will—as is the case with the instrumental technologies discussed above—but also with our creative collaboration. Annunziato's algorithmic line, Ghaibeh's sympathetic animated lines, Kawai's video feedback, the snaking lines of Ivorian wax cloth, psychedelic posters, and the other abstract lines I've discussed here have a creative effect on our embodied perception. Collective innervation, as the film historian Miriam Hansen explained, imbues technology with the social relations and sensuousness that capitalism denies.[35] So participating in new technologies is an occasion for our bodies to form novel responses. That's what we do when we cultivate feeling like abstract lines. In Spinoza's term, enlarging our powers of perceptual empathy helps us to gain adequate ideas, converting passive affect to knowledgeable action.

Feeling like an abstract line, then, allows us to feel what we have in common with non-organic life—life forces that animate plants, rocks, molecules, electrons. I hope that, rather than succumbing to overwhelming media affects and well-designed experiences, we can continue to take risks and cultivate our inner powers of feeling in common with life in general. This way we can create zones of power and 'useless' beauty that will serve as batteries for collective action.

Endnotes

1. Daria Martin, Interview with Fiona Torrance, a mirror-touch synaesthete, 18 March 2013.
2. Daria Martin, Interview with Anonymous, a mirror-touch synaesthete, 5 Nov 2012.
3. Daria Martin, Interview with Anonymous, a mirror-touch synaesthete, 5 Nov 2012.
4. Gottfried Wilhelm von Leibniz, *The Monadology and Other Philosophical Writings*, trans. Robert Latta (London: Oxford University Press, 1965).
5. Matthew W. Campbell, J. Devyn Carter, Darby Proctor, Michelle L. Eisenberg, and Frans B. M. de Waal, 'Computer animations stimulate contagious yawning in chimpanzees', *Proceedings: Biological Sciences* (2009), 276, 1676, 4255–9.
6. Miriam Bratu Hansen, 'Benjamin: Mistaking the Moon for a Ball' in *Cinema and Experience: Siegfried Kracauer, Walter Benjamin, and Theodor W. Adorno* (Berkeley: University of California Press, 2012), 132, 18.
7. De Waal, 4258.
8. Gilles Deleuze and Félix Guattari, '1440: The Smooth and the Striated', in *A Thousand Plateaus: Capitalism and Schizophrenia*, trans. Brian Massumi (Minneapolis: University of Minnesota Press, 1987), 496–7.
9. Laura U. Marks, *The Skin of the Film: Intercultural Cinema, Embodiment, and the Senses* (Durham and London: Duke University Press, 2000).
10. Deleuze and Guattari, *A Thousand Plateaus*, 499.
11. Deleuze and Guattari, *A Thousand Plateaus*, 497–8.
12. Deleuze and Guattari, *A Thousand Plateaus*, 499.
13. David Morgan, 'The idea of abstraction in German theories of the ornament from Kant to Kandinsky', *Journal of the History of Ideas* (1996), 57, 2, 238.
14. Deleuze, *Spinoza: Practical Philosophy*, trans. Robert Hurley (San Francisco: City Lights Books, 1988).
15. Deleuze and Guattari, *A Thousand Plateaus*, 248–50.
16. Gilles Deleuze, 'Painting and Sensation', *Francis Bacon: The Logic of Sensation*, trans. Daniel W. Smith (Minneapolis: University of Minnesota, 2002), 31–8.
17. Laura U. Marks, *Enfoldment and Infinity: An Islamic Genealogy of New Media Art* (Cambridge, MA: MIT Press, 2010), chapters 4 and 5.
18. Margaret Olin, 'Self-representation: resemblance and convention in two nineteenth-century theories of architecture and the decorative arts', *Zeitschrift für Kunstgeschichte* (1986), 49, 3, 391–4.
19. Robert Vischer, 'On the Optical Sense of Form: A Contribution to Aesthetics', in H. F. Mallgrave and E. Ikonomou, eds., *Empathy, Form, and Space: Problems in German Aesthetics, 1873–1893* (Santa Monica, CA: Getty Center for the

History of Art and the Humanities, 1994), 109.

19. Robert Vischer, 'The Aesthetic Act and Pure Form', trans. Nicholas Walker, in Charles Harrison *et al.*, eds., *Art in Theory, 1815–1900: An Anthology of Changing Ideas* (Oxford: Oxford University Press, 1998) [original German publication 1874].

20. Morgan, 'The Idea of Abstraction in German Theories of the Ornament from Kant to Kandinsky', 317–41. Quote is from Wölfflin, 'Empathy and the Problem of Form', *Art in Theory, 1815–1900*, 713.

21. Gustav Jahoda, 'Theodor Lipps and the Shift from "Sympathy" to "Empathy"'. *Journal of the History of the Behavioral Sciences* 4(2),158. 158. Jahoda argues that Lipps treated sympathy and positive *einfühlung* as synonyms.

22. Theodor Lipps, '*Aesthetik. Pyschologie des Schonen und der Kunst, part one, Grundlegung der Aesthetik*' (Hamburg and Leipzig: Leopold Voss, 1903), trans. and quoted in Morgan, 'The Idea of Abstraction in German Theories of the Ornament from Kant to Kandinsky', 234.

23. Morgan, 'The Idea of Abstraction in German Theories of the Ornament from Kant to Kandinsky', 236.

24. Interestingly, Lipps also described 'negative' *einfühlung*, in which another person's antagonistic gesture repels us. He wrote that when he sees a person with an arrogant attitude, 'My inner being objects; I feel in the arrogant look a life-denial or life-inhibition affecting me, a denial of my personality.' This description accords remarkably well with Spinoza's description of the way another person's angry or threatening attitude diminishes my own powers of acting.

25. Susan Lanzoni, 'Empathy in Translation: Movement and Image in the Psychological Laboratory', *Science in Context* (2012), 25, 3, 301–27.

26. Baruch Spinoza, 'Ethics', part III, prop. II, in *Improvement of the understanding, Ethics and Correspondence of Benedict de Spinoza*, trans. R. H. M. Elwes (New York: Wiley, 1901), 131.

27. Tom Gunning, 'Moving away from the index: cinema and the impression of reality', *Differences* (2007), 18, 1, 39.

28. Computer animation is a fairly Platonic medium, in that each of its forms is the expression of an algorithm.

29. See for example Jonathan Crary, *Suspensions of Perception: Attention, Spectacle, and Modern Culture* (Cambridge: MIT Press, 2000); Jonathan Beller, *The Cinematic Mode of Production: Attention Economy and the Society of the Spectacle* (Lebanon, NH: University Press of New England, 2006).

30. http://www.affdex.com.

31. http://www.affdex.com.

32. '"DeepFace" could provide instantaneous facial recognition via Facebook', *Russian Times*, 19 March 2014, http://rt.com/usa/deepface-instantaneous-facial-recognition-facebook-706.

33. Yaniv Taigman, Ming Yang, Marc'Aurelio Ranzato, and Lior Wolf, 'DeepFace: Closing the Gap to Human-Level Performance in Face Verification', undated paper published by Facebook, 2014.

34. Caroline Winter, 'The Mind's Eye: Synesthesia Has Business Benefits', *Bloomberg Businessweek*, 9 January 2014.

35. Hansen, 'Benjamin: Mistaking the Moon for a Ball', *Cinema and Experience*, 132–45.

Synergy and Synaesthesia

Anthony Chemero

Accordingly, just as we say that a body is in motion, and not that motion is in a body, we ought to say that we are in thought and not that thoughts are in us.

Charles Saunders Peirce (*Writings 2*, 227.)

Introduction

The so-called cognitive revolution of the late 1950s ushered in a new interdisciplinary science of the mind, with contributions not only from psychologists, but also from neuroscientists, linguists, philosophers, and computer scientists. Ever since then, it has seemed natural to scientists and many non-scientists to understand thinking as a kind of computation. Indeed, the central idea of the cognitive science is an analogy—minds are to brains as computer programs are to computers. This analogy has been extremely fruitful for both scientific discovery and technological innovation. If your perceptions, thoughts, and the like are computational processes running on your brain, we might study them by writing software that runs on a laptop. This approach has led to a decade-long interplay between scientific experimentation and computational modelling. At the same time, however, the idea that thinking is a kind of computation has saddled psychologists and cognitive neuroscientists with an unapologetically Cartesian understanding of our own minds—thinking is pure reason, separable in principle from the body, action, and sociality. Descartes himself thought that the body was a machine; the cognitive revolution treats the mind as a machine as well, a machine that performs computational operations on representations

of the environment. This Cartesian understanding of the mind has been seen as problematic by many cognitive scientists. Happily, things in the cognitive sciences are changing, with the focus shifting away from computation and towards understanding embodied experience. In this chapter, I will describe some of the phenomenological underpinnings of this new embodied cognitive science, along with some of its scientific results. Together, these point to an understanding of humans as having fuzzy, ever-changing boundaries and as being deeply connected to the world and other humans. I will also explore the way this view of humans should affect our thinking about mirror-touch synaesthesia.

Phenomenology and the Lived Body

What is required to have the sorts of experiences and thoughts that we have? One answer, the one proposed by Descartes, is that we need a rational soul that interacts without the material world through our pineal glands. The cognitivist answer to this question, as we have just seen, is that we need a particular kind of brain—a brain that is a kind of computer and minds that are computational manipulations of representations in that computer. These computational manipulations are essentially a materialist version of the Cartesian rational soul. In both cases, it is a matter of having certain rational, conceptual, mental abilities.

The phenomenological philosopher Maurice Merleau-Ponty gave a very different answer to this question.[1] His answer is that the foundational requirement for having the sorts of experience we have is the lived body. Perceiving, experience, and thinking, according to Merleau-Ponty, are essentially embodied activities; the human mind in general is necessarily bodily, or 'incarnate'. The lived body opens up the possibilities that make up the world. We do not entertain these possibilities mentally, by thinking about them or imagining them. Instead, we are open to them through the skills and habits of the lived body. Merleau-Ponty calls our constant readiness to deploy those skills the 'body schema'. It makes the world intelligible and hence constitutes the possibility of relating to objects and regions within it. Body schema similarly prefigures the possible experience of the world around us. A body schema consists of the body's readiness to deploy its habits and skills in every possible situation and thereby opens up the possibilities that give a situation its significance. So, for instance, our skills of reaching and grasping give form to objects that we encounter as within our reach

and as graspable. Our basic motor skills, as well as our more involved culturally inflected habits, place us in an environment that consists of things to be done, objects to be manipulated. Unlike in the Cartesian understanding, the mind is not a separate substance that mysteriously interacts with a mechanical body. Consciousness is essentially incarnate. To be conscious is to be embodied. 'The union of the soul and the body is not established through an arbitrary decree that unites two mutually exclusive terms, one a subject and the other an object. It is accomplished at each moment in the movement of existence'.[2]

Moreover, Merleau-Ponty argued for malleability of the lived body, with his long discussion of the experience of a blind person using a cane to explore the environment. The blind person's lived body changes when he or she is carrying the cane, so that he or she doesn't experience the cane in his or her hand, but the world at the cane's tip. When this happens, the blind person's body schema, and therefore experience, changes. Merleau-Ponty calls this 'changing our existence by appropriating fresh instruments'. In doing so, he moves beyond the body, to what is now called 'extended mind' or 'extended cognition'.[3] A cognitive system is extended whenever it is, in part, constituted by things outside the biological body. To say that a cognitive system is, in part, constituted by things outside the biological body is to claim something stronger than to say that these things causally impact or enable cognition. Words on a page or monitor impact cognition, without being part of a thinking thing. Similarly, there could be no human thought without our oxygen-rich atmosphere, but oxygen in the atmosphere is not part of a thinking thing. To claim that cognitive systems are extended is to say that they are, in part, constituted by, that is made up of, things outside the body. In Merleau-Ponty's example, the lived body that experiences the environment is partly constituted by the cane.

Explaining the Extended Lived Body

As noted above, Merleau-Ponty and later phenomenologists explain the changing boundary of the lived body by pointing to what Merleau-Ponty called the 'body schema'. To many contemporary cognitive scientists, influenced by the Cartesian assumptions that structure the discipline, it would be natural to think of the body schema as a kind of mental or neural representation of the body, of the sort that neuroscience textbooks call 'body maps'. Merleau-Ponty would

have rejected this, as would later phenomenologists. Essentially, we are our lived bodies. Our lived bodies are not objects in the world, and we do not represent them. In this, Merleau-Ponty and other phenomenologists are at odds with most contemporary cognitive scientists and cognitive neuroscientists, including those who have worked on mirror-touch synaesthesia. There are, however, a growing minority of cognitive scientists who follow Merleau-Ponty in rejecting representationalism. Although there are some differences amongst them, ecological psychologists,[4] enactivist cognitive scientists,[5] and sensorimotor theorists[6] are all influenced by Merleau-Ponty and other phenomenologists. For expository convenience, I will paper over the differences and lump these three groups together as 'radical embodied cognitive scientists'.[7] A key unifying feature amongst radical embodied cognitive scientists is that they try to do cognitive science without invoking mental or neural representations. These anti-representationalist cognitive scientists share the view that perceiving, seeing, experiencing, and the like are things that we **do**, not things that happen inside of us. Consider perceiving by touch. To be able to perceive by touch, you need to explore by actively hefting, running your fingers over edges, and the like. Perceiving by touch requires exploratory work, and sensory stimulation alone is not sufficient. According to these approaches, all our senses are like touch in that they require active exploration of the world. Accordingly, this active exploration is part of experience, so active touch and other senses are a form of extended cognition, with experiences being constituted by the brain, body, and environment.

A second key point of agreement amongst radical embodied cognitive scientists is the preference for explaining extended cognitive systems as self-organising, and therefore subject to the same kind of mathematical modelling that one applies to self-organising systems in other sciences. A self-organising system is a system that exhibits regularities that arise without a plan or leader but emerge from the interactions of the parts of the system. Self-organising systems can do this by using energy from their surroundings to create patterns. Consider, to take a mundane example, the whirlpool pattern that forms when a toilet is flushed. The water molecules temporarily move in a coordinated way that is very atypical for water molecules. They can exhibit this pattern of behaviour because potential energy from the water in the tank is released when the toilet is flushed. This energy enables the pattern to form and last until the energy is dissipated, after which the water molecules go back to their more typical behaviour. Physicists who work on self-organisation would call this behaviour of water molecules in

a flushing toilet a **synergy**.[8] A synergy is a collection of components that act as a temporary self-organising unit and in which the components exhibit behaviour that is constrained by being parts of the synergy. The top portion of the following figure depicts a set of components as separate from each other, for example a collection of water molecules in a toilet. The middle portion of the figure depicts constraints amongst some networks of those components, so that the connected molecules will behave collectively. The bottom portion depicts the synergy—constraints acting on the already constrained networks of molecules, so that a coherent collective pattern of activity (a whirlpool) emerges.

In a synergy, constraints cause groups of components of a large system (top) to act in unison (middle) and produce an overall coherent behaviour (bottom). Reproduced from Riley MA, Richardson MJ, Shockley K, and Ramenzoni VC (2011) Interpersonal synergies. *Frontiers in Psychology* 2 (38), doi: 10.3389/fpsyg.2011.00038 © 2011 Riley, Richardson Shockley and Ramenzoni.

Synergies[9] might seem odd from a metaphysical or mechanistic point of view; a synergy is an aggregate entity that constrains the behaviour of the smaller-scale components that make it up. Synergies, thus, imply a kind of downward or circular causation that strains our ordinary understanding of causes and effects. Nonetheless, there is nothing strange or magical about synergies—they occur routinely in nature and are well understood by physicists. The pattern in your toilet flushing is a synergy; convection rolls in boiling oil are synergies; bird flocks are synergies. In each of these cases, components form leaderless, temporary coalitions in which the behaviour of the components (molecules, birds) is constrained by being part of the whole (the whirlpool, the flock) that they make up.[10]

One of the key ways to identify synergies is that they are temporary coalitions that exhibit **interaction-dominant dynamics** and are therefore **interaction-dominant systems**. This technical term can be read quite literally—a system exhibits interaction-dominant dynamics when the interactions amongst the components dominate or override the dynamics that the components would exhibit separately. Systems with interaction-dominant dynamics (i.e. interaction-dominant systems) are genuinely unified systems. Over the last few decades, it has been demonstrated that many well-functioning physiological systems are interaction-dominant systems. Examples of this include human heartbeats (Peng *et al.*, 1995) and gait patterns (Hausdorff *et al.*, 1995), indicating that the chambers of the heart, the locomotory system, and parts of the human brain are interaction-dominant systems. Although the chambers of the heart display interaction-dominant dynamics, they are not a synergy, because they are not a temporary coalition. Hearts are like the water in a flushing toilet in that they are both interaction-dominant systems, but they differ in that the chambers of the heart form a more long-standing collaboration.

Over the last few decades, synergies have made their way into the cognitive sciences, especially as practised by radical embodied cognitive scientists. For example, there is mounting evidence that synergies are the chief mechanism according to which brain areas work together to enable and control behaviour—brain areas move into temporary coordinated patterns in order to enable animals to complete a task, and become uncoordinated once the task is completed.[11] Crucially for current purposes, the results on interaction dominance and physiology provide a way to understand extended cognition—an organism and a non-bodily object comprise a single, extended cognitive system if

they are coupled to one another in the same way that the components of a well-functioning physiological system are coupled to one another. That is, an organism and a non-bodily object comprise a single, extended cognitive system if they collectively comprise a synergy with interaction-dominant dynamics. My own experimental research has focused on extended human-tool synergies, in which human participants and the tools they are using competently form temporarily unified systems. We have argued that these human-tool synergies are real-time alterations of the lived body, as occurs when a blind person uses a cane.[12] Demonstrating this is tantamount to demonstrating that human-plus-tool systems can temporarily be as tightly integrated as the components of a beating heart are. The psychologists Dobri Dotov, Lin Nie, and I have demonstrated this empirically in the lab. We have shown that cognitive systems can be made to extend beyond the periphery to include artefacts that are being used. Participants in our experiments played a simple video game, controlling an object on a monitor using a mouse. For a 6-second period of each trial, the connection between the mouse and the object on the monitor was disrupted, so that the mouse movements no longer controlled the object on the monitor. We measured the movement dynamics at the hand–mouse interface and found interaction-dominant dynamics during regular game play, but not during the mouse disruption.[13] As discussed above, this indicates that, during normal operation, the computer mouse is part of the interaction-dominant system engaged in the task. That is, during smooth playing of the video game, the human-plus-video-game was a synergy. The fact that such a mundane experimental set-up (i.e. using a computer mouse to control an object on a monitor) generated an extended cognitive system suggests that extended cognitive systems are common. Interacting with technology alters and extends your lived body, just as happens when a blind person uses a cane to cross the street or when you feel the street through your bicycle.

This research supports claims by Merleau-Ponty and other phenomenologists that the lived body is malleable and the boundaries of what is experienced as the self change over time. Moreover, it explains malleability of the lived body, not in terms of the brain temporarily changing its map or model of the body to temporarily include the tool, but rather in terms of the temporary coalition formed by the brain, body, and tool.[14] The explanation, in other words, is not of the brain changing the way it controls the body in order to adapt to the attached tool, but rather of the activity of the brain, body, and

tool being mutually and interactively constrained. No component of a synergy is the controller. Importantly, this means that the explanation maintains the anti-representationalism that radical embodied cognitive scientists share with Merleau-Ponty.

Interpersonal Synergies and Mirror-Touch Synaesthesia

We can now, finally, put phenomenology (and radical embodied cognitive science) in touch with mirror-touch synaesthesia. The neuroscientists Michael Banissy and Jamie Ward[15] (both contributors to this volume) suggest that mirror-touch is a matter of 'self-other blurring' caused by a softening of the neural self-representation and atypical self-other neural processing. Both Merleau-Ponty's phenomenological philosophy and the results of the radical embodied cognitive scientists show that the self is indeed blurry. Humans have a malleable lived body and routinely participate in synergies that include tools. However, neither the phenomenology nor the scientific explication of the malleable lived body supports Banissy and Ward's assumption that this involves a blurred self-representation in the brain, i.e. neural structures that typically form a representation of the self, but in mirror-touch synaesthetes represent more than the self. The explanation of the malleable lived body in terms of human-tool synergies does not invoke representation at all. While there is evidence that the neural activity of mirror-touch synaesthetes is atypical, there is also good reason to think that whatever is happening in the brains of these synaesthetes is adaptive. The good reason for thinking this is the decades of research on **interpersonal synergies**.[16]

That pairs or collections of humans can form synergies should not be a surprise, considering that bird flocking was one of the examples of synergies used above. In bird flocks, no particular bird is in charge of the speed or direction of the flock, and the behaviour of individual birds is determined by the behaviour of the flock that they make up. The same sort of collective control is very common in human interpersonal behaviour. Remember the last time you danced or jogged with someone—you and your partner formed a temporary unit, in which each of you allowed your behaviour to be constrained by the unit you comprised. The earliest work on interpersonal synergies was done by the American psychologists Richard Schmidt, Claudia Carrello, and Michael Turvey.[17] They showed

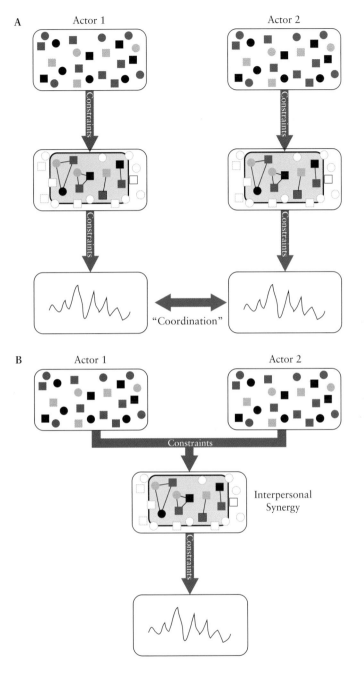

The components of a synergy that are constrained to act as a unit are often in more than one individual. This is an interpersonal synergy. Reproduced from Riley MA, Richardson MJ Shockley K and Ramenzoni VC (2011) Interpersonal synergies. *Frontiers in Psychology* 2 (38), doi: 10.3389/fpsyg.2011.00038 © 2011 Riley, Richardson Shockley and Ramenzoni.

that while two people swing their limbs in synchrony, they are connected to one another in the same way that the limbs of a single individual are connected. That is, the interpersonal connection between two people is a temporary version of the intrapersonal connection amongst the parts of a single person. More recent work has shown similar interpersonal synergies arising when people sit next to one another on rocking chairs,[18] when they converse,[19] when people collaborate in novel video games,[20] and when professional jazz musicians improvise together.[21] Perhaps the most striking example of research on interpersonal synergies, or at least the funniest, is work by the psychologists Steve Harrison and Michael Richardson.[22] They had people walk on treadmills together, one in front of the other in four conditions: the person in the back blindfolded; the person in the back not blindfolded; the person in the back blindfolded, and the participants coupled with a block of Styrofoam; and the person in the back not blindfolded, and the participants coupled with a block of Styrofoam. What they found was that whenever there was some coupling between the walkers (that is, in the latter three conditions), they formed an interpersonal synergy. Moreover, the interpersonal synergy they formed led them to collectively adopt common quadruped gaits such as pacing or trotting.

These interpersonal synergies are a straightforward demonstration that self-other blurring is common indeed, and not at all particular to mirror-touch synaesthetes. Humans routinely form interpersonal synergies, and doing so is beneficial. In one of many demonstrations that this is the case, the psychologists Alexandra Paxton, Rick Dale, Drew Abney, and Christopher Kello have shown that interpersonal synergies enable and structure dyadic conversation, and that arguments disrupt interpersonal synergies.[23] More broadly, interpersonal synergies are not consistent with the Cartesian assumptions that came along with the cognitive revolution. They imply that the human mind is not a rational machine separable from the body, from action, from other humans. Interpersonal synergies also imply that minds do not work via machine-like manipulations of representations. When two humans engage in a conversation or cooperative video game play, they are not straightforwardly physically connected in the way that water molecules are; there is no straightforward sense in which one participant's neurons connect to the body of the other participant. It wouldn't make sense to say that your representations of our conversation control my participation in it. Indeed, no mechanical account of interpersonal synergies is available, and

satisfactory explanations of it are multi-scaled, taking account of both component- and systems-level dynamics, and interactions between them.

This scientific research on synergies reinforces the claims made by phenomenologists and radical embodied cognitive scientists that perceiving, experiencing, thinking, and the like are things that we do, not things that happen in our brains. We do them by forming tight connections to the world around us, not by building internal models of the world around us. The phenomenological philosopher Martin Heidegger put this by saying that '[T]he perceiving of what is known is not a process of returning with one's booty to the cabinet' of consciousness after one has gone out and grasped it'.[24] The scientific research on **interpersonal** synergies suggests that perceiving, thinking, experiencing and the like are things we regularly do in concert with other people, forming connections that we temporarily structure and which temporarily structure us.

All of this points to a particular understanding of mirror-touch synaesthesia. Mirror-touch synaesthetes feel seen touches on other human bodies; some also feel touches to other objects. The lived body is malleable, and what humans experience as themselves changes over time, sometimes including inorganic pieces of the environment such as musical instruments and sometimes including organic pieces such as other people. This malleability is not the result of a malleable self representation or any kind of self-other processing, but of our ability to participate in synergies. Mirror-touch experiences arise from the formation of interpersonal synergies. The point is made well in the following autobiographical note from a mirror-touch synaesthete, interviewed by the editor of this volume:

> When I was a child, I had this strange belief that we were all meant to share consciousness with each other; almost a kind of mass telepathy. I remember thinking it was so strange that we would each only experience our own minds and not those of others.[25]

What is so interesting about this is that, given what I have been suggesting, the childish view was the correct one, not just of mirror-touch phenomenology, but of the phenomenology of nearly all humans. Like the rest of us, mirror-touch synaesthetes **do** experience the minds of others. We don't do so via telepathy, but by participating in interpersonal synergies. In contrast, the mature belief that we only experience our own minds is a reflection of Cartesian assumptions—our

minds are things inside us, separable from our bodies, our actions, our environments, other people. These deeply engrained assumptions are also built into the cognitive sciences, and in the assumption made by Ward and Banissy that mirror-touch has to be the result of something happening only in the brains of the mirror-touch synaesthetes. The arguments of the phenomenologists and radical embodied cognitive scientists suggest that these Cartesian assumptions are mistaken. The scientific research on synergies suggests that the boundaries of the self are malleable and that the self is often subsumed into an interpersonal synergy. This is true of mirror-touch synaesthetes and the rest of us. Once we set aside Cartesian assumptions, there is nothing strange about mirror-touch synaesthesia; it is continuous with the everyday experiences we all have. As the epigraph from the American Pragmatist philosopher Charles Peirce has it, thought is not in us, we are in thought; we are often in it with others.

Closing Question About Artworks

These considerations about phenomenology, embodied cognition, and mirror-touch point to a question about works of art. Mirror-touch synaesthesia serves as a reminder that the lived body is malleable, and there is less separation between the person and the world than we adults believe. We participate in synergies, both with tools and with other people. We are with them, unreflectively and without building internal representations of them; we literally connect to them temporarily. The question is whether we might connect to works of art in the same way. We don't always—some works of art, especially conceptual ones, we experience as Cartesian subjects, by thinking about them and interpreting them. In some extreme cases of this, we can do so without actually seeing or hearing the artwork—seeing Duchamp's *Fountain* in person seems beside the point. But this is surely not the case with all works of art, which leads to the following question for future embodied phenomenologists of art: what is it like to be with a work of art?

Endnotes

1. See especially Maurice Merleau-Ponty (1945), '*Phenomenology of Perception*', trans. Donald Landes (Routledge, 2012). There are multiple interpretations of Merleau-Ponty's views. The one I rely on here is spelt out in Stephan Käufer and Anthony Chemero, '*Phenomenology*' (London: Polity Press, 2015).

2. Merleau-Ponty (1945/2012), 91.

3. See, for example, A. Clark, '*Being There*' (Cambridge: The MIT Press, 1997); A. Clark and D. Chalmers, 'The Extended Mind', *Analysis* (1998), 58(1), 7–19.

4. J. J. Gibson, '*The Ecological Approach to Visual Perception*' (Boston: Houghton-Mifflin, 1979).

5. F. J. Varela, E. Thompson, and E. Rosch, '*The Embodied Mind*' (Cambridge, MA: The MIT Press, 1991).

6. J. K. O'Regan and A. Noë, 'A sensorimotor account of vision and visual consciousness', *Behavioral and Brain Sciences* (2001), 24(5), 883–917.

7. Anthony Chemero, '*Radical Embodied Cognitive Science*' (Cambridge, MA: The MIT Press, 2009).

8. H. Haken, 'Introduction to Synergetics', *Cooperative Phenomena in Multi-Component Systems* (1973), 9.

9. Like 'paradigm' before it, the term 'synergy' has been coopted by the business and marketing communities. As used here, 'synergy' does not mean the same thing as the bastardised use of the same word in business and management speak. Capitalists ruin everything.

10. You are not allowed to just call something a synergy. There are statistical tests for determining when a collective behaviour results from a synergy. Interested readers should consult Haken (1973, op. cit); M. Riley and J. Holden, 'Dynamics of cognition', *WIREs Cogn Sci* (2012). doi: 10.1002/wcs.1200; or Michael Richardson and Anthony Chemero, 'Complex dynamical systems and embodiment', in L. Shapiro, ed., *Routledge Handbook of Embodied Cognition* (2014).

11. For example, W. J. Freeman, 'Origin, structure, and role of background EEG activity. Part 4. Neural frame simulation', *Clin Neurophysiol* (2006), 117, 572–89.

12. For example, D. Dotov, L. Nie, and A. Chemero, 'A demonstration of the transition from readiness-to-hand to unreadiness-to-hand', *PLoS ONE* (2010), 5, e9433.

13. The details of this are beyond the scope of this essay. In short, we measured hand-on-mouse movements using a motion capture system. We analysed the movements using detrended fluctuation analysis, one of several analytic techniques designed to detect interaction-dominant dynamics. See Dotov *et al.* (2010) for the nitty-gritty.

14. This is not to say that there are no changes to what neuroscientists call body maps in the brain. However, the theoretical assumptions concerning synergies suggest that the changes in the brain are caused by the incorporation of the tool, i.e. instead of that the incorporation of the tool is caused by changes in the brain. For details on this, see G. Van Orden, G. Hollis, and S. Wallot, 'The blue-collar brain', *Frontiers in Physiology* (2010), 3, 207. doi: 10.3389/fphys.2012.00207.

15. Michael Banissy and Jamie Ward, 'Mechanisms of self-other representations and vicarious experiences of touch in mirror-touch synesthesia', *Front Hum Neurosci* (2013).

16. M. Riley, M. Richardson, K. Shockley, and V. Ramenzoni, 'Interpersonal synergies', *Frontiers in Psychology* (2011), 2, 38. doi 10.3389/fpsyg.2011.00038.

17. R. Schmidt, C. Carello, and M. Turvey, 'Phase transitions and critical fluctuations in the visual coordination of rhythmic movements between people', *Journal of Experimental Psychology: Human Perception and Performance* (1990), 16, 227–47.

18. M. Richardson, K. Marsh, R. Isenhower, J. Goodman, and R. Schmidt, 'Rocking together: dynamics of intentional and unintentional interpersonal coordination', *Human Movement Science* (2007), 26, 867–91.

19. F. Cummins, 'Towards an enactive account of action: speaking and joint speaking as exemplary domains', *Adaptive Behavior* (2013), 21(3), 178–86.

20. P. Nalepka, C. Riehm, C. Mansour, A. Chemero, and M. Richardson, 'Investigating strategy discovery and coordination in a novel virtual sheep herding game among dyads', *Proceedings of the 37th Annual Meeting of the Cognitive Science Society* (2015).

21. A. Walton, M. Richardson, P. Langland-Hassan, A, Chemero, and A. Washburn, 'Musical improvisation: multiscaled spatiotemporal patterns of observation', *Proceedings of the 37th Annual Meeting of the Cognitive Science Society* (2015).

22. S. Harrison and M. Richardson, 'Horsing around: spontaneous four-legged coordination', *Journal of Motor Behavior* (2009), 41, 519–24.

23. D. H. Abney, A. Paxton, R. Dale, C. T. Kello, 'Complexity matching in dyadic conversation', *Journal of Experimental Psychology: General* (2014), 143(6), 2304–15. A. Paxton and R. Dale, 'Argument disrupts interpersonal synchrony', *Quarterly Journal of Experimental Psychology* (2013), 66(11), 2092–102.

24. Martin Heidegger (1927/1977), *Sein und Zeit*, 17th edition (Tübingen: Max Niemeyer, 1993), 89.

25. Daria Martin, Interview with Anonymous, a mirror-touch synaesthete, 2012.

The Art of the Relational Body:
From Mirror-Touch to the Virtual Body

Brian Massumi

Primitively our space-experiences form a chaos, out of which we have no
immediate faculty for extricating them. Objects of different sense-organs,
experienced together, do not in the first instance appear either inside
or alongside or far outside each other, neither spatially continuous nor
discontinuous, in any definite sense of these words. . . . This primitive chaos
subsists to a great degree throughout life so far as our immediate sensibility
goes . . . The general rule of our mind is to locate in each other all sensations
which are associated in a simultaneous experience, and do not interfere with
each other's perception.

> William James[1]

Corresponding to every feeling within us, some motion takes place in our
bodies.

> C. S. Peirce[2]

A process set-up anywhere reverberates everywhere . . . Every possible feeling
produces a movement, and that movement is a movement of the entire
organism, and of each of its parts.

> William James[3]

There must be a continuity of changeable qualities. Of the continuity of
intrinsic qualities of feeling we can now form but a feeble conception. The
development of the human mind has practically extinguished all feelings,
except a few sporadic kinds, sound, colors, smells, warmths, etc., which now
appear to be disconnected and disparate . . . Originally, all feelings may have
been connected in the same way, and the presumption is that the number of
dimensions was endless. For development essentially involves a limitation

of possibilities. But given a number of dimensions of feeling, all possible
varieties are obtainable by varying the intensities of the different elements.
Accordingly, time logically supposes a continuous range of intensity in
feeling. It follows, then, from the definition of continuity, that when any
particular kind of feeling is present, an infinitesimal continuation of all
feelings differing infinitesimally from that is present.

 C. S. Peirce[4]

In mirror-touch synaesthesia, the sight of touch to another's body elicits the feel-
ing of the touch in the corresponding location of the observer's body. This effect
is frequently discussed in the literature as a spatial 'confusion' or an 'error' in
the ability to discriminate self and other.[5] Construing it in this way carries an
implication, whether intended or not, of a 'normal' cognitive base-state of a
private subject peering out on the world and representing it to itself, anchored
in the safehouse of a discrete, clearly positioned body container. The labelling
of the phenomenon as 'mirror-touch' synaesthesia, rather than 'sight-touch'
synaesthesia on the model of other synaesthesia nomenclature (sound-colour,
colour-grapheme, shape-taste), encourages that implication. A cognitive mis-
take must be occurring, the name says, of the kind mirrors produce. As when
we catch a glimpse of ourselves as we pass a mirror that we didn't know was
there and experience the sudden jolt of seeing another person who looks just
like us. Or when we use a mirror to tweeze an errant hair and find ourselves
spatially confused as to which direction is left and right. The first description of
mirror-touch synaesthesia in the scientific literature in 2005 took place around
the same time another discovery with the same first name was beginning to
register in a major way in popular knowledge and imagination. It is rare to
find a discussion of mirror-touch synaesthesia that does not also mention mir-
ror neurons—specialised neurons that respond when the movement of another
body is perceived by firing in a pattern that is identical to that which occurs
when performing the action. Same name, same 'confusion', same 'error'. Same
implied bias—that our perception is fundamentally a passive reception of an
image constituting a private representation of the world, which, under normal
conditions, is then cognitively corrected to purify it of illusions of perspective
and other unthinking errors.[6] But the passive reception model upon which the
cognitive model of representation is grounded is precisely what the discovery

of mirror neurons irrevocably calls into question, in a way that has important implications for mirror-touch synaesthesia. Before drawing conclusions about the implications for art and culture of either mirror neurons or mirror-touch synaesthesia, it is important to purify the perception of these perceptual phenomena of the nominative mirror bias. It is self-evident that our perception **participates** in the world before it can be said in any way to **mirror** it. To understand the way in which mirror-touch synaesthesia participates in the world, it is necessary to reconsider it in the larger context of synaesthetic experience in general, and synaesthesia in the still larger context of the forming of perception and what it says about the nature of the body.

Many tools for this reconsideration are found in the literature on mirror-touch synaesthesia itself. But since the scientific literature is less focused on reformulating fundamental questions about the nature of perception than it is on identifying neural correlates to the experiences under investigation, an assist from philosophy is needed. As the collage of opening quotes indicate, philosophy (or, in James's case, psychology before it had completed its separation from philosophy) knew of phenomena like those associated with mirror neurons more than a hundred years before their scientific discovery and was already thinking about them in relation to multisensory experience. Similar concepts to those articulated by James and Peirce in the quotes above were central to the thought of Bergson ('nascent action') and Whitehead ('reenaction' as the primary phase of perception). This early philosophical inquiry, whose orientation can broadly be described as process philosophy, situates the question in a different conceptual trajectory than is usual for the contemporary scientific literature. The direction it indicates is consonant in many ways with the contemporary theoretical currents of embodied cognition and enactive perception studies. But it significantly diverges from them in two important ways. First, in calling into question the very category of cognition, bumped from its position of primacy by what can only be described as aesthetic categories. Second, in insisting that the genesis of perception can only be understood using a radically different conceptual tool set than that used to describe its fully formed structures and functions—and this applies even to such basic notions as the concepts of space and position. The following discussion will follow the trail of some of the conceptual links made in the opening quotes in order to open the discussion beyond representation—even beyond cognition—towards an artfulness of the body, in the genesis of perception, occurring in an emergent domain with a cast all its own.

1. 'Development essentially involves *a limitation of possibilities*' (Peirce). A body's capacity to produce determinate experience is acquired through a process of limitation. Neurophysiologically, this translates as a developmental passage from a neonatal 'exuberance' of 'functional hyperconnectivity' to a 'pruning away of unused connections', completed by age nine, and a strengthening of the remaining connections through learning.[7] It has been experimentally demonstrated that the quantitative neuronal hyperconnectivity of early life corresponds qualitatively to a field of perception that is characterised by an exuberance of multi-modal sensations. 'Children's perception should resemble that of adults with synaesthesia.'[8] The 'inhibition' of synaesthesia in adult perception is not complete. This is particularly true of clinical synaesthetes, who retain conscious awareness of certain cross-sensory associations. But 'remnants of these associations appear to exert unconscious influences in non-synaesthetic adults' as well.[9]

This suggests that the difference between neurotypical perception and synaesthetic perception cannot be construed in terms of a deviation from the norm. Synaesthetes do not **add** a deviation from the normal path of development. They just **prune** the same developmental path less fully. They consciously retain remnants of the developmental exuberance of experience (and often put them to use, for example as mnemonic devices). Neurotypicals prune to the trunk.[10] They inhibit multi-modal experience rising to the level of consciousness, retaining only single-channel perception—vision that is only sight, separated from what is felt by the touch; an audition that is only a sound, and not a colour. The separation of experience into perceptual modes corresponding to the separate physiological channels of sensation is not fundamental to experience and is not a developmental destiny. What is primary is, in fact, a lack of separation between the senses. This is not a simple confusion. Rather than a lack of distinction or indifference, it is an exuberant hyperdifferentiation, in continual variation—a 'continuity of changeable qualities' (Peirce). Primitively, experience comes as a 'continuity of intrinsic qualities of feeling [of which] we [neurotypicals] can now form but a feeble conception. The development of the human mind has practically extinguished all feelings, except a few sporadic kinds, sound, colors, smells, warmths, etc., which now appear to be disconnected and disparate . . . Originally, all feelings may have been connected in the same way, and the presumption is that the number of dimensions was endless' (Peirce). The original continuum is composed of an infinity of varieties of multisensory fusions, in continual qualitative

variation. The difference between the synaesthete and the neurotypical is that the synaesthete consciously retains a wider swath of the fusional continuum (albeit not much more of its changeability, since, amongst clinical synaesthetes, the retained associations tend to become coded so as to appear invariant).[11] The fact that the full continuum persists unconsciously despite its 'practical extinguishment' in 'normal perception' means that 'when any particular kind of feeling is present, an infinitesimal continuation of all feelings differing infinitesimally from that is present' (Peirce). This means that neurotypicals remain neurodiverse in *potentia*.

The cross-connection between senses is not fully 'extinguished'. Peirce says that it is 'practically' extinguished. The separation of the senses is a tendential limit never actually reached. What normally pass for mono-sense experiences are, in fact, cross-modal fusions presented in a dominant sense. For example, to see the shape and texture of the object is to perceive, in vision, its potential feel in the hand. To feel that potential touch is to see the potential kinaesthetic experience of walking towards the object.[12] Sight envelops potential other-sense experiences and would not achieve its own definition as a determinate vision without them. It is well known, for example, that object vision cannot develop without movement. Every 'single' sense experience is the envelopment in a dominant mode of appearance of an 'infinitesimal' (virtual) continuation of other-sense experiences. Every perception is a **composition** of the full spectrum of experience, 'practically' appearing as if it were disparate and disconnected from the continuum.

Each perception normally comes in a dominant experiential key. That dominant mode of appearing, however, is imperceptibly held aloft by a multisensory composition without which it would have no purchase and take no determinate shape. In the final analysis, the 'limitation' necessary for the development of determinate experience is more a question of relief—strata rising by gradations to a pinnacle—than of either/or. A sight held aloft in vision by a virtual touch. The touch enveloping a kinaesthesia. Perceptual strata in composition—a geology of experience. What distinguishes clinical synaesthetes from neurotypicals is that, in the experiential mode in which their synaesthesia presents, their conscious perception peaks not in a mono-sense experience, but in the broader stratum of a particular cross-modal connection. Clinical synaesthetes and neurotypicals have it in common to background the infinite changeability of the continuum of qualities of experience. This is done through codings that become

second nature, forming a repertory of perceptual habits and skills.[13] They attend preferentially to their respective peaks of experience.

If a perception is a composition, there is an artfulness to it. Neurotypicality and synaesthesia are each, in their own right, arts of experience. Their respective pinnacles of experience rise from the shifting ground of changeable qualities whose continual variation is habitually and skilfully overlooked at that experiential height. However, 'given a number of dimensions of feeling, *all possible varieties are obtainable by varying the intensities of the different elements*' (Peirce). A number of dimensions of feeling are always given. Thus experience can always be **recomposed** by varying the intensity of its elements. The artfulness of experience can be built upon further, leading to the formation of new perceptual habits and skills.[14] In the process, new varieties can be obtained. This amounts to a continuation of the development of perception, evolving towards new peaks, presenting itself in new determinations that are, in principle, infinite in their variety. While this artfulness of experience is in no way limited to the institutional domain of art, its expansion is one of the things art can do, when it earns its name. It earns its name by bringing intensive variations into relief—when it takes as its mission to vary the 'geological' intensities formative of experience (rather than combining already determined forms).

Since the defining limitation of the normal composition of experience is achieved through inhibition, it stands to reason that the reintensification of perception is enabled by disinhibition. This means that the composition involved cannot be achieved entirely voluntarily. The full-spectrum complexity of experience must be **released** before it can be rebuilt upon. The operation of artfulness of experience cannot be entirely voluntary. In fact, it escapes the opposition between the voluntary and involuntary, the self-effecting and the intentional. If one brings one's perception to the edge of release and inhabits the resurgent complexity, has one acted upon experience—or released oneself to be acted upon by it? Has one composed a perception—or been composed by the process of perception taking form? In that process, is one's will and conscious thought but one element on the continuum, entering into the fusional mix?

2. Mirror-touch synaesthesia is a composition of experience that entertains the same relation to the shifting geology of experience as other varieties of synaesthesia. Like all peak determinations, its effect appears from the compositional

background of other-sense textures that do not themselves appear.[15] The specific-
ity of mirror-touch synaesthesia is that its vision–touch fusion immediately raises
questions concerning the space of experience. It seems to collapse the distance
between two bodies. To put it that way, however, assumes that the space of per-
ception at the formative level is structured according to the same spatial schema
as peak neurotypical perception, and that mirror-touch synaesthesia 'errs' by
deviating from that schema, ending up spatially 'confused'. But is not the percep-
tion of space also a composition? Is not the ability to project an invariant spatial
grid on the world of perception the abstract product of a certain multisense
fusion consolidated into a skill and a habit? Our everyday navigation of the
world occurs through the inter-operation of the visual signposting of punctual
landmarks and the kinaesthetic dead reckoning on a roiling proprioceptive sea.
Our sense of living in a coordinate grid is a formalised, geometrical abstraction
from this multisense complexity which, once it has been acquired as a skill, is
consciously overlaid upon experience. There is no reason to say that a phenom-
enon like mirror-touch synaesthesia arises from a defect in spatial experience.
Given what was said earlier about the continuum of experience and its relation
to synaesthesia, it would be more precise to say that it returns to the conditions
from which neurotypical spatial perception arises and peaks from them other-
wise. This raises the question of how the potential for spatial perception accord-
ing to an abstract geometric gridding is enveloped in the continuum of intrinsic
qualities of feeling of which we normally have but a feeble conception, but from
which all definitive experiences nevertheless rise. What are the precursors of spa-
tial perception on the continuum?

'Primitively, our space-experiences form a chaos, out of which we have no
immediate faculty for extricating them. Objects of different sense-organs expe-
rienced together *do not in the first instance appear either inside or alongside or
far outside each other, neither spatially continuous nor discontinuous*, in any
definite sense of these words' (James). The potential for the experience of space
is not extended. In other words, there is no preoperative schema of juxtaposition
arraying points in external relation to each other, as on a coordinate grid. The
potential for spatial perception is enveloped on the multisense continuum. The
sensations of the senses which will compose themselves into space-experience do
not appear, in the first instance, outside or alongside each other. With no outside
or alongside, 'inside' has no meaning. Neither does continuous nor discontinuous.
An infinite continuum, it must be remembered, is not an actual formation of

smooth transition. If it were, it would be extensive. That would make it a space. The continuum of potential experience is not a space. It is not composed of points, but rather of qualities. It is a qualitative domain.

A qualitative domain is intensive. It is defined less by continuity in the extensive sense than by potential cut and recomposition. A qualitative continuum is one whose nature is to be cut into, in order for a limited expression of the potential it holds to definitively appear. Uncut, it is too intensely full of itself for anything in particular to come of it. At each cut into the continuum, it is as if the qualitative domain folded over on itself, like origami. With each refolding, it presents a new facet. A stand-out form held aloft by an imperceptible organisation of subfolds stands out in experiential relief. Tectonics of folding must be added to the idea of a geology of experience. A qualitative continuum is defined as one that cannot be cut without changing in nature.[16] It cannot origami itself into an experiential prominence without re-expressing itself with a difference. To conceive of the continuum in itself, outside any unfolding from a cut, it is necessary to think in terms of **mutual inclusion**—a simultaneity of infinite qualitative varieties that are 'located in each other' and 'do not interfere with each other' (James). In Bergson's vocabulary, they are in a state of mutual 'interpenetration'. In Deleuze's vocabulary, they are in a state of 'reciprocal presupposition'.

This mutual inclusion of an infinite variety of qualitative varieties is a limit-concept. The reality of the continuum in itself is unactualisable. It is virtual. This virtual 'chaos' (James) might more accurately be renamed, using one of James's own signature terms—a **confound**. The continuum is not chaotic in the sense of an unformed mess. It is a virtual form of hyperdifferentiation of potential qualities of experience, found together, each in the other, confounded, fused together, in simultaneity and without interference. This is not a mess. It is a hyperorder of qualitative varieties in mutual interpenetration, ready to express—always in a stand-out facet, limitatively expressing the infinite variety of the continuum, in a particular composition of the geology of perception, with its own relief.

How, if 'we have no immediate faculty for extricating' an expression, is the cut ever made? How do we not implode into the intensity, lost in the infinite virtual folds of potential experience?

In a word: through **movement**. Every movement makes a cut—it brings certain elements of experience into relief, origami-ing the continuum on the fly. Originally, it is not we who move our body volitionally. It is our body that is moved, by the variation of experience in the making. The infant body is a chaos

of involuntary fits and starts. The baby is possessed by movement; it is a creature of undirected activity. Our body's potential for development is this primitive chaos. We begin bodily lost in the intensity of the qualitative confound of experience. Far from being a chaos in the sense of pure randomness, the confound of experience in the making is hyperfull of differentiations, pre-tracing potential orders too numerous and changing to be able to register yet. Little by little, by dint of repetition, certain multisense connections start to stand in relief: a touch on the lips and a taste of milk; the sound of footsteps announcing the imminent arrival of a touch on the lips and a taste of milk; a texture against the skin; a shape suddenly registering in a blindly groping hand; a sight settling on the shape. From this limited, chaotic self-organising, nexuses of intersense experience gradually appear and come to stand out against what is henceforth the experiential background of the confound of experience. The nexuses register. They crystallise into objects. The objects return in a pattern of juxtapositions, disjunctions, and conjunctions, forming a web of extensive relations. From that web, a sense of an abstract extensive order finally emerges: an order of alongsides, outsides, and insides. Space has come. It has come out of movement, patterned by its repeated variation.

There is a primacy of movement. Primitively, the movement is undirected. But as objects appear, so does directness. It is not at first so clear as a willing-toward. The body is still being moved, but gradually the moves become less random and more patterned. The body is first moved, outside its own control, by a chaos of appetition. The appetition settles into preferential directions, as perception settles into objects designating termini for appetition's striving. Appetition starts out uncontrolled but becomes directed. It starts unconscious but rises to consciousness with the emergence of the system of objects and its extensive spatial order. This extensive ordering enables directionality by enabling discrimination—limited focus on a delimited locus. The primitive chaos of the body is now more composed. It had been captured, by and for appetition's directional channelling. The body can now orient itself and navigate the confound. Our sense of self is the product of this capture.

Once again, the achieved directedness is not so clearly a question of voluntary control taking over from involuntary activation. It is not so much that we now control our impulses, matured into desires and intentions. What has happened is that our appetitions have become self-possessed of their own emergent patterning. It is less we who possess self-control than that our appetitions **emergently**

self-possess us. Before we can be said to be in any way subjectively in possession of ourselves, we are bodily possessed of movement coming into possession of its own orientability, mapping its emergent patternings into an extensive order. We are self-composed by this process of emergence, predicated on movement's patterned relation to itself, bootstrapping itself from the infinitely open qualitative domain that is the confound of experience, in a developmental order-out-of-chaos effect. Our possession by this emergent order-out-of-chaos effect 'subsists to a great degree throughout life' (James). We continue to be self-possessed of our appetition's patternability and, as a function of its self-patterning, its orientability. The primitive chaos of the body follows us throughout life, providing a ready field for re-emergence. If this were not the case, our world of experience would lose its intensity and plasticity. It would mineralise into the gridding that emerged from it. It would plateau in it and content itself with the directional predictability of its own flatness.

The importance of this for mirror-touch synaesthesia is that although the phenomenon seems to pertain to space, it must be understood more fundamentally to concern **movement.**[17] In view of the role of movement in the genesis of experience and of the self, the supposed spatial 'confusion' involved in mirror-touch synaesthesia must be conceived of very differently.

3. 'Corresponding to every feeling within us, some motion takes place in our bodies' (Peirce). Physiologically, the motion in our body accompanying every feeling is the firing of mirror neurons, recruiting an extended network of activations throughout the brain. But this is just the somatic tip of the experiential iceberg. As Raymond Ruyer says, the movements in the brain are but the form in which experience most directly appears to the outside observer. In other words, they are the registering of experience as an extensive system of movement, for a learned observer schooled in spatial gridding. The imperceptible regions of the iceberg are the intensity of experience from which the extensity of spatial experience peaks. In itself, experience is an unlimited confound of infinite, self-folding complexity (physiologically registered in the extensive folds of the brain). In intensity, movement is not activation at a point in a grid, or displacement between two points on a grid, or even the co-activation of a network of points. Qualitatively, experience is 'a process set-up anywhere' that 'reverberates everywhere' (James), rippling through the confound of experience. 'Every possible feeling produces a movement, and that movement is a movement of the entire organism, and of

each of its parts' (James). But 'organism' must not be understood as limited to the physiological tip of the iceberg. It must be understood to include the virtual 'tectonics' of the confounded domain of potential variation from which all determinate experience rises.

The mutual inclusion of potential takings-determinate-form of experience has an order that does not map one-to-one to the system of extensive orientation to which it gives rise. All of the variations are in absolute proximity to one another, registering all the others in its own changeability. A change in one variety ripples into a change in all the others, in mutual deformation, like the rubber band Bergson uses as an example of the 'qualitative multiplicity' that experience is aboriginally.[18]

The complexity of the hyperorder, of which we can only give ourselves a feeble conception, can be intuited if we imagine every variety of potential experience moving simultaneously, with infinite speed, into all others, passing thresholds between sense modalities and forming multisense fusions in profusion as it goes. This is movement in place, without displacement. An imperceptible vibration of potential variations on experience, rehearsing themselves, in intensity.[19] The displacements of the physiological body in extensive displacement in space is doubled in intensity by a vibratory virtual body of pure variability. A determinate experiential form origamies into relief when an actual movement cuts its patterning and orientation into the vibratory intensity of the virtual body, drawing out a determinate stand-out expression of the potential it enfolds. This moving act of composition is action upon action, extensive movement cutting into the continuity of intensive movement, to unfold its own discrete form from it.

The closest geometrical approximation to the hyperorder of the virtual body is not the extensive grid defined by the Cartesian coordinates. It is topological. Topology is the geometry of continuous deformation. It is the mathematics of folding. A topological form is not limited by boundaries in Cartesian space. It is limited by events—by cuts. A topological figure comprises all of the foldings and stretchings and refoldings that fall within the limits of two cuts, as when a rubber band breaks.[20] The rubber band of experience 'breaks' when extensive movement cuts into the vibratory intensity of the virtual body, throwing out a shard of experience, which then stands out for itself against the integral background of the variability of experience from which it came. From the point of view of this discretely appearing, limited form of experience, the continuum of

experience against which it stands out is not a background in any spatial sense. It is the field of emergence of experience: its genesis, its imperceptible interval of formation. The topology of experience can only be thought by resituating spatial experience with respect to the interval of its genesis in the topology of experience. Topological transformation implies a virtual time of transformation—pure process.

Extensive geometry is exoreferential—it enables points, and the objects occupying them, to be located in relation to each other according to a system of external relations. Topology is **endoreferential**—it concerns the processual mutual inclusion of variations. These are defined by what are called 'internal relations', although the term is misleading because the concept does not connote insideness, but rather mutual interpenetration—a mutual inclusion that is 'in' nothing but the infinite, incessant passing into and out of each other of the ungriddable qualitative variations whose simultaneous in-each-otherness composes the time-like process-space of the virtual body. Not the inside of experience, but experience's **immanence** to its own changeability.[21]

From this point of view, the mirror-touch synaesthesia effect of a touch that is at two places at once is completely understandable. Mirror-touch synaesthesia retains the passing into and out of each other of two modes of experience—vision and touch—bracketing exoreferential positioning on the spatial grid as well as movement as extensive displacement on that grid. **The mirror-touch effect occurs on the virtual body** where the non-locality of such spooky action at a distance is the norm, by processual dint of the mutual inclusion. To say that mirror-touch has to do with spatial confusion is to be confused about the fact that the physiological body is the tip of the iceberg of the virtual body. Instead of registering a determinate stand-alone experience on the spatial grid, mirror-touch synaesthesia contrives to double-register the same experience simultaneously at two different points in extensive space-perception.[22] This is the result of a folding of vision and touch into each together on the virtual body, their in-each-otherness immediately refracted onto two points on the coordinate grid of developed experience. The mirror-touch effect is a limited expression of the integral, everywhere in-each-otherness of the infinitely, qualitatively multiple transformations of the virtual body. The expression is limited, to two. But that is still more multiple than one.

Understood in this way, mirror-touch synaesthesia is not an error in spatial perception. It is a less-limited-than-normal expression of the truth of the body

(the truth of the body's virtual doubling by its own potential for variation).[23] Neither is mirror-touch synaesthesia an error in self-other distinction. A synaesthete does not come out of the experience of mirror-touch confused as to where the touch can be located spatially. It is just that before the touch is located spatially, it refracts at infinite speed into two locations, so that the **qualitative nature** of the event immediately registers. The spatial gridding of experience is bracketed for an imperceptible interval, so that the truth of its genesis in ceaseless qualitative transformation may express itself in the defined form of a touch that as directly concerns me as you. As directly concerning me as you is a definition of **sympathy**. Sympathy is the qualitative nature of the event.[24]

What mirror-touch synaesthesia makes palpable is the fact that the genesis of experience is fundamentally sympathetic. The virtual body **is** the very process of sympathy, by virtue of which any transformation anywhere on its continuum by nature reverberates everywhere. In the genesis of experience, a transformation cannot solely concern you and not me, or vice versa. Such distinctions belong to the plateauing of fully developed experience in the diminished intensity of extensive perception. But this does not mean there is a confusion between you and me. It means that in the genesis of perception, there is a mutual inclusion in the virtual body whose topological complexity is afold with experience's forming, of what in developed experience will selectively concern only one, as opposed to other. You and I, self versus other, are cut from the same immanence of experience unfolding into spatially distributed, determinate expressions. Distinctions like self and other are but the tip of the iceberg whose imperceptible topological vastness is, processually, as much in one's development as in another's, in that both are in each other's potential to mutually transform by virtue of their co-implication in the same event. The formative **relation** of co-implication in the same event is the changing ground of experience. If the virtual body can be said to represent anything, it is this relationality of the life of the body.

The scientific literature speaks of the simultaneous in-each-otherness of two experiences in mirror-touch, and more generally of the operations of mirror-neurons with which it is associated, in terms of 'empathy'. The concept of empathy implies an interiority of experience. Etymologically, 'empathy' means 'in-feeling' (as opposed to sympathy's 'feeling-with'). The connotation of an interiority of experience suggests a base-state of separation from the world and from other bodies that must then be overcome. That overcoming is usually conceived in terms of identification. Anywhere notions of identification are employed, the

notion of a private world of interior experience is reactivated, whether intended or not. Identification assumes the coordinate grid of spatial separations as an a priori given. It further assumes that the selves 'inside' of which experiences occur are separated subjectively from each other in much the same way as are points in space. These separations are overcome—actually illusionarily disavowed— by projection. One self projecting its experience across the spatial divide and 'mistaking' what belongs to the opposing self as being 'inside' of itself. There is no doubt that identification happens. But it is a secondary process, occurring on the derived stratum of extensive relation.[25]

The primary process is the non-locality of sympathy—the immediate relationality such that what is set up anywhere reverberates everywhere. This is the generative level of all experience, and the seat of all development, which continues to exert an at least unconscious influence. The same must be said of this aboriginal sympathy, as was first said of synaesthesia, and then the 'chaos' of spatial perception—it subsists throughout life. Its process doubles all bodily experience with a virtual body representing the capacity of experience to vary through events of relation. Although the virtual body cannot be said to 'exist' in space or in metric time, as the measure of displacement across space, it is as real as relation. It 'subsists' immanent to all spatial location and moments of time, in the topological recess of experience's in-the-making.

Mirror-touch synaesthesia stands as a reminder of the primary process of the origami of experience. Its here-and-there, simultaneously in-me-and-you effect points to the imperceptible activity of the virtual body folding out into determinate experience. It signposts the body's continual endoreferencing to its own relational variations and to its inexhaustible, eventful capacity to change. The mirror-touch duality, instead of being denigrated as a defect, can be seen as an index of the more encompassing—in fact, indefinitely mutually inclusive—qualitative multiplicity of the floating geology of the processual iceberg of the living, moving body. It can be appreciated as a gateway opening back onto the formative complexity of experience—to the artfulness of the body's self-possession of experience.

Mirror-touch synaesthesia's artfulness of the body can be an example to art, in the sense of a specialised arena of activity. It is a reminder to art that, given a number of dimensions of feeling, all possible varieties are obtainable by varying the intensities of the different elements—that experience can always be recomposed, if it is its formative intensities, rather than its already acquired forms, that

are attended to. Art, attentive to the relational complexity of experience's in-the-making, can make itself the experimental practice of composing new peaks of perception expressing the living, moving body's qualitative multiplicity, unfolding in new variations its capacity to change.

Endnotes

1. William James, 'Principles of Psychology', vol. 2 (New York: Dover, 1950), 181–4.
2. C. S. Peirce, 'Some Consequences of the Four Incapacities', in Nathan Houser and Christian Kloesel, eds., The Essential Peirce: Selected Philosophical Writings, vol. 1 (Bloomington: University of Indiana Press, 1992), 44.
3. James, 'Principles of Psychology', 2, 371, 380–1.
4. Peirce, 'The Essential Peirce', 1, 323–4.
5. See, for example, Michael J. Banissy, Vincent Z. Walsh, and Neil G. Muggleton, 'Mirror-touch synaesthesia: a case of faulty self-modelling and insula abnormality', Cognitive Neuroscience (2011), 2, 2, 98–133.
6. I do not mean to suggest that the dangers of this model are unacknowledged or that many authors do not consciously work against it. The point is that the difficulties of effectively surpassing it are considerable and require dedicated philosophical labour. An unintended return to the passive reception model occurs frequently in the literature at critical points, piggy-backing on the vocabulary of representation, imitation, body image, and body map, all of which implicitly presuppose an inspecting, cognising subject. These slippages are most palpable when the first-person pronoun is resorted to, for example in

discussions of how 'we' relate to the phenomenon under discussion.
7. Daphne Maurer, Laura C. Gibson, and Ferrine Spector, 'Synaesthesia in Infants and Very Young Children', in Julia Simner and Edward M. Hubbard, eds., The Oxford Handbook of Synaesthesia (Oxford: Oxford University Press, 2014), 46–7.
8. Maurer, Gibson, and Spector, 50.
9. Maurer, Gibson, and Spector, 51.
10. I am borrowing the term 'neurotypical' from the autistic self-affirmation movement where it is used to refer to non-autistics. The term is beginning to gain wider currency amongst a number of communities whose 'neurodiverse' perceptual or cognitive manners of being are considered, according to prevailing standards, to depart from the norm. See Erin Manning, 'Always More Than One: Individuation's Dance' (Durhan, NC: Duke University Press, 2013) and 'The Minor Gesture' (Durhan, NC: Duke University Press, forthcoming).
11. Maurer, Gibson, and Spector, 54.
12. George Berkeley, 'An Essay Towards a New Theory of Vision', in A New Theory of Vision and Other Essays (London: J. M. Dent & Sons, 1957 [1709]), 13–86.
13. Maurer, Gibson, and Spector, 54–6.
14. Although synaesthesia is fundamentally involuntary, its rising to the consciousness level of explicit experience can be acquired. As the next paragraph argues, this does

not mean, however, that it becomes voluntary; rather, it has the status of an acquired automaticity (i.e. a habit). See Daniel Bor, Nicolas Rothen, David J. Schwartzman, Stephanie Clayton, and Anil K. Seth, 'Adults can be trained to acquire synethetic experiences', *Scientific Reports* (2014), 4, 7089, doi:10.1038/srep07089.

15. 'Mirror-touch synaesthetes have been found to show an increased tactile sensitivity, which is in line with evidence of heightened perceptual processing of the synthetic concurrent in other variants of synaesthesia. ... Mirror-touch synaesthesia is a consequence of increased neural activity in the same mirror-touch network that is evoked in non-synaesthetic controls when observing touch to another person and therefore may be mediated by the "normal" architecture for multisensory interaction' (Michael J. Banissy, 'Synaesthesia, Mirror Neurons, and Mirror-Touch', in *The Oxford Handbook of Synaesthesia*, 589).

16. Cut out the yellow band of the spectrum of natural light, as many LED lightbulbs do, and what you get is not more or less light, but a different quality of light.

17. The central role of movement is seen in mirror-touch synaesthesia in the fact that 'observed touch to another person in a video evoked a significantly more intense synaesthetic experience than observing similar touch in static photographs' (Banissy, 587).

18. Henri Bergson, '*Creative Evolution*', trans. Arthur Mitchell (New York: Dover, 1998), 265.

19. Whitehead on vibration: 'We shall conceive each primordial element as a vibratory ebb and flow of an underlying energy, or activity ... each primordial element will be an organised system of vibratory streaming' (A. N. Whitehead, '*Science in the Modern World*' [New York: Free Press, 1967], 35; see also 131–6; 154–5). Bergson on vibration, the imperceptible interval of perception's arising, inhibition, the difference between intensive and extensive relations, and change: 'May we not conceive, for instance, that the irreducibility of two perceived colours is due mainly to the narrow duration into which are contracted the billions of vibrations which they execute in one of our moments? If we could stretch out this duration, that is to say, live it at a slower rhythm, should we not, as the rhythm slowed down, see these colours pale and lengthen into successive impressions, still coloured, no doubt, but nearer and nearer to coincidence with pure vibrations? In cases where the rhythm of the movement is slow enough to tally with the habits of our consciousness, as in the case of the deep notes of the musical scale, for instance, do we not feel that the quality perceived analyses itself into repeated and successive vibrations, bound together by an inner continuity? That which usually hinders this mutual approach of motion and quality is the acquired habit of attaching movement to elements—atoms or what not—which interpose their solidity between the movement itself and the quality into which it contracts ... Motion becomes then for our imagination, no more than an accident, a series of positions, a change of [external] relations; and, as it is a law of our representation that in it the stable drives away the unstable ...' (Henri Bergson, '*Matter and Memory*',

trans. Nancy Margaret Paul and W. Scott Palmer [Mineola, NY: Dover, 2004], 269). Deleuze on vibration, event, and extension: 'The event is a vibration with an infinity of subharmonics or submultiples, such as an audible wave, or an increasingly smaller part of space over the course of an increasingly short duration. For space and time are not limits but abstract coordinates . . . in extension' (Gilles Deleuze, *The Fold: Leibniz and the Baroque*, trans. Tom Conley [Minneapolis: University of Minnesota Press, 1993], 77; see also 4, 95–6).

20. For more on the topology of experience, see Brian Massumi, 'Strange Horizon: Buildings, Biograms, and the Body Topologic', in *Parables for the Virtual: Movement, Affect, Sensation* (Duke: Duke University Press, 2002), 177–207.

21. The five traditional senses are exteroceptive, or exoreferenced. Proprioception is the interoceptive sense par excellence. It is essentially endoreferential and must be understood topologically. As such, it is the actual sense functioning closest to the virtual body, whose geometry of internal relations it shares. See Massumi, *'Parables for the Virtual'*, 58–61, 168–9, 179–84.

22. This applies equally to the 'specular' and 'anatomical' variants of mirror-touch synaesthesia Specular mirror-touch synaesthesia is when the experienced location of a touch is reversed, as in a mirror, and anatomical mirror-touch synaesthesis is when the reversal does not take place so that a touch on the right side is experienced on the left. From the point of view developed here, even in the anatomical variant, where there seems to be a direct correspondence, there is still an underlying topological transformation folding sight and touch into each other.

23. The link between mirror-touch synaesthesia and the virtual body is exemplified by the fact the most common cases of acquired mirror-touch synaesthesia occur in amputees who experience a phantom limb (Banissy, 594). The mirror-touch effect occurs when touch is perceived on another body on the corresponding limb. It is as if the loss of the actual limb leaves the body with only a virtual body to operate with in that region of experience, and striving to complete the circuit between the physiological and virtual body gives rise to a consciousness of the virtual body in the form of a virtual touch.

24. For an extended discussion of sympathy in this connection, working from David Hume's account, see Brian Massumi, *'The Power At the End of the Economy'* (Durham: Duke University Press, 2015), 60–5.

25. The scientific literature distinguishes between cognitive, motor, and emotional empathy. What I am referring to as sympathy integrally combines the motor and the emotional, and contrasts these taken together with the cognitive (here, the conscious peaking of experience). Giacomo Rizzolatti, one of the discoverers of mirror neurons, remarks upon the indissociability of the motor and emotional in mirror neuron-related experience: 'The fact remains that these [emotional and empathic] phenomena have a common functional matrix similar to that which intervenes in the understanding of actions' (Giacomo Rizzolatti and Corrado Sinigaglia, *'Mirrors in the Brain: How Our*

Minds Share Actions and Emotions'
[Oxford: Oxford University Press,
2008], 192). Once again, I am not
arguing that the concept of projection
is universally accepted amongst
researchers or that the model of
identification is never called into
question. The issue, once again, is
the tenaciousness of philosophical
presuppositions and their tendency to
return uninvited. The work of Vittorio
Gallese (a co-discoverer of mirror
neurons) on empathy understood
in terms of a 'shared manifold'
than underlies, and gives rise to,
the sense of self **and** other is close
to the perspective advocated here
(excepting its continued use of the

concept of representation): Vittorio
Gallese, 'The roots of empathy: the
shared manifold hypothesis and the
neural basis of intersubjectivity',
Psychotherapy (2003), 36, 171–80,
doi: 10.1159/000072786. Freedberg's
and Gallese's concept of unmediated
'simulation' of physical involvement
with other's feelings, associated
with mirror neurons, is allied to the
philosophical concepts of reenaction
or nascent action mentioned at the
beginning of this article: David
Freedberg and Vittorio Gallese,
'Motion, emotion, and empathy
in esthetic experience', *Trends in
Cognitive Sciences* (2007), 11, 5,
197–203.

Intimate Otherness

In Conversation

Thomas J. Csordas and Trisha Donnelly

If I see someone touching his or her cheek with a finger and I immediately feel a touch on my cheek, it may not be as astounding as it first seems and may also be of far broader consequence than it at first seems. The starting point for elaborating this thesis is the phenomenological concept of intersubjectivity, our bodily coexistence in the world with others. Intersubjectivity in this sense does not mean a single subjectivity shared between two or more people, nor does it mean a relation between two isolated subjectivities or egos. Thus the mirror-touch is neither the 'same' touch nor is it 'as if' my cheek were touched. As Edmund Husserl, the founder of phenomenological philosophy suggested, it is based on a deep and immediate (in the sense of unmediated) experiential analogy each of us spontaneously makes with other people. The prominent phenomenologist Paul Ricoeur elaborated this idea using the phrase of another person being essentially 'like me,' and the equally prominent phenomenologist Maurice Merleau-Ponty likewise described our experience of another person as 'another myself'.

For Ricoeur, the critical principle in Husserl's theory of intersubjectivity is the analogy that the alter ego is an ego 'like me'. Ricoeur makes a very delicate and absolutely critical point in insisting that Husserl does not use analogy in the sense of reasoning by analogy of the form A is to B as C is to D. This erroneous argument would be stated in the form 'what you experience is to the behavior that I am observing as what I experience is to my own outward behavior, resembling yours',[1] the error being that one can compare lived expressions and observed expressions on the same plane. For Ricoeur, the key to Husserl's use of analogy is the word 'like', for it is this likeness that ensures that our interpretation of others is:

not only immediate, it is recurrent, in the sense that I understand myself on the basis of thoughts, feelings, and actions deciphered directly in the experience of others [this] use of analogy is built, precisely, on the description of the perception of others as being a direct perception. It is out of this direct reading of emotion in its expression that one must, through explication, bring out the silent analogy that operates in direct perception.[2]

Being a subject for oneself is entirely discontinuous with the lived experience of another person, but perceiving another person is radically different from perceiving a thing because it is characterised by a 'co-positing' of two subjects simultaneously, and '[t]his doubling of the subject is the critical point of the analogy'.[3] We are neither isolated cogitos that must bridge a gulf of solipsism nor participants in the same shared subjective substance. We are similar—all others are like me in the sense that all others 'are egos just as I am. Like me they can impute their experience to themselves',[4] and in this sense, the words I, you, he, she, we, and they are equal and analogous. The importance of this principle of analogy is that phenomenology does not 'assume anything other than the analogy of the ego in order to support all the cultural and historical constructions described by Hegel under the heading of spirit, so that phenomenology holds itself to the claim of postulating only the reciprocity of subjects and never a spirit or some additional entity'.[5]

In Merleau-Ponty's view, the analogy through which intersubjectivity is constituted forms a kind of fabric of recognition that others are similar kinds of being inhabiting a shared world as bodily beings:

It is thus necessary that, in the perception of another, I find myself in relation with another 'myself,' who is, in principle, open to the same truths as I am, in relation to the same being that I am. And this perception is realized. From the depths of my subjectivity I see another subjectivity invested with equal rights appear, because the behavior of the other takes place within my perceptual field. I understand this behavior, the words of another; I espouse his thought because this other, born in the midst of my phenomena, appropriates them and treats them in accord with typical behaviors, which I myself have experienced. Just as my body, as the system of all my holds on the world, found the unity of the objects which I perceive, in the same way the body of the other – as the bearer of symbolic behaviors and of the behavior of true reality – tears itself away from being one of my phenomena, offers me the task of a true communication, and confers on my objects the new dimension of intersubjective being or, in other words, of objectivity.[6]

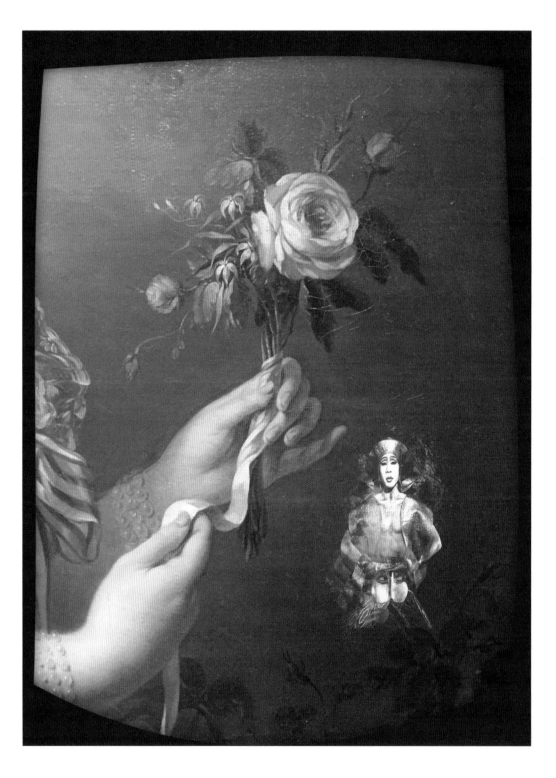

Insofar as we perceive that others perceive, and insofar as there is a possibility of agreement on what we perceive, objectivity is created by intersubjectivity, which is also an experientially concrete intercorporality. In other words, what we call objectivity is predicated on our implicit agreement that the world exists for us in common, and it is critical in this view that this common world is based on our shared bodily being. Merleau-Ponty uses the German *Ineinander*, literally 'in one another', a term he draws from Husserl and defines as 'the inherence of the self in the world and of the world in the self, of the self in the other and the other in the self'.[7]

If this is what intersubjectivity really is,[8] then it is also the ground of empathy, but there is more to be said about how it is possible. Following this phenomenological line of thought, what makes possible this intersubjectivity understood as analogy-based coexistence with others is an even more intimate alterity grounded in the existential structure of our embodiment. Think of it this way: we can surprise ourselves, and indeed we are always a bit outside ourselves, outrunning or lagging a bit behind and seldom in perfect accord with ourselves; at the same time, we are inevitably surprised by others, given the impossibility of perfectly coinciding with them in thought or feeling, mood or motivation. In this sense, the problem of subjectivity is that we are never completely ourselves, and the problem of intersubjectivity is that we are never completely in accord with others. Yet from a more positive standpoint, the very possibility of intersubjectivity with others is based on the implicit recognition that we also have an element of otherness within ourselves. My argument is that alterity is a fundamental aspect of human being—let us say an elementary structure of existence.

To make this notion of alterity of the self as embodied otherness more precise, first consider Merleau-Ponty's discussion of the intertwining or chiasmus between the sentient and the sensible within our own bodies: 'My hand, while it is felt from within, is also accessible from without, itself tangible, for my other hand'[9]—a 'double sensation' referred to elsewhere in this volume. Furthermore, he observes that one can have the curious situation of one hand's touching an object and at the same time being touched by the other hand, such that there is a criss-crossing and reversibility of the sentient and the sensible:

> There is a circle of the touched and the touching, the touched takes hold of the touching; there is a circle of the visible and the seeing, the seeing is not without visible existence; there is even an inscription of the touching in the visible, of the seeing in the tangible—and the converse; there is finally a propagation

of these changes to all the bodies of the same type and of the same style which
I see and touch—and this by virtue of the fundamental fission or segregation
of the sentient and the sensible which, laterally, makes the organs of my body
communicate and founds transitivity from one body to another.[10]

Merleau-Ponty struggles for metaphors to describe this intimate alterity of
embodiment, trying two leaves or layers, two halves of a cut orange that fit
together perfectly but are still separate, two lips of the same mouth that touch
one another in repose, 'two circles, or two vortexes, or two spheres, concentric
when I live naively, and as soon as I question myself, the one slightly decentered
with respect to the other'.[11]

To further describe the kernel of embodied otherness, Merleau-Ponty uses
the French word *écart*, which can be translated as 'gap', 'interval', 'distance',
'difference', or 'lapse'. Gail Weiss calls attention to this term in a brief, but
important, chapter, calling it a 'space of non-coincidence that resists articulation
. . . the unrepresentable space of differentiation . . . the invisible "hinge" that
both makes reversibility [between the sensible and the sentient] possible and,
simultaneously, prevents it from being fully achieved'.[12] Merleau-Ponty indeed
takes pains to emphasise that:

> it is a reversibility always imminent and never realised in fact. My left hand is
> always on the verge of touching my right hand touching the things, but I never
> reach coincidence; the coincidence eclipses at the moment of realisation, and
> one of two things always occurs: either my right hand really passes over to the
> rank of touched, but then its hold on the world is interrupted; or it retains its
> hold on the world, but then I do not really touch it—my right hand touching,
> I palpate with my left hand only its outer covering.[13]

In this respect, Weiss observes that '*écart*, as the moment of disincorporation
that makes all forms of corporeal differentiation possible, is also precisely
what allows us to establish boundaries between bodies, boundaries that must
be respected in order to respect the agencies that flow from them'.[14] Yet it is the
ground not only for boundaries, but for intersubjectivity and intercorporeality.
To reiterate, the *écart* 'founds transitivity from one body to another'. Merleau-
Ponty says: 'If my left hand can touch my right hand while it palpates the tan-
gibles, can touch it touching, can turn its palpation back upon it, why, when
touching the hand of another, would I not touch in it that same power to espouse
the things that I have touched on my own?'[15] Here my emphasis is on this inevi-
table moment of embodied otherness as the kernel of the self's alterity, an inner

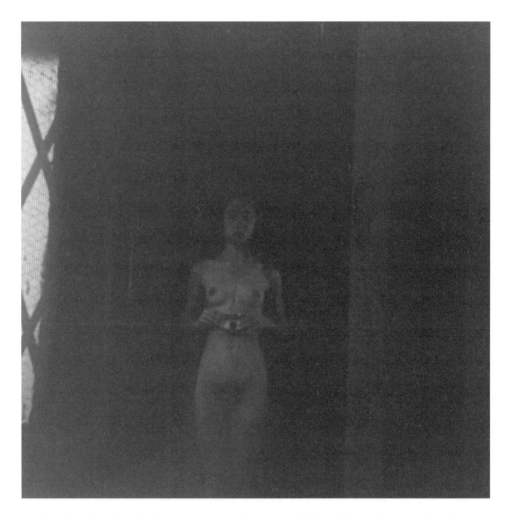

Adrian Piper, Food for the Spirit # 1 (gelatin silver print, 1997), 1971. Adrian Piper, *Food for the Spirit*, 1971 (photographic reprints 1997). 14 silver gelatin prints and original book pages of a paperback edition of Immanuel Kant's *Critique of Pure Reason*, torn out and annotated by Adrian Piper. 15" × 14,5". *Detail:* photograph #1 of 14. Collection Thomas Erben. © APRA Foundation Berlin.

reversibility that corresponds to the reversibility between self and other, and forms the existential ground for the phenomenon of mirror-touch synaesthesia.

Elizabeth Grosz carries this line of thinking a step farther, not only grounding alterity in embodiment, but making it the very precondition of embodiment:

> Bodies themselves, in their materialities, are never self-present, given things, immediate, certain self-evidences because embodiment, corporeality, insist on alterity, both that alterity they carry within themselves (the heart of the psyche lies in the body; the body's principles of functioning are psychological and cultural) and that alterity that gives them their own concreteness and specificity (the alterities constituting race, sex, sexualities, ethnic and cultural specificities). Alterity is the very possibility and process of embodiment: it conditions but is also a product of the pliability or plasticity of bodies which makes them other than themselves, other than their 'nature,' their functions and identities.[16]

Grosz makes these comments about alterity in the context of sexual difference, but in general the insistence on alterity of which she speaks is a direct consequence of the indeterminate pliability and plasticity that is emphasised by much contemporary scholarship on embodiment and, for our purpose, can be identified with the body's spontaneity in contrast with its 'natural' (regular and law-governed) functions and cycles.

Slightly and, I might add, inevitably decentred, the 'fundamental fission or segregation' of the écart is also over-determined. We can see it in our mirror image, the encounter with which Lacan (1977) argues is formative of the self at an early stage of development.[17] We can see it in the bilateral symmetry of our bodies, which is, moreover, an imperfect symmetry, as anyone can observe who has attempted to grow nicely balanced sideburns on a face with one ear inevitably slightly higher than the other. In another sense, the phallus is the other of the male, as the fetus is the other of the female. Certainly both the phallus and the pregnant female are images that can be found throughout human religion as symbols of the divine. But the other on the body's outside that is the phallus is different from the fetal other within. Specifically, when the penis becomes the phallus, it is 'sovereign', and the man who withdraws his allegiance in a moment of doubt can be punished by the disappearance of this other, the reversion of the phallus to a mere penis, leaving him to drown in the mirror of abandonment. In the case of the fetus, the valence of dependency is reversed; it is the fetus that is profoundly dependent and cannot exist alone. Thus there

are two gendered modes of intimate embodied otherness with different valences of dependency and therefore different potentials for becoming vehicles of the divine. From this standpoint, the recurrence of the phallus and the pregnant female in religious symbolism does far more than to signal the veneration of potency or fertility.

The domain of religion is where the intimate alterity of embodiment that undergirds our intuitive fascination with the mirror-touch phenomenon taps into something much larger. For alterity in this sense is the phenomenological kernel that is ultimately elaborated into the religious sentiment in all its multitude of forms.[18] To make this claim more concrete, consider the classical phenomenologist of religion Rudolph Otto, who claimed that the object towards which the religious consciousness is directed is a *mysterium tremendum et fascinans*, and the central characteristic of which he described as follows:

> Taken in the religious sense, that which is 'mysterious' is—to give it perhaps the most striking expression—the 'wholly other,' that which is quite beyond the sphere of the usual, the intelligible, and the familiar, which therefore falls quite outside the limits of the 'canny,' and is contrasted with it, filling the mind with blank wonder and astonishment. . . . the essential characteristic . . . lies in a peculiar 'moment' of consciousness, to wit, the *stupor* before something 'wholly other' . . . [19]

The invocation of blank wonder, astonishment, and stupor is striking, but I would call attention instead to the phenomenon of the 'wholly other', pointing as well to the manner in which Otto cites the 'limits of the "canny"'. Gerardus Van der Leeuw had a corresponding observation about the object of religion:

> The first affirmation we can make about the Object of Religion is that it is a highly exceptional and extremely impressive 'Other.' Subjectively, again, the initial state of man's mind is amazement; and, as Soderblom has remarked, this is true not only for philosophy but equally for religion. As yet, it must further be observed, we are in no way concerned with the supernatural or the transcendent: we can speak of 'God' in a merely figurative sense; but there arises and persists an experience which connects or unites itself to the 'Other' that thus obtrudes . . . this Object is a departure from all that is usual and familiar; and this again is the consequence of the *Power* it generates.'[20]

This formulation is somewhat more sober than Otto's, even in the way it identifies amazement as the initial state of man's mind. It also, at least momentarily, speaks of God in a figurative sense and of the supernatural and transcendent as

secondary to the encounter with otherness. My intent is to invert the argument of these classical phenomenologists of religion, suggesting that their error was to make a distinction between the object and the subject of religion when the actual object of religion is objectification itself, the rending apart of subject and object that makes us human and, in the same movement, bestows on us—or burdens us with—the inevitability of religion. To be precise, the 'object' of religion is not the other; it is the existential aporia of alterity itself that is the phenomenological kernel of religion.

For Otto, the numinous can be understood only 'by means of the special way it is reflected in the mind in terms of feeling'. Following Schleiermacher, he identifies this feeling as a certain kind of dependence. He names this 'creature-feeling . . . the emotion of a creature, submerged and overwhelmed by its own nothingness in contrast to that which is supreme above all creatures'.[21] Is this creature the infant or the animal, or the adult in prayer? It has been said that apes cannot swim and indeed often panic and drown because, unlike other mammals including dogs and horses, which swim instinctually, they are rational beings and reason tells them that they will drown if they breathe in water. Humans cannot swim instinctually either, but we have the capacity to imagine beyond reason, and it allows us to transcend ourselves—to surprise ourselves—and figure out how to move around in the water.

The image of water, of being submerged, the invocation of the creature, of dependence, and most of all of our attempt to come to grips with alterity suggest the relevance of Georges Bataille's theory of religion, in which animality and water figure heavily. Bataille's work invokes a profound alterity by inverting the expected relation between immanence and transcendence. In his view, the goal of religion is to recapture the intimacy of an immanence prior to all alterity, and he shows how very strange that is. The primary image is that of one animal eating another. 'What is given when one animal eats another is always the fellow creature of the one that eats',[22] in complete immediacy and without there being between the two any relation of subordination, difference, dependence, transcendence, objectification, discontinuity, consciousness, or duration. Since for the animal, nothing is given through time; the destruction of the eaten is 'only a disappearance in a world where nothing is posited beyond the present'.[23] Bataille might respond to Otto that this is the original creature-feeling, as opposed to the feeling of having been created that Otto implies. And far more than the feeling of being submerged, far more even than a feeling that is

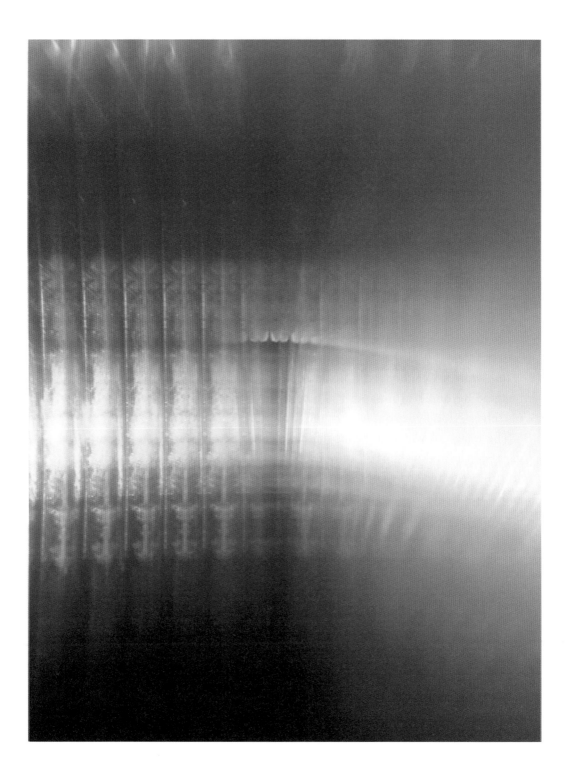

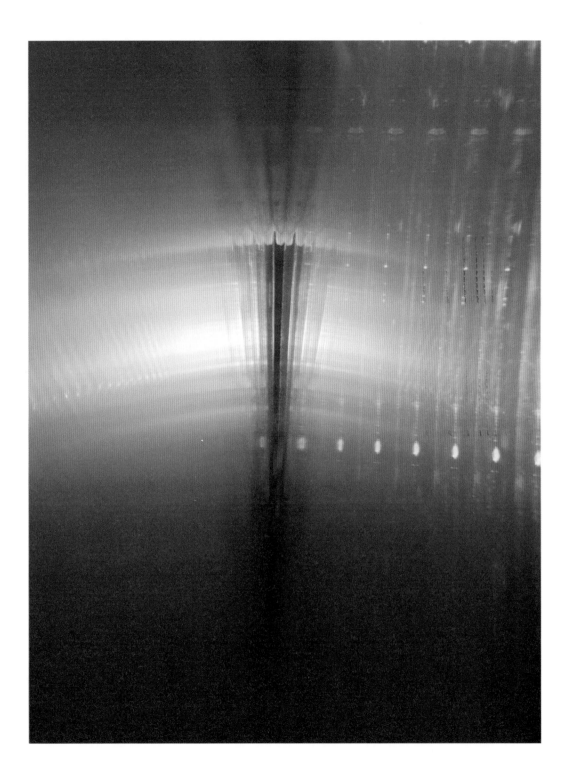

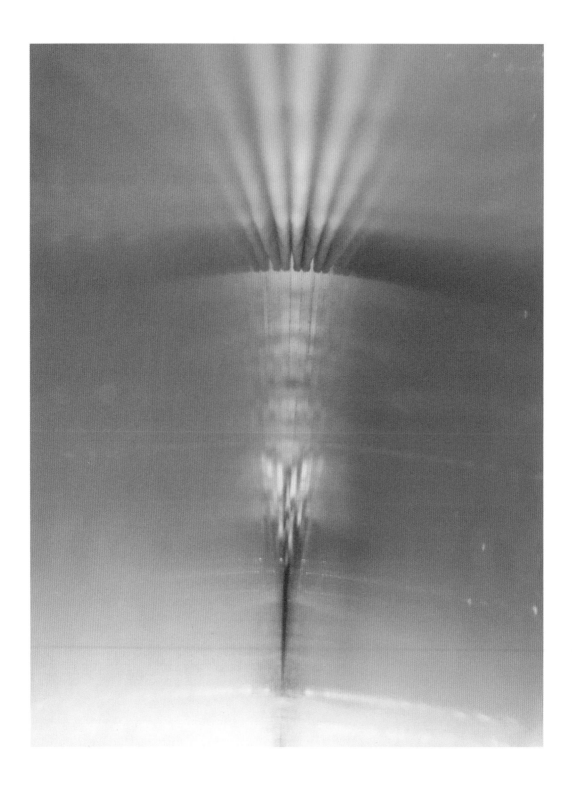

'oceanic', this ultimate intimate immanence of animality is a mode of being 'in the world like water in water'.

For Bataille, the moment that renders us human is the moment in which we posit an object. The initial object is the tool, the 'nascent form of the non-I',[24] and the moment of alterity and discontinuity constituted by positing an object is what Bataille calls 'transcendence'. From this moment, he demonstrates an inexorable unfolding of a consciousness that reduces the original immanence of the world to thingness and invents a supreme being that is also a kind of thing considerably impoverished from the animal sense of continuity. Discontinuity multiplies as humans sequentially develop sacrifice, festivals, warfare, military order, universal empire, and industrial order by means of processes including dualism, reason, transcendence, mediation, morality, clear consciousness, and sovereign self-consciousness:

> Man is the being that has lost, and even rejected, that which he obscurely is, a vague intimacy. Consciousness could not have become clear in the course of time if it had not turned away from its awkward contents, but clear consciousness is itself looking for what it has itself lost, and what it must lose again as it draws near to it. Of course, what it has lost is not outside it; consciousness turns away from the obscure intimacy of consciousness itself. Religion, whose essence is the search for lost intimacy, comes down to the effort of clear consciousness which wants to be a complete self-consciousness: but this effort is futile, since consciousness of intimacy is possible only at a level where consciousness is no longer an operation whose outcome implies duration, that is, at the level where clarity, which is the effect of the operation, is no longer given.[25]

Insofar as we are human, we are always already in the world from the stance of alterity so that, paradoxically, it is identity and continuity that are alien to us and hence frightening and 'vertiginously dangerous'.[26] It is immanence, and not transcendence, that constitutes the true otherness of animal oblivion to which our consciousness aspires but which, asymptotically, 'it must lose again as it draws near to it'.[27]

Put otherwise, 'intimacy is the limit of clear consciousness';[28] consciousness as such cannot grasp intimacy because intimacy cannot be reduced to a thing. But consciousness can undo itself, reverse its reductive operations in order to reduce itself to intimacy, by dissolving and destroying utilitarian 'objects as such in the field of consciousness', thereby returning 'to the situation of the animal that eats

another animal'.[29] The sovereign act of destroying objects is simultaneously the destruction of the subject as an individual, 'but it is insofar as clear consciousness prevails that the objects actually destroyed will not destroy humanity itself'.[30] This is a form of violence, but it is necessary 'for anyone to whom human life is an experience to be carried as far as possible',[31] and it leads directly to the limit, the impossible. When we search for the existential structure of this final alterity, we must take our clue from Bataille's observation that humanity's first object is the tool and combine it with Marcel Mauss's insight that humanity's first tool is the body.[32] But the body is also the site wherein this 'internally wrenching violence that animates the whole . . . reveals the impossible in laughter, ecstasy, or tears', and this impossible is nothing other than 'the sovereign self-consciousness that, precisely, no longer turns away from itself'.[33]

Let us pursue this theme of intimacy. The phenomenologists of religion had not only a too objectified understanding of the 'wholly other', but one that was too grandiose. Instead of the wholly other projected onto cosmic majesty, our concern here is precisely the intimately other. The intimate alterity that we are pursuing in contrast to the wholly other is not the intimacy of animality, but one that can only be an intimation of that intimacy, insofar as it begins necessarily from our human consciousness. As we have seen, one of the ways that Otto characterized the wholly other was that it was outside the canny, and, indeed, he equated the uncanny with the Numinous.[34] Here we must fold Sigmund Freud into our account for the manner in which he captures a much more intimate alterity in this feeling. In his study of religious representations of the monstrous, religious studies, the scholar Tim Beal compares the two writers' approaches to the uncanny or *unheimlich* as follows: 'What Otto calls "wholly other" Freud would call "other" only insofar as it has been repressed. For Freud the *unheimlich* is only "outside the house" (the house of the self, the house of culture, the house of the cosmos) insofar as it is hidden within the house.'[35] Yet the progression from self to cosmos within Beal's parentheses is itself a clue that we need not choose between the two, for the wholly other and the intimately other are two sides of the same leaf.

In this respect, the image of otherness in Freud, insofar as it relates to our topic, is to be found less in the notion of the sovereign id or the hidden unconscious than in the notion of the uncanny. My emphasis is not on the uncanny as frightening, but on the uncanny as close to us, as intimately other. First, there is something uncanny about the word itself—not only can *unheimlich* refer to both the wholly

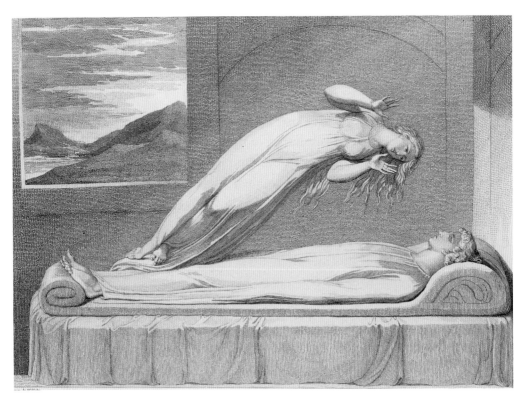

William Blake, illustrations to Robert Blair's *The Grave*. Object seven: The Soul Hovering Over the Body Reluctantly Parting With Life (1805–08). © The Trustees of the British Museum.

other and the intimately other, but the root word *heimlich* can, in certain contexts, mean its opposite. *Heimlich* can mean something that is familiar or agreeable, but also something hidden and kept out of sight. Although Freud is unclear about the precise relation between the two meanings, there appears to be a development along the lines that what is familiar becomes private, what is private becomes hidden, and what is hidden becomes spooky. In any case, there is a semantic alterity in this word such that '*heimlich* is a word the meaning of which develops in the direction of ambivalence, until it finally coincides with its opposite, *unheimlich*'.[36]

Although Freud says nothing explicitly about religion, he approaches it in summarising the two closely related phenomena that are the sources of the uncanny: 'An uncanny experience occurs either when infantile complexes which have been repressed are once more revived by some impression, or when primitive beliefs [animism] which have been surmounted [by reason] seem once more to be confirmed'.[37] Freud too easily discounts, I think, the importance of a rival's theory that highlights uncertainty about whether something is living or not—a body ambiguously dead or alive, an automaton ambiguously animate or inanimate—because it does not quite fit the psychoanalytic account. It is also curious that, amongst his examples, he does not mention the feeling of a presence that is not really there. This would be a feeling that we could contrast both to the feeling of invisible divine presence in religious experience and to the feeling of concrete intimacy in the caress of another person. But including these, and with a somewhat broader notion of alterity building on Freud's intuition, we can see one reason that religion can never go away—that it will always return and return in a myriad of forms. In the language that I have been developing here, the return of the repressed is the inevitable betrayal of identity by alterity, the re-enchantment of the world that imposes itself as soon as the disenchanted world finally becomes so familiar as to begin to appear strange—that strange interchangeability or transposability of *heimlich* and *unheimlich* that Freud talks about. The point again is that the other is much closer than we would be led to believe by the phenomenologists of religion or at least that there is no understanding of the wholly other without the intimate other.

Let me specify this sense of intimate alterity with a concrete ethnographic instance from my studies of Catholic Charismatic healing. In what I called 'imaginal performances', Jesus or the Virgin Mary would often appear or be evoked in healing prayer that took the form of visualisation, in which one of these divine presences would speak and engage the afflicted person in a healing embrace.

Although these presences can be understood as internal transitional objects in a psychoanalytic sense and even as ideal objects or Others to which one can have a mature, intimate relationship that serves as a prototype for intimacy as an aspect of a sacred self, I wanted to push the interpretation farther. I suggested that this experience is a genuine intimacy with a primordial aspect of the self that is the existential ground for both its fundamental indeterminacy and the possibility of an intersubjective relationship—its own inherent otherness. In other words, the imaginal Jesus **is** the alterity of the self. In this sense, to speak of intimacy with oneself is not to speak metaphorically. It is instead to say that the capacity for intimacy begins with an existential coming to terms with the alterity of the self and that the presence of Jesus is an embodied metaphor for that condition of selfhood. This is the Jesus that speaks with a 'still, small voice' within and whose presence is an act of imagination.[38]

This intimate alterity appears again in the Charismatic practice of 'resting in the Spirit', in which a person is overwhelmed by the divine power/presence and falls, typically from a standing position, into a sacred swoon. Although again we cannot fail to strike a psychoanalytic chord in noting the 'oceanic' passivity before an omnipotent paternal deity that characterises this experience, I also suggested that the experience is constituted in the bodily synthesis of pre-objective self processes. This is to say that the coming into being of the 'divine presence' as a cultural phenomenon is an objectification of embodiment itself. Consider the heaviness of limbs reported by people resting in the Spirit. Quoting Plugge, the philosopher R. M. Zaner points out that 'within the reflective experience of a healthy limb, no matter how silent and weightless it may be in action, there is yet, indetectably hidden, a certain "heft"'.[39] This thing-like heft of customary bodily performances defines our bodies as simultaneously belonging to us and estranged from us, and hence the alterity of self is an embodied otherness. While resting in the Spirit, the heft that is always there for us indeterminately and pre-objectively is made determinate and objectified. Its essential alterity becomes an object of somatic attention within the experiential gestalt defined as the divine presence. The divine presence is an intimate presence in a way that, because it encompasses multiple modalities of the body-self, surpasses human companionship. Like the divine presence in imaginal performance, resting in the Spirit thus offers both a surrogate source of intimacy for the lonely and a prototype for human intimacy.[40]

This alterity of the self can be taken in at least two senses. According to Zaner, self-presence and presence to the other are the two foundational moments of self.

Zaner understands self-presence as 'situated self-reflexivity' and presence to the other as an 'urgency ... to reveal itself to other inwardly realized selves'.[41] This is tellingly reminiscent of the urgency or energy that Otto says is an element of religion's *mysterium tremendum*. Yet on the level of the intimately other, rather than the wholly other, I think it appears more clearly as imagination and desire. The vivid presence of Jesus or Mary in Charismatic imaginal performance is a culturally specific way to complete the second foundational moment, providing an ideal Other to correspond to the moment of self-presence. A second sense of the self's alterity is grounded in our very embodiment. Zaner shows that the inescapability of our embodied nature and the limitations it imposes contribute to the feeling that our bodies are in a sense 'other' than ourselves. Our intimacy with our own bodies also implicates us in whatever happens to them, and realisation that we are thus 'susceptible to what can happen to material things in general' corresponds to experiencing the 'chill' of mortality. In addition, our bodies are always 'hidden presences' to us, both insofar as autonomic processes typically go on outside of awareness[42] and insofar as the possibility persists of seeing ourselves as objects from the perspective of another. Our bodies are thus hidden presences to us at the same time as they are compellingly ours, and accordingly Zaner argues:

> My body is at once familiar and strange, intimate and alien: *'mine' most of all yet 'other' most of all*, the ground for both subjective inwardness and objective outwardness. Whatever I want, wish, or plan for, I irrevocably 'grow older,' 'become tired,' 'feel ill,' 'am energetic.' ... The basis for *the otherness* (and thereby the otherness of everything else) *of the embodying organism is its having a life of its own*, even when the person is most 'at home' or 'at one' with it.... The otherness of my own body thus suffuses its sense of intimacy.[43]

The necessity of this embodied alterity of the self, even when one is most 'at home' evokes the notion of the *heimlich* (homelike) and the *unheimlich* (uncanny). Zaner's discussion shows that the uncanny is grounded not necessarily in an abstract recognition of mortality, but in the concreteness of everyday embodied existence, in which the 'chill' is present even 'at home'.

A final image moves us into the intersection of religion and the aesthetic and comes from William Blake, the poetic master of alterity and imagination. Plate 11 of his manifesto *The Marriage of Heaven and Hell* reads as follows:

> The ancient Poets animated all sensible objects with Gods or Geniuses, calling them by the names and adorning them with the properties of woods, rivers,

mountains, lakes, cities, nations, and whatever their enlarged and numerous senses could perceive. And particularly they studied the genius of each city and country, placing it under its mental deity; Till a system was formed, which some took advantage of, and enslaved the vulgar by attempting to realize or abstract the mental deities from their objects: thus began Priesthood; Choosing the forms of worship from poetic tales. And at length they pronounced that the Gods had ordered such things. Thus men forgot that All deities reside in the Human breast.

Blake's theory is evidently a theory of primal animism, but it is even more a theory of poetic and corporal bringing-to-life made possible by the 'enlarged and numerous senses' of the prelapsarian moment. For Blake, the fall is a flight from concreteness to abstraction and the slavery of mystification, a binding off of the human imagination. Blake's manifesto is thick with meaning, and I would suggest that the notion of alterity of the self as embodied otherness coincides with this position, because when Blake says that all deities reside within the human breast, I want to take him literally and say, yes, the breast and the limbs and the genitals and the head and the manner in which all are synthesised into the same bodily existence.[44]

Freud framed his essay on the uncanny as a discussion of aesthetics, saying that the uncanny is a province of aesthetics that has to do with the frightening. If the uncanny is essential to religion and the aesthetic, how can we distinguish the two? I might want to say, again following Blake's theory of imagination, that I do not want to distinguish the two—but it is more precise to say that they are distinguished in that, though alterity is important to both, alterity itself is the object of religion. To state this point in more general terms, when alterity is elaborated in and for itself, we are in the domain of religion, but when it is elaborated as oppression of the other, we are in the domain of politics; when it is elaborated as competition, we are in the domain of athletics; when it is elaborated as pathological, we are in the domain of medicine and psychiatry, and when it is elaborated as subtle, striking, or challenging beauty, we are in the domain of art and aesthetics. It is precisely an attempt to invoke the intimate alterity of embodied intersubjectivity in the aesthetic dimension that led to the collaborative juxtaposition of text and image in this chapter. Just as the tactile and visual are intertwined in mirror-touch synaesthesia, so we hope the verbal and the imaginal reflect one another in this experimental bimodal dialogue.

Endnotes *Thomas Csordas*

1. Paul Ricoeur, '*From Text to Action: Essays in Hermeneutics II*', trans. K. Blamey and J. B. Thompson (Evanston: Northwestern University Press, 1991), 237.
2. Paul Ricoeur, '*From Text to Action*', 237.
3. Paul Ricoeur, '*From Text to Action*', 238.
4. Paul Ricoeur, '*From Text to Action*', 239.
5. Paul Ricoeur, '*From Text to Action*', 239.
6. Maurice Merleau-Ponty, '*The Primacy of Perception*', James Edie, ed., trans. William Cobb (Evanston, IL: Northwestern University Press, 1964).
7. Maurice Merleau-Ponty, '*The Primacy of Perception*', 306.
8. See Thomas Csordas, 'Intersubjectivity and intercorporeality', *Subjectivity* (2008), 22, 110–21.
9. Maurice Merleau-Ponty, '*The Visible and the Invisible*', trans. Alphonso Lingis (Evanston, IL: Northwestern University Press, 1968), 133.
10. Maurice Merleau-Ponty, '*The Visible and the Invisible*', 143.
11. Maurice Merleau-Ponty, '*The Visible and the Invisible*', 138.
12. Gail Weiss, '*Body Images: Embodiment as intercorporeality*' (New York: Routledge, 1999), 120–1.
13. Maurice Merleau-Ponty, '*The Visible and the Invisible*', 148.
14. Gail Weiss, '*Body Images*', 128.
15. Maurice Merleau-Ponty, '*The Visible and the Invisible*', 141.
16. Elizabeth Grosz, '*Volatile Bodies: Toward a Corporeal Feminism*' (Bloomington: Indiana University Press, 1994), 209.
17. See Jacques Lacan, 'The Mirror Stage as Formative of the Function of the I', in *Ecrits*, trans. Alan Sheridan (New York: Norton, 1977), 1–7.
18. For a more elaborated view of this argument, see Thomas Csordas, 'Asymptote of the ineffable: embodiment, alterity, and the theory of religion', *Current Anthropology* (2004), 45, 163–85.
19. Rudolf Otto, '*The Idea of the Holy*' (Oxford: Oxford University Press, 1923), 26–7.
20. Gerardus van der Leeuw (1938), '*Religion in Essence and Manifestation*' (Princeton: Princeton University Press, 1986), 23.
21. Rudolf Otto, '*The Idea of the Holy*', 10.
22. Georges Bataille, '*Theory of Religion*' (New York: Zone Books, 1989), 17.
23. Georges Bataille, '*Theory of Religion*', 18.
24. Georges Bataille, '*Theory of Religion*', 27.
25. Georges Bataille, '*Theory of Religion*', 56–7.
26. Georges Bataille, '*Theory of Religion*', 36.
27. Georges Bataille, '*Theory of Religion*', 57.
28. Georges Bataille, '*Theory of Religion*', 99.

29. Georges Bataille, '*Theory of Religion*', 103.
30. Georges Bataille, '*Theory of Religion*', 103.
31. Georges Bataille, '*Theory of Religion*', 110.
32. See Marcel Mauss, 'Les Techniques du Corps', in *Sociologie et anthropologie* (Paris: Presses Universitaires de France, 1950).
33. Georges Bataille, '*Theory of Religion*', 111.
34. Rudolf Otto, '*The Idea of the Holy*', 40.
35. Timothy K. Beal, '*Religion and its Monsters*' (New York: Routledge, 2002), 8.
36. Sigmund Freud, 'The "Uncanny"', in *The Standard Edition of the Complete Psychological works of Sigmund Freud* (London: Hogarth Press, 1955), 226.
37. Sigmund Freud, 'The "Uncanny"', 249.
38. See Thomas Csordas, '*The Sacred Self: A Cultural Phenomenology of Charismatic Healing*' (Berkeley: University of California Press, 1994), 57–8; see also Csordas, '*Body/Meaning/Healing*' (New York: Palgrave, 2002).
39. Richard M. Zaner, '*The Context of Self: A Phenomenological Inquiry Using Medicine as a Clue*' (Athens: Ohio University Press, 1981), 56.
40. See Thomas Csordas, '*The Sacred Self*' (1994), 246; see also Csordas, '*Body/Meaning/Healing*' (2002).
41. Richard M. Zaner, '*The Context of Self*', 153.
42. See also Leder, 1990.
43. Richard M. Zaner, '*The Context of Self*', 54–5.
44. William Blake, '*The Complete Poetry and Prose of William Blake*', David V. Erdman, ed. (New York: Doubleday, 1988), 38.

Note: Portions of this text previously appeared in Thomas J. Csordas, 'Asymptote of the Ineffable: Embodiment, Alterity, and the Theory of Religion', *Current Anthropology* (2004), 45, 163–85.

Zoneland.

Endnotes *Trisha Donnelly*

i. *From the rose drips a mist of a soul*
 beloved.
 　Of Kaisik Wong—didn't he arrive
 as a hologram temporarily?
 　Born 1950–Died 1990.
 　Deity channel for the dance floor,
 for alteration of this parallel. Work
 built from pattern of thought.
ii. *Dual illustration—Emile Galle,*
 Les Main plus manifestation of an
 electronic wraith.
 I can take this hand as a projector.
 Device for an electrical light connection
 to the field of alterity experience.
 Is there a sense word for the
 mind's entrance to a field?
 Death submerged waits as a form-
 　to know.
 Light would fire through
 　these glass digits of a drowned
 　corpse and multiply the all of all—
 infinitely.

 Galle held alterity -
 This field—
 of spatial parallel
 for the dispersed body.
 Glass flesh-eaten and creature held.
 Does death seem a partner?
 Or union with a total body such as
 　the ocean.
 Electrified liquid is a fast container.
 Sense that extends
 a bridge or tissued link
 to a waiting field
 where
 awareness runs vapor between
 cells/emotions/tissues/intuition
 of others.

 Cellular awareness—the passion.

iii. Adrian Piper's *Food for the Spirit*.
 One of a series of photos taken
 during summer of 1971 in her New
 York apartment. Piper, while reading
 Kant's *Critique of Pure Reason* and
 subsisting on juice and water—
 isolating herself entirely, leaving the
 apartment rarely—would photograph
 herself at the exact moments she felt
 deeply affected and overwhelmed
 by the ideas, when she felt herself
 entirely disembodied.
 　Within the state of mind accessed
 with both silence and language—a
 traverse in isolation and of the
 cellularly coded mind/memory. The
 image radiates as partially nebulous—
 as if she herself is appearing from, or
 transforming into, a panel of haze.
 Youth and consciousness are parallel
 states, both remembered and reached
 for in perpetuity—or ignored and
 rarely stabilised. Document **of** self **by**
 the body—then reversed. Gender and
 intensity displayed, then destroyed.
 Transit into the constantly darkening
 clouds of a thought chased. Reading
 to feed hunger within the mind for
 shock, clarity, and confusion—
 consciousness ever building, ever
 clearing. Her interior sense of a prime
 directed the act of record. The early
 scientific belief that vision was a
 projection from within, as opposed to
 a reception from the world without
 is broken and shifted—reviving the
 diagram where energy and material
 existence shoots out from the eyes,
 from the reader.

iv. *What could sound absolute be if not a*
universe made of all sounds? A surface
or a sphere where no silence interferes,
where there is no break in the perfect
relationship of one note to one note,
where all of them are prolonged to
infinity, in every dimension, not in
succession but simultaneously. And
what about this scale is limitless in pitch
and depth? Isn't it a circle or a single
note? Or even perhaps silence? And
what is our music if not the very fragile
reflection of this immense scale summed
up in a sound that is still inaudible to us,
a series of more or less accidental and
arbitrary breaks the form various scales?
 From Luc Andre Marcel's 'Cahiers
 du Sud', quoted in Pierre Schaeffer, *In*
 Search of Concrete Music (Berkeley:
 University of California Press, 2012),
 122.
v. The warm chest of a dog. An animal
 who by no means should permit us to
 reach under their jaw and neck and
 touch their breastbone. Somehow
 temperature is most readable in
 this area—sinew, breath, heartbeat,
 patience. This vulnerable location
 on their bodies seems to radiate
 and project out the balance of all
 beings sharing this parallel. The area
 is transferred into a grey electric
 and shifts all colour to materialise
 as a massive negative in wait—a
 grounding force.
vi. This is a diagram in reference to
 Thomas Csordas's concept of the
 'asymptote of the ineffable'. Named
 in reference to a mathematical
 principle, the asymptote demonstrates
 two curves never meeting, nearing
 closely a cruciform. Not falling
 together, but the sensation of near.
 That the sense of alterity and the
 proximity or attraction to the infinite
 is magnetically close, but separated by
 momentum of the line.

See Blake's illustration and the arch
of the spirit re-entering.
 In hitting upon a mathematical
metaphor for the title of this essay, I
surprised myself. I am not typically
one to think in mathematical terms.
But it is precisely the capacity to
surprise oneself that I want to draw
attention to as an initial indication
of my argument's direction. We
can surprise ourselves; indeed, we
are always a bit outside ourselves,
outrunning or lagging a bit behind
and seldom in perfect accord with
ourselves. In making this observation
I am neither appealing to the
unconscious nor putting forward
a description of consciousness. My
point is about being-in-the-world,
our human condition of existence
not only as beings with experience
but as beings in relation to others.
And here also we are inevitably
surprised by others, given the
impossibility of perfectly coinciding
with them in thought or feeling,
mood or motivation. In this sense, the
problem of subjectivity is that we are
never completely ourselves, and the
problem of intersubjectivity is that
we are never completely in accord
with others.
 Thomas Csordas, 'Asymptote of
 the ineffable: embodiment, alterity
 and the theory of religion', Current
 Anthropology (2004), 45, 2, 163.
 In analytic geometry, an asymptote
 (/ˈæsɪmptoʊt/) of a curve is a line such
 that the distance between the curve
 and the line approaches zero as they
 tend to infinity. The word asymptote
 is derived from the Greek σύμπτωτος
 (asumptōtos) which means 'not falling
 together', from ἀ priv. + σύν 'together'
 + πτωτ-ός 'fallen' (*Oxford English
 Dictionary*, second edition, 1989).

Unless otherwise noted, all images are by Trisha Donnelly.

Four or Five Jaws

Fiona Torrance

When I see others touched, I feel touch and temperature and am also sensitive to gesture and bodily movement. I have a confirmed diagnosis from St Thomas' Hospital, London, of 'complex' (multiple) synaesthesia, including especially strong mirror-touch diagnosed by Dr Michael Banissy. The mirror-touch I have can result in depersonalisation and blurring of self and others. I've been diagnosed in the past with autistic tendencies, although much of this may be related to the sensory overload I feel as a mirror-touch synaesthete.

Synaesthesia gives wonderful experiences and itself is not disabling. However, my synaesthesia at times causes confusion when I am overwhelmed by too much observed touch. In public, I may feel grabbed and groped at. Seeing someone being punched has literally knocked me out. After being in public for a few hours, I need the solitude of home. I alter my lifestyle and modify my behaviours and feel enthusiastic about life. Others who do not have an inner 'compass' may struggle to regulate their emotions and response.

I was under neuropsychiatric treatment at St Thomas' for management of mirror-touch with medication and cognitive therapy. Before I discovered inner reflection time, I'd be prone to just react to things. The initial instant of perception is sometimes confusing or frightening or absolutely exhilarating, depending on what I see. An 'angry room'—for example, one full of glass—used to cause me to feel instantly angry. Glass and mirrors disturb my equilibrium. In environments I can control, I keep reflective surfaces such as glass and mirrors to a minimum. This is because when I see something without a physical mirror present, there is already an automatic reflection of what is seen in the mind or mind's eye. It feels like I have a visual field on the top of my head, in the soft, crowny area. Mirrors, glass, or shiny surfaces create multiple reflections that confuse and

almost blind the mind's eye. Without the mind's eye, I cannot function. It disturbs 'seeing without eyes' and 'hearing without ears'.

Now I have a buffer of time to stop and reflect and modulate my emotion before acting. In the past, I might have recoiled from a person who I perceive with an animal head or with hands made of strange textures, like sponge or metal. Perhaps these images are my synaesthesia translating an intuition; other people would say 'I had a feeling about that person'. With reflection, there is time to realise that what I am sensing is not 'real' but a product of my sensitivities. My neuropsychiatrist says that the difference between schizophrenia and synaesthesia is that I know that these perceptions aren't 'real', aren't shared by others. These images don't frighten me because I know they are a product of my synaesthesia at work. A person with schizophrenia might perceive similar images but believe them to be real.

Without medication, an overload of touch was accompanied by other sensory changes. For example, I might sense the colour orange, the taste of bile, or smells of burnt coffee. I might experience nausea, migraine, proprioceptive disorientation, or Alice in Wonderland syndrome, in which objects appear much larger or much smaller than they actually are. My perception of where my body parts are can be knocked out of place, causing me to lose my balance. Sometimes I can't feel my arms at my shoulders or my hands at the ends of my arms, and my arms feel instead as if they are in my intestines. I have experienced this in office environments and have had to lie down on the floor due to disorientation and exhaustion. On the other hand, my mind feels far sharper off medication, recall of dreams is crystal clear, and I feel a burning creativity.

Mirror-touch can cause confusion between self and others. For example, once I took the wrong London bus. I got off at a stop near a hat and bag shop and went to look inside. In front of me was a lady who was standing in front of merchandise. I said: 'Excuse me,' but she did not move aside. I said: 'Excuse me, may I pass you.' Again, she did not move. So I decided to step forward and gently try and pass her. I walked slap bang into a mirror. The lady was me! I did not recognise myself.

Artworks come alive to me. At the National Gallery, looking at a painting of a boy with his foot in the water, I felt as if I was really standing in water, standing inside the painting experienced as a real setting. I take care with what media I choose to enter into. Soap operas are sickly and many films are simply humans replaying their games and are not how I want to perceive or

experience life. We do not have a choice when mirror-touch experience occurs, as it cannot be controlled, but we do have a choice in the fiction that may trigger an effect.

The following is a list of some of the elements that I particularly enjoy seeing in artworks or would depict in an artwork myself, and why. The meaning these images have to me may not be the same for someone else, and I respect this. Some of these images might be disturbing to others, but not to me because they are part of what I accept about myself. Creating expressions of, or desiring to see, these images in art is a form of self-validation.

Eyes

speak. When someone closes their mouth and stops verbalising, they continue to speak with their eyes. Eyes touch. There are times when I look outside and it is like the physical veins and muscles of my eyes extend out into the branches of the trees.

Willow Trees

are like extended legs with toes like roots that tickle the air, the earth, or the water. Sometimes my legs feel that way.

Body Distortion

There are two distinct types of body distortion that I experience. One is the moving of my body parts, for example my arms to my intestines. The other type of body distortion occurs when I reach overload or am not on medication to reduce sensitivity. I can wake up as if my head is a ball bouncing on a pillow of cement. I feel I am that ball and experience the bouncing, the solid surface, and sounds. It is bit haunting. Sometimes I feel as if I have four or five jaws.

Ears

can be in the centre like inner hands. Just like eyes can be in the tips of the fingers. I can hear without ears.

Hands

take on different forms for different people. Some have corduroy hands; others have hands of barbed wire or clay. Hand substance varies per person and says a lot about who they are and how I think I should respond. My own hands move

into my stomach area, but I don't see other people's hands there. However, I see faces in the stomach area of others.

Amputation

I have experienced many times in dreams and just after waking up having no hands at the ends of my wrists. I have felt distraught at the loss of my hands.

Noses in Mid-Air

I use this image to describe two things. Faces on the stomach of others create walking noses where the lungs join below the sternum. The second kind of 'noses in mid-air' are the lines of smell-colours that follow people as they walk in front of me.

Avocados and Pears

are like torsos with no arms and legs. There are times I feel like just a torso, having lost my limbs.

Baldness

Sometimes I feel allergic to the hair on my body. Baldness symbolises a form of relief, a form of honesty.

Kites

represent my many experiences of being out of my body: seeing myself sleep; walking behind, or to the side of, myself; and flying. I often fly in my sleep.

Clowns

are in everyone. Clowns mime, so words are not necessary. Movement and facial expression changes shades of colour. My non-verbal communication ability is much higher than my ability to use words.

Clouds

are breath seen. I can imagine enough breaths breathing a cloud into existence.

Moss

is green mist, a soothing blanket that covers a naked mind, soul, and body.

Water

There are times I feel as if the air around and in me becomes water and I navigate myself, slowly, as if under water. The heart slows almost to a stop and I experience a very sharp sensation of total clarity, the senses responding automatically without direction of streaming thoughts.

Morphing

Time for me sometimes become non-existent or extremely slow. It feels as if people around me move in slow motion within one of my inhalations or exhalations. It is as if they don't know I am there and I become not just my own breath but theirs, their bodies. I morph into everything around me—what is there becomes me and I become it.

Compass

Birds and other creatures have in-built navigation. People have automatic navigation too, like when they chew food, knit, and watch television at the same time. When you stop to think about these processes, the automation is interrupted, and you may make a mistake, like a knitter dropping a stitch. I become acutely aware of brain/body automation when my body mapping goes out. I may pour boiling water into a cup that I think my hand is holding in a certain place, only to burn myself and find the cup is not there.

Distortion

If you had to storyboard your day or section it into clips, the scenes of each story or clip contain distortion, in terms of how objects or human interactions are seen and thought about. Recognising patterns of distortion changes the meaning of time too.

Patterns

I see patterns in everything I experience. Patterns engulf me. I move in patterns, enter and exist in the patterns of others and nature. My physical sensations and movements are affected by patterns. I love some calming and rhythmic patterns for the way they make me feel. Others are divisive and disturbing, depending on the objects and angle of the walls in the room. Patterns have colours and numbers for me, according to the shapes created.

Shapes

Patterns make shapes within and without and may move as if through dimensions, pulsating, either speeding up heartbeats or slowing them down.

Abstraction

is a way of showing something to avoid obviousness. In saying so, I recognise the meaning I experience, in abstract, is not necessarily the meaning experienced by another. To put it another way, the mind filters of another may be an abstraction to me.

Frames

hold or contain a story.

Observing

is personal. The act of watching can be like the composition of a song or the choreography of a dance. Mirror-touch is not judgemental. It is what it is—living in the moment, and some people cannot do this as they are held down by past trauma or fear of the future. Mirror-touch experiences give curiosity and surprise. I do not understand the concept of boredom because of this. There is always so much to see!

I wish I had more time to document all my synaesthetic sensations. For example, this morning I woke up and looked at my bedroom wall; it was full of faces, each in great detail. They are there on the wall; I can see them clearly. If I had the time and talent, I'd draw them all.

Trance Notebook #2
[nerdy questions about exact pitch]

Wayne Koestenbaum

today's the
anniversary of
Pearl Harbor

———————

I'll never wear
Fiesta Bisque

———————

 I'm
a 'super-cool'
stutterer

———————

 'dress and
run,' jock check,
gym coach's
mustache, his French-
teacher wife, her
teeth, shrill
voice, inability
to teach me colors,
exclamation-point
eyebrows

———————

thunderstorms, black
chunky glasses,
international food
court of 1964

––––––––––––––––––

 last Sunday's
dying cockroach
my sentimental pet

––––––––––––––––––

 defiant
personality syndrome?
Cy Twombly book on
my lap—

––––––––––––––––––

hair pattern on Cliff's
legs, barbecue
pit near the creek—

––––––––––––––––––

 not
liking Updike's *Midpoint*
is part of my intellectual
history, more important
than never reading
Thucydides

––––––––––––––––––

an attraction to line,
not because it's phallic,
but because I like it

––––––––––––––––––

French
kisser near the donut
shop parking lot and
a used copy of *The
Fox*

anonymous
mushroom-head penis
wielder in the Public
Garden, Botticelli
didn't draw you

Christo
wrapped me

balletic
make-out sessions with
plagiarists

'let's
include cocksucking
in our low-key friendly
chats'

I wrote
down every word the
drunk jocks muttered

like a
Sicilian folksong sung
in French translation by
Tino Rossi, 1920

————————

or blueberry
pancakes soaked in bourbon

————————

or
a bowl of inedible
toffee suckers

————————

like a
Contes d'Hoffmann performance
in Nice, 1942—
yes, there were operetta
performances during the war

————————

I thought poop was
Satan—which means
I loved Satan, or
considered him a co-
conspirator, a radio play

————————

a non-
stop figure-skater

————————

or forgetting how to
bake chocolate chip
cookies, and choosing
derangement over
daffodils

———————————

 so I
can violate them
in the clothing store
where I buy a
woman's seersucker
jacket

———————————

 let me
try on the woman's
Fourth of July patterned jumpsuit

———————————

 sell me a clip-on
bow-tie or a mock
fringe chapeau worn on
the collarbone—a
new style of 'shoulder
hat,' a cape to
protect your shoulders
from rain and chill and
to prevent the wearer
from sliding (like
Mickey Mantle) into
a third gender

———————————

now I've
reached the 'clinker' zone
of perforated opportunities

—————————

 —perforated appurtenances

—————————

but then Edith Piaf
suddenly thrilled me

—————————

a newly
discovered Venezuela, a
view—

—————————

a *rendre compte,*
a liar on the corner
(thirsty corner) of
23rd and 9th, a gazelle,
a rendezvous chapel

—————————

(a chaplet of
daisies around my
pleurisy brow)—

—————————

flirty and lubricated
in medias res

—————————

he mentioned
La Forza del Destino as

touchstone, and I
asked repeated nerdy
questions about exact
pitch (there's no such
thing as exact pitch)

 translate
13 French compositions
into German and
distribute them as
pity leaflets in Dresden—

 and the clinking
of fragile petals

 your kerchief
and your early death
a Beethoven keepsake—
like Steinhof
church atop the
schizophrenic hill

 we claimed
old age as our icy
mirror, our Breughel

I may be the
cousin of Maya
Deren but I
live in Chile among

refugees of a
God That Failed psycho-
analysis

———————

my
brutalist tutor, my
Meneghini

———————

j'ai
besoin de vous he
sentimentally told his
Russian mistress, O
Tuscan olive oil, O
cyanide, O tanned
drill team thigh of
a perseverator, O
wig of the pale
cancer death of the
scarlet ibis, bad
short story, bad
collaborationist

———————

I didn't know Matisse
was also a sculptor

———————

like a Julie London
impersonator, the hum
of the malfunctioning
heater

———————

he went to San José
State College, where my
father taught—

————————————

one of
those wife-beaters I
tend to fall in love with

————————————

thank you
for smashing my
Sondheim LPs

————————————

like a sucked-on
Lifesaver, an epidural

————————————

little
garbage disposal,
little male pattern baldness

————————————

I smell
cookies baking—an
immodest proposal,
an accusation shaped
like a children's picture
book based on Cultural
Revolution purges, dear Father

————————————

it shouldn't have
provoked disgust,
but it did

———————

wonder why my right
hand (murderer
drowned in malmsey
butt) is sweaty

Prp4AShw

Mark Leckey

This is a Proposal for a Show. Which is going to happen at some point but at the moment just exists here.

This is a Proposal for a Show that will be populated by Things that have one foot in this World and one in another. And it's going to toggle between the two.

I picture two prosthetic arms, one Ancient, one Modern, reaching out as far as they can to grasp All That There Is.

Where no distinction is drawn between things Mental and things Material, things Physical and things Immaterial.

No distinction drawn between things Sacred and things Profane; both spheres, Above and Below, in coexistence.

Every aspect of the environment in constant communication.

And I have put the Show together under the theme of communication between Man, Animal, and Machine. Each of these figures would then be assigned particular parts that fit back into the other two.

Man has monstrous and mechanical bodies. Animals are fossils, dead things, and spirit creatures. Machines have circuitry, embodied spirits, all kind of numinous.

And all this comes together to make this one colossal, assembled Body made up of Man, Animal, and Machine, which will be the Show.

Mark Leckey *UniAddDumThs* 2013–15. Installation Dimensions variable. Mark Leckey Installation view, *UniAddDumThs*, Kunsthalle Basel, Switzerland, 6 March–31 May 31 2015. Mark Leckey, Installation view *UniAddDumThs*, view on 'Machine'; Kunsthalle Basel, 2015. Photo: Philipp Hänger.

This is a Proposal for a World in which Dumb Things sing a song as exuberant as this.

And these are some of the works that will be in it.

We start with Machines:

a drawing by an autistic boy who thought he was a machine,

a drawing of the olfactory bulb of a dog,

an animation by Jean Suquet of Duchamp's *Large Glass*,

an image of Hannah Wilke's *Through the Large Glass*,

Economiac, a machine at the LSE that shows how the economy works via water through pipes and tanks,

Pygmalion and Galatea, a painting,

a Moog, a massive Moog synthesiser,

Pierre Molinier's *The Shaman*,

Dwight Mackintosh's *Masturbating Men*,

François Dallegret's *Cosmic Soup* from the 60s,

Thomas Birell's *Motorway*,

James Rosenquist's *Highway Trust*,

Richard Hamilton's *Five Tyres Remolded*.

This is a clay concept car I'd like to get hold of;

this is a 3D print, a rapid prototype print of a forensic car crash;

this is a DVD and a headset with car stereo speakers that I would show these two videos with;

this is Matthew Barney's *Drawing Restraint 7*, and *Window Licker* by Chris Cunningham for Aphex Twin;

this is a video by Alex Hubbard where he makes a weird sculpture of a car and then drives it.

Now we're on to Animals.

All the animals will be displayed against a big medieval painting backdrop.

These are some African sculptures of a lion and a leopard;

this is a Soviet space dog suit from the National Space Centre in Leicester;

this is David Musgrave's *Snoopy*;

this is Barry Flannegan's *Hare*;

this is an Egyptian mummified cat which is in the British Museum;

this is the vegetable lamb which is in the Museum of Garden History;

this is some fairy fan art that I found online;

Mark Leckey *UniAddDumThs* 2013–15. Installation Dimensions variable. Installation view, *UniAddDumThs*, Kunsthalle Basel, Switzerland, 6 March–31 May 2015. Mark Leckey, Installation view *UniAddDumThs*, detail from 'Animal'; Kunsthalle Basel, 2015. Photo: Philipp Hänger.

this is a minotaur, a medieval fabulous beast;

this is a photograph of a balloon show with a giant Churchill dog;

this is a dirigible, an airship in a photograph;

this is the rocking phallus from *A Clockwork Orange*;

this is Martin Creed's *Protuberance*;

this is a model from a bacterial flagellum;

this is Derek Boshier's *Dome*;

this is Robert Breer's *Floats*;

this is an image of Hyperion, Saturn's moon;

this is from Red Rover, a photograph of Mars;

this is the sun setting on Mars;

this is a model of Sputnik;

this is a project called *Cosmic Dancer* where they took a sculpture into space;

this is Allen Jones's *Temple*;

this is the unveiling of a Henry Moore;

this is the frontispiece for Hobbes's *Leviathan*;

this is a costume for a green man;

this is Blake's *Ghost of a Flea*;

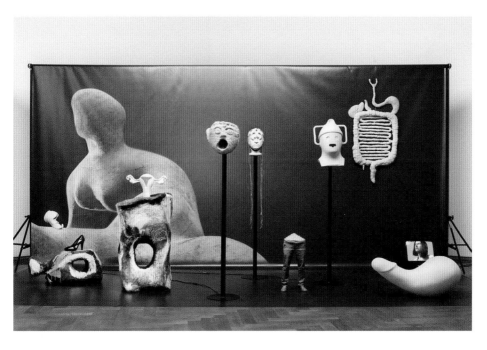

Mark Leckey *UniAddDumThs* 2013–15. Installation Dimensions variable. Installation view, *UniAddDumThs*, Kunsthalle Basel, Switzerland, 6 March–31 May 2015. Mark Leckey, Installation view *UniAddDumThs*, view on 'Man'; Kunsthalle Basel, 2015. Photo: Philipp Hänger.

this is Patrick Proctor's *Kite Standing in a Room*;

and this is *Avatar Days* by Cormac Kelly.

Now we're on to Bodies.

And we start with *Skeleton Dance*, an old Disney cartoon.

This is a CT scan of a mummy;

this is a reconstruction of Lindow man, one of the bog men;

this is a rapid prototype 3D head of Walt Disney;

this is the reliquary of St Eustace;

this is a green-screen medieval head that would have its thoughts projected;

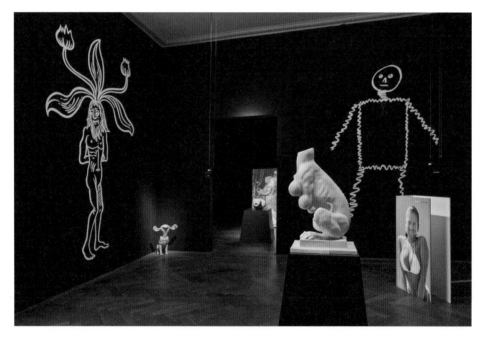

Mark Leckey *UniAddDumThs* 2013–15. Installation Dimensions variable. Installation view, *UniAddDumThs*, Kunsthalle Basel, Switzerland, 6 March–31 May 2015. Mark Leckey, Installation view *UniAddDumThs*, view into 'Monster'; Kunsthalle Basel, 2015. Photo: Philipp Hänger.

this is a life mask of William Blake, and he would have his thoughts transmitted by a directional speaker above his head;

this is a hand puppet by Paul Klee of an angel standing in front of a whale's eye from Disney's *Pinocchio*;

this is a high-magnification photograph of the surface of a sculpture or a painting, a study for a film of Turner's *Angel Standing in the Sun*, in very close detail, get all the impasto on HD;

this is a photograph by Jim Richardson of light pollution;

this is Dr Dee's *Scrying Mirror* made of obsidian;

this is a collage by Andy Holden, a young artist;

this is all the frames from Hitchcock's *Vertigo*;

this is a page from the Guttenberg Bible;

and this is a petition, a North American Indian petition.

Display, just quickly.

This is what I call the *Infinite Mirror Box*: it's a two-way mirror.

You put an object inside this box and it shows the thing for Infinity.

SECTION V

Double Sensation

In Conversation

Catherine Wood and Sha Xin Wei

CATHERINE WOOD (CW): I'm drawn to performance because I feel it has the rawest set of possibilities for configurations of social relations that are not assumed to be fixed, as a kind of crucible of what a 'culture' of or for art might be.

I was attracted to dance initially through my interest in minimalist sculpture, through looking at the work of Carl Andre, Robert Morris, and Donald Judd. This work in the post-war period radically absented depictions of the body. I became interested in how the body was reinstated through the viewer—the spectator's physical relationship to the sculpture—and in how, even more explicitly, that relationship was theatricalised and imagined in a fictional and artistic way through the parallel performance work developed in New York around the same period by Yvonne Rainer and Simone Forti. As a curator, I began to want to think about a broader *mise en scène* that took in the whole white cube gallery space that included the physical presences of the spectators.

That broader space includes at least two levels of spectatorship. One is about an inner circle of participant-spectators directly encountering the artwork, and another is about the vicarious participation of those watching the inner circle. I separate out these two levels, but in reality, work such as Carl Andre's magnesium squares, to be walked upon, prompts a simultaneous awareness of both, imaginatively.

One important example for me in terms of the relationship between choreography, sculpture, and the museum was an exhibition by Robert Morris in 1971 at the old Tate Gallery *Bodyspacemotionthings* where he created a sequence of sculptures for visitors to climb up and roll on and swing on—

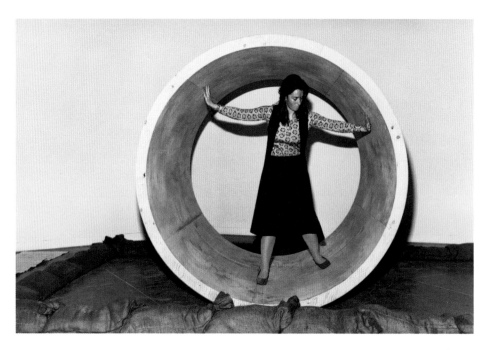

Robert Morris, *Bodyspacemotionthings*, Tate Gallery, London (1971). *Bodyspacemotionthings*, 1971, Robert Morris (1931–present). USA © Tate, London 2016.

plywood and rope constructions that echoed the Judson dance experiments, especially the early 'dance constructions' of Simone Forti with whom he had collaborated. The spectators became direct participants on one level, and on another level outside that, people watched.

At either 'level' of spectatorship, in choreographic terms, people are making and constituting what the aesthetic experience is, reimagining it. Relationships are immediately set up, and on this basic level, this spectatorship is social. Nicolas Bourriaud, in his famous (and somewhat unfairly I think much derided) work *Relational Aesthetics*, described people as a medium in this work of the 90s.[1] But I think the social is too complex—it's not enough to say you can treat the body, or a situation involving the reciprocal awareness of two or more people, like paint or a sculpture or a video, as a medium. Traditional art media and human presence and relations can be—should be—productively entangled in the making of art. I still think Jacques Rancière's observations about the distribution of the sensible and about the basis of the

'politics of aesthetics' being found within the taking of positions makes the best sense of this.

SHA XIN WEI (SXW): In our Topological Media Lab, you might walk into a situation where we improvisatorially condition sites. It could be read as installation art, it could be read as performance experiment, but it could also be read as merely interior design, or architecture, or lighting design. I've been working particularly with artists looking at the boundaries between what constitutes a performance and what constitutes everyday unmarked action. So, Catherine, we were looking at similar works, at Yvonne Rainer, Joan Jonas, and Steve Paxton active in New York in the 60s and 70s. At the Lab, we've been looking at how to make variations of experience that question how to condition an event such that everyday activities could acquire great symbolic charge—every term in that phrase is important.

In my first career, I was working on what people call scientific 'visualisation', but I was never very comfortable with it—it didn't seem to explain how people, even scientists, get intuition about these models that they are building. If you look at how biochemists work, they wave their hands. You can see pictures of the eminent mathematician Maryam Mirzakhani working on the floor on large sheets of paper, drawing doodles, over and over again. So I was interested some time ago in the question of the limits of representation. It started as a practical question: what are the limits of representation in doing scientific work?

I was not satisfied with any of the answers I was getting from my colleagues in logic and computer science, and it seemed to me that my friends in literature and phenomenological philosophy had accounts that sounded more like what I was experiencing while doing mathematics as a poetic, creative enterprise, rather than as an instrumental enterprise of describing reality. I decided to transpose those questions into a medium where people who were not specialist could get more access to it. And that's why I started working with people from theatre, dance, and music. We might look at the relationship between movement and memory, or movement and identity. Over the past decade, philosophers came to us and said: 'It looks like your art lab is a place where we can do experiments— not just read about accounts of psychological experiments, but actually engage in the process of making up our own events.' So how do we, for example, reflect philosophically upon events that are based on time-based media and movement **in** time-based media and movement? That's different from having philosophers

look at dancers and choreographers and then talking about what those dancers are doing. If we look at quantum mechanics, one of the basic implications we get is that there is no separation between observer and observed; this is the question of entanglement and non-duality. We experimentalists or philosophers, or critics and curators cannot, should not try to step outside the phenomenon about which we are speaking. That's been the challenge all these years—making sure that the makers are themselves part of the experiment, consciously.

> CW: It's interesting that you mentioned creating 'symbolic charge' through choreography. Rainer, Judson, and Forti were actually trying to foreground action and movement **without** it having any symbolic charge, trying to present the pedestrian and the ordinary on its own terms. But, of course, that builds a different kind of symbolic charge than a theatrical, metaphorical one. The 'primariness' of the quotidian gesture itself was symbolic of a different conception of what performance could be. 'Ordinariness' symbolised a deliberate stepping away from classicism or modernism.
>
> Yvonne Rainer evacuated expression from her dancers' faces. And the face—as in the old-fashioned portrait that affectively engages the viewer—continues to be such a blind spot in contemporary art. When you step back to think about it, it's a bizarre condition that we've been involved in art that does not deal with this as human beings, and that everything is conceptualised and formalised to such an extent that this has not been part of the discourse for some time. There has been a suspicion of being 'affected', because affect is used so much in commercial strategies in the twentieth century, in advertising, an art of manipulation.

SXW: Emmanuel Levinas wrote profoundly not about the face, but about faciality or frontality.[2] It's not just a physical, a visual face; it's about faciality, of facing somebody. I think affect needs to account for that. When learning sign language, I was taught that when you sign with a deaf person, it is extremely rude to break the gaze. You must not avert your eyes. It's like putting your hands over your ears when you're talking to somebody. It's the directedness of attention that is important.

In our Lab, we approach this work exploring movement and event by bracketing the question: 'What is a human being?' I call that sometimes a 'non-anthropocentric' approach to questions of ethics and aesthetics. It doesn't deny humans at all; it's just a matter of starting out without first assuming that we are at the

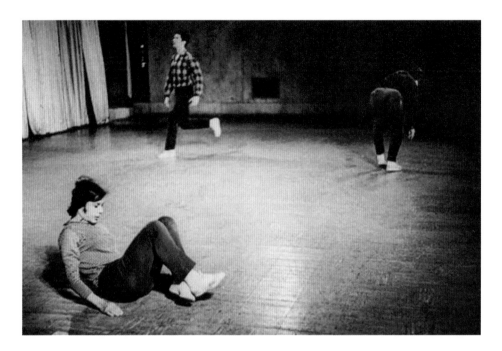

Performance of Yvonne Rainer's *The Mind is a Muscle: Trio A*, Judson Memorial Church, Greenwich Village, New York (1966).

centre of the universe. I think we can gain some purchase on how things move us or how we move things by not taking an anthropocentric point of view. But still, the real challenges come back to ethics. How can we come up with ethics, or aesthetics, but not start by assuming that we know who we are?

 cw: I'm struck by this questioning of our assumptions about what the human subject is, or what the boundary or shape of the human subject is. In certain dance practices that I've looked at, one being Boris Charmatz's project *Musée e de la Danse* (2013), this question has come up in terms of behaviour that does or doesn't fit into assumed patterns. Through Charmatz's very intimate, observational practice of self-performance—movement generation, and then group improvisations—new kinds of patterns of subjectivities and boundaries emerge. This experiential, bodily practice and the social interactions that can be built from this point have the capacity to destabilise what we think we know about subjectivity and where the subject begins and ends.

Perhaps it's not going far enough to only reinstate the figurative and an awareness of the social in relation to the art object, because it's true that you could also position the much broader question of a larger substrate—the animals and plants and everything else in the universe ought to come into that ecology of the art object too. Simone Forti, for example, whose work in improvisation has been very influential for the younger generation of choreographers, made works such as *Onion Experiment* (1961) in which the natural growth of the bulb forced it to move and fall off its position on top of a bottle. Her attention to animal movement also extended the boundaries of the human body, or human language, towards new and nuanced relations with its environment. But I find it really hard to talk about art without putting the human mind at the centre. As much as the image I'm conjuring of the social isn't about psychology, I'm still approaching it through my brain. Through these artists, and others, I'm interested in how alternative or expanded forms of perception through the experience of art in its broadest sense extend our capacity for language beyond cognitive patterns that we use in more 'efficient' ways (for survival).

sxw: I think it's fascinating, the way you've put it. And this is why over these years we've been working with dancers, choreographers, and musicians—because we wanted to set aside certain cognitivist models of subjectivity. And in terms of method, we wanted to set aside theories that are primarily articulated in words. Highly trained movement artists are articulate in words, but also articulate in body; they have their own vocabulary. They can 'do again' the movement experiments that we are talking about in a way that I say is a kind of science, because it is reproducible. It's not pre-linguistic, but it's extra-linguistic; it's beyond the limits of what that form can represent, and it complements it.

Coming back to Rainer and the everyday versus the symbolic, I think this is a two-way street. One way is to look at everyday activity and to embed it into a marked event. The other way, which is what we're trying to do with the Lab, has been to look at everyday events, which are 'unmarked' conditions—bus stop, airport, sidewalk—and also to work with people who are not self-identified as artists—pedestrians, some janitor, etc.—and create everyday activity in the everyday contexts themselves, which can acquire symbolic charge. If I move my cup in such a way that I begin to hear sound as a result of my gesture that I would not hear ordinarily, then it begins to acquire extra signification.

cw: Are you talking about a mode of aesthetic perception that is honed, or trained? This is something that I have been interested in too, that the space of art and the encounter with art is a space of training of your perception.

sxw: To use Martin Heidegger's language, it's like attunement, right? A nice word in English would be orientation—to orient. Robert Irwin famously talks about his work as attuning or orienting attention. How can artworks direct our attention, converge attention, focus, generate?

cw: Attention is a form of participation, in contrast to the literalised participation of some recent artworks. A Rirkrit Tiravanija meal is seen as something you can participate in, or a Carsten Holler slide, and looking at a painting is seen as something you are not participating in, because you are not **literally** doing anything. The notion of agency encompasses the fact that you can choose what to give your attention to—you can choose what to look at or look away from as much as you can choose whether to slide down a slide or eat a meal. In some of Boris Charmatz's pieces, your agency as a viewer might appear to be thwarted by the artist in the sense that you are invited to simply sit still and watch the dancers, but in a different way it is propelled because as a viewer you need to actively follow and try to assimilate the continuously shifting complexes of movements onstage. So there is an active exchange that is going on, as one actively 'edits' one's attention to the presence of, say, 24 dancers performing simultaneously in *Levée des Conflits* that remains ultimately always incomplete, because one could always view it differently.

At another level, Shannon Jackson's analysis of the many social and political factors that comprise the conditions for viewing art is very relevant to Charmatz's work with institutional formats; she notes the politics that underwrite a city's infrastructure, its traffic lights and roadways, and how they connect to her experience of driving to the theatre, even before its own architecture, convention, and 'content' are considered.[3] Likewise, with his '*Musée de la Danse*' (renaming the national choreographic centre of Rennes as such in 2009), Charmatz has worked upon opening up new spaces for the practice, teaching, and inventing of dance that re-frame his—and others'—choreography as object.

In a performance situation, there is often a deliberate sense of unsettledness. Once you 'museumify', it feels that the future is also somehow inevitable. As a museum curator working in performance, I have—perversely—

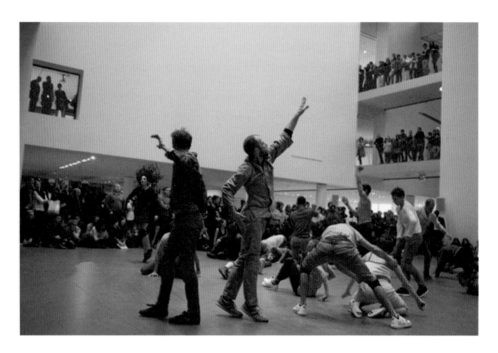

Levée des Conflits Extended/Suspension of Conflicts (part of *Musée de la Danse: Three Collective Gestures*, MoMA (October 18 to November 03, 2013). Artwork by Boris Charmatz, *Levée des conflits extended/Suspension of Conflicts* © 2013 *MoMA*, reproduced with permission of MoMA.

come to love the fact that you can't really historicise performance, and when you try to access the history of performance through re-enactments by the next generation, or even by the artists themselves, there is still a sense that the past isn't fixable because you can't really grasp it, and therefore it becomes difficult to 'plot a trajectory'. The future is not inevitable; it remains open.

sxw: The 'unsettledness' of some events brings into play this notion of the potential versus the actual. What is the potential? What could be happening, given the conditions now? And that plays into the question of the social imaginary, political imaginary, cultural imaginary, historical imaginary, and then at some point, sometimes, we need to make a commitment. So then it becomes an event; it becomes actual.

I resonate very strongly with the use of the term 'field' or 'fabric'. I'm going to do something that is visual and I'll describe it. I'm holding a piece of paper in

my hand, a blank sheet of paper. I can draw, let's say, a social network by put-
ting a few dots on the paper and drawing lines between them. But that's not the
way I want to think about sociality. So let's take one of these dots; that's me, the
putative social agent. And what I do is I take this piece of paper and I poke a
hole where that dot is—I remove the dot. The question is: what's the 'other'? In
the first case of the graph, it's just a bunch of other dots. The others' other is the
other human others, who are the social agents. But if I take this piece of paper
and I just remove this one dot that represents myself, what's left? It's the whole
sheet of paper. It is this entire, dense material. So this way of thinking about the
other is a lot thicker. And that's why I think 'field' and 'fabric' are really interest-
ing terms to use when trying to talk about relationality.

It's a good thing to talk about the 'social' before we talk about moral or polit-
ical questions, because in a sense we can ask: 'What's underneath? What's the
stuff of which political actions are made?' I remember having a discussion with a
friend who is a very committed social activist who wanted to go into journalism.
I explained that one of my problems, at least with American news agencies, is
that they focus on events. What is an event? What is newsworthy? Even history
is written around events, like the signing of the Magna Carta. Material culture
studies, on the other hand, is about everything that is happening all the time
that's completely uneventful, right? Like in Fernand Braudel's famous works on
the history of cutlery in Europe—a thousand years of the evolution of the use of
forks![4] A friend of mine who is an archaeologist is merely looking at discolora-
tions in the mud; that's all there is sometimes of ancient cultures.

There is a substrate to the event, which is all the dense stuff that is happen-
ing—social relationships, social activity, which is changing all the time. So where
does art come into play? Maybe some artists do actually participate in that
'magma', but that runs the risk of being invisible, right? Some artists consciously
make art meant to be invisible that only occasionally gets framed, by institutions
necessarily, and then becomes visible. So this is super interesting; now we have
the ability to maybe also frame, to make these frames on the fly.

 cw: Of course, the whole ritual of the museum is designed in a cer-
tain way to train your perception before you even get to the artwork. Even a
museum like Tate Modern is set up essentially to show white cube galleries of
painting and sculpture that one is supposed to wander through, glancing at
things; it still doesn't really very well accommodate the time-based intensity

of video, even though that's interspersed in sequences of rooms containing painting and sculpture. This time-density question is a problem in terms of museum viewing, and the ritual that we're used to, and the way that our perception has been orientated and attuned by that frame, which is derived from the eighteenth-century museum. And so one of the things I'm thinking about here, and which I'm working on with the new Tate film curator Andrea Lissoni, is how to orchestrate exhibitions that take time as the founding structure of experience in the encounter with art, rather than space. This also problematises the notion of 'chronology' as the backbone of the collection.

An experience that has really made me aware of how much we rely on this indoor etiquette of museum ritual was the *Performance Room* series that we've done online, which was broadcast to an audience on YouTube—10- to 15-minute performance pieces broadcast live online because I was frustrated by watching performance online that was always a second-hand documentation of something that had happened for a primary, live audience. And also just to use technology in a way that's more domestic and intimate, rather than exotic, like the ways that we use Skype to talk to each other. But it was quite shocking the first time we did this because we advertised the first *Performance Room* with Jérôme Bel widely on YouTube, so we had a very broad audience, and the feedback and many of the comments that we were getting live were confused, angry, some abusive, but then also occasionally appreciative, coming from an audience who had just come across us when they were looking for cat videos or how to fix their laptop videos!

Jérôme Bel and Joan Jonas, who usually work in live situations, were both quite freaked out by not being able to feel the audience. They were excited by this idea that there were lots of people watching online all around the world and making comments, but they both expressed, in different ways, that it was very strange and alienating not to be able to feel an audience's mood or response *in situ* in the way they usually could. It was quite alienating. The artist Nora Schultz dealt explicitly with this state of alienation in her work *Terminal* (2014)—imagining herself to be trapped in a kind of waiting room at the end of the network, in the presence of a bodyguard.

We had this debate afterwards as to what it meant to place art outside the very familiar restrained behaviour of the museum, and into people's bedrooms when they're home alone and they can say whatever they want; you know, they're not going to be escorted off the premises for shouting 'this

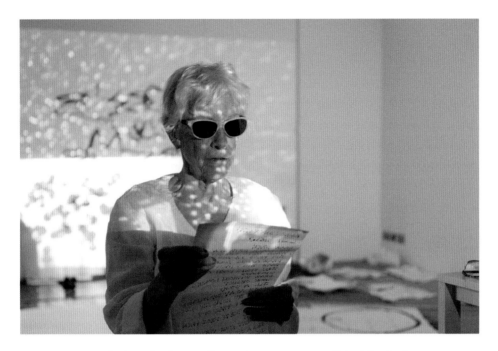

Joan Jonas, *Draw Without Looking*, online performance as part of Tate Live Performance Room (2013). *Draw Without Looking*, 2013, Joan Jonas (1936–present) USA © Tate, London 2016.

is rubbish!' It made me wonder, actually, about our aspirations for how art could attune perception or reach people, without more of a defining frame in which you know you're encountering art. Perhaps the institutional or ritual frame is necessary, even to create a protected space in which art can be seen. Much as we have talked since the 1960s about the blurring of art and life, it made me realise how fragile art is actually and how vulnerable it can be in a cacophony of noise of other things competing to entertain you.

sxw: When we started the Lab in 2001, one of the founding conditions was that groups of people were co-present in the same place at the same time. We came together with very cutting-edge work in gesture tracking, real-time video, choreographic video, gestural sound, sound spatialisation, all that stuff, the whole nine yards and more, because it was already the late 1990s. And when the web came out, I was very disappointed. Now it's been 20 years, and I can say it's a huge step back. And I decided very consciously to go in a different

direction and to look, in fact, at theatre and music and the arts as a mode of investigation.

I would like to talk about the museum situation. I think it is incredibly important to have a framing, or rather I should say a 'conditioning' of the event, which could be a matter of putting a candle on the table to condition the table for a different kind of meal than one that does not put the candle on the table. Which is different from saying 'I'm going to go outside now to the restaurant or buy a ticket into the room'. If we have institutions around us, we can condition experiences much more powerfully—there are certainly more resources one can apply, such as simply a wall to cut out traffic noise. It is harder to do that in the home where we have the kids running around.

So actually it is a very subtle question, about what I sometimes call 'substrate art', or infrastructure art. Look at the air conditioning in a building, or the city streetlights, or the public transportation system. Or look at the rapid bullet trains in China worked on by Linnaea Tillett, the incredibly thoughtful New York-based lighting designer.[5] How do we build such things with an aesthetic intent, as well? We might work with building engineers, who would normally wire up a building so all the lights can be controllable, and we say: 'Please, give us control of the lighting instruments, so that we can do something "fun" with it'. Or what does it mean to modulate artistically the lighting design, say, of the gallery, so that it is a layer on top of all the other aesthetic actions and events that are happening at the same time?

> cw: This brings to mind Ryan Gander, who created air currents in the empty galleries, in the opening of *Documenta (13)*, which literally affected you without you quite knowing why or what it was.[6] An artist called Gerry Bibby who had a show at The Showroom in London in 2014 did something also with the heating system and dismantled all the radiators and had them re-plumbed;[7] he was definitely clear that it was not institutional critique, but it was about the operation of a small non-profit space and its economy in relation to the building as a backdrop or a support for the art, and switching those two things around—the comfort of the employees versus the aesthetics.

sxw: Can I ask you how the practices you describe relate to those of institutional critique, like those of the LA-based artist Michael Asher, who founded the genre and who, in the 1970s, made interventions into the museum architecture such as moving a wall? Or to Andrea Fraser, who, from the 1980s, made

works such as *Museum Highlights* (1989) in which she, in the performative personae of 'museum tour guide', drew attention to supposedly incidental features such as the water fountain or the donor panels, rather than the painting and sculpture?

Art in the twentieth century, and philosophy as well, has been about questioning its frames. What signs, choices of materials or techniques, positionings of work, person-role, or site frame some artefact or event as art? At the medium scale, the framing conditions are social, and they appear to us as institutions. A lot of critical art practice from Brecht to CAE and Guerilla Grrls and Pussy Riot has been directed at institutions. Other sorts of work, such as SymbioticA's work with tissue culture and genetic technology, aims more at the political economy of the technologies that allow us to manipulate the most powerful substrate media of our time.[8] The nineteenth- and twentieth-century categories—however powerful they remain for social institutions—won't detect these phenomena at this micro-fine scale. Instead we need new concepts to adequately critique these new materials and new phenomena.

To be clear, I'm not talking about a critical commentary **of** technology where the artist is still using tools as given: paint, chisel, laptop, mobile phone. I'm talking about articulating a critique in the modification of the very medium itself. Let me give you an example in the domain of responsive environments and the Topological Media Lab. Instead of taking the practices of theatre and the technologies of performance as given, over the past 15 years, we very deliberately examined how nuance, gesture, intention, rhythm, emotional intensity, and intersubjectivity emerge from activity without presuming we know what everything is—things like body, citizen, or even video projector. For example, instead of treating the projector's output as a picture to be viewed on a flat surface, we think of its output as a form of structured light shining through the air, a million rays each potentially modulated independently, thanks to computation, according to contingent gesture and action by a different process. Contact improvisation and other forms of dance reconstitute a collective body out of individual bodies and elements of bodily movement. We can critique every entity this way by asking not what it is, but how it comes to be—whether it is a body, a sentence, a gesture, a social habit, a legal code, a social organism like a lab. The Lab has been-a new kind of hybrid, fusing practices from the theatre company, engineering team, science lab, reading group, and nest. It was an experiment forming an 'ecology of practices'—to borrow Isabelle Stengers's notion.[9]

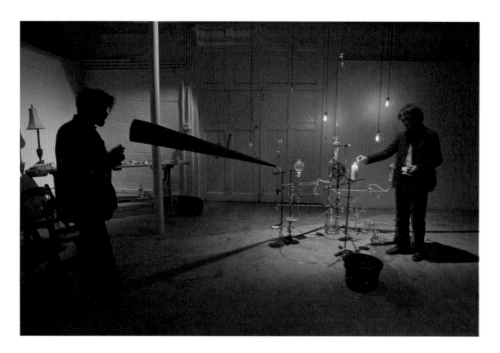

Installation with candle, water, and responsive media, by Michael Montanaro and Topological Media Lab + Alkemie artists for the Play Symposium co-curated by Sha Xin Wei at the University of Chicago (November 2013).

cw: And in the museum, it's a kind of melting pot of directional influences that I'm interested in—a combination of what the work proposes and how the institutional frame in which you encounter it encourages you to behave and how the other people there behave. I have begun to imagine this as a kind of 'soft architecture' that is part-architectural, part-human; it's what institutions are made of (structures and behaviours) and it's what shapes the ritual of the encounter with art. What I like in much recent art is that this is visibly shifting towards a dynamic, flexible situation that performs its madeness, rather than appearing as set or given. The artists I've mentioned, from Rainer to Brisley to Fraser to Charmatz and Ei Arakawa, all, in different ways, initiate situations in which we become aware of ourselves watching, of our role as viewers, of our positions in relation to the 'art', and of the potential for these dynamics to be reconfigured through movement, desire, mutual will, or antagonism.

Endnotes

1. See Nicolas Bourriaud, '*Relational Aesthetics*' (Paris: Les Presses du Réel, 1998).

2. Emmanuel Levinas, '*Totality and Infinity: An Essay on Exteriority*', trans. Alphonso Lingis (Pittsburgh: Duquesne University Press, 1969).

3. Shannon Jackson, '*Social Works: Performing Art, Supporting Publics*' (New York & London: Routledge, 2011).

4. Fernand Braudel, '*The Structures of Everyday Life: The Limits of the Possible*', trans. Siân Reynold (University of California Press, 1992).

5. For more details of Linea Tillett's lighting design for the Tangula Train, Beijing, see http://www.tillettlighting.com/tangula-train.

6. Ryan Gander, '*I Need Some Meaning I Can Memorize (The Invisible Pull)*', *dOCUMENTA (13)*, 2012. See Jonathan P. Watts, 'Ryan Gander', *Frieze*, Issue 50 (October 2012), https://frieze.com/article/ryan-gander-0.

7. '*Gerry Bibby: Combination Boiler*', The Showroom, London (30 April to 21 June 2014), http://www.theshowroom.org/exhibitions/gerry-bibby.

8. For more information on the work and projects initiated by SymbioticA, see the website of The Tissue Culture and Art Project, http://www.tca.uwa.edu.au.

9. Isabelle Stengers, 'Introductory notes on an ecology of practices' (notes prepared for ANU Humanities Research Centre Symposium, August 2003), *Cultural Studies Review* (2005), 11, 1. doi: http://dx.doi.org/10.5130/csr.v11i1.3459.

Fieldwork's Double. When Images and People Meet at the Margins

Massimiliano Mollona

At last, for the first time, by means of the machine, in their own likeness,
our dreams are projected and objectified. They are industrially fabricated,
collectively shared.
 They come back upon our waking life to mold it, to teach us how
to live or not to live. We reabsorb them, socialized, useful, or else they
lose themselves in us, we lose ourselves in them. There they are, stored
ectoplasms, astral bodies that feed off our persons and feed us, archives of
soul. We must try to question them – that is, to reintegrate the imaginary in
the reality of man.

> Edgar Morin, *Cinema or the Imaginary Man.*
> Originally published in *Le cinéma ou l'homme imaginaire.*
> *Essai d'anthropologie sociologique.* (Les Editions de Minuit, 1978).
> English translation copyright 2005 by the regents of the University of
> Minnesota Press.

Introduction

In the preface to *Abstraction and Empathy* (1907), the German art historian
Wilhelm Worringer recalls the day when, as a student, he was fishing for inspi-
ration at the Trocadero museum in Paris. The museum was empty and young
Wilhelm could hear the echo of his footsteps through the cold and lifeless plas-
ter reconstructions of medieval cathedral sculptures. All of a sudden, a ghostly
figure stepped into the room. That ghost turned out to be George Simmel, the
Berlin philosopher who had become extraordinarily popular amongst young
intellectuals and artists for his *Philosophy of Money*.[1] Simmel's book explores the
notion of 'value' from the perspectives of both economics and human psychol-
ogy. It argues that human beings valorise their social and economic environment

through a process of mental abstraction that is made possible by some mediating objects. These media capture the flow of life in the shape of solid images and forms at which humans can gaze from a distance. They refract and reflect emotions, desires, and projections back to their beholders, thus making them aware of the value of their selves and of their actions. For Simmel, money and cinema were two of such technologies of valorisation of the self. For one unforgettable hour, Simmel and Worringer sat together in silence in the museum, sharing the 'atmospheric aura' of that magical encounter.[2] Then, as unexpectedly as he had appeared, Simmel vanished from the room. Whether real or imaginary, the encounter inspired Worringer to look at art through the lens of human psychology, especially the feelings of empathy and distance. Worringer describes empathy (*einfühlung*, borrowed from Robert Vischer and explored elsewhere in this volume) as a drive to self-affirmation and over-identification with the (art) object leading to the feeling of exhaustion, absorption, and outflow of vital energy from the empathic subject's body. In their acts of over-identification, empathic subjects blur with their environment and lose their sense of self. Thus, the dark side of empathy is self-alienation. Abstraction is the opposite impulse to sever oneself from the contingencies, entanglements, and movements of everyday life and to seek refuge in simplified patterns and minimal forms of existence—reclusive, contemplative, and unemotional. Empathy and abstraction are on a continuum of human experience—one is a drive **towards** life, leading to loss and self-annihilation; the other is a movement **away from** life that generates detachment and, at the same time, a sense of inter-relatedness. These movements are as much political as they are mental. Only in exceptional social systems, for instance in classical Greece, a magical balance between empathy and abstraction was achieved and such a balance was reflected in the figure of the ornament or the generalised use of money.[3] Whereas for Simmel, the ever expanding circuits of money, finance, and images under capitalism destroyed social intimacies and depersonalised, standardised, and dematerialised life. Besides becoming the exclusive medium of human exchanges, money blurred together different value systems (love, interest, honour) into a singular materialistic ethos. Sharing a similar anthropological curiosity, Worringer and Simmel asked how empathy and abstraction might have been articulated in societies located at the margins of western capitalism. Worringer seemed to be attracted by what he viewed as the calm abstraction of Asian societies, exemplified by the beauty of the simple line, whereas Simmel longed for a pre-modern world

based on more concrete and less standardised value systems than those under capitalism.

Worringer's and Simmel's anthropological quests remain important. At the margin of the hyper-mediated, over-individualistic, and abstract social relations of western capitalism, do communities based on unmediated, collective, and sensuous social relations exist? And if they do exist, what do they look like? The work of the Brazilian avant-garde artist Helio Oiticica was inspired by a similar search for a sensuous and unmediated mode of existence. From 1959 to 1963, Oiticica developed several versions of the *parangoles*—multilayered painted capes and tents meant to be worn on the body and danced with. The artist came up with the idea of the *parangoles*, observing his father—an entomologist at the Museu Nacional—classifying *Lepidoptera*, a species of hermaphroditic butterfly. Oiticica described the *parangole* as 'colour-structure in space'—a sensuous environment blurring the boundaries between the audience, the artist, and the artwork.[4] Capturing light and colour in the slow rotational movements of their wearers, the *parangole* expanded their bodies into soft wings and voluptuous folds, conjuring a magical space where colour could be touched and human bodies transformed themselves into bodies of colour. By establishing a sensuous and empathic connection between viewer, artist, and artwork—an 'existential unfolding of inter-corporeal space which violates the wearer's being as an individual'[5]—the *parangole* challenged western and bourgeois notions of authorship and spectatorship. Besides stretching beyond the boundaries of the human body, the experience of the *parangole* was also a journey of radical, if not violent, self-abstraction—from human to animal to pure light. Inspired by the psychedelic life force of the favelas of Rio de Janeiro, their samba culture, Dionysian carnival, and sprawling architecture, the *parangole* was an allegory of Brazilian underdevelopment. Rooting Brazilian modernity in a simple synaesthetic gesture, the *parangole* is also an experience of temporal displacement—of upside-down history. 'We are the new primitives of a new primitive era. We have to start to live the ritual again, the expressive gesture.'[6] His association of the radical art gesture with Brazil's underdevelopment was described by the art critic Roberto Shwarz as yet another instance of the paradox of Brazilian modernity which can only exist as coterminous with European modernity.[7] Perhaps, as well as working against the sensorium of western capitalism, the colourful lines of flight of the Amazonian butterfly were sketches of a non-anthropocentric future.

The French surrealist and socialist philosopher Roger Callois was also interested in butterflies and their gestures of radical empathy. In *Mimicry and*

Legendary Psychasthenia, he describes the disorienting effect of mimicry in Amazonian butterflies.[8] Expanding their bodies into lateral appendages that look like petals, lichen, or leaves from the surrounding environment or scaling them up into scary owl faces, these butterflies lost themselves in space. Mimicry, Callois argues, begins as an act of self-preservation but ends up in 'self-renunciation'. Expanding plastically in the environment, the mirroring body exhausts itself in space and 'acquires a mode of reduced existence, which in the end would no longer know either consciousness or feeling – the inertia of the élan vital, so to speak'.[9] The gesture of radical empathy of Amazonian butterflies, in which the empathic subject goes through a violent self-transformation, involving a loss of self and spatial and temporal disorientation, is seen by Callois as a political act—a gesture of becoming self-less.

The Double Consciousness of Fieldwork

Callois was linked to the tradition of 'ethnographic surrealism' which emerged in Paris in the 1920s from a collaboration between the anthropologists of the newly formed *Institut d'Ethnologie*—Michel Leiris, Marcel Mauss, and Marcel Griaule—and the surrealist artists André Breton, Antonin Artaud, and Georges Bataille. Surrealist anthropology had a utopian, rather than a scientific, agenda, aimed at a radical critique of modernity and capitalism based on the 'double movement' of making the familiar strange and familiarising the stranger. Working through juxtapositions, ethnographic surrealism unveiled the wild nature of post-World War I Paris—showing the violence of its mechanised slaughterhouses, peasant folk masks, and bourgeois dinner parties—and at the same time, it made the 'savage other' look familiar and civilised, showing how non-capitalist institutions—gift giving, reciprocal exchanges, extended families, cooperative work, consensual associations—were more egalitarian and just than the corrupted institutions of the state, the church, the factory, the political party, and the patriarchal family that dominated industrial societies. Ethnographic surrealism sees humans as situated in an unstable state of double consciousness—both good and evil, selfish and generous, collectivist and individualist. As in Artaud's theatre, where actors and non-actors mingle, it looks at human identities not as fixed or authentic, but as emerging from the world of dream, the realms of the erotic and the unconscious, and played out in strategic rituals and public

performances. Unlike traditional social science, surrealist anthropology looks at other cultures aesthetically and sensuously: as living forms and patterns of movement and feeling that envelop the rich texture of life.

In animistic cultures, dreams are manifestations of other people, especially ancestors entering the dreamer or speaking through him in order to achieve their ends; people are mirrors of the gods, living images of **their** dreams. Like them, anthropologists in the field are continuously under the spell of dreams, fantasies, and projections. Images may come close, touch their skin, enter their bodies, expanding or distorting them from within, pulling them out of place or out of scale, tearing them open, and turning them inside out. Like the mimicry of butterflies described by Callois, fieldwork is a process of radical absorption into the sensuous geographies and uneven temporalities of the surrounding environment. It often involves personal loss and expanded consciousness—a 'double act' of self-disruption and value creation. The double movement of fieldwork is both visual and haptic—on the one hand of self-projection, absorption, contact, close-up, and fade and on the other hand of distancing, cutting, over-flowing, separation, and self-mutilation.[10] Cinema and fieldwork share the same existential duplicity.

My fieldwork in a Brazilian steel town involved a similar process of empathy and distancing. The steel plant sits on a tropical valley like a mechanical flower—with smoky filaments, wet extensions, and saturated colours. Inside the steel complex, blue blossoms and mango trees sprout from broken pipes and disused machines. Capybaras and wild iguanas run on the silvery carpet of the coal department. The sounds of crickets and of high-voltage electric cables coalesce. The glowing red of the sunset can't be distinguished from the fire of the furnace. Modernist architects planned this city as an allegory of the Brazilian family. Vargas was the father, the steel company, the mother, and the workers the sons.[11] Entering Brazil Square, the town's main plaza, is like stepping into Vargas' presidential palace and familiarising with the psyche of the nation. The focal point of the square is a vast fountain surrounded by allegorical statues. Two naked women, Industry and Nature, are lazily stretched out with their toes nearly touching the turquoise water. On the other two sides, steelworkers are blinded by the electric light of the furnace. Smaller in size than his 'children', Vargas welcomes the visitor in a double-breasted suit, with one hand in the pocket and one holding a cigar. You can nearly smell it. The square brings to life ancient ideologies and stereotypes (of fathers, mothers, and workers), entangling humans and

statues in relationships of nostalgia, reciprocity, and intimacy—curly moustaches in white paint below Industry's nose; old men gossiping with Vargas as if in a dinner party; eyes squinting in the sun in solidarity with the steelworkers.

I settle down in a favela between the steel plant and grazing land owned by the company. I spend my days talking with people in the street and playing snooker in the local club. I learn which streets and topics to avoid and the rules of the informal economy. The street I live in is infused with sensuous beauty—the melancholic songs of my neighbour, colourful kites, the smell of roasted pigtail and rotten papaya. In the steel plant, I interview workers and managers and study photos from its archive, which I am the first academic researcher to access in the company's history. It takes me only a few months of fieldwork to realise that this industrial town is much better off than the rest of Brazil. Industrial wages are well above the national average, welfare and offices run smoothly, and even favelas are being pulled out of misery by the anti-poverty programmes of the government. In the photographic archive, I learn of the company's glorious history. I see a coffee valley of ex-slaves, violent generals, and poor peasants slowly transforming into a modern proletarian city. I see: a massive Cineplex showing Hollywood movies; modern X-ray machines that look through patients' bodies; elegant managers behind mahogany desks; working-class wives becoming 'steel queen' for just one night. I see the slow inroad of logistics into the tropical forest—the nervous system of roads, bridges, and highways and the bare skeleton of the company, with metal frames, beams, and pipes, moving through the jungle like a leopard. Has Vargas' utopia of workers' capitalism and Brazil's industrial modernity materialised at last? Or am I buying into the corporate propaganda?

One day, while I am driven along the *Presidente Dutra* road, a boy of about five years old appears from nowhere. The truck in front of me runs him over, killing him instantly. I am only a few metres away at the moment of impact. I can see clearly his upper torso opening in slow motion, unfolding into a crown of red petals. The truck enters into my body too like a sharp knife, splintering my torso. At home, in the mirror, I can see it floating over my legs, half-open, leaking out red sand and soft material. 'Your problem'—an Umbanda priestess friend of mine tells me—'is that that boy is incarnated in you.' For many days, I feel I have lost control of my painfully open torso. The boy takes me to places I should not be. I keep returning to the company's archives.

Then something strange happens. My life and the life of images start to converge.

REALITY	IMAGE (Black-and-white 1946)
A gigantic roll of the mill crushes a worker, leaving him paralysed.	The metallic body of the roll runs along one diagonal of the photo. Along the opposite diagonal, underneath the roll, is the twisted torso of a dead black worker. A severed leg sticks out from underneath the roll, stretching the body into an oddly elongated shape. The worker is in denim trousers and a T-shirt and wears no protective clothing. His head is turned away from the roll, facing the camera. His eyes are open. His straw hat is in immaculate shape. From the open crown of his head, a dark shadow of blood—a constellation of dots, drips, and soft material—leaks into the lower part of the photo.
REALITY	IMAGE (Colour, 1985)
There is a demonstration. The company-police track down the demonstrators with aerial photos.	A kaleidoscope of grainy dots of all colours, mainly brown and red. A tree trunk and a car roof stand out from this colourful sea like floating wreckages. On closer inspection, the small dots reveal themselves as being the bodies of a demonstrating crowd. Their micro-movements and gestures have a nervous energy. The crowd looks angry and hunted down.

REALITY

Someone calls me on my mobile and says: 'You got to leave this town or we'll kill you like a pig'. Having reported the threat to a company manager, I am put under company protection. My bodyguard looks like a gangster.

IMAGE (Black-and-white 1946)

A young, handsome, dark-skinned man, with a sleek moustache and greased hair, is standing on the threshold of a villa. Wearing a double-breasted suit, spats, and shiny shoes, he stares at the camera intensely and with a menacing grin. Behind him, inside the dark home is the crime scene. Outside, half cropped from the photo, is a forensic photographer looking at the young man with an entranced expression. Is the young man the detective or the killer?

REALITY

In the smelting shop, a subcontractor smiles at me and says, 'Do you know that if you fall in there your body will melt in less than five minutes?

IMAGE (Black-and-white 1950)

A musical band is performing on top of the company's furnace in front of a crowd of workers. The band members are all black. They are all dressed in black. Their makeshift stage is filled with fresh flowers. One of them is crying. Another is holding his fist up. A sign on the stage says: 'He disappeared inside the furnace'.

REALITY

In the archives, I find several pieces of evidence of corporate manslaughter and arms deals with old and new dictators.

IMAGE(S)

(Colour 1972 – marked 'confidential')
A twisted machine inside a gutted furnace cabin. Black corrosions, open cuts, and brown and red liquid splashes—of blood or chemicals—on the walls reveal evidence of an explosion. An arrow marked in pen points towards the control panel of the machine. Small handwriting indicates 'faulty electrics'.

(Black-and-white 1982 – marked 'confidential')
An Arab man dressed in a kaftan, Middle Eastern headwear, and dark glasses shakes hands with the company's CEO, both smiling at the camera. The focus of the photo is on the 'FRAGILE' sign on the wooden box in front of them. On the back of the photo, in blue pen is written 'vetted by the weaponry department of Ministry of Foreign Affairs'.

(Photo collage, undated). President Juscelino Kubitschek and US foreign minister Eisenhower in the presidential car visit the steeltown/Adolf Hitler admires a model prototype of the WV beetle car.

One night I am awakened by the noise of someone rustling at my home's front door. Through the glass door, I see the shadow of a man. Then, shifting my gaze into the inside of the glass, precisely on the spot where the man's shadow was cast, I see a gigantic moth (the size of local bats) flapping its papery wings in slow motion. As I get closer, the moth becomes still. I can now see the intricate and sinuous brown ornaments on its wings and four dark violet eyes staring at me hopelessly. Shifting my glance back to the glass, I notice that the man's shadow has gone. Have I mistaken the moth for the man's shadow? Did I take the noise of the moth trying to escape for that of an intruder trying to break in? Staring closely at the animal's abstract patterns, as I travel through that organic landscape, I lose consciousness. The noise of someone rustling at my entrance door wakes me up. Through the glass door, I see the shadow of a man. As I open the door I am blinded by strong sunlight. It's my bodyguard. 'I have been knocking at your door for hours. I was afraid that something had happened to you. I was trying to break in to see if you were OK.' A few days later, my priestess friend tells me: 'that moth was the spirit of the boy whom you saw dying on the highway. He

returned to bid you farewell. Your time here is finished. You must return home'. Perhaps because the explanation made sense to me or perhaps because, ex-post, I reconstructed that the shadow of the bodyguard was in fact the same as the one I saw the night before, I decided to end my fieldwork and return home.

In Search For a Cinematic Consciousness

When, during my fieldwork, I was taken by an image, I did not expect to be sucked into the historical hallucinations of a corporate archive—that my memory would become history, and history my memory. Did my experience of déjà vu stem from the strong emotional bonds I made with the images I encountered in my fieldwork, including my own primitivist fantasies? Or was I simply experiencing Brazil's under-development—a future with an uncanny resemblance with its photographic past?

That images have an animistic power has been a central trope of anthropology and art history, from James Frazer[12] to T. J. Mitchell.[13] On the other hand, how much humans share with cinema—the way they both weave together fantasy and reality, projections and images, light and matter—was a central theme of mod-ernist art and politics.[14] Siegfried Kracauer, the German sociologist and film theo-rist, and another student of Simmel, described, for instance, how the cinematic technique of close-up produced an extreme feeling of empathy and absorption—which transformed human faces into vast mental landscapes—and, on the other hand, the detachment effect produced by fast editing.[15] He lamented the fact that contemporary cinema had lost the balance between abstraction and absorption (akin to Worringer's empathy) that characterised early cinema and that it had become a technology of 'mass distraction' (read 'abstraction') for the industrial proletariat. For the film scholar Jonathan Beller, the distraction effect of cinema is even more evident in the current post-industrial capitalist regime where the abstraction of images and the abstraction of finance reinforce each other.[16]

The spatial and temporal displacement and self-other blurring experienced in cinema and fieldwork are similar to some experiences of mirror-touch synaesthe-sia collected by the editor of this volume.[17] Entering other people's bodies, travel-ling through emotional landscapes, experiencing bodily distortions being formless, half-open, dividual, rather than individual—made of fingers, noses, feet, or eyes—which can live on their own or come together as a reflection of the movements of the other. Expanding optically, zooming in on the grainy textural surface of life

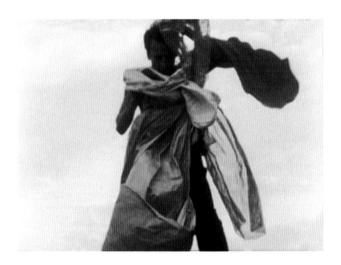

Hélio Oiticica with P4 Parangolé, Cape 1, 1964. Still from *HO*, a film by Ivan Cardoso, 1979. Collection Museo Nacional Centro de Arte Reina Sofía, Madrid.

where all objects are in motion—or zooming out, into flat and abstract patterns of energy without movement, mirror-touch can function like cinema, suspended between haptic and distant ways of seeing. All these experiences are windows onto the performative, sensuous, animistic, and empathic modes of interaction of non-capitalist societies or 'zones', where human choreographies are open and every person is embedded in networks of human and non-human relationships. Perhaps the importance of these experiences is that they bring back a haptic, tactile, and unmediated dimension in the midst of increasing life-abstraction under capitalism. These experiences teach us how to be human, finding a balance between the flow of life acting upon us and our framing of reality through a particular viewpoint. Part of this process of becoming human may involve coming to terms with our cinematic consciousness or, as Morin puts it, with cinema as 'man's double'.[18] Let images touch us and become part of us. Let us expand our bodies into sensuous visual extensions (like Oiticica's *parangoles*). Let us become 'cinematic skin'[19]— fragile optical membranes connecting the inside and the outside of our person-hood, media of different sources of light. In the context of the de-humanising, impersonal, and abstract forces of capitalism, becoming human again may entail finding the right distance between dreams and life and making up stories and life forms that are at the same time immediate, tangible, and fantastical.

Endnotes

1. George Simmel, '*The Philosophy of Money*' (New York: Routledge, 1978), 1900.
2. Wilhelm Worringer (1907), '*Art and Abstraction. A Contribution to the Psychology of Style*' (Martino Fine Books, 2014), 34.
3. Richard Seaford (2004) and David Graeber (2013) argue that the invention of money in classical Greece was responsible for the simultaneous emergence of both idealism and materialism. Richard Seaford, '*Money and the Early Greek Mind: Homer, Philosophy, Tragedy*' (Cambridge: Cambridge University Press, 2004). David Graber, '*Debt: The first 5,000 years*' (New York: Melville House, 2013).
4. 'Notes on the Parangolé' ('*Anotações sôbre o Parangolé*', published by the artist on the occasion of the exhibition *Opinião 65*, 1965 at the Museu de Arte Moderna, Rio de Janeiro) reprinted in *Hélio Oiticica*, 93–6, 93.
5. November 1964, Archives Hélio Oiticica (document 0035.64) in Irene Small, '*Morphology in the Studio: Hélio Oiticica at the Museu Nacional*', *Getty Research Journal* (2009), 1, 110.
6. 'Notes on the Parangolé', 1965, reprinted in *Hélio Oiticica*, 93.
7. Roberto Shwarz (1992), '*Misplaced Ideas: Essays on Brazilian Culture*' (London, New York: Verso Books, 1992).
8. Roger Callois and John Shepley, '*October*' (1984), 31, 16–32.
9. Callois and Shepley, 32
10. Elsewhere, I discuss the links between anthropology and cinema and their two sometimes overlapping 'movements'—one of inward, linear, and empathic approximation **towards** reality and another of critical abstraction **from** reality. See Massimiliano Mollona, 'Observation, performance and revolution: exploring "the political" in visual art and anthropology', *Visual Anthropology* (2013), 26, 34–50.
11. Vargas Getúlio was the president of Brazil who built the steel town in the 1940s.
12. James Frazer, '*The Golden Bough*' (London: Macmillan & Co, 1922).
13. Thomas Mitchell, '*What Do Pictures Want? The Lives and Loves of Images*' (Chicago: The University of Chicago Press, 2006).
14. For instance, Vertov and Eisenstein and Deleuze's study of cinema.
15. Siegfried Kracauer, '*Theory of Film. The Redemption of Physical Reality*' (Princeton University Press, 1960).
16. Jonathan Beller, *The Cinematic Mode of Production. Attention Economy and the Society of the Spectacle* (Dartmouth College Press, 2006).
17. See, for instance, the testimony of Nicola Mamo or the chapter by Fiona Torrance.

18. Edgar Morin, '*The Cinema, or the Imaginary Man* (University of Minnesota Press, 2005).

19. The surrealist artist Artaud famously described cinema as the 'skin of things, the epidermis of reality' in Antonin Artaud, '*Selected Writings*', Introduction Susan Sontag, trans. Farrar, Straus, and Giroux (Berkeley, CA: University of California Press, 1976), 151.

Empathy's Ghosts

Daria Martin

A pale scientist, sitting in a darkened room, listens to a recorded voice, delivering a testimony: 'When I see patterns I get a visceral, tactile response. Especially on a large scale, like a rug or a big weaving, I feel them pressed against the front of my body, as if I were wearing something soft.'[1]

Film Still, Daria Martin, *Sensorium Tests* (16mm film, 10 minutes, 2012).
© the artist, courtesy Maureen Paley, London.

The voice is that of a mirror-touch synaesthete; a scientist is studying her. What does this researcher want of the synaesthete, this person of extraordinary physical empathy? What is he dreaming about as he listens to her murmured stories?

This fictional scene begins my film *Sensorium Tests* (2012), which was stirred by the impulse to understand minds that are strange, yet somehow familiar. Such an impulse, of course, has a long history in psychoanalysis, which not only imagines the unusual on a continuum with the normal, but also recognises the ways in which we project elements of our unconscious desires onto others.[2] Lives that seemingly exceed our own capacities tend to fascinate. The contemporary psychoanalytic writer Adam Phillips, for one, has explored the ways that, for all of us, and not just for artists, idealised lives run in parallel to our lived ones, illuminating and expanding the contours of our limitations. Envy points us towards what we want, what we lack. The protagonist who breaks the rules, the alter ego who lives life at a greater scale, the one who took the chances that we didn't—these fantasies are for Phillips 'potentially productive forms of frustration,'[3] bridges between desire and reality that charge that gap with tension and yet, perhaps, lead towards real satisfaction.[4]

In this chapter I explore what it might mean when a 'normal' person imagines the perceptual world of someone with mirror-touch synaesthesia. Why listen to stories told by such a synaesthete? Why research, write, or make a film about her? As someone who has personally done all of these things, I am bound to enquire about my own motives. What might this fascination say about my unconscious, my desires?

It may seem obvious that I am 'projecting' aspects of my own assumptions, and even repressed personal qualities, into the mirror-touch synaesthete, and consequently idealising her; indeed, this is probably the case. But rather than dwell on the Freudian unconscious, with all its attendant conflict shaped by personal history, I would like to propose first that my fascination with the mirror-touch synaesthete says something about my—and others'— more universal neurobiological unconscious. Cognitive scientists' recent term, the 'new unconscious', describes many surprising processes that were previously assumed to require higher-order processing, including goal pursuit and cognitive control.[5] Processes of mimicry, including those of mirror systems, discussed elsewhere in this volume, also occur without intention or deliberation. For example, already in 1975, the psychologists S. M. Berger and S. W. Hadley created an experiment in which electrodes placed on participants' faces picked up tiny movements around their

lips while videotapes were shown of another person stuttering.[6] The participant-observers were utterly oblivious to their own miniscule oral movements.

Most of us are unaware of our lips twitching while watching someone else stutter, but a mirror-touch synaesthete might feel a palpable tug at her lips. The threshold theory of mirror-touch describes a situation in which the mirror systems active in all of us are in overdrive for the synaesthete, so that the process of mimicking another's motor movement, implicit for most of us, is, for the mirror-touch synaesthete, driven above the threshold of consciousness and vividly felt.[7] Those of us without mirror-touch might begin to examine our own responses to witnessed touch as perhaps a shadow of the more conscious mirror-touch experience. When a mirror-touch synaesthete watches someone punched, he feels the impact; we cringe. When a mirror-touch synaesthete watches a couple kissing, she feels the warm press of lips; we may pucker up.

As non-synaesthetes, we do not feel the ouch and awe of these moments in the same visceral way that the mirror-touch synaesthete feels them. But we may want to look more closely at that threshold of consciousness to examine how much of the experience of physical empathy, actually, is submerged or how accessible to our senses are some signals. The same scientists who forwarded the threshold theory of mirror-touch almost immediately qualified it because they speculated that if we were all subject to such a threshold, we might sometimes, in rare moments, exceed it ourselves—and they contended that we do not. In their experiment, they pointed out, the non-synaesthetic controls did not feel conscious touch at the sight of someone else touched: 'there was no hint of feeling observed touch in any of the non-synaesthetic subjects.'[8] And yet, if we are attentive, some of us may notice that, some of the time, we *do* feel a light jolt of pain when witnessing another harmed or a whispered caress when spying an embrace. Although it is a speculative proposition in scientific terms, we might—imaginatively—conceptualise such barely palpable micro-perceptions as glimpses of our hidden, unconscious processes, as delicate signals that break past the radar of our awareness. We might imagine these as dimly registered traces—not symptoms or slips from a Freudian unconscious, but evidence of empathic processes that take place all the time implicitly in our brains and bodies.

The mirror-touch synaesthete may, at first blush, seem a nebulous creature, our unlived shadow-life. And yet, of the two—us and the synaesthete—who is the shadow, the ghost?

In an experiment room bordered by a one-way mirror, a woman takes a seat, ready to be tested. The male scientist and a female colleague watch from darkness through the mirror.

Film Still, Daria Martin, *Sensorium Tests* (16mm film, 10 minutes, 2012).
© the artist, courtesy Maureen Paley, London.

Our unlived lives may recall existences we once had, or had just begun, and then lost. Or they may, merely, point towards lives we imagine we once had. The mirror-touch synaesthete, in particular, may remind us of capacities we fantasise having once upon a time: a more vivid sensorium, fuller empathies. And these fantasies have some scientific basis; it has been suggested that certain kinds of synaesthesia are present in all neonates[9] before neurological 'pruning' pares the senses into more discrete channels, and although studies have not yet been done on mirror-touch amongst infants, psychoanalysts from Freud to D. W. Winnicott to John Bowlby have remarked upon the self-other

blurring present in infancy. Debates in the neuroscientific community are ongoing about whether we are born with mirror systems intact or whether we develop them in response to social situations, and about whether these systems can directly, on the neural level, be damaged or enhanced throughout our lifetimes.[10] But what is known is that empathic responses more generally can indeed be altered by life experiences and that, specifically, they are negatively impacted by trauma.[11]

On a personal scale, we are all vulnerable to traumatic experiences and thus subject to a loss of empathic capacity. And in the Western world particularly, these personal losses are embedded within a larger cultural one—the widely lamented and debated trauma of the 'Cartesian Cut'. The influential neuroscientist Antonio Damasio, who argued from the 1990s that emotions are central to our capacity to reason, describes, in *Descartes' Error*, the ways in which the philosopher's famous statement 'I think therefore I am', separating the thinking mind from the non-thinking body, is a fallacy with long-lasting consequences. Damasio conceptualises, instead, embodiment as the ground for thought:

> . . . long before the dawn of humanity, beings were beings. At some point in evolution, an elementary consciousness began. With that elementary consciousness came a simple mind; with greater complexity of mind came the possibility of thinking and, even later, of using language to communicate and organize thinking better. For us then, in the beginning it was being, and only later do we think. We are, and then we think, and we think only inasmuch as we are, since thinking is indeed caused by the structures and operations of being.[12]

One might feel this sense of 'being', the fullness of sensibility, of sensitivity, to be somehow out of reach, and in this case the mirror-touch synaesthete gives traction to extend to greater capacities. Imagined thus, our (apparently) diminished perceptions are the ghosts and the mirror-touch synaesthete our living body— or perhaps—our facilitating medium, offering these phantoms greater visibility. And if, as the art and media theorist Hans Belting argues, the body is the primary medium for images,[13] then the mirror-touch synaesthete's skin is an ideal ground on which to articulate images. The synaesthetes interviewed for this volume give rich accounts of vivid, and sometimes startling, impressions; one synaesthete described feeling the brushstrokes in a painting by Albrecht Dürer slicing against her cheek 'like blades of grass'.[14]

And yet these images are not fixed, like tattoos etched in skin, nor do I want to imply one universal, static image of **the** mirror-touch synaesthete, as if this existed. Indeed, it is the fluid, and often moving (in both senses), quality of these images that interests me, and the 15 interviews with mirror-touch synaesthetes that undergird this volume reveal lively variegations of sensation. These stories provide a 'channelling' of ghosts—ours, the synaesthetes'—that implies a continuum of experience and yet illustrates the granulation of difference— idiosyncratic stories distinct from those that typically emerge from the experimental psychologist's laboratory.

After all, is there not a certain absurdity in attempting to scientifically isolate the synaesthete's leakages? What might occur when the 'Cartesian Cut' scores right through the perception of a mirror-touch synaesthete?

A standing fan is placed opposite our experimental subject C. An assistant touches its side, while another assistant touches C's cheek.

Film Still, Daria Martin, *Sensorium Tests* (16mm film, 10 minutes, 2012). © the artist, courtesy Maureen Paley, London.

I made the situation of a laboratory testing of mirror-touch the subject of *Sensorium Tests*, which fictionalised the first experiment on a mirror-touch synaesthete conducted in 2005 by the cognitive neuroscientist Sarah-Jayne Blakemore and colleagues (including Jamie Ward, contributor to this volume).[15] Their experiment with the mirror-touch synaesthete 'C' in a controlled laboratory followed a serendipitous encounter with the same woman in 2003 at a public synaesthesia presentation to which C responded by casually remarking on the touch she felt while watching others being touched. While the listening scientists were astonished to learn about a whole new category of previously unnamed synaesthesia, C was equally astonished to discover, for the first time in her life, that others did not experience the same sensations. She had assumed that feeling touch when others were touched was utterly normal.

In the laboratory tests that resulted, a series of moving images of touch to inanimate objects, and finally a person, being touched were displayed on a computer screen.[16] The objects depicted had anthropomorphic qualities—a speaker, a fan, and a lamp each faced her with a mute 'face' atop a 'neck'. While these objects and then a human were touched on their 'cheeks', simultaneously, C was touched on a cheek as well—sometimes mirroring the seen touch, and sometimes in counterbalance on the 'wrong' cheek. The actual touch to C's cheeks came from a solenoid 'tapper', so that no peripheral movement towards the face could be seen. C's measured confusion between 'real' and synaesthetic touches to her own cheeks, greater than that of non-synaesthetic controls, proved her perceptions were genuine, and although one of the experiment's findings is that C did not experience synaesthetic touch in response to the objects, subsequent experiments have found that other synaesthetes do feel these sensations. The experiment also proved, using functional magnetic resonance imaging (fMRI) brain imaging, that regions in her tactile mirror systems were in overdrive and that she was, as she claimed, consciously experiencing touch.[17]

Sensorium Tests weaves several artistic inventions into this scenario, but the first adaptation from fact to fiction was a change of the spatial configuration of the experiment. In the original experiment, C lay on the bed of a large fMRI machine, inside of which was placed a video screen displaying the prompting touches, a scenario that does not leave much space for visual exploration. In my film, the experiment is liberated from the brain-scanning device, to allow a

larger scientific device of sorts to enclose the goings-on—an experiment room, containing C and her visual interlocutors, is placed alongside another darkened room from which scientists view her through a one-way mirror. Although this voyeuristic configuration is these days used more often for police line-ups than for psychology experiments, here, it makes rather explicit a kind of seeing that is, in many ways, the opposite of C's. While C viscerally feels the stroke to another's cheek, my fictionalised scientists analyse these movements, protected by the safety of invisibility.

What might this invisibility shield? What sort of shortcomings might this position of voyeurism mask?

> *The female researcher remains perfectly poised, like a statue. The man is more distractible: from his task of listening on earphones to synaesthetes' testimonies he turns, apparently filled with frustration and desire, to watch the real synaesthete, just in the next room.*

Film Still, Daria Martin, *Sensorium Tests* (16mm, 10 minutes, 2012).
© the artist, courtesy Maureen Paley, London.

Sometimes a too-painful question is best looked at from a side view. Like the male scientist in *Sensorium Tests*, I will turn now from one kind of fascinating mirroring to another—a sideways gesture that will eventually pivot back. My attention shifts to another subject, another instance of empathic resonance in which mind and body are moved by an image, in which phantoms—in this case, phantom limbs—are a sensuously palpable part of reality.[18]

The owner of a phantom limb, an amputee or, on occasion, a person born without a limb, possesses an internal body map that expands beyond where others perceive it to end. For some who experience this phenomenon, phantom arms gesticulate in lively harmony with spoken conversation, while for others less fortunate, the limb is paralysed, felt as frozen immovably into the position in which it was held (often by a cast) before amputation.[19] Irene, a patient of the neuroscientist V. S. Ramachandran told him: 'I try to move my phantom, but I can't. It won't obey my mind. It won't obey my command.'[20] Irene's sensation, and others like it, Ramachandran speculates, may be a result of 'learned paralysis', a slow acceptance of the disconnect between the will to move and the resistance of the limb trapped in a cast, which persists even once the physical limb is amputated. Whatever the cause, the effect is eerily frustrating: this phantom is imprisoned (and often also in pain). It is difficult to imagine how another person could possibly influence this obscure situation.[21]

To help patients activate agency in a petrified limb, Ramachandran considered engineering expensive virtual-reality devices to simulate the feeling of motion, before alighting on a fast and cheap option. His invention—the mirror box—is an ingeniously low-tech device, about two feet wide, bisected by a commonplace mirror. The two equally sized chambers on either side of the mirror are punctured by holes through which the user's hands can slide. The top is open, and if the user leans slightly towards the reflective side of the mirror, she will see her hand doubled: one hand becomes two. The choreography of the device is such that when this hand waves, they both do, in symmetrical calisthenics.

The exercise is not impressive if both hands are physically present (as for me and, most likely, you), but imagine that one of the 'hands' slipping through the holes, hidden behind the merrily reflective mirror, is an incapacitated phantom hand. For patients suffering from phantom limb paralysis, the mirror box is a miracle cure. The patient watches the hand wave about freely, doubled in reflection, and her brain makes the connection via this visual image that the waving hand is her phantom hand waving. The stiffened phantom limb is restored

to lively movement.[22] For many patients, the mirror box instantly lifts long-ingrained paralysis (and attendant pain) in the moment of use and, if practised with regularly, eliminates the uncomfortable sensations altogether. The uses of this device are tractable and widely needed, particularly in communities affected by war or its aftermath. For example, the End The Pain project, a non-profit initiative founded in 2008, supplies mirror boxes to victims of Vietnamese land-mines—such as Thiet Nguyen Xuan, whose years of suffering due to burning phantom fingers were relieved with a few weeks of using the box—and aims to supply some 300,000 more.[23]

The 'miracle' of the mirror box is all the more striking because of its modest, straight-from-the-tool-shed materials, like those that many artists use to craft their fictional visions. Several artist friends are fascinated by the mirror box since this object realises our aspirations—the box confirms that it is possible to start with the physical, the visible, to leapfrog to an illusion and, from there, mobilise an invisible realm of subjectivities. The mirror box seems to celebrate the notion that images have power—real, liberating power in people's lives.

My hope for my films, too, is that they might mobilise a viewer's sensorium, and feeling of potential action, in part through the ways that moving bodies onscreen solicit mirroring and, more subtly, through the invitations of roughly sensuous and recognisable surfaces that conjure associative memories, even

Diagram of V. S. Ramachandran's mirror box.

Drawing for the set of Daria Martin's *Sensorium Tests*.

as they obscure the films' fictional transparency. This pull and push between absorption and gentle alienation creates a gap that both frustrates and engages. Idealised images are probed: some of my films also use a moving camera to project or 'feel into' spaces otherwise inaccessible to viewers, allowing physical exploration of architectural models or small artworks; *In the Palace* (2000), for instance, placed several actors inside a scaled-up, life-size version of an Alberto Giacometti sculpture. In this film of mine, and others, aesthetic empathy, described by the German term *einfühlung* (literally 'in-feeling')[24] operates in both explicit and more implicit ways.

One feels, quite literally, into Ramachandran's mirror box, but feeling in with imagination, one might picture the mirror box as a tiny theatre for two hands that enacts a drama of the locked versus the liberated. And if one were to take the mirror box as a model and scale it up to architectural proportions, the resulting object would resemble the set of *Sensorium Tests*. My film too moves between two chambers: on the mirrored side, hands move—waving—as our apparently more sensitive, even more able-bodied subject, a mirror-touch synaesthete, performs in accord with the experiment. On the darkened, pained side, two ghostly scientists remain still, nearly paralysed by their waiting.

What are these scientists waiting for? What might this synaesthete's open senses contribute to their body of knowledge, their view of the world?

The man in the darkened room becomes more attentive as C's cheeks are touched, even slapped. She cringes, then returns her attention to her partner.

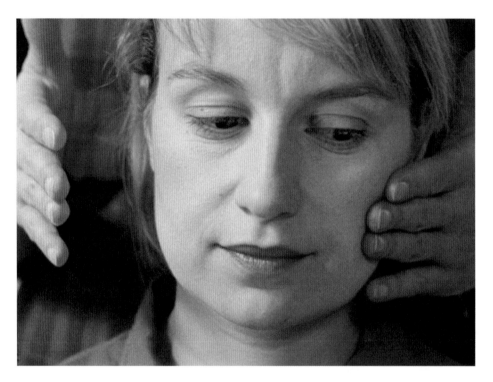

Film Still, Daria Martin, *Sensorium Tests* (16mm, 10 minutes, 2012).
© the artist, courtesy Maureen Paley, London.

Of course, the staging of *Sensorium Tests*, and of the mirror box, has its strict limits. After all, both the scientific laboratory and the therapeutic box offer two identically constructed and carefully differentiated chambers, preserved from the contamination of distractions. Moreover, the mirror box is effective in part because of the precise symmetrical mapping between its constituent parts—the intact right hand, reflected, looks very much like the old left hand. Experience out in the world, where social bodies are less symmetrical than real ones, is not normally so evenly weighted, so primed for the right distribution of attention.[25] The 'other' does not exist to serve our fantasies or to complete our losses. Mirror-touch synaesthetes are not at hand on a daily basis to tutor us non-synaesthetes in sensitivity.

Nor are mirror-touch synaesthetes ideal empathic models, perfectly suited to enact compassion out in the world; and in this, they may reflect our problems and frustrations too. For the mirror-touch synaesthete, in the larger, less controlled world, the presence of their own 'other' may overwhelm as much as it enables. Amongst our interviewees for this volume's collection, one synaesthete regularly experiences panic attacks; another has to lie down on the office floor to recover from sudden floods of information; and most report needing to leave a room or the cinema when onscreen violence gets too intense.[26] When confronted with a cascade of intense physical, and often emotional, empathy, the mirror-touch synaesthete may be able to embrace vulnerability, or may have to retreat to a state of lonely abstraction, as this synaesthete describes:

> I oscillate between absorption—in which the body opens up to the objects and sensations coming from outside—I genuinely believe that I am part of the world—and moments in which I understand that this blurred state is my own internal property and I become aware of being an individual. This detachment can be politically empowering, creating an understanding of the human condition of being social—collective—but also alienated, individual and lonely.

This synaesthete seems to imply that the oscillating movement between absorption and detachment—immersing in, and then separating from, a collective other—is itself empowering. The synaesthete continues: 'This is a core human dilemma. How do we recognise uniqueness and yet avoid the self-centred and socially disruptive individualism that we can see magnified in late capitalism?'[27] How, we might ask, can we move between the capacity to feel and act upon empathy for others, and yet, to recognise difference? This restless back-and-forth implies a partial satisfaction and a partial frustration at both poles, a sensitivity to wanting, and a desire for what might be. Psychoanalyst and artist Bracha Ettinger, inspired in part by French philosopher Emmanuel Levinas' ethics of intersubjectivity, describes 'borderlinking' between 'partial subjects' in which 'the borderline of our encounter is not fixed but moving, affected by caring and empathy and fascination (as well as antipathy and horror) and uncognisingly known.'[28]

How might the contours, indeed the thresholds, of our subjectivity be shifted by looking at art? Between empathy and distance, how might the border of our encounter with art move?

An assistant who has been a wallflower on the sidelines of the experiment sits down opposite our subject. Both women's cheeks are touched in a rhythm of mirroring and complements, sometimes in synch, sometimes out.

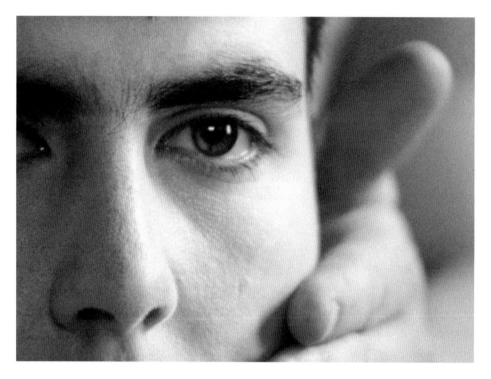

Film Still, Daria Martin, *Sensorium Tests* (16mm, 10 minutes, 2012). © the artist, courtesy Maureen Paley, London.

To attend to these movements we may again open ourselves to latent sensations shifting below our threshold of awareness or just barely discernably above it. I am referring again to the ghostly traces of mirror system responses: our shudders and twitches. Phenomenologists train themselves to track these small somatic responses, not with sophisticated electronic instruments, but through practised introspection. The best of these philosophers are not (as far as we know)

neurologically different, like synaesthetes, but rather use a rehearsed attunement to their bodies as the ground for philosophical speculation. The film phenomenologist Vivian Sobchack has spent decades examining the ways that the aesthetic experience of watching films can increase our sensitivity and indeed create what she calls a 'cinesthetic' experience in us all. And although Sobchack was largely responsible for the 'embodied turn' in film studies, she doesn't presuppose a viewer with any special capacities for empathy; in fact, her cinesthetic viewer might start his journey from a position of distance and only gradually be 'provoked' or 'solicited' and 'caught up without a thought' by images onscreen.[29] Here Sobchack articulates her body's mirrored responses as she views cinematic images, responses that create an uncomfortable gap between her body's desire and the world onscreen:

> . . . the cinesthetic subject both touches and is touched by the screen . . . my skin's desire to touch streams towards the screen to rebound back on itself and then forward to the screen again and again. In the process my skin becomes literally and intensely sensitized . . . What is more, in this unthought carnal moment of an ongoing streaming toward and turning back of tactile desire, my sense of touch—'rebounding' from its only partial fulfillment on and by the screen to its only partial fulfillment in and by my own body—is *intensified*.[30]

Sobchack's longing for greater contact is frustrated but results ultimately in a heightened awareness of her own sensing, her wanting. This oscillating, partially stymied subject, intending towards the screen, through 'rebounding' cycles of yearning and only partial satisfaction, is transformed by her longing—and by the ways the body makes up for that want—into a state of greater sensitivity. One might imagine that the relationship to the screen here works as a training ground for a relationship to any 'other'. Like the mirror box's phantom reflections, Sobchack's filmic images also shift contours of subjectivity. Like the process of longing and frustration that Phillips, and our politicised synaesthete describes, Sobchack's, too, is productive.

What might such transformative experiences of looking at art produce in the world?

*Moments of synchronous touching occur. The synaesthetes' and assistants'
cheeks are touched on opposite sides. The synaesthete announces her sensa-
tions: 'Both'. She feels touch on both cheeks. The coincidence is repeated, and
she utters again: 'Both . . . Both.' The watching male scientist rises abruptly
and fishes for a cigarette.*

Film Still, Daria Martin, *Sensorium Tests* (16mm, 10 minutes, 2012).
© the artist, courtesy Maureen Paley, London.

A transformation occurs too near screens or windows at the end of *Sensorium
Tests*. After travelling through spaces of contact, of immersion, of distance, all
navigated by the performer's glances, the camera's and the viewer's own, an event
takes place: the male scientist leaves his one-way mirror, repulsed or inspired by
the synaesthete, and gazes out the back window of the lab, watching and listen-
ing, his senses alive. The mirror's glossy armour, dissolved by daylight, reveals
the scientists to the synaesthete. And the fictional scientific experiment as such is
spoilt. But the ground has shifted and there is now something deeply interchange-
able between our laboratory's two parts. One might imagine such a scenario as,

again, analogous to what goes on inside the mirror box: the paralysed phantom limb is liberated and able to move, becoming equivalent to a 'real' limb—influencing and building on its partner in lived existence.

If *Sensorium Test*'s mirror box has done its work, then we might enquire about what happens next outside this box in truly lived existence. I have made two more films that explore how mirror-touch synaesthetes struggle with uneven power dynamics in both primary and passing relationships,[31] but I am also, in parallel, curious about real mirror box users' experiences, after the experiment's success. How do their interactions with these freeing images affect their capacities to act in the world? We know that these users are relieved of pain, but fewer stories are told about how these phantoms move, once liberated, about how these ghosts are integrated into life. First-hand accounts are rare—but, conveniently, again, Sobchack throws light on how such an experience is actually lived. She hasn't, as far as I know, needed to use a mirror box after her leg was amputated many years ago, since her phantom leg is already alive and well and working in relationship with her prosthetic leg. Here she relates her insights into the relationship between these parts of her body, describing a therapeutic outcome that many would envy:

> Standing and walking, each leg bears equal weight and value in the pair's mimetic reciprocity, the joint [. . .] cadence of their gate attuned and responsive to the immanent demands of their intentional task. Although one's center of gravity shifts with prosthetic use, there still is, indeed, a center around and from which one's two legs get their marching orders. 'Phantom' limbs, 'prosthetic' limbs, 'real' limbs: their difference is one of degree, not of kind—and less in function than in material substance. . . . I don't walk around feeling incomplete or as if something is missing (even without my prosthesis) insofar as I can, if I will, stand to my height and walk (even with crutches).[32]

Sobchack's attuned cadence models an integration of loss and ability, a metaphoric and embodied transcendence of the Cartesian Cut. She lives more wholly responsive.

Why, then, does the mirror-touch synaesthete fascinate? I would like to propose that the difference between ourselves and mirror-touch synaesthetes is 'one of degree, not of kind' and that these empaths have something important to tell us about our own real capacities, and their limits, including our receptivity to art's transformations. If I have a desire to engage with the mirror-touch synaesthete, then it is in the hopes that the gap between desire and reality—including the frustrations that sometimes idealised images may evoke—moves from one stalled by paralysis to one that moves towards possibility.

Endnotes

1. This moment and those that follow describe points in my film *Sensorium Tests*, originally on 16 mm, 10 minutes, 2012.
2. For a concise, pocket-sized introduction to psychoanalysis, see Daniel Pick, '*Psychoanalysis: A Very Short Introduction*' (Oxford: Oxford University Press, 2015).
3. Adam Phillips, '*Missing Out: In Praise of the Unlived Life*' (London: Hamish Hamilton, 2012), xix.
4. Phillips' analyst was, in turn, trained by D. W. Winnicott, whose ideas about the creative potential of a 'transitional space' are described in Siri Hustvedt's essay in this volume.
5. See Ran R. Hassin, James S. Uleman, and John A. Bargh, eds., '*The New Unconscious*' (Oxford and New York: Oxford University Press, 2005).
6. Cited in Tanya L. Chartrand, William W. Maddux, and Jessica L. Lakin, 'Beyond the Perception-Behavior Link: The Ubiquitous Utility and Motivational Moderators of Nonconscious Mimicry' in Hassin et al. eds., *The New Unconscious* (2005). Original paper: S. M. Berger and S. W. Hadley (1975), 'Some effects of a model's performance on an observer's electromyographic activity', *American Journal of Psychology* (1975), 88, 263–76. It should be noted that this experiment did not postulate that mirror systems underlay the mimicry tested; mirror neurons were only discovered in macaque monkeys in the early 1990s by the neuroscientist Vittorio Gallese and his team at the University of Parma, following research which began in the 1980s. See Vittorio Gallese, Luciano Fadiga, Leonardo Fogassi, and Giacomo Rizzolatti, 'Action recognition in the premotor cortex', *Brain* (1996), 119, 593–609.
7. See S. J. Blakemore, D. Bristow, C. Frith, G. Bird, and J. Ward, 'Somatosensory activations during the observation of touch and a case of vision–touch synaesthesia', *Brain* (July 2005), 128, 7, 1572.
8. Blakemore *et al.*, 1582
9. Simon Baron-Cohen, 'Is there a normal phase of synaesthesia in development?', *Psyche* (1996), 2, 27.
10. Celia Heyes, 'Where do mirror neurons come from?', *Neuroscience and Biobehavioral Reviews* (2010), 34, 575–83.
11. Maria Allessandra Umiltà, Rachel Wood, Francesca Loffredo, Roberto Ravera, and Vittorio Gallese, 'Impact of civil war on emotion recognition: the denial of sadness in Sierra Leone', *Frontiers in Psychology* (September 2013), 4, 523. doi: 10.3389/fpsyg.2013.00523.
12. Antonio Damasio, '*Descartes' Error: Emotion, Reason, and the Human Brain*' (New York: G. P. Putnam's Sons, 1994), 248.
13. See Hans Belting, '*An Anthropology of Images: Picture, Medium, Body*', trans. Thomas Dunlap (Princeton

University Press, 2011) and Belting, 'Image, medium, body: a new approach to iconology', *Critical Inquiry* (Winter 2005), 31, 302–19.

14. Elinor Cleghorn, Interview with Anonymous, a mirror-touch synaesthete, 21 July 2014.

15. See Blakemore *et al.*, 'Somatosensory activations during the observation of touch and a case of vision–touch synaesthesia', (July 2005), 1571–83.

16. See Michael J. Banissy and Jamie Ward, 'Mirror-touch synaesthesia is linked with empathy', *Nature Neuroscience* (2007), 10, 7, 815–16.

17. See Blakemore *et al.*, 'Somatosensory activations during the observation of touch and a case of vision–touch synaesthesia', (July 2005), 1575–80.

18. There is also a concrete link between phantom limbs and mirror-touch synaesthesia. Almost a third of amputees report a tactile sensation on their amputated phantom limb when watching someone else being touched. See Aviva I. Gollera, Kerrie Richards, Steven Novak, and Jamie Ward, 'Mirror-touch synaesthesia in the phantom limbs of amputees', *Cortex* (January 2013), 49, 1, 243–51.

19. For a fuller description of Ramachandran's experiments with the mirror box, see V. S. Ramachandran and Sandra Blakeslee, '*Phantoms in the Brain: Human Nature and the Architecture of the Mind*' (London: Fourth Estate, 1998), 39–62.

20. Ramachandran and Blakeslee, 36.

21. A similar question sparked off the field of psychoanalysis. Together with the Austrian physician Josef Breuer, Freud documented the first case of the talking cure after Anna O was treated by Breuer for a number of hysterical symptoms, including the paralysis of her arm, which, he discovered, had its origins in a traumatic nightmare. It was released through the catharsis of the dream's retelling. But I am writing here not so much of the 'talking cure' as perhaps a 'looking cure'.

22. Although the reasons that the mirror box works are still somewhat mysterious, Ramachandran conjectures that it is the activation of mirror systems, and consequently an implicit perception of movement, by the visual image of the moving arm that liberates the phantom limb. See http://www.bbc.co.uk/news/magazine-15938103.

23. Stephanie Hegarty, 'What phantom limbs and mirrors teach us about the brain', *BBC News Magazine*, 5 December 2011, http://www.bbc.co.uk/news/magazine-15938103.

24. See Robert Vischer, *Über das optische Formgefuhl: Ein Beitrag zur Aesthetik* ('*On the Optical Sense of Form: A Contribution to Aesthetics*'), (Leipzig: Herrmann Credner, 1873).

25. Even in my film, the laboratory is not airtight: a phone rings; light glints off of a watch; the subject sneezes; a poster falls. Distraction leaks into the experiment. The synaesthete James Wannerton (who, against type, plays the voyeuristic scientist in *Sensorium Tests*) has commented that he feels his synaesthetic responses slightly altered by the particular conditions of laboratory experiments.

26. See Daria Martin, Interview with Anonymous, a mirror-touch synaesthete, 15 October 2012 and Martin, Interview with Torrance, 18 March 2013.

27. Daria Martin, Email correspondence with Nicola Mamo, a mirror-touch synaesthete, 7 July 2012.

28. Bracha L. Ettinger, '*The Matrixial Borderspace*' (Minneapolis, London: University of Minnesota Press, 2006), 145.

29. See Vivian Sobchack, 'What My Fingers Knew', in Vivian Sobchack, *Carnal Thoughts: Embodiment and Moving Image Culture* (Berkeley, CA and London: University of California Press, 2004), 77–8.

30. Sobchack, 78.

31. Daria Martin, '*At the Threshold*', 16mm film, 17.5 minutes (2014–2015) and '*Theatre of the Tender*', 16mm film, 9 minutes (2016).

32. Vivian Sobchack, 'Living a "phantom limb": on the phenomenology of bodily integrity', *Body and Society* (2010), 16, 3, 51–67.

Double Consciousness/Double Shooting

Rabih Mroué

Rabih Mroué, *Shooting Images*, video still (2012). Artwork by Rabih Mroué, *Shooting Images* © 2012 Mroué/Sfeir Semler Gallery, reproduced with permission of Mroué/Sfeir Semler Gallery.

An image can shock us, hurt us, and burn our eyes, as Georges Bataille once said. Images can play the role of nerves and transmit pain and feeling into our whole body. They can be almost agonising to watch.

In the first year of the Syrian revolution, there were several videos uploaded on the Internet by Syrian protesters, in which we witness the protester,

who is filming, being shot by a sniper or by one of the regime's soldier forces.

These videos show the moments of **eye contact** between sniper and cameraman, when the gun's line of sight and the camera's lens meet.

We see and hear the sniper shooting, and from the movement of the mobile phone, we sense that the cameraman is falling to the ground.

The cameraman is always off-camera; he remains outside the image. And no one can tell whether he is dead. Onscreen, there will be no blood, no corpse, and no real violence.

Everything will happen outside the image and inside us: inside our bodies and our minds, on our skins.

Not all videos allow the viewers to 'look with' those who have made them. There are few videos, like these, which give their viewers this sense of being where the action is. (We know that fiction films and video games are virtual.)

We capture with our eyes exactly the same thing that the protester's eyes captured through his mobile's lens.

We feel the zoom in and out with our own eyes. We feel the speed and the rhythm of the protester's body holding his mobile phone and filming, even though we are not moving.

Through his eyes, we witness what happened to him. We are engaged; we are not passive.

Not working with our eyes, but with our own past experience, each spectator establishes what is off-camera. It is a construction. Violence exists outside the image, and we reconstruct it.

The absence of the off-camera is projected clearly in our minds and translated to real sensations by our bodies. We see it, we feel it, we listen to it, we touch it. It has weight and warmth.

My concern is to learn again how to look and to see, because in our present time, invaded by images of war and catastrophes, I feel myself blind and numb. And

Rabih Mroué, still from *The Pixelated Revolution* (lecture-performance, 2012). Artwork by Rabih Mroué, *The Pixelated Revolution* © 2012 Mroué/Sfeir Semler Gallery, reproduced with permission of Mroué/Sfeir Semler Gallery.

if I decide to open my eyes to see these images, I am not seeing, but I am aching and maybe dying a little.

> No representation, no metaphors, no allegories. Everything is direct: the blood is blood, the pain is pain, and the death is death.

> This is why, in my works, when I use one of these videos or images, I insist on playing them frame by frame, to make them look artificial, to desacralise them, to analyse, deconstruct, and dissect them. It is my way to learn how to see and think about what we are seeing.

Theatre-makers have a big responsibility not to misuse their authority for the sake of their ideological purposes by trying to manipulate their audience. This is also why the theatre-makers should free the stage once the show is done—to keep the space empty for other voices and propositions.

The artist and spectator should be equal partners in dialogue. No one owns the knowledge.

I do theatre in order to talk about my doubts and my uncertain thoughts, to ask questions to which I have no answer.

I don't like participatory theatre. The audience should have the chance to take a certain distance from what they are watching, to formulate their own opinions. And by busying the audience with participation, we, theatre-makers, lose our chance to share our doubts and thoughts.

In the Syrian protester's videos, we feel pain and fear, but with no direct identification since neither the victim nor the perpetrator has a face, a personal past, or a future.

So, after watching the video, what is left for us is only to face ourselves, to be with one's self.

Whenever there is eye contact between two people, there is always the possibility to see one's image reflected on the eyes of the other and vice versa. In the Syrian protester's video, the sniper has to fix his eye on the viewfinder of the gun and the cameraman has to fix his eye on the viewfinder of his camera, and as soon as their eyes meet, both the sniper and the cameraman can say the same thing: 'I can see my image reflected in one of your eyes.'

Logically, the eye contact between the two persons will create two mirrors (two pupils) facing each other. The sniper can see his image reflected in the eye of his victim. And the victim can see his image inside the eye of the sniper. As long as eye contact is maintained, the images are there too. Thus, the two mirrors will create a feedback loop of the same two images, an endless *mise-en-abyme* that hypnotises.

And by being hypnotised before any action is executed, both will become complicit. As if in every human being, there are both persons: a criminal and a victim. This is why the duration of eye contact between the two can't stay for long and must be cut before both or one of them is hypnotised. One of them should react quickly; either the cameraman should run

away and hide, or the sniper should shoot and kill. This way, the complicity is cut.

Is it possible to bring the perpetrator into the light and to ask him to talk about the reasons for his crime? And should we only rely on the victim's testimony?

In a suicidal operation, both the perpetrator and the witness are eliminated. The crime remains obscure, incomprehensible, and easy to consider as a terrorist act.

I am not defending the perpetrators or underestimating the testimonies of the victims. Rather, this is a way to get out of the dichotomy that divides everything into black and white, good and evil, innocent and guilty. These kinds of dichotomies make life unbearable and almost impossible to live.

I wrote this dialogue for my brother, in a play in which, onstage, he describes recovering from a brain injury inflicted during the Lebanese civil war:

> Descartes says: I think therefore I am.
> Kundera says: I ache, therefore I am.
> There was a time in my life when I was not thinking, and I was not aching, but I was.
> I knew I was, because of two things: my eyes that were moving, and the people around me who were moving.
> So I move, therefore I am, although there was nothing moving in me, except my eyes.

When someone is conscious, then he or she can confirm: yes, I am.

And there is something always moving between thinking and aching, between reason and emotion, between here and there . . . Life is about moving. Stillness is death. But what if nobody recognises my moving, can I still say: I am?

If I am in pain and no one feels my pain or if I have a thought and no one listens to me, then what happens? When we don't know about a certain incident, then it is as if it doesn't exist. Today, if an event is not covered by the media, then it is as if it has not taken place. Social media is so important for people, because it gives us the possibility of communicating without the use of our bodies, thus without pain.

Rabih Mroué, *Double Shooting*, installation view (2012). Artwork by Rabih Mroué, *Double Shooting* © 2012 Mroué/Sfeir Semler Gallery, reproduced with permission of Mroué/Sfeir Semler Gallery.

There are many things happening around us that we are not aware of. If we don't see the **other**, it does not mean that the other does not exist. It is there, but we can't see it, can't recognise it.

And then suddenly, one day, this **other** stands in front of us. Isn't this what is happening today with the so-called ISIS? Everybody is shocked and asks: 'But where did these people come from? Where were they?' As if they came from the unknown, from another planet. In reality they were within us, living in the same society, in the same house, but our eyes were closed.

In Conversation

Judith Hopf and Joel Salinas

JOEL SALINAS (JS): I'm a neurologist and a mirror-touch synaesthete. I feel the sensation of touch on my own body when I see other people, and even inanimate objects, being touched. Before I knew about mirror-touch synaesthesia, I would have never been able to say: 'I have mirror-touch synaesthesia—let me tell you about it'. I first learned about synaesthesia during my first year of medical school. That was when it quickly became clear that my day-to-day sensory experience wasn't the same as most other people's. A few years later, while being studied by synaesthesia researchers, I was surprised yet again to discover that my sensory perceptions were different from others, that I had mirror-touch synaesthesia.

The decision to go into neurology was a natural progression. I'm enraptured by the idea of being in a constant lab where my interaction with everyone is an experiment in understanding the brain. The brain is such a black box. Being a neurologist is partly an intellectual means for relieving some of the tension I experience between the external and the internal. One of the challenges I struggled through was whether it's possible to be open about my subjective synaesthetic world and still maintain enough credibility to challenge mainstream ideas within my field.

'Normal' is often confused with 'normative'. That is, the common conception of normal conflates the concept of 'health' with the most statistically prevalent biological or behavioural states. Though labels are a way for people to understand the differences between 'normal' and the outside of normal. Traditionally, the way that we consider things outside of normal is as 'abnormal' or 'paranormal' and that implies pathology, a harmful disease to explain a rare observation. It will take a fair amount of cultural shifting to understand neurological differences that don't impair social functioning

as traits, rather than conditions. As a neurologist, I can appreciate some of these differences in brain functioning from person to person. In the absence of established disease, these differences represent a kind of 'neurodiversity'.

JUDITH HOPF (JH): It might be helpful to use labels sometimes, but it's tough to handle it right. For example, there's a need to be 'out' spoken about sexuality in order to develop one's identity freely. Labelling can be quite liberating in that sense, but on the other hand, it can be brutal and reductive. We might psychologise in a practical, Freudian way, hoping to get over conflict zones by verbalising them, but sometimes speaking about things does not solve the physical realties. In art schools, now students feel they have to talk through and explain their work, and as a teacher I tell them that they don't have to. They start to make sense of things before they've even had a chance to find out something they don't already know. This is in part why I work visually, to get into these more awkward spaces.

Often I work with things lying around me to talk about problems. I made sculptures out of drinking glasses, piled to look like glass columns, and added paper leaves to give them the appearance of bamboo. You can look through the transparent glass, which is super fragile, but at the same time, it's quite massive—three metres high. Whenever I've installed the sculptures in a museum, the curators are afraid that people will run into them, but nobody has, because you feel that the tower is very heavy. It makes you wonder about the distance and nearness of things to your body.

Sometimes I want to go beyond the joy with the visual and to make clearer messages and that's of course storytelling. My films are quite outspoken; they communicate directly. When I began making films, and acting in them myself, I discovered that I had a lot of physical presence and energy. It was a shocking and joyous discovery.

I have this disability where I'm a bit smaller than other people. Growing up, I had a lot of aggressions; I was always a bit angry with my body, as it didn't function like it should. I was always depending on a lot of help from others but trying to ignore everything. My physical action and presence in my films was very freeing for me.

JS: I'm picturing what you're saying about performing in your own films—like you're being viewed by others through binoculars in reverse, so that the audience, in an attempt to understand your experience, creates a false, yet tangible, perception of distance.

Judith Hopf, *Bamboos* (Documenta 13), installation view (2012). Courtesy the artist, Kaufmann Repetto, and Deborah Schamoni.

Judith Hopf, *Zählen* (2008) 16mm transferred to video, production still, 3:38 minutes. Courtesy the artist, Kaufmann Repetto, and Deborah Schamoni.

JH: Yes. It was always tough for me to find a non-aggressive relation to my physical appearance. You can't change your body or change the situation. I guess for all of us, it's not so easy to find a relationship between body and mind because the body is such a wonder—whether under a microscope or in full. The different appearances, forms, and knowledges of our bodies are really to be celebrated, but it's not so easy to find the point where you can celebrate it.

JS: My own mirror-touch has the potential to be an impediment in healthcare, but ultimately it's something that helps me as a doctor, something I appreciate greatly. In training, I was sometimes caught off guard by an unexpected gory scene and had to distract myself to recalibrate. But more often, the stimulus and effect are subtler; let's say, I'll be tending to a patient who seems calm, and then I'll notice, as they're describing their experience in the hospital, that they're slightly upset. I might sense subtle changes in their facial expression accompanied by tension in their upper extremities. I'll then begin to reflect on thoughts that are congruent with the physical experience—my

own remembered experiences that induce anxiety or stress. With this aware-ness, I can even find myself playing out the narrative that the patient might be telling themselves internally, and I have to check back in with my true internal state and affirm where their perspective ends and mine begins. That gives me at least the insight to be able to address their concerns very specifically. Some-times I'll just ask: 'What is it that you're most concerned about right now?'

As physicians, we focus a lot on the numbers—the lab values and the vital signs—which are all very important, of course, but putting these in the context of the patient's own hopes and fears helps them to feel more empow-ered about their body. A common feeling that patients have is betrayal—their body, or fate, has betrayed them. I see this a lot more in younger people or those that don't usually get sick. They ask: 'How can this be happening to me?' When it does, it suddenly alters the framing of their world. They feel alone.

JH: I was recently in the hospital for a broken leg. I didn't so much empathise more with other patients because I was one myself, but rather, I recognised that we are all in crisis. I've spent a lot of time in hospitals and I have quite constant pain because I have so much trouble with my leg muscles. And because my leg is traumatised by multiple operations, the sensitivity to pain gets more and more out of control; the nerves are like paths that get broader and broader, the more you walk on them. I try to include the process of pain in everyday life by doing a lot of relaxation and breathing and organised sports. But still it is strange because I always forget about it if I don't have it. And as soon as I do have it, it stops me from doing a lot. I can't plan for it. So I try to avoid walking on a certain point because it might hurt—I stop before I even try it.

JS: It's interesting how, internally, pain has such a powerful domin-ion over your attention. An expression I've heard a lot in my work is: 'This is the worst pain of my entire life'. The patient might appear to be sitting comfortably and in no apparent distress, but the attention and framing have shifted, so that there's no other pain that exists other than **that** pain that has suddenly consumed their whole world.

And yet, pain is amorphous and people's response to it can vary dramatically. There is physiologic pain where the nerves are injured, leading to neuropathy or neuralgia wherein the nerves constantly send a pain message to the brain. And then there's the higher-order process, which is your brain perceiving the pain. The power of this higher-order process is evident when

Judith Hopf (in collaboration with Deborah Schamoni) *Hospital Bone Dance*, still (7 minutes, digital video, 2006). Courtesy the artist, Kaufmann Repetto, and Deborah Schamoni.

you focus on the pain and it actually becomes worse, or if you somehow play it down in your own mind, the injury seems less painful. There's a whole body of thought around internal feedback and refocusing exercises as ways to decrease your sensitisation to pain over time.

JH: Joel, as a doctor, if you experience so many different things at once, how do you order all the sensations? I'm just wondering if it isn't extraordinarily tough to find one's position. In Germany, the doctors have a very authoritarian manner. That has changed a bit in the last ten years, but in other European countries, people still make jokes about German doctors as 'the Gods in white'. I made fun of this situation in my film *Hospital Bone Dance*, which is set in a public hospital where patients are just numbers. A patient who has been turned away comes back with a whole ghost troupe.

JS: One way that people in the clinical field—both doctors and nurses—survive the level of necessary efficiency is through a numbing process.

Particularly during the training and residency phases, you are flung into environments where you are expected to make very challenging decisions about acute situations at any hour of the day or night, and sometimes on very little sleep. It's hard to give yourself the space to reflect and process. A lot of doctors, just out of necessity, will press the mute button on their internal state.

In answer to your question about how I manage all the sensations, imagine you are using a computer where all the processes are running and let's say that one of those windows is the mirror-touch experience. I minimise that sensory window, so that it's not taking up all of my desktop space. The process is still going on in the background and it still affects the other processes in the computer. And if I ever want to focus back on it, I just click on it and maximise the window again.

JH: You move between distance and nearness, in your experience?

JS: Yes. Usually there's a tension between nearness and distance. There's a distance in perspective, but also an intimacy. Something captured in the interviews that Daria [Martin] and Elinor [Cleghorn] have conducted with mirror-touch synaesthetes is the way that mirror-touch responses can throw others off balance. When synaesthetes have an insight about another person's internal narrative and then directly express this insight, it can come across as irritating, patronising, or threatening. There's that tension in mirror-touch experience between a need to be near and a need to be far.

I haven't had a diagnosis of autistic tendencies, but I can see in myself some of the defining sensory traits.[1] I imagine the same might be true of other mirror-touch synaesthetes. How would the duality of mirror-touch and autistic traits—which we might think draw out opposite qualities on the empathy spectrum—balance out? On the one hand, you can seem to others as hyper-empathic, but on the other, you might actually be internally attuned only to the mechanical or sensorial aspects of the experience. There's 'empathy' as emotional sharing and then there's 'empathy' as physical mirroring. Depending on the type of tests psychologists use, you will get different impressions of what empathy is and whether or not the person tested is truly 'empathic'. Do you relate with others? Do you feel what other people experience? That kind of a test might not necessarily be specific in terms of distinguishing whether somebody has a high amount of emotional empathy versus a mirrored physical experience, since there's likely to be an interaction between the two. People

with autistic tendencies don't necessarily have a conventional emotional connection with others, but if you happen to have mirror-touch, you might at least have that unemotional, physical sensation to bolster a closer human connection. One mirror-touch synaesthete interviewed for this book summed it up nicely: You can feel what other people are feeling, but you don't necessarily feel it with your heart.

Another possible explanation for the association is that the more overwhelming experiences of mirror-touch can cause the synaesthete to protectively withdraw from social contact, which may lead to the development of behaviours that can be found in autistic spectrum disorders. As such, you might observe overlap in behaviours among an autistic spectrum disorder and in mirror-touch in the same person only because of the ways we conceptualise each of them. It's an issue of construct.

JH: I've been reading Hannah Arendt's book *The Human Condition* (1958) where she strengthens practical ideas concerning political action in contrast to the 'contemplative'.[2] She looks to Ancient Greece where conflict zones were seen as a challenge, which should not be neutralised but discussed in the public sphere from various political viewpoints. In contrast, she wonders about a tendency of an American society in the 1950s to create distance from their actual doings. Already in the 50s, Arendt anticipated the ways we distance ourselves from brutality and conflict zones by not being physically involved. But, of course, it's necessary to be clear about the things we do together here on Earth.

JS: I think people are gradually becoming more entrenched in a constant state of crisis, whether it's personal, existential, global, political, social, or economic. It's part of the nature of our biology to try to deal with a crisis with a fight or flight reaction and these reactions intrinsically involve creating a distance. From a survival standpoint in a state of crisis, how much good does it do you to be able to reflect on your own emotions and the emotions of others?

JH: Does cooperation help us in those situations? When I was studying art, I was hoping to find only sensitive and sensible people around me, but that wasn't the case. Artists, of course, operate in the same competitive, organised system as the rest of us. After a hundred years of Modernism, audiences are also conditioned in how to look at, and think about, art. I think it's interesting as an artist to include dumbness and insensitivity, rather than avoid it all the time.

I try to distance my work from the message that I want to convey, which is often about the physical abilities we have here on Earth. We need some distance because if I talked directly about the problems, it would be a constantly complaining speech. I make work with humour, so that people have the chance to think that it's just a joke, even though Freud would say there's more to it. Conceptualism from the 60s onwards taught us that art should be more distanced and unemotional, even though Martin Kippenberger and other male artists—less

Judith Hopf, *Erschöpfte Vasen/Exhausted Vases* (2012).
Courtesy the artist, Kaufmann Repetto, and Deborah Schamoni.

so women—used humour as a gun. My career was helped by circulating my films on the Internet where laughs and emotions were allowed.

But with the Internet now, we don't find an end and a beginning so easily and I feel quite filled up. With my *Exhausted Vases* pieces, I want to talk about this feeling of emptiness. You turn the vase upside down and it's no longer functional. It's, of course, not always read in that sense; sometimes people just like it because it's comic or they feel that it reflects contemporary art culture because a critic looks very seriously at art and here the artwork looks back at you. The object forces the audience to perform around it.

JS: It sounds like humour is a way for you to cope with the struggle of correspondence between your body's outer appearance and your internal thought process. For you, that struggle for correspondence might be mediated by the size of your own body not fully corresponding to your thought process. The converse is true for me—my internal thought process mediates the lack of correspondence to my external body. In my interview for this volume's qualitative study, I mentioned how, in seeing objects, I can experience a mirrored proprioceptive sensation. If I look at a telephone pole, I might have the sensation of being elongated in the mirror image. The internal perspective of my body map doesn't match up with its actual physical structure. I imagine that if my external body truly matched up with my synaesthetic, dynamic body mapping, I would end up looking like some kind of psychedelic amoeba.

JH: Questioning conformity is essential. It is what drives all my conversations—and not only because of my special position as a disabled person. Cultural studies has helped us to understand that although so many cultural differences exist, we are not out of the crisis—we are still normative and this is extremely stressful. Racism is like this: it goes through people's minds in a fluid way. Even if I tend to believe that material resources should be evenly distributed, when it comes to human psychology, we can learn so much from each other's differences. They should be celebrated.

I think art has big potential to communicate differences at very complex levels. We can take the time to get together and take things seriously that are not so labelled. Aesthetics are endless.

Endnotes

1. In 2013, the American Psychiatric Association (APA) published a revision of its influential diagnostic text, the *Diagnostic and Statistical Manual* (referred to as the DSM). This fifth edition of the DSM included revisions to the diagnostic criteria for autism and Asperger's syndrome; DSM 5 introduced an emphasis upon the 'spectrum' nature of these conditions, which encompasses the identification of an individual's variable needs under the umbrella term Autistic Spectrum Disorder, replacing previous DSM criteria, which named individual diagnostic subgroups. For review, see Meng-Chuan Lai, Michael V. Lombardo, Bhismadev Chakrabarti, and Simon Baron-Cohen, 'Subgrouping the autism "spectrum": reflections on DSM-5', *PLoS Biology* (April 2013), 11, 4.

2. Hannah Arendt (1958), '*The Human Condition*', second edition (Chicago and London: The University of Chicago Press, 1999).

Mirror-Touch Reader

These quotes are drawn from a collection of semi-structured interviews with mirror-touch synaesthetes, conducted by the two of us (in person, by Skype, and by email) between November 2011 and July 2015. We contacted these 13 synaesthetes, who self-identified as having mirror-touch, through synaesthesia social networks as well as scientific groups. Three had been tested in the laboratory to confirm their mirror-touch. They ranged from ages of 21 to 53, hailed from the US, UK, Europe, and South Africa, represented a fairly broad range of incomes and backgrounds, and included four men. We structured the conversations with a scripted set of questions covering encounters with people, objects, art, and films—from which many welcome tangents arose. These synaesthetes' testimonies are published here in short excerpts and numbered, rather than named, to respect the wishes of many interviewees who preferred to remain anonymous. Although these quotes could be grouped in many different ways, here they are arranged into four groups that loosely correspond to the four sections of this volume, and we've signposted some sub-themes that relate to the concerns in those sections. Unsurprisingly, however, the experiences of these mirror-touch synaesthetes spill well beyond the bounds of our categories and raise many new questions for further exploration. Scholarship, scientific investigation, and artistic interpretation of mirror-touch have only just begun, and synaesthetes will have much more to tell us.

Elinor Cleghorn and Daria Martin

Feeling In

Mirrored Touch and Beyond

I experience mirror-touch sensations as if in a mirror when I'm facing somebody. If side by side, the right side corresponds with the other person's right side.(3)

> I feel touch from what I see. When someone is hitting or striking, I feel it also like a strike, on the same part of the body. When I see touch on a right cheek, I can feel it on the left cheek, or on the same, or on both.(10)

You know when you have butterflies in your stomach? Imagine that on your face, or another part of your body . . . a whipped kind of a feel—very light, but real.(3)

> Sometimes, especially when cold is involved, I can feel a slight burn, like you feel when you rub snow on your face, but very lightly.(9)

When I am working as a massage therapist, what I feel is a little diffuse, like a warm syrupy sensation that often begins at the back of my head and sometimes drips down my body. I start to salivate, my mouth tickles, and I feel pleasure as when I am the one on the table getting a massage.(5)

> I can feel everything I see on my hands and tongue. If I touch something with my hands, it amplifies the feeling on my tongue. When I see people interacting with each other physically, I feel that on my body, especially on my hands and tongue.(7)

A lot of the time I feel a texture on my hands or a taste in my mouth, and sometimes I feel the touch on my shoulders or my knees or my toes.(12)

> If you told me a story now: 'I went for a walk, it was breezy, then suddenly I walked into a house and the fire was on and it was hot', I'd feel the breeze, then I'd feel the hot, as I go along. They call it mirror-touch, but it's more what is suggested to your senses. It's not just that I have to see it; if I hear about it, think about it, or I'm just reminded of it, I'd experience it.(4)

I try to avoid people with hoarse voices, because even if I think their voice is really pretty, it makes me cough a lot, as if I was trying to correct it.(9)

> When people are eating, it's horrible. I actually feel like food is being shoved into my mouth.(12)

I was captivated by velvet fabric as a child because the sensation of velvet on my fingers is probably the closest correlate to what my skin feels like when I'm having more of a pleasurable mirror-touch sensation. The same thing is true of angora sweaters that have a very soft, light pile. When I see them, I will get a little feeling of that glow all over my skin.(5)

Mirrored Pain

It doesn't matter what the emotional or moral context of the violent image is, it's just going to hurt.(6)

> There was this woman at the grocery store, and her little boy grabbed a shopping cart and fell backwards and smashed his head on the ground—you could hear it. My eyes went grey, and I fell to my knees and my head hurt so bad, just like someone had bashed me in the back of the head.(12)

When I see someone who has been hurt, perhaps a man with a cast on his arm, I get shooting electrical sensations down the back of my legs. This sensation originates at my sacrum and shoots down the back of my legs all the way to my heels. The sensation is quick, sharp, and painful. It is also precise—if someone was standing in front of me, I could draw on his or her body with a marker precisely where I feel pain.(5)

> Moving through rooms of people in a hospice who are on their deathbeds; watching my grandmother die . . . Those were very intense mirror-touch moments. They weren't necessarily emotional moments; I know that sounds terrible, but the physical feeling was like having your lungs fill up with fluid—well, as much as my mind can imagine that. That pressure . . . like someone stepping on you.(12)

Some films that really disturb me due to shooting pain:
Fight Club, *Requiem for a Dream*, any of the *Godfather* films.
I am not typically triggered by highly fantastical depictions of violence, such as the *Star Wars* films or the *Lord of the Rings* trilogy.(2)

> Blood isn't so much an issue for me; ruptured flesh is a problem.(5)

The one thing I hate is when someone has an eye problem, and it's red, because my eye stars to itch and burn!(9)

When people talk about eating food that's gone bad or any type of internal injury, then I completely lose it.(6)

I cannot bear films with burning, freezing, or wounding.(8)

I will have pain sensations in (my arms and legs) if I see a broken piece of glass, or rusty nails sticking up from a board. I saw a photograph of the wreck of the MS Costa Concordia in Italy that really detailed the rocks, sticking up into the hull of the ship where the ship was ripped open.(5)

Mirrored Emotions

My mirror-touch can have a physical component that can make me want to cry, or feel so tense or angry if a person is very stressed or furious. I can feel it physically because I move nervously or have tics.(9)

I feel an overall physical manifestation of the emotion of another person. There is an automatic backflow of that information that goes to my brain from the physical sensation that pulls up those emotions in me; it's not so much a deliberate process as it is an automatic process.(3)

I feel more emotionally connected to people, which brings me happiness. At the same time, mirror-touch makes me more sensitive to people's emotions. Often-times that causes anxiety.(13)

The strongest sensations are emotional where I experience the emotions of those around me. I literally experience a homunculus of the other in my mind.(3)

I definitely think that a lot of my emotional reaction ends up being defined by the people around me, which can be very difficult.(11)

My girlfriend enjoys the fact that I instantly respond to her change in emotion. However, this is not always the case, as sometimes I will experience a large emotional change in her, but she will not want to speak about it, and it becomes hard for me to then ignore it.(1)

One thing I notice that I have that other people don't have: I always see people's inner child. No matter who they are or what they are doing, I always see their humble side. If I look at someone being really horrible, I can look at them for the reasons they were broken down. When you're a child, you're less inhibited; when you're a grown-up, you're inhibited.(4)

My mirror-touch is much more pronounced when I am around children and I feel emotions that I only felt as a child.(8)

If I'm around someone whose emotional experience is very strong, and I'm around them for a sustained period of time, it gets to a point where I am unable to keep the volume down actively enough. I can put myself in a very dark place because of it.(3)

> For me, it really manifested in middle school. I had very strong emotions that my friends were feeling. One of my friends was clinically depressed and had attempted suicide multiple times. I would feel that within her. There was this one time when she kept getting worse, and no one could see it, but I could feel it.(11)

When listening to the radio, if a heavy metal song comes on and they start to scream, I feel this cold tension wrapping around my body. I hate it and cannot disassociate the incoming emotions from my emotions.(1)

> They're so happy and they're hugging each other, and I'm so happy . . . (6)

I don't want to make it seem voyeuristic, but I can watch others hugging or enjoying life and be a part of their own joy as well as my own joy, and their joy amplifies my own joy.(3)

Modulation of Mirror-Touch

If I look at something and intentionally think about it, I can feel on my hands what the texture of the thing would be. Deliberate thought can definitely make the sensation more intense. There are my baseline, unconscious, involuntary reactions, and then I can intensify things if I really focus on them.(6)

> If I see someone hugging or kissing, I get the feeling of affection. If I think about it, I can feel the actual physical sensation, but that is uncomfortable around people I am not very close to.(8)

I do not think that I have ever tried to turn my mirror-touch synaesthesia up simply because of its natural intensity, but to turn it down I usually cover it with colours from my other types of synaesthesia.(7)

> A scientist friend of mine asked: 'It must be like being on LSD all day, how can you stand it?' We all learn about focus. I can focus when I'm reading,

when I'm working, so this is to push it down. And to make it stronger, when I'm relaxed, I can put away a lot of other things.(10)

I am more comfortable with these feelings when I am watching a film because I do not feel like I am invading someone's privacy. Film images can therefore feel more powerful.(13)

> I find it unsettling to watch scenes where the actor is not experiencing the emotion they are trying to portray. It feels very dissonant to me. I have a constant debate in my head as to whether subtle emotions I experience from the actors are intentional or unconscious.(1)

Usually I don't like violence, especially watching someone smashed in the face, it just hurts—but if the acting is really bad, or there's a lag in the sound effects, it's fine.(12)

> I once dated a guy who got really sick with a hereditary blood clotting disorder, and he didn't know what it was and he had this big seizure and he was in a coma for a month. When he was awake and not under anaesthesia and they were poking and prodding him, it was so painful for me. Standing there watching him, I would just have to leave. But when he was anaesthetised, I didn't feel it.(12)

Empathy with Artworks, Architecture, Surfaces

Paintings are noisy and personified, a lot of personality. Personality is a big deal in paintings.(4)

> Albrecht Durer! . . . the paint strokes are like blades of grass—I can feel them brushing on my face.(12)

An artist colleague told me about a sculpture: 'I don't like this because it has unloved parts'. And this is really what I feel. When I have the impression that the artist is not with his mind on this part, then the empathy doesn't work. Looking at a Brancusi, you can see that he is completely crazy about the tension of the surface, and the empathy works.(10)

> The textures of some pieces of art that I have seen have so tempted me to touch and/or eat them that I have had to walk away, lest I actually disturb the piece.(7)

I think that there would be essentially a space for every emotion, for every feeling. If I were a city planner, I'd make it a very calm place, a very relaxing place; very cool, clean lines; great open views . . . and then I think there would be a portion of the city that would be much more structured, with many things going on, lots of activity. I think it would be a place where you could move between and choose which kind of feel you want.(3)

> We went to Santorini for three weeks, to an old fishing village. Now this village was made of concrete, and it is all shaped by hand—the windows, the steps, the houses; everything, every wall, is made by hand. And then when we went to the airport. the metal, rectangular shapes were a shock to my body.(10)

I would create more streets that curve. I would make buildings that had more curving shapes, and buildings that have neo-classical columns and cupolas. There's a protectiveness to these features, a sheltering quality that we get when standing under them, almost as if they were a second sky.(5)

> I definitely would like sidewalks to be made of either moss or grass or something soft, that I can grip, because that grounding sensation is very helpful to me.(11)

Sharp edges—it's like I'm hurting myself without touching anything. There are certain fabrics I dislike, which give me a weird sensation in the hand, as if I had touched the fabric for hours and it almost hurt.(9)

> The trend towards very spare, linear interiors and buildings is a real turn-off for me from a synaesthetic standpoint, because there's nothing pleasing to the tactile sensibilities. People don't furnish their homes with fabrics or textures that beg to be touched. This kind of design is very cerebral; it's meant to be pondered, and not necessarily meant to be touched.(5)

Expanded Embodiment

Self-Other Blurring

I mostly view mirror-touch from the scientific approach, because that's my background. If I were to see it from a less scientific point of view, I would summarise it as one less barrier between myself and the rest of the world.(3)

You know when you look at a watercolour painting, the lines are often not precise, and there is a blurring of line, colour, and detail—that's what my more positive mirror-touch perceptions feel like. There's a blurriness, like the lines of my body, the container that my skin represents isn't a hard, fixed line but is instead a transition of sorts.(5)

This empathy, it is a flowing process—the emotion is osmotic. I am always looking for a situation where I don't have the border, I don't have to protect myself, and I don't have the tensing.(10)

Things go through you, people go through you, and noises go through you.(4)

Seeing somebody cry and trying not to cry yourself; seeing someone yelling and feeling your neck constrict because you feel you are yelling as well; feeling like your voice is straining, even though you are not saying anything . . . I think I have spent my life confusing my sensations with others'.(12)

I can very easily change my behaviour to what is needed in different social contexts. By imitating the social behaviour, the bodies, how they move . . . (10).

When I see people in the grocery store, or in the street, and they walk a certain way, I will automatically walk that way. It may be offensive! But I'm not meaning to make fun of anybody, and I'm not trying out an experiment—it's just something my body does.(12)

I'll meet someone for the first time and I'll make some general observations, and the more time I spend with them, the more I'll almost begin to mimic them, and it gets to a point where it's almost like I'm a twin of them. I've learnt to control it, so it doesn't come off as creepy.(3)

While I don't, at the very centre of myself, 'become' another person, I feel like my proximity to other persons is greater. That sense of being right next to their experience.(5)

I am not sure that it would be appropriate to say that I confuse my sensations with those of other people, but at times it is as though I am feeling through another person. It can be utterly devastating.(7)

With people I have very strong relationships with, something very interesting happens. When I am with them, I assume a large portion of their core belief systems about reality, and it is like I put on a helmet, with tinted glass. I can only experience reality filtered through their filtering system. When I have been away from them for a few days, the helmet disintegrates and I regain clarity again. It is a very strange sensation.(1)

> I do special body training, and there is this old woman who has these amazing, skinny, very long fingers, very elegant, and when I think about this, I feel it on my hands. My hands are the opposite; they are small, strong, and short!(10)

Movement

In 1976, I was fascinated by the Romanian Olympic gymnast Nadia Comaneci because she was just a few years older than me and she captured the heart of the world as a young girl competing at a very high level of performance. I would sit with my friends and watch her. As Nadia moved through her routines, my body would twitch and my muscles would move as she moved, and my friends just considered me a freak. I couldn't explain it, and I wasn't trying to do it, and I just found the more I watched her, the more the muscles in my legs would fire, and my legs would move.(5)

> I watch the painting move, partially in my mind and partially externally. In a sense, it is actually moving because my eyes are moving around very quickly. (13)

I've never felt mirror-touch with a [static] artwork since it doesn't move. I can feel mirror-touch with a still image if I am very still.(9)

> Still images do not affect me (8).

Mapping to Artworks and Objects

Reflective surfaces are interesting in that they give a very clean frictionless feeling.(3)

> If I am looking at a chair, I can feel the contours and texture of the chair as it would feel if I were touching it, sitting in it, or throwing it.(13)

If I were to see brick, I get the feeling of the brick; wood I get the feeling of the wood.(3)

> A 'breathing pattern' can be very relaxing. I was watching a show and it started with an animated computer pattern and I couldn't watch it because my breath stopped.(10)

If I see a tortuous line moving, I sometimes can feel it on my body, but not for long.(9)

> Sometimes entwined objects give me that pleasant mirror-touch sensation.(5)

The more wrapped up I get in a movie, I get to a point where essentially I lose myself. The mirror-touch stops being about the feeling on myself and becomes a lot more about me becoming what I am watching. I essentially stop existing for that period, and all I am is a collection of stimuli—of movements and touch and experiences—that are a part of the movie.(3)

> *Girl with Dragon Tattoo*—awoke repeatedly for mornings after watching the film, as if I was the man lying naked in the fetal position.(2)

Here are a few things that I remembered affect my mirror-touch while watching cinema:

- During action scenes, I sometimes notice various muscles in my arms and legs twitching. It is as though half the muscles are trying to imitate the action on screen, and the other half are trying to remain still.
- My breathing is affected quite often. For example, when someone breathes in loudly (in real life or on film), I find it difficult to breathe out at the same time. When people are underwater or holding their breath, I find it hard to breathe as well. There are also certain high-pitched (non-human/artificial) sounds which make it hard to breathe in.
- When people put on clothing, I often feel the fabric against my skin, often on the palms of my hands and my legs.
- When there are scenes involving cars or motorbikes, I feel arcs and elliptical partial shapes next to me, as vehicles zoom past other vehicles.(1)

The left side of *Portrait and a Dream* by Jackson Pollock (which I have seen in person) feels like floating shapes in my mouth, and the right side feels like gritty shapes in my mouth.(7)

> Horror films, really crass films, and grotesque imagery in artworks absolutely appall me because feeling these images on any part of my body (especially my mouth) is rather unpleasant. Also, these types of images can smell rather pungent.(7)

I couldn't look at a Francis Bacon because I feel swallowed and torn apart and completely weak. It's horrible.(10)

> The keys of a piano, or the strings of a guitar, I can feel as physical sensations when watching people play. And that's a joy. Feeling sensations on the arm, on the hands, on the back, on the toes! It's intimate.(12)

I'll look at a work of art and suddenly my leg or my knee needs to move up when I see a certain shape, or my elbow needs to move in a particular direction. When I look at a large artwork, I will actually do an automatic contortion of my body.(12)

> What I enjoy a lot about the sculptor Chihuly's work is that it is very tactile. For example, if I were to see one of his spheres with spikes coming off it, I wouldn't have to be actually touching it to have the sensation of being that sphere with spikes. It would essentially evoke the unusual sensation of being spiked. Imagine the sensation on your skin if spikes were to come out from your centre and stretch the skin without tearing.(3)

I love to stand in front of the Giacometti . . . very straight, upright, erect, but erect from the inside, you know? And it is a very good feeling. So I love to stand in front of them and feel I am getting longer, and I'm directed in the cosmos, like they are.(10)

> I will experience a 'spatial distortion' where I feel I am either in a different spatial configuration or that I am somehow in between elements of the art-work I am looking at. When this happens, I have to look away to feel spatially stable again.(2)

If I were to make an analogy of it, it would be like when you go to the funhouse and you see yourself in the mirrors stretched into weird figures; it's that same feeling

when you see more abstract objects. It's like my brain tries to map that body or that face onto me, so my body is turned and twisted into those figures.(3)

Objects have personalities.(4)

Intimate Otherness

Mirroring to Technology

On occasion, when my computer freezes, I feel like it is difficult to breathe, or I feel like there is some sort of obstruction in my mind.(1)

Pressing touchscreens can make me feel as if I am prodding my own chest or stomach. Sometimes it feels as if certain technologies and screen displays grope at me. My temperature and stomach sensations are affected by technologies.(2)

If someone else is touching my phone, I can feel a sensation in my back. It feels as if someone was tapping me with the hard rubber of the phone case.(12)

When the computer turns on, especially when the little light comes on, there's kind of a warming sensation. With the iPhone, as I swipe across panels or across the screen, I get the feeling of the movement across my face. Or if I'm typing on the keypad on my phone, I get the feeling of the little button pushing on my lips or around my mouth.(3)

If a fly or a stain is on my computer screen, it seems to me that it is on my face. Or if my phone screen is greasy, I feel the need to take a shower.(9)

I have an emotional connection to objects, especially technology. My laptop is 3 years old, her name is Claudia, and she is absolutely wonderful. When she messes up, I'm just like: 'Honey, no, we'll fix this!'(11)

Alterity and Connectedness

I've had dreams of myself connected, as if my body is spread across a web. And you're just part of that web with loads of others, one stitch in a massive tapestry. But on the other hand, your stitch is crucial; you drop a stitch and the fabric runs.(2)

When I was a child, I had this strange belief that we were all meant to share consciousness with each other, almost a kind of mass telepathy. I remember thinking it was so strange that we would each only experience our own minds and not those of others.(1)

One of the wonderful things that the synaesthesia gives me is an awareness of the interconnectedness of things. I have a friend who shares this view, and we have such a rapport when we speak. Sometimes we'll be in a group, and she'll say to me: 'I'm looking forward to being alone with you, so that we can speak as we usually do'. It's like jumping into a stream, connecting to something larger than ourselves.(2)

I love dance, and gymnastics too. In dance, when we were all doing the same thing, it was like a heavenly unison, a kind of synchronicity that I had never experienced before with other people. When we all have the same movements, it's such a joy.(12)

I love spending time with small children and animals, because what I experience from them is so much simpler than the deeply complex emotions of adults. When I focus on their emotional purity, I feel a profound happiness that borders on the spiritual. I believe that animals and very young children do not have the same conscious–unconscious split and that their minds are more unified.(1)

For me, all things are animate. The stones, the clouds . . . As artists have said, stone is not a dead material, it has a life. Philosophers are talking about this— it is not meant in a metaphorical way.(10)

Overwhelm and Sense-Making

I feel like a sponge! I don't become another person, but I get the whole package of how they feel in the moment. I think that the concept of colour is important— if someone is very angry, it is like I am tinted with this colour, and it becomes a physical sensation.(10)

My mirror-touch may be linked to other synaesthesia experiences which can cause domino effects. A synaesthetic image, for instance, can give physical experience.(2)

I am prone to panic attacks, and sometimes they are triggered by the emotions of others. For example, the other day, I was on a bus and a panic attack hit me

out of the blue. It was only after a minute or two that I realised the person next to me was extremely angry at something they were reading on their phone and were feeling increasing levels of rage.(1)

> This is what happens with mirror-touch. You take on the other person's emotional feeling. You then process the emotion and try and reason it intellectually. From this logical reasoning process and through sensory distraction, you may return the sense of emotion back to your normal, natural state. Sometimes this can take a lot of time and the emotions of others can be draining or cause emotional overload.(2)

When I see a movie in the evening, the next morning, I have all the images coming and I have to lay in bed, and I have to digest the images, and they come, and if I have digested them, then I can go into the world.(10)

> When I am in crowds, I always take off my glasses, so I don't have to feel so much.(1)

My mirror-touch has made family and friend gatherings slightly more difficult because processing all the physical interactions via my mirror-touch synaesthesia can be rather crushing mentally.(7)

> My political views are very strongly influenced by this empathy. But I don't, I couldn't, read any daily newspaper.(10)

Double Sensation

Double Consciousness

I was talking the other night with a couple of friends and one of them started rubbing his arm with his other hand, and he asked if I felt that in my arm or my hand. And I answered that it depended on what part of him I was focusing on.(6)

> The emotional state of others definitely amplify my own feelings. Also, if I'm around people who are really happy and I'm feeling depressed, I feel happy, but my mind is still depressed. There are conflicting emotions there.(11)

I get frightened when two people are fighting and the man is being mean to his girlfriend, say, and you see him point his finger . . . I feel what she is feeling, and

then I feel—sometimes simultaneously—like him. And I'm mad at her, and I feel **my** finger on her chest.(12)

> The worst feeling is two opposite emotions being perceived simultaneously. For example, if I have just woken up from a peaceful dream, and there is a sound of someone screaming in pain in the street beneath my apartment window, I feel as though my conscious mind is being torn apart.(1)

I think my mirror-touch helps me in a way, now that I'm older, to understand different sides of a story or where other people are coming from, or at least to be interested in where the supposed 'villain' is coming from. I'm interested in this, more than most people, I think.(12)

> It is sometimes like I am watching two movies at once. The one movie is what I am seeing with my eyes, and the other movie is the same person behaving in line with the hidden emotions I am picking up. For me, it seems that my mirror-touch has a counter-intuitive inversion to it where I experience subtle emotions much more strongly than those which are overt and in the forefront. When there is complexity, multiple layers, and subtlety is employed, I have a much more profound experience.(1)

The emotions of another person are like an orchestral piece where there is a general key and a mood, but there are also so many emotional layers. At the top is the most superficial emotion, which the person consciously experiences. Beneath this are usually layers of their value system informed by social context, beneath which I feel layers of 'structural instability' (for example, they have not learnt how to give themselves acceptance), and beneath that are old, fundamental needs which are feeding energy up through the layers above. I feel all of this. Interestingly, I cannot feel my own emotions to this depth. I can only feel the top few layers. Even more interesting is that if I record myself speaking and play it back to myself, I can feel the same depth as I do with others.(1)

> On the one hand, I can come off as more withdrawn—I don't necessarily need social interaction much—but at the same time mirror-touch can make me more of a social person because when I am in a social situation, I have the feeling that I have a better concept of all these underlying social nuances that are going on. So I can kind of eventually rub in with all those aspects of it.(3)

Retreat

I can't control my mirror-touch at all. I can only distract myself and hope it works.(8)

> I shut off my peripheral vision and keep my head down, usually, and block things out.(12)

If I'm with someone who's irritated or grieving and I pick up on those emotions, I'll begin to feel those emotions and my brain will begin to fill in with all the reasons why I'm irritated and all the reasons why I feel the grief. As all that information comes in, I can essentially check in with my own feelings and assess whether there are legitimate reasons for me to feel depressed or irritated. It can become quite clear that it's coming from the other person's emotions.(3).

> When *Avatar* came out, a friend of mine said: 'This would be the movie for you. But never look at it. It would be too much for you.' Then I saw it later on the small screen, which was different. On the small screen, I can stand to see things because I can have the distance——it is just me and an object.(10)

It is as if a thin cord related me to the movie's character, and if I concentrate on the space around me, the sound, etc., I can make it disappear. It is almost like hanging up on someone on the phone.(9)

> I can't stand to see people hurting. I would prefer to be isolated and not deal with people than to be around people who need help because I'll be compelled to help them.(11)

Neurodiversity

When I was a child, my mother would say: 'Don't make such a theatre!'(10)

> My mother hoped I would study physiotherapy. She invited me to the hospital where she worked, so that I could meet and intern with the physical therapy department. But I couldn't tell my mother that it physically hurt for me to see people who were injured. I thought everyone had the same perceptions: intense shooting electrical pain down their legs upon viewing an injury or wound, and conversely, delicious glowing skin-level warmth when other

people touch. And so I assumed something was deeply and drastically wrong with me, that the problem was mine.(5)

My mother would say, when I was little: 'You can't possibly feel what these people are feeling! You can't possibly!' And I would think, 'Why can't I? What are you talking about? Don't you? What do you mean?' I used to be a really frustrated kid. And I couldn't communicate why I didn't want to go to this place, or why I didn't want to be around these certain people.

My father would insist that my brother and I were totally ridiculous. We both have mirror-touch. But we have this kind of great communication—laughing, joking, sarcasm . . . With other people, we thought we were kind of elite. We were snobs! Because, you know, 'how could they not see what we just saw!'(12)

> I think that a lot of violence and crime occur because people are able to disassociate themselves from what is happening and ignore that their actions have affected other people. With mirror-touch, they would not have this luxury.(1)

When I started to study philosophy, I realised that for me, it is a completely normal concept—in contrast to most other students—that nobody can really confirm that his perception is like the perception of another.(10)

> Mirror-touch has made me deeply connected to the idea that we all embody tremendous differences that are not necessarily visible. It has made me very interested in the tremendous diversity of ways that we express intelligence in this world.(5)

Frames of Experience

I can't control what I do and do not feel, however, I can control what I focus on and consciously attend to. It is like an orchestra playing. You are not able to stop hearing certain instruments, but you are certainly able to focus on a certain instrument's melody more than others.(1)

> When I am at a museum and seeing a work in front of my face, my mirror-touch is more intense.(12)

Colour saturation and fantastical images help prime my brain for synaesthetic experience. Also, the environment for viewing the artwork can help foster

synaesthetic perception—low light, pink-hued light, soft furnishings, rounded edges on surfaces/furnishings; these aspects of environment can help boost my experience of mirror-touch.(5)

> Artists talk a lot about this moment of concentration, when you're completely immersed and lose yourself in the moment of working. And so for me, as a mirror-touch synaesthete, concentration is important. For example, music can destroy everything, but special music can help me.(10)

Mirror-touch experience as a choreography may be beautifully creative.(2)

Glossary

Abstraction Relating to concepts and ideas, rather than concrete 'reality'; in art, the departure from traditional representations of physical objects.

Aesthetics Philosophical study of the principles associated with artistic experience.

Affect Sometimes used to describe the expression of an emotion or physiological effect; in Deleuzian thought, an impersonal feeling which occurs prior to a personal perception or emotion.

Agency The capacity of a person to act intentionally in a given situation.

Alterity In philosophy and anthropology, a term used to describe 'otherness', that which is not oneself.

Anthropocentrism Approaches that privilege human existence and experience as central.

Anthropomorphism The attribution of human characteristics to beings, forms, or objects that are not human.

Attunement Skilful, affective response to a feature of the environment or another person, which discloses what matters for our interaction with that feature or person.

Autoscopy The experience in which an individual perceives the surrounding environment from a position outside of his or her own body. An 'out-of-body' experience.

Body maps Neural maps of the body found in the brain, which guide and monitor the body's position in space, its response to activities, and its relationship to others.

Body schema The implicit motor capacities, abilities, and habits that disclose the meaning of the environment and enable skilful engagement with it.

Cartesian dualism After René Descartes, the grounding of consciousness in the thinking self; the separation of mind and body.

Cognition Conscious and non-conscious processes involved in acquiring knowledge through thought, experience, and the senses.

Concurrent In synaesthesia, the 'extra' experience induced.

Consciousness State of awareness of both self and environment.

Contingent Dependent on, or conditioned by, something else.

Double consciousness The simultaneous holding in awareness of both one's own point of view and that of the other.

EEG An electroencephalogram, or EEG, is a recording of brain wave activity, which measures messages sent by cells in the brain, detected through electrical impulses along the scalp.

Einfühlung A central concept in nineteenth-century German aesthetic philosophy, translated literally as 'feeling in', which describes a viewer's physical and psychological empathy with artworks.

Embodied cognition A position in cognitive science and the philosophy of mind that seeks to understand how embodiment and the physical features of the body beyond the brain shape mutual interactions between mind, body, and world.

Embodiment In philosophy and psychology, emphasises the centrality of physiological or bodily factors in the shaping of psychological and cognitive experience.

Empathy The ability to share in, and understand, the feeling, thoughts, or attitudes of others.

Enactivism A theory of mind based on the principle that cognition is not predetermined, but rather produced through the mutual 'enactment' of world and subject.

Epistemology The philosophical study of the nature of human knowledge and the extents of its use.

Ethnography The branch of anthropology that studies and describes individual cultures.

Existentialism The philosophical study of the nature of the human condition and questions of existence, including individual responsibility, freedom, and choice.

Explicit In psychology, refers to a conscious process.

Extensive A concept in the work of the philosopher Gilles Deleuze, which derives from physics and is associated with substances and states that have externally spatialised properties.

Extramission theory A theory of vision proposing that visual perception results from emissions (for example, rays of light) directed from the eye to the perceived object.

Feminism A range of political and philosophical movements and ideologies, which seeks to achieve and define social, personal, and intellectual equality for women through the advocacy of equal rights for all genders.

fMRI Functional magnetic resonance imagery, or functional MRI, is a technique used in neuroimaging, which measures the brain's response to activity by detecting changes in blood flow that occur during different neural processes.

Haptic Relating to the sense of touch.

Identification In psychology/psychoanalysis, identification is a psychological process by which the individual unconsciously assimilates the other.

Immanent Refers to spirit permeating the material world, rather than residing in a realm apart, in contrast to 'transcendent'.

Implicit In psychology, refers to processes that occur without the subject's direct, or conscious, awareness.

Inducer The stimulus that elicits synaesthetic perception.

Intensive A concept in the work of Gilles Deleuze, which derives from physics (in contrast to, but not in direct opposition to, the extensive) and is associated with substances and states that are qualitative, affective, and durational.

Intercorporeality A concept first proposed by the phenomenological philosopher Merleau-Ponty which concerns the mutual connection between one's own body and the body of others.

Interoception The ability to read and interpret sensations arising from the viscera and internal tissues of the body (for example, sensing of the pace of one's heartbeat).

Intersubjectivity A term originating in the work of the phenomenological philosopher Edmund Husserl, which refers to the mutuality of subjective states between individuals.

Intra-action Term coined by the feminist theorist Karen Barad, which, in contrast to 'interaction', recognises that agencies materialise through mutuality.

Kinaesthesia The sense of one's bodily movement by means of proprioception.

Metaphor In linguistics, a figure of speech in which a subject is referred to by a term that does not literally describe it.

Metonym A subset of metaphor, which operates through proximity between two concepts and involves the naming of one thing in terms of a meaning or concept with which it is associated.

Micro-perception A concept in the work of Gilles Deleuze and Felix Guattari, which describes not a quantifiably 'small' perception, but rather a qualitatively different perception that is implicitly felt.

Mirror neurons Neurons (first identified in macaque monkeys) that are shown to be active both when an action is performed and when a performed action is witnessed.

Mirror systems System of mirror neurons that have been identified in humans.

Mirror-touch synaesthesia A neurological condition in which visual perception of touch elicits conscious tactile experiences in the perceiver.

Mise en abyme Containment of an entity within another identical entity; image of an image.

Mnemonic A system of ideas, associations, or patterns that assists memory.

Molar A concept in the work of Gilles Deleuze and Felix Guattari that describes entities, which (counter to the 'molecular') are territorialising and often associated with, or governed by, hierarchical systems of organisation.

Molecular A concept in the work of Gilles Deleuze and Felix Guattari, which describes phenomena composed, or structured by, particles that escape representational and hierarchical systems of organisation.

Multimodal Refers to the activation of multiple sensory modalities in response to a given stimuli.

Neuroaesthetics A relatively new field of interdisciplinary research, which explores the role of neural mechanisms in aesthetic encounters.

Neurodiversity Umbrella term used to describe the positive value of variations in cognitive functioning across the human species.

Neurology The medical specialty concerned with the diagnosis and treatment of disorders of the nervous system, which includes the brain, the spinal cord, and the nerves.

Neuron A nerve cell that carries and transmits information within the brain or between the brain and other parts of the body.

Neuroscience The scientific study of the structures of the brain and nervous system.

Non-anthropocentrism In contrast to anthropocentricism, non-anthropocentric approaches do not privilege human existence and experience as central, but rather encompass the value of other beings and entities.

Ocularcentrism The privileging of vision over the other senses in Western cultural thought.

Ontology Philosophical study (traditionally a branch of metaphysics) concerned with the nature of being, as well as the basic categories of being and their relations.

Partiality A concept used by the feminist philosopher Donna Haraway that emphasises difference and situatedness, over the totalitarian hierarchy of unified ideologies.

Phenomenology The philosophical study of the structures of experience and consciousness.

Pre-lingustic Of or at a stage before the development of language (by the human species) or the acquisition of speech (by a child).

Projection In psychology, the attribution of the properties of the self, such as thoughts, feelings, and motivations, to another person or agency.

Proprioception The sense of the relative position and movement of neighbouring parts of the body and muscle tension.

Representationalism The view that animals perceive and think about their bodies and environments by building and manipulating mental structures that represent their bodies and environments.

Semiotics The study of signs and symbols and their use or interpretation.

Sensorimotor Relating to the combined functions of the sensory and motor (motion) activities.

Shared manifold hypothesis A conceptual tool introduced by Vittorio Gallese to account for intersubjective communication between self and others, driven and enabled by the mirror system.

Simulation theory An account of empathy that proposes that we understand the minds of others by using our own experiences as models.

Situatedness In feminist philosophy, refers to the production of knowledge as particular to the relation of the knower to the known.

Social In psychology, refers to the actual, imagined, or implied presence of others.

Social neuroscience An interdisciplinary field of research that seeks to understand the role of neurological processes and mechanisms in social functioning and, in turn, to explore how social function impacts neurological processes.

Somatic Relating to, or affecting, the body.

Synaesthesia A neurological phenomenon in which the stimulation of one sense evokes involuntary, conscious, and subjective perceptual experience in one or more different senses. Also, in a different meaning, an artistic trope relating to metaphor.

Synergy A collection of components that act as a temporary self-organising unit, in which the components exhibit behaviour that is constrained by being parts of the synergy. Synergies exhibit emergent behaviour.

Top-down modulation Describes the way in which hard-wired neural processes are impacted by 'higher-order' cognitive processes, including expectation and attention.

Topology A branch of mathematics concerned with those properties of geometric configurations which are unaltered by elastic deformations (including stretching, bending, and knotting).

Transcendent Beyond or above the range of normal or physical human experience.

Transdisciplinarity A theoretical and methodological approach to research from and through two or more different disciplines which both integrates and moves beyond single-discipline approaches.

Transitional space In the theory of the psychoanalyst D. W. Winnicott, describes the intermediate area of human experience between inner reality and the outside world.

Transversal Associated with the work of Gilles Deleuze and Felix Guattari, refers to a movement across systems or structures of organisation that is deterritorialising. In art and art theory, the transversal refers to fields of research and practice that bring heterogeneous modes and methodologies into collective dialogue.

Uncanny In psychology and psychoanalysis, describes the strange condition of experiencing phenomena that are simultaneously familiar and unfamiliar.

The Virtual In Deleuzian thought, the virtual is an order of potentiality that is real but not actual, ideal but not abstract.

Index

Note: Figures are indicated by an italic *f* following the page number; Endnotes are indicated by 'n'.

brain, the (*cont.*)
 and perception of pain, 60–1, 62, 331
 and perception of touch, 58–9
 right temporo-parietal junction (rTPJ)
 social cognition, 63, 64
 somatosensory cortex, 59–60
 temporo-parietal occipital junction
 (TPJ), 63, 64, 146
Brancusi, Constantin, 127, 344
Braudel, Fernand, 279
Brazil, steel town fieldwork, 25, 291–6
breathing, 141, 248, 331, 350
 mirrored, 5
 patterns, 348
 when watching cinema, 348
Breton, André, 290
Breuer, Josef, 319n21
Bruguera, Tania, 11
Bruno, Giuliana, 15, 17, 27
Bühler, Charlotte, 143
buildings, as pliant surfaces, 110
buri nazar wale slogan, 95–6

C
Callois, Roger, 289, 290, 291
canny, the, 224, 231
capitalism, 11, 25, 173, 174, 288–9, 290,
 292, 297, 313
carpets
 dragons on, 155, 157f
 Drake Hotel, Chicago, 152f
 patterns, 151, 161–2
Carrello, Claudia, 184
Cartesian
 cut, 305, 317
 dualism, 11, 19, 357
Catholic charismatic healing, 22, 234
Chalayan, Hussein, 172
chaos, 191, 197, 198–9, 200, 204
Charmatz, Boris, 25, 275, 277
Chemero, Anthony, 20, 27
Chihuly, Dale, 129, 130f, 349
Chihuly in the Garden (Chihuly, glass
 sculpture), 130f
children, 49, 52, 137, 143, 194, 343, 351
chimpanzees, 153

chinoiserie motifs, 163
choreography, 49, 250, 271, 274, 277, 297,
 309, 356
cinema, 12–13, 73, 110, 113, 114, 120, 291
 Bombay, 17, 103
 books, 79
 contemporary, 88, 296
 mirror-touch while watching, 348
 Wong Kar-wai, 110
cinematic
 consciousness, 296–7
 images, 315
 movement, 169
 skin, 297
cinesthetic subject, 13, 315
Cioffi, Maria Christine, 146
Cleghorn, Elinor, 7, 19, 64, 125–36
clinical synaesthetes, 194, 195
clothing, 109, 155, 348
clouds, 248
clowns, 248
cognition, 8, 25, 84, 159, 179, 193, 348,
 357
 embodied, 8, 12, 20, 48, 188, 193, 358
 extended, 179, 180, 182
 social, 60, 63
cognitive
 framing, 82
 revolution of the late 1950s, 177, 186
 science, 48, 177, 178, 180, 182, 188
 system, extended, 179, 180, 182, 183
cold sensations, 5, 137, 340
collective
 innervation, 174
 powers, 151, 174
Collins, Phil, 11
coloured
 hearing, 3, 4, 125
 letters, 21, 29n14, 125
 phonemes (letters and numbers), 125
 voices, 71
colours, 74, 76–8, 79, 83–4, 110, 289, 351
 black and white, 77–8
 and emotion, 76
 grapheme-colour synaesthesia, 57
 making sense of, 75–8

mirror-touch (*cont.*)
 categorising, 125
 examples of, 340–1
 experiences of, 340
 management of, 245
 as a metaphor, 8
 modulation of, 343–4
 neurocognitive model, 129
 reader, 339–56
 as a social synaesthesia, 24, 126
 study in social neuroscience, 29n13
 see also touch
mirror-touch synaesthesia
 categorisation of, 17–18
 definition of, 360
 description in scientific literature, 192
 to embodiment, 56–8
 fourth dimension and, 78–83
 interpersonal synergies and, 184–8
 introduction to, 5
 participation in the world, 193
 virtual body and, 208n23
 see also synaesthesia
mirrors, 15, 42, 102, 245, 324, 349
Mirzakhani, Maryam, 273
mise en abyme, 360
Mitchell, W. J. T., 24
mnemonic, 21, 71, 85, 114, 118, 360
molar, 159, 360
molecular, 159, 360
Mollona, Massimiliano, 16, 25, 27
moment of concentration, 356
Monadology (Leibniz), 152
monads, 153, 166
money, 288, 298n3
monkeys, macaque, 10, 59,
 127–8, 318n6
montage, 74, 75, 85
Montanaro, Michael, installation with
 candle, water and responsive
 media, 284f
Moore, James, 146
Moore, M. Keith, 140
Morgan, David, 166
Morin, Edgar, 287, 297
morphing, 249

Morris, Robert, 11, 42, 271
 Bodyspacemotionthings exhibition,
 271–2
Mortal Coils (Schneemann installation), 51
moss, 248
mother, and fetus, 140–1
movements, 74, 199–200, 347
 central role of, 207n17
 cuts, 198
movies *see* film(s)
Mr Norris Changes Trains (Isherwood), 91
Mroué, Rabih, 26
 Double Shooting (installation), 326f
 The Pixelated Revolution (lecture-
 performance), 323f
 Shooting Images (video still), 26, 321f
Mucha, Alphonse, advertisement for Job
 rolling paper, 166, 167f
multimodal, 360
Musée de la Danse (Charmatz), 275, 277, 278f
Museum Highlights (Fraser), 283
museums, 279–80, 282, 355
music, 49, 74, 85, 144, 169
 and colours, 28n7, 75
 and sound, 75
 visual, 29n8
mutual interpenetration, 198, 202

N
narcissism, 41–2
narrative, 144
Nathdwara, India, 100
navigation, automatic, 249
nazar (evil eye), 17, 93, 95, 99, 100
nazar utharna (removal of the evil eye), 95,
 96, 98
nearness, 22, 24, 328, 333
nerdy questions about exact pitch, 23,
 251–60
neuroaesthetics, 5–8, 360
neurodiversity, 328, 354–5, 360
neurological conditions, 3, 138, 146, 360
neurology, 327, 360
neuron, 360
 see also mirror neurons
neuroscience, 360